TREASURES FROM SCYTHIAN TOMBS

in the Hermitage Museum, Leningrad

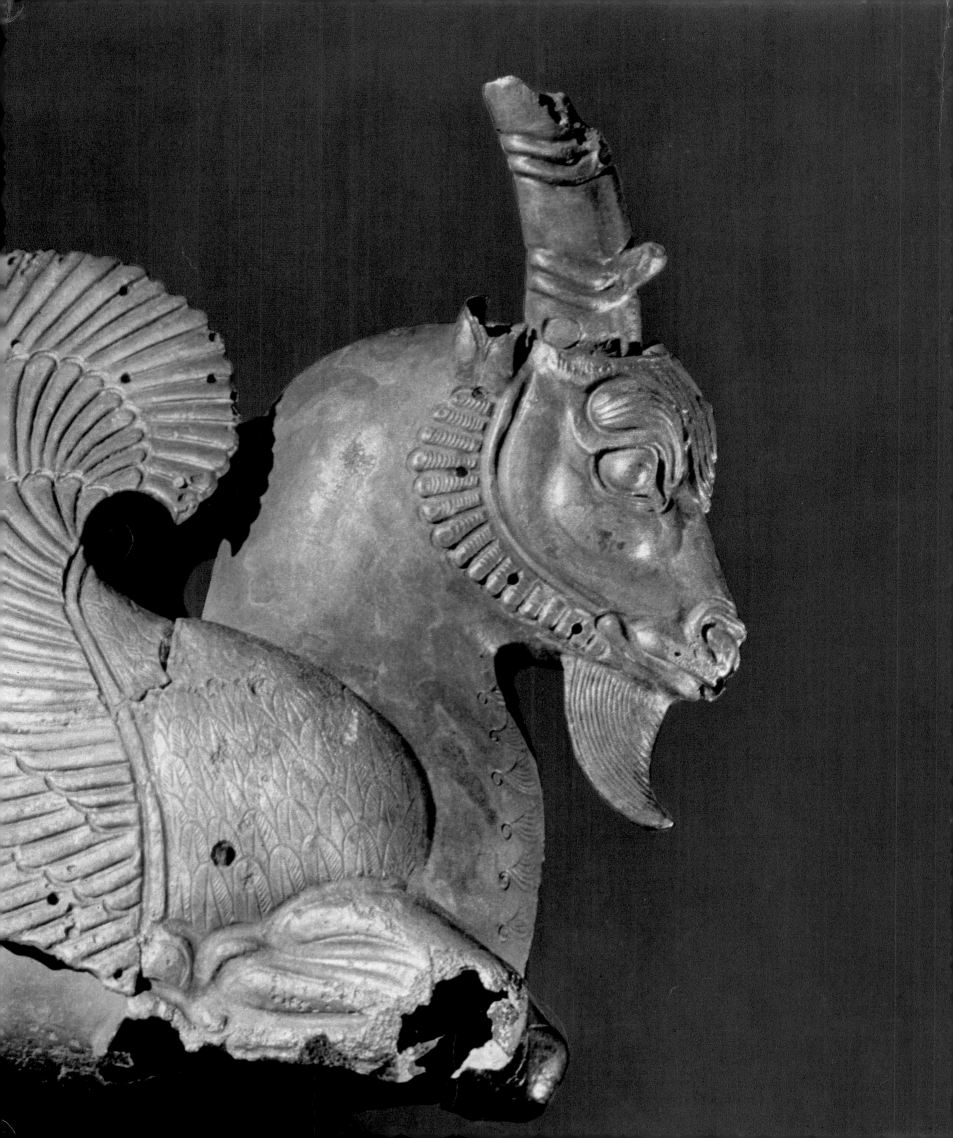

M. I. Artamonov

TREASURES FROM SCYTHIAN TOMBS

IN THE HERMITAGE MUSEUM, LENINGRAD

with an introduction by Tamara Talbot Rice

photographs by Werner Forman

190 colour plates

298 black-and-white plates

23 diagrams and 2 maps

THAMES AND HUDSON · LONDON

Frontispiece: finial shaped like the sculptured forequarters of a capricorn

Professor Artamonov's text, translated from the Russian
сокровища скифских курганов by V. R. Kupriyanova,
has been abridged for this edition

Designed by B. Forman

CONTENTS

INTRODUCTION

From south and east of the Carpathians and north of the Caucasus eastward to the mountains of Mongolia and Siberia stretches a vast area of comparatively flat land. Bounded in the west by the Danube and in the east by the Yenisei, it is the one major geographical feature which both Europe and Asia share; appropriately, it has been named the Eurasian plain. Watered by several large and numerous smaller rivers, its tracts of fertile land alternating with desert steppes have attracted a succession of primitive peoples, mostly nomadic, since very early times. Excavations carried out in various sections of it have led to the discovery of artifacts dating as far back as 30,000 BC. Some of the people who made them, such as the community associated with the site of Kostenki, just south of present-day Voronezh, or that far away to the east at Malta, slightly north of Irkutsk, to mention only two, were already able to fashion votive statuettes of artistic merit. By the Neolithic Age, many sections of the Eurasian plain were inhabited by settlers who, though continuing to rely on their skill as hunters and fishermen for much of their food also, whether living in the region and period of the Ukraine's Tripolje culture or in parts of western Siberia, were engaged in cultivating the soil. On the upper reaches of the Yenisei and in the Altaian lowlands, others had turned to pastoral occupations, domesticating sheep, goats, dogs, pigs and so on, learning to rear and care for them in order to improve their diet and to obtain regular supplies of wool, leather and felt. These advances were to result in the birth and establishment of nomadism — a way of life which is wholly dependent on the ability of those practising it to maintain and control herds of domesticated animals. By the first millennium BC nomadism was flourishing in the Eurasian plain. Though it

9

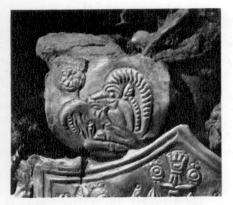

2 DETAIL OF GOLD CASING FROM
THE SWORD HILT SHOWN IN
PLATE I

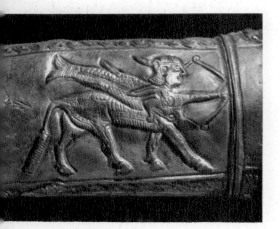

3 DETAIL OF GOLD SCABBARD
CASING SHOWN IN PLATE I

embraced the whole of it, it may well have originated in its Asiatic section. By about the year AD 1000 it had spread across northern Iran and penetrated to Anatolia. To this day, groups of nomads are occasionally encountered here and there in central Asia, Iran and Anatolia.

The nomadic way of life is one of extreme complexity and hardship. The herds on which the tribe's survival depends are in constant need of pasture, water and protection, all of which have to be ensured regardless of climatic vagaries and disasters. Dangers of many kinds continually threaten a tribe's existence, demanding from each member initiative and daring, and at the same time prompt obedience to the chieftain. Indeed much of a tribe's well-being rests on each tribesman's recognition of the chieftain's supreme authority. However, each tribesman is also a freeman, whose personal life centres on his family in which his word is law. Though the nomadic way of life obliges those who follow it strictly to limit their possessions, from the very dawn of nomadism each nomad has been the sole owner of his chattels. Communal ownership is unknown among nomads, nor have personal possessions of any family unit ever been subjected to any form of control. These customs help to account for the variety which distinguishes the non-essential possessions, those classified as luxury wares, which are associated with specific nomadic communities. A comparison of such articles with those essential to each tribal family in antiquity reveals a disparity in wealth which serves sharply to distinguish the burials of rich members of the tribe from those of no less free or characteristic poor members.

The Eurasian plain contains innumerable mounds of different aspect, size and type, all of which were erected by nomads as burials for their dead. Many have been flattened by the combined action of time and man; many still await discovery. The earliest of those that have been excavated belong to the Neolithic Age and include the rich royal burials of Maikop in the Kuban, while the latest date from the 13th to the 15th century AD and are assigned to the Mongol and Tartar warriors who invaded Russia early in the 13th century and remained in control of much of the country for over two hundred years. Excavations have shown that a large number of the mounds had contained numerous objects of great intrinsic value; they testify to the wealth and prowess of many nomadic chieftains, for much of a tribe's prosperity was related to the tribesmen's skill as raiders and their courage and success in battle. Of all the burials, the most exciting are surely those which were erected by the Scythian and kindred tribesmen in the course of the first millennium BC in what is now the south Russian section of the plain, for the objects which have been recovered from them are decorated with designs which form a distinct, remarkably vital and interesting school of decorative art.

There is ample evidence that the culture which we associate with the Scythian nomads was shared with but minor local variations by the majority of the tribes living

in the Eurasian plain during the years when the Scythians controlled large sections of it, and that this culture made itself felt among the tribes living in remote regions of the Asiatic sector. When we contemplate the Scythian way of life, the diversity, ingenuity and range of their possessions, the extent of their influence ceases to surprise. In the utilitarian sphere tribesmen in the Scythian world provided themselves with such practical objects as tables with detachable, tray-like tops, rugs, felt hangings, cushions, satchels and purses, not to speak of a wide variety of tools and an immense range of cooking utensils and weapons. These included great cauldrons, generally mounted on a cylindrical base enabling them to be stood in a fire instead of suspended above it. Their handles were often in the shape of animals. All these objects were lavishly decorated, though the finest ornamentation was carried out on valuable metal vessels, articles of personal adornment and the gold plaques intended as dress trimmings, as well as on weapons and horse trappings. For these the Scyths often used gold, encasing their weapons and saddles in elaborately worked thin sheets of gold and adorning their horse trappings with metal or wooden decorations.

The Scyths were illiterate and many basic facts relating to their history remain unknown to us partly for that reason. Major problems that await solution concern the precise region of the Eurasian plain which served as their first homeland; existing evidence suggests that it was situated to the north-east of the Caucasus. There is also reason for thinking that the Scyths were Indo-Europeans, possibly of Iranian stock, and that they spoke an Iranian language which was probably related to Avestic, but which varied slightly with each region and major tribal unit. The Scyths enter history as victorious warriors. Their military successes were probably largely due to their ability to ride on horseback. Some scholars believe that they were the first people to have done so; this is open to question but no one can deny that the Scyths were among the world's earliest and assuredly its most accomplished horsemen. Their prowess in riding did much to raise their standard of life. It also gave them an immense advantage over those of their fellow nomads who were unable to do so, as it did over the settlers living on the edges of the plain. The rider's superior speed and mobility were valuable assets in the battle-field, on raiding expeditions and out hunting, enabling the tribal light-cavalry units to contend successfully against the foot archers and charioteers of such great military powers as China and Assyria. It was as much in order to maintain the tribesmen's skill in horsemanship as it was for the purpose of keeping them entertained and of encouraging youths to train for warfare that, at certain established periods in the year, Scythian men gathered to test their ability in mounted contests similar to those in which horsemen in Afghanistan and Outer Mongolia still delight. The horse became the Scyth's most cherished possession. Though the tribes kept large flocks of sheep, they attached most importance to their herds of horses, carefully rearing and

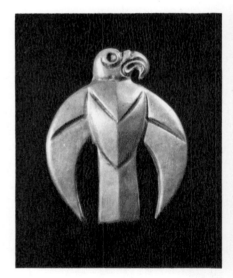

11

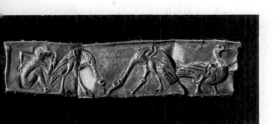

6 RECTANGULAR PLAQUE. GOLD

7 RUNNERS FOR REINS. BONE OR HORN

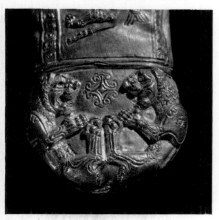

8 DETAIL OF GOLD CHAPE CASING

then devoting many hours to breaking and riding them. No Scyth ever used the horse as a draught animal; for this purpose, in the west, he retained oxen and, in the east, camels. It is unlikely that he even allowed his womenfolk to ride his horses. He and his sons alone did so; and at death their favourite mounts went with them to the grave. Thus virtually every Scythian burial is a horse burial, although Professor Artamonov found that this did not apply to the Scyths who were buried in shaft graves in the Crimea during the 4th century BC.

Unrest among the tribes living in the vicinity of the Oxus probably caused the Scyths to migrate westward. They must have reached the region of Lake Urmia early in the 8th century BC, for Assyrian chroniclers mention their first appearance on their country's borders during King Sargon's reign (722—705 BC). Herodotus thought that the Scyths invaded Assyria when pursuing the Cimmerians — a somewhat similar nomadic community who lived and controlled what is now southern Russia prior to the Scyths. Professor Artamonov dates the advent of the Cimmerians or, as he terms it, their invasion of Assyria, to the years 722—715 BC, years when, he believes, the Scyths had got no further in their western migration than those regions of the River Araxes which came in consequence to be known as Sakasana; but Jettmar[1] believes that in 714 BC the Scyths were allied to the Cimmerians, who were at war with the Urartians. Artamonov considers that it was not until 673 that the Scyths, acting as allies of the Mannaeans and the Medes, came into conflict with an Assyrian military unit engaged in collecting the tribute owed to Assyria by the Medes. By then the Scyths, living as they were at a time when the Bronze Age was giving way to the Iron Age, had for the most part replaced the bone arrowheads of their forebears by the bronze or iron trefoil-shaped types which are associated with them. Artamonov tells us that their chieftain was killed during the raid and that his successor, King Partatua, made his peace with that country. It was therefore a joint Assyro-Scythian force which raided Manna but failed to prevent the Medes from forming themselves into a powerful state. According to Artamonov Partatua's son, Madyes, was still allied to Assyria in 654 BC, when he engaged the Cimmerians, now entrenched in Cappadocia, in battle, put them to flight and pursued them, killing their chieftain in Cilicia. After a hiatus, during which he loses track of them, Artamonov resumes their story in 623 BC when, he tells us, they helped the Assyrians to defeat the Medes engaged in besieging Nineveh. Certain other historians assign that event to the year 635 BC, believing that it was then that the Scyths pursued the Cimmerians across Phrygia, invaded Lydia and looted the Greek coastal cities. All scholars agree that the Scyths were so elated by their victory over the Medes that they pressed forward — according to Artamonov, in company with the Babylonians — into Syria and Palestine but that, on reaching Philistea, they consented to be bought off by King Psamatek and to withdraw west

12

of the River Halys. It was there that they set themselves up as masters of what is now north-western Iran. Soon they were regarding themselves as peers of the Babylonians and Medes. By 594 BC, the Medes could no longer endure their arrogance. Artamonov has described how their king therefore invited the Scythian chieftains to a banquet and treacherously put them to death as they partook of it. The Scyths were left leaderless and as such proved no match for the Medes. In 585 BC they were forced to relinquish their Iranian conquests and to agree to withdraw from the area in the direction from which they had invaded it.

The Scyths moved northward, passing through Urartu. Then some veered east, to settle between the Caspian Sea and the Sea of Aral, where they intermingled with the local population, some eventually merging with the Parthians, while others pressed on towards India to become assimilated by the Dravidians. Others again lingered in the Kuban district of the Caucasus, but the majority pushed further north before turning west to take possession of the section of the Eurasian plain which lies between the River Don and the River Dnieper. The group of nomads to whom it is alone correct to apply the name of Scyth formed the kingdom known as that of the Royal Scyths on the lower reaches of the latter river. Some were gradually to move further west and eventually to penetrate to the Danube.

The ramification of the Scythian and kindred clans is so involved and embraces so many obscure tribes that, regardless of the information contained in the works first of Assyrian chroniclers, then of classical geographers and historians, it remains difficult to assign each to a specific region; it is therefore not unusual to find most of the nomads who, from the 7th to the 3rd century BC — the period covered by Prof. Artamonov in this book — lived in what is now the south Russian section of the plain, referred to as Scyths.

That over-simplifies the situation, for there were different groups of nomads living on the borders of the kingdom of the Royal Scyths and in more distant regions who had a history of their own. To the north of the Royal Scyths, moving from west to east, there were the Getai, the Agathyrsi, the Neurs with, to the south of the latter, a pocket of Scythian settlers. Next came the territory of the Androphagi with, to the north of them, that of the Melanchlaeni, and to the east of the Melanchlaeni, the Budini. These communities doubtless included a number of people of Thracian, Slavic, possibly even of Finnish origins. East of the Don the Sauromatians, nomads who shared the Scyths' way of life and culture, controlled the north Caucasian lowlands, while the Sarmatians — the nomads whose heavy cavalry units were to play so decisive a part in the destruction of the Scyths during the closing centuries of the pre-Christian era — were to appear from the east on the upper reaches of the Don during the 4th century BC.

Still further to the east in central Asia, the Sakas were in command, while the Hsiung-Nu were living in the Altai and as far eastward as western Mongolia. All these

13

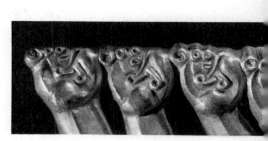

9 DETAIL OF THE SHIELD BOSS
SHOWN IN PLATE 22

10 POLE-TOP ENDING IN A ROSETTE.
GOLD

11 DECORATED HOLLOW ROD. GOLD

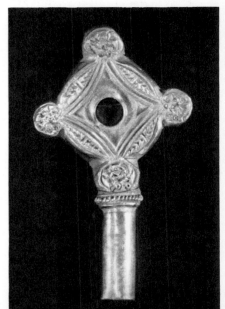

12 HOLLOW TERMINAL.
SILVER, GOLD

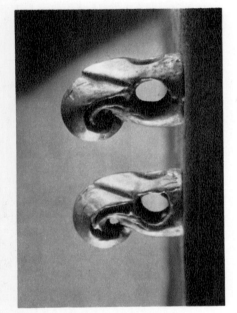

13 RUNNERS FOR REINS. BRONZE-GILT

major tribes, together with numerous minor ones, formed a single material cultural community. There were, however, religious, artistic and political differences between them. Thus, in contrast to the Sarmatians, who favoured a matriarchal rule and whose unmarried women fought the tribe's enemies as bravely as did its men (thereby inspiring the Greek tales concerning Amazons) the Scyths obliged their womenfolk to live in subservience and to minister to their needs by cooking their food, making their clothes from the hides they had cured and transformed into leather or furs, pounding wool into felts of various qualities and thicknesses, sewing with gut thread they had made from the sinews of dead animals, using buttons they had cut from their antlers, horns and bones. Did the women weave their own stuffs? We do not know for certain, but there is much evidence to suggest that they did. When a tribe was on the move Scyth women, girls and young children travelled in covered waggons, sleeping and living in these; or else the felt hoods would lift off to form tents; sometimes, separate tents were set up for them. When the men went to war, to a rally or a lengthy hunting foray, the women took over the tending of the flocks and herds in addition to caring for the children. It was they who milked the mares which supplied the tribe with its favourite beverage.

The founding of the kingdom of the Royal Scyths coincided with the expansion of the settlements which Greek colonists had established on the northern shores of the Black Sea into flourishing city-states. The first Greek settlers had come there in the 8th century BC following in the wake of sailor-prospectors who had been lured to those distant coasts by tales of Jason and the Golden Fleece. The sailors had come in search of gold, but the colonists were seeking the grain and foodstuffs which their homeland was unable to produce in sufficient quantities. The expansion of their settlements into such flourishing ports as the virtually self-governing city-state of Olbia, situated near the mouth of the Bug and Dnieper, of Panticapaeum, which was situated close to present-day Kerch, or of Chersonesus near to present-day Sevastopol, and the prosperity of smaller outposts, such as Tanais on the Don or Phanagoria on the Taman peninsula, must surely in each case have resulted from a startling expansion of trade. That development must to a great extent have been due to the skill and speed with which the Royal Scyths, though few in number, established themselves as overlords of their section of the plain, using their position to act as extremely efficient middlemen in the trade carried out between the settled agriculturists of the hinterland and the Greek merchants living in these ports. The efficiency with which the Scyths gained control of the inland trade cannot be ascribed entirely to tribal discipline. The Scyths must surely have learnt a great deal about trade and administration during the years they had spent in western Iran, either as allies of the Assyrians and Babylonians or as rulers over smaller, yet scarcely less sophisticated people. That experience must also have helped to develop their sense of self-importance, their belief that they were fit to

14

temples for their deities, there were no major monuments in which to display their artistry. Since they venerated the elements, they worshipped the gods personifying these in the open, choosing for preference some spot hallowed by tradition. Thereby they unconsciously enhanced the importance of their burials for, apart from the facts which Herodotus and other scholars of the classical age were able to discover, our knowledge of Scythian art and customs depends on what archaeologists have deduced from studying excavated tombs and the objects which they have recovered from them.

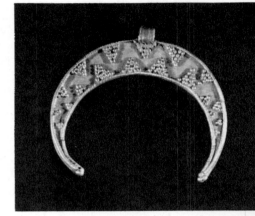

The rites performed at the death of a Scythian noble reveal how costly these funerals were, both materially and in terms of human and animal life. According to Herodotus, the embalmed body of a dead chieftain dressed in his finest clothes and jewellery was placed on a cart and carried for a period of forty days to all parts of his territory. It was accompanied on this journey by his tribesmen who expressed their grief by lopping off their ears and cropping their hair, and who continued to mutilate their bodies as they advanced, shouting and wailing to the accompaniment of rattles and bells in order to frighten evil spirits away. Burials could not take place until forty days after the death had occurred. By then even a chieftain's tomb would be ready, the approach to the burial chamber and the chamber itself having been dug and fully furnished. On the day of burial the corpse was lifted from the funeral cart and carried to its prepared place within the tomb. The standards, pole terminals and rattles which had been carried in the funeral procession were placed in the grave and the dead man's weapons laid beside and within easy reach of him. It was not unusual for a ruler's concubine and head servants, such as his cup-bearer, head groom and cook, to accompany him to the next world. The same fate was meted out to his horses. The human victims were buried wearing their finest clothes and jewellery, the horses clad in their ceremonial harness and trappings. The cart which had carried the dead chieftain to all parts of his territory was placed either in the burial chamber or in the passage leading to it. Then the grave was filled in and when the mound marking its site had been raised, a wake was held on its summit. In due course, yet a further ceremony had to be performed. According to Herodotus, on the first anniversary of the chieftain's burial fifty warriors chosen from the freemen enrolled in his bodyguard were put to death together with their mounts. Then each was hoisted onto his dead horse, the stake impaling him to it penetrating the earth, thus keeping both upright. The fifty sacrificed victims were arranged in a circle around the mound for the purpose of guarding the tomb from desecration — a duty they proved powerless to perform, at any rate where tomb robbers were concerned.

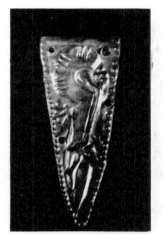

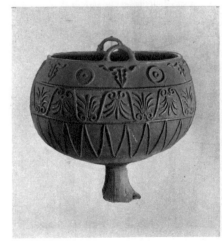

Scythian burials of importance contained such quantities of articles of intrinsic value that most of those that have been excavated turned out to have been plundered in antiquity. Nevertheless the thieves generally overlooked or discarded so many objects,

17

22 GOLD BUTTON

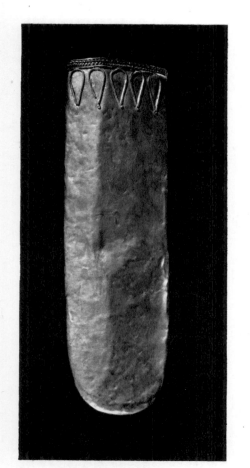

23 SWORD CHAPE WITH ALMOND-
SHAPED CELLS. GOLD

that an astonishing number either made of or encased in gold, electrum, silver, bronze, iron and other valuable materials have been recovered, in addition to numerous weapons, tools, utensils, fragments of clothing, furnishings, furniture and so on. These show the Scyths to have been outstandingly gifted exponents of an art which, though primarily zoomorphic in character, makes frequent use of geometric and floral motifs. It is an art which, largely because of the originality with which they were able to blend in it realism and stylization and to create numerous variations on certain given themes, arouses our interest in these nomads who roamed the Eurasian plain some two and a half millennia ago.

Reliable information concerning the origins of Scythian zoomorphic art and the date of its birth still eludes us. The style already appears in a highly developed form in the objects which have been recovered from the earliest barrows known to us. Nor does it undergo any radical changes during the remainder of the Scythian period, though Professor Artamonov draws attention to certain minor stylistic modifications in the 4th century BC. For instance, in the Alexandropolsky burial, the ornamentation is flatter and more schematic in character. Until we discover more about the art of the Cimmerians, we cannot tell whether they influenced the art of the Scyths, who were to replace them in southern Russia, and if so, to what extent. Certain features in the essentially decorative art of the Scyths point to the possibility of the earliest work having been executed on wood or stone, their techniques having seemingly been retained by the craftsmen who worked the costly metals which the wealthy Scyths substituted for the less precious materials. Although this theory is probably sound, it does not help to solve the problem of whether the Scythian carvers were self-taught, evolving their own designs, or whether they acquired their knowledge and their repertory from the woodmen of the forest belt or the bone carvers living on the coasts which fringe it to the north. Neither can we as yet assess the significance of the animal forms which recur with such frequency in Scythian art, in particular whether the stag and its antlered relatives served originally, as some scholars believe, a magical or religious purpose; nor ascertain whether the geometric designs that were regarded as symbols by the sun-worshipping communities of antiquity, and which appear in Scythian art, had a special meaning for the Scyths. We know nothing about the artists themselves, whether they formed a distinct class or whether each household was responsible for the decorations which adorned its possessions; nor do we know the conditions under which the jewellers and metal-smiths worked. Some scholars have suggested that the men who created the metalwork may have been foreigners, possibly prisoners of war. This is a view with which it is difficult to agree, since it would surely have been well-nigh impossible for aliens to master so distinctive a style sufficiently to enable them to produce works of uniform quality and character. Neither is it likely that craftsmen who

18

had been accustomed to a settled form of life would have been able to work efficiently when leading a nomadic existence; conversely, had men such as these established themselves in some neighbouring settlement, archaeologists would surely by now have discovered traces of their workshops. Most of the objects made in the Scythian style must be accepted as Scythian creations. Since metalworkers in the Minussinsk Basin are known to have used portable forges in pre-Scythian and early Scythian times, the possibility of the Scyths having done so should perhaps be borne in mind.

Another problem awaiting solution concerns the source of Scythia's gold supplies. Very considerable amounts of this costly metal must have been needed for the production not only of the numerous objects which have been recovered from Scythian burials but also for those which the robbers removed and which can reasonably be assumed to have been more valuable than the ones they disregarded. The ancients believed that griffins, of both the lion-headed and the eagle-headed varieties, kept hourly watch over the gold deposits of Tibet and Siberia. Can the frequency with which these creatures appear on Scythian objects be regarded as an indication that the tribesmen shared that belief, and if so, that they obtained their gold from Asia? Whatever the source of the supply, there is nothing to show how they paid for it. During much of their history they possessed no coinage. The absence of material finds other than arrowheads, which are known to have served on occasions as currency, may perhaps indicate that some consumable luxury commodity such as wine could have been used for the purpose.

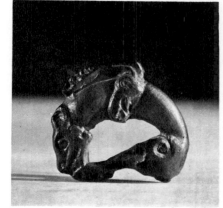

24 BRONZE PLAQUE

Practically every object belonging to a Scyth is decorated over its entire surface. Certain authorities have ascribed the over-all nature of the decorations to a *horror vacui*, an aversion to plain surfaces. It seems equally rational to trace it to a love of design so fervent that, because of the limitations resulting on the one hand from the absence of buildings and, on the other, from the need strictly to limit the number of their possessions, the Scyths gave free expression to their delight in ornament whenever the opportunity presented itself. The profusion of decorations is such that at times the figures of small animals appear on the bodies of larger ones.

25 BRONZE PLAQUE

The animals which animate Scythian art are invariably spirited; often they are rendered with the greatest mastery. The gold plaque in the form of a recumbent stag, twelve inches long, which was recovered from the Kostromskaya burial (pl. 62) is one of the finest and most characteristic examples of the style. The manner in which the animal is portrayed, squatting with its legs drawn up beneath its belly, seemingly in repose yet by no means relaxed, for its head is raised as if scenting danger, is typical of the art. Its antlers are stylized and the way they are shown extended along its back emphasizes the decorative nature of their treatment. The technique employed is specifically Scythian, the gold being worked to form inclined planes; by reflecting the

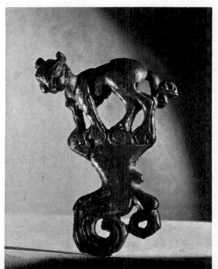

19

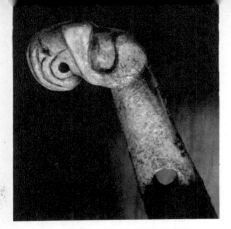

26 FRAGMENT OF A CHEEK-PIECE.
BONE OR HORN

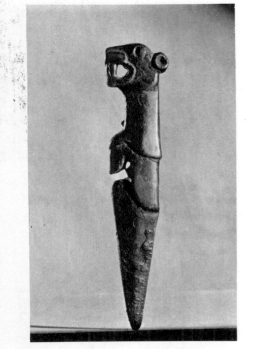

27 ELONGATED PLAQUE. BRONZE

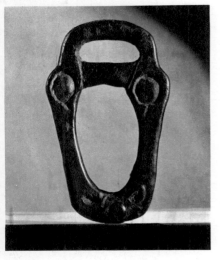

28 BRONZE BUCKLE

light these serve to stress the tautness of the animal's muscles and to endow it with vitality. A similar blending of naturalism and stylization is to be found in other masterpieces, such as that of the gold panther from Kelermes (pl. 22). Animals either modelled in high relief or in the round lose none of their character and forcefulness when presented curled into a circle even when, as the nomads of western Siberia in particular were wont to show them, their hind-quarters are turned in inverse direction to the body, as, for example, is the case with the gold beast of prey in the form of a plaque from Solokha (pl. 78). Other essentially Scythian compositions include combat scenes, often involving a beast of prey and an antlered one, as on the plaque which decorated a saddle found in the Chertomlyk burial (pl. 120). Birds with prominent beaks also occur frequently but, rather surprisingly, the horse is represented relatively seldom. Zoomorphic junctures or elaborations and superimposed designs play so prominent a part in the art that these must have been invested with considerable significance by the nomads. They are to be seen in an especially vigorous and successful form in the bronze standard illustrated in plate 58.

Masterpieces such as these proclaim the talent and superb skill of the artists who created them. Seen in this light, it seems no more than natural that the Scyths should have responded to the artistic trends prevailing in the leading contemporary states. Thus, dependent on the locality and period in which they lived, as well as on the trade routes which passed close to their grazing grounds and the political and commercial links which they formed, the Scyths were influenced by the art of Iran and Greece, sometimes even by Egyptian art and, in the Altai, by that of China. Professor Artamonov is quick to draw attention to the Iranian and Greek elements in Scythian art, noting the presence of the former more especially in the earlier Caucasian barrows such as Kelermes, but also finding evidence of it in such burials as the Melgunov. That influence is responsible for designs consisting of processions of animals, of winged lions and of beasts whose prototypes are to be found in Iranian art. Greek elements appear with greater frequency, and Artamonov shows how, with the passing years, this influence steadily increases. Having first stemmed largely from Ionia, it is the Greek colonials who make their impact increasingly felt in southern Russia, until in due course their native style takes precedence over that of the other foreign schools.

In order to appreciate how much Scythian aristocrats were bemused by Greek culture, it suffices to recall the fate of Scyles, ruler of the Royal Scyths in the 5th century BC. On reaching manhood he became so passionate an admirer of things Greek that he eventually married his widowed Greek stepmother. Then, oblivious of the profound attachment felt by his tribesmen for their nomadic culture and way of life, Scyles secretly acquired a house of the Greek type in Olbia. He used to steal away to it whenever possible and eventually could not resist attending the celebration, in a neigh-

bouring temple, of the Dionysian rite. His bodyguard discovered this. Outraged, the tribesmen broke into the town and murdered Scyles as he left the temple. Though no other Scythian was ever to express his philhellene sympathies so clearly, wealthy Scyths did not cease to acquire objects of Greek workmanship, whether imported or locally made. Greek amphorae and delicate pottery vessels have been found in many a Scythian burial; some, like the subject of plate 140, are of excellent quality. Other Scyths acquired silver dishes or medallions decorated with scenes drawn from Greek mythology (pl. 216): with Medusa heads, the figure of Silenus, satyrs, dancing maenads, whether shown in conjunction with Greek motifs such as the palmette or with eastern ones and even such delicate examples of Greek workmanship as the ivory plaques decorating the Kul Oba sarcophagus (pl. 258). The colonial Greeks seem to have been very willing to work for Scythian patrons. They were perhaps too dependent upon them as commercial middlemen, perhaps too nervous of their behaviour, when angered, not to do so. The fact that three identical sword sheath casings of Greek workmanship were found in the Chertomlyk burial indicates that certain local workshops made a habit of working for the nomads. An outstanding series of objects, all of Greek workmanship, must have been executed to the specific orders of individual Scythian patrons. Each vessel in the series records scenes drawn from Scythian life. They are rendered in such detail and so convincingly that it is evident that the craftsmen responsible must frequently have seen the incidents they portray. The famous Chertomlyk vessel illustrated in plates 62-63, with its frieze of horsemen engaged in lassoing, breaking and harnessing their horses, is perhaps the most exciting and evocative of them all, but the comb from Solokha (pl. 147/8) is among the most beautiful and the most sophisticated. The series as a whole records the physical appearance of the Scyths as well as their profusely trimmed clothes and characteristic weapons. The latter clearly illustrate the use made by the Scyths of the foreign elements which were within their reach. Thus such essential weapons as their daggers or *akinakes* and the heart-shaped guards on their swords stemmed from the Iranian world while the *gorytus*, a combined bow and arrow case, derived from Greece.

By studying Scythian art, considering the problems which it raises with regard to the Scyths themselves and the light which it throws on their relationships with their neighbours, it becomes possible to distinguish and appreciate those elements in the art of these neighbours which such of their less-sophisticated contemporaries as the nomads particularly admired. That knowledge in turn contributes something to our own understanding and appreciation of the Iranian and Greek cultures of the first millennium BC.

Tamara Talbot Rice

21

29 CHASED PLATE. GOLD

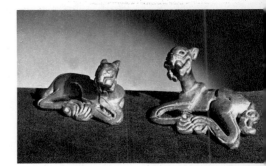

30 BRONZE PLAQUES

31 BRIDLE FRONTLET. GOLD

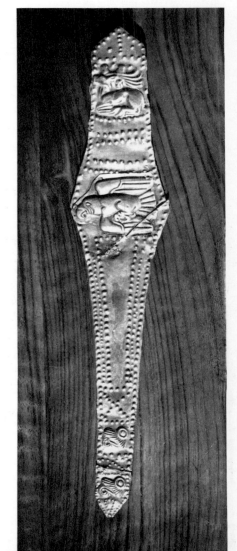

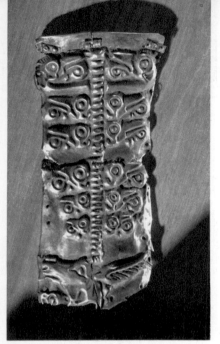

32 RECTANGULAR MOUNTING. GOLD

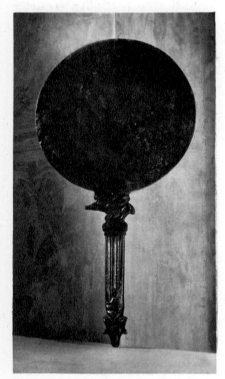

33 MIRROR WITH HANDLE. BRONZE

I SIXTH CENTURY BC

The vast majority of the rich burials of the Scythian period have been plundered at some stage, some of them soon after the funeral. In some instances it was only the bodies of the horses that were left undisturbed, for which reason archaeological excavations of Scythian mounds usually reveal horse trappings and a few oddments that happened to be left in the human graves. The methods of burial in the Scythian period differed greatly in various parts of the country. It is highly probable that this reflects ethnographic differences between various tribes united by a Scythian culture.

The most ancient burials attributable to this culture are found in the region of the lower Dnieper and in the north Caucasus. The so-called Melgunov treasure derives from the former; the objects were found in the Titoy mound near Kirovograd as early as 1763 but no precise information is available regarding the burial or the manner in which the tomb was furnished. They are believed to have lain in a cist six feet below the surface. The finds were presented by General Melgunov to Catherine the Great.

The most remarkable part of the find is a sword in a gold-mounted scabbard, decorated with figures of fantastic monsters either with the body of an ox, or a beast of prey having a scorpion-like tail, with the head of a ram, or a lion, or a man, or an eagle with fish-like wings ending in a beast's head (pl. 1); each monster holds in its hands a bow and arrow (fig. 3). On the heart-shaped guard of the scabbard are two winged gods placed on either side of the tree of life (pl. 2); at the tip the oval chape is ornamented with two heraldically confronted lions. On the projection near the upper end of the scabbard, which served for fastening the sword to the belt, is the figure of a recumbent stag. The heart-shaped cross-piece of the hilt, in a poor state of preservation, is ornamented with two figures of recumbent goats (fig. 2). Its hilt is surmounted with an oval pommel and is decorated with a conventionalized plant design.

Besides the sword, there were: a gold diadem consisting of three rows of chains passed through nine rosettes (fig. 4); gold plaques with figures of apes and birds (fig. 6); seventeen solid figurines of birds with spread wings (fig. 5); a bronze clasp with lion-head terminals, and a number of other objects of lesser importance. There were no horse harness ornaments, probably due to the fact that the horse burial, if it existed, was not found.

In the north Caucasus the oldest Scythian-type barrows with rich grave goods were found in the Kuban valley. They are unlikely to be actually Scythian since, according to classical authors, the Kuban region was inhabited by Maeotae and not Scythians. Yet it is precisely in these barrows that early Scythian culture is to be found in its most vivid and characteristic form. Unfortunately, the very rich Kelermes mounds were opened not by a professional archaeologist, but by a treasure-seeker named Schultz. In

1903, he excavated four mounds that apparently had not been robbed, and found in them a number of valuable ornaments and weapons. We know next to nothing about the construction of the tombs in these mounds. Two further barrows belonging to the same group were excavated by N. I. Veselovsky in 1904 and found to be plundered, but here definite records are available as to the way they were planned. In both mounds the grave was shaped as a spacious rectangular pit, its sides forming ledges. Remains of wooden posts were found at the bottom of the grave. These separated off the greater part of the floor to form a special chamber, probably intended for the human burials. On two sides of it skeletons of horses were lying along the wall: twenty-four of them in the first mound, twelve on either side; and sixteen in the second one, eight on either side (App. III).

As the horses had not been disturbed by the robbers, parts of their trappings remained — that is, iron or bronze bits, bridle plates, numerous white beads and so on. Of particular note were numerous bridle ornaments, made of bone, shaped like ram-heads, ram-birds, horse-hooves, twisted beasts, and little cylinders (fig. 7). In both mounds, together with the horses, were found the pole-tops typical of Scythian burials, which probably adorned their wagons. In the first mound there were fourteen of them: two made of bronze, shaped like heads of long-eared animals (asses or mules) (pl. 5), the others in the form of openwork spheres or ellipsoids with two or three small bobbles inside. Three of these finials were of iron, the rest of bronze. One had the shape of a griffin's head (pl. 4). In the other mound seven spherical pole-tops were found.

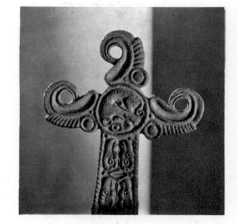

34 CROSS-SHAPED PLAQUE. BRONZE

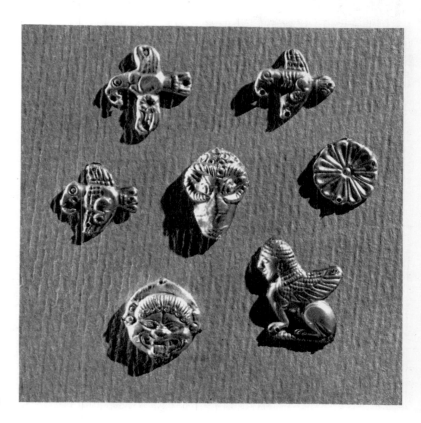

23

35 GOLD PLAQUES

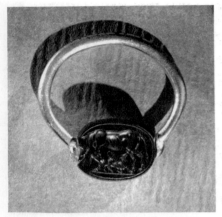

36 RING WITH BEZEL. GOLD, GLASS

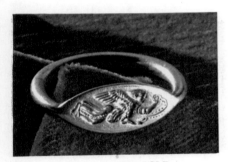

37 RING WITH BEZEL. GOLD

In addition, thin gold plates, partially decorated with spirals, were collected from the grave. These had adorned leather or wooden parts of the now perished harness (pl. 49).

The human burials in both mounds had been plundered and damaged, so little remained of the grave goods. Pieces of a bronze cauldron, some fragments of pottery, small beads of glass, gold, cornelian and other materials, three gold rosettes, another gold plaque decorated with a hare's head, bronze arrow-heads, and a limestone slab with a square hollow (probably an offering stone) were found in the first mound. In the second mound the following articles were found: a bronze cauldron with two handles, a bronze kettle, two bronze helmets (pl. 48), a rod terminal with a denticulated pattern in gold leaf (fig. 12), a bronze mirror with two small bosses in the centre of its obverse side finished off with a boss displaying the figure of a twisted beast (pl. 35) similar to that carved on bone bridle ornaments from the same mounds, and several dozen bronze arrow-heads, some white beads and one carnelian bead.

These two very similar mounds belong to the first half of the sixth century BC. The precious objects found by Schultz in the Kelermes mounds date to about the eighties and seventies of the same century.

The most noteworthy of these is a sword in its scabbard (pl. 6, 7; fig. 8), resembling the one from the Melgunov treasure described above. Although no designs wholly corresponding to those which decorate the sheaths of both the Kelermes and the Melgunov swords appear on any known objects originating in Asia Minor, in their over-all character the figures shown on them bear a close resemblance to the famous Assyrian creatures guarding Assurnasirpal's palace gate, and still more the monsters overthrown by Gilgamesh or Marduk engraved on seals. Both in subject and style these figures, as well as the composition, consisting of two genii placed on either side of the tree of life, are of Near Eastern, most probably Assyrian, origin.

An iron axe with the handle and butt encased in gold (pl. 9—19) is another remarkable ceremonial weapon found in the Kelermes mounds. In addition to the tree-of-life composition — figures of gods, however, being replaced here by figures of goats (pl. 19) — the handle and socket of the axe display various (mostly recumbent) animals, such as lions, panthers, goats, stags and antelopes. Among these there is also a bridled horse, a boar and an imaginary beast. All of these are executed in a mixed style, achieving a *chiaroscuro* effect through relief modelling with graphic treatment of detail.

Among the other decorated weapons should be mentioned a large rectangular gold plate, probably a *gorytus* casing (pl. 21). It is divided by relief lines into twenty-four rectangular compartments, each containing the stamped figure of a stag similar to those on the sword scabbard and on the gold casing of the axe. The two vertical edges of the plate are ornamented on either side with a border of sixteen uniform figures of a carnivore. The same beast of prey, possibly a panther, appears in a similar attitude in

24

a solid gold plaque which served as the centre-piece of a shield (pl. 22—24). It is shown with all four paws, the head thrust forward as though tracking game. The tail and paws are so rendered as to show the same wild animal, only in a curled-up position (fig. 9). This figure of a beast twisted into a circle also recurs on the back of the bronze mirror, and on carved bone bridle ornaments found in the Kelermes mounds by N.I. Veselovsky. The almond-shaped ear of the panther in the shield centre-piece is divided into triangular sections, similar to ornamental bridle plates from the first Kelermes mound, as well as the scabbard decoration of the sword from an early mound in the Dnieper region, the Pointed Barrow at Tomakovka. Its round convex eye is inlaid with white and grey, the pupil with brown enamel, while the nostrils are filled with white paste.

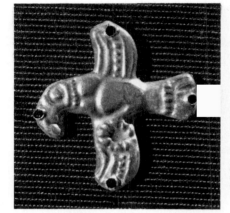

Noteworthy also are three gold diadems, all ribbon-like and embellished with rosettes. On one of them — found decorating a bronze helmet, according to Schultz — the rosettes alternate with figures of sitting birds; to the upper edge of the band little rosettes and figurines of birds perching or in flight are affixed while the lower edge is ornamented with rosettes only (pl. 27, 28). In the middle of the second diadem is a sculptured head of a griffin, while the lower edge has hanging from it a row of drop-like pendants terminating, at the end of the band, in two ram-head pendants on long chains (pl. 25, 26).

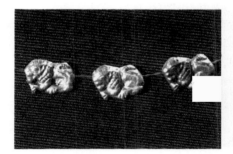

One of the most remarkable objects from the Kelermes burials is a silver mirror, the back of which is ornamented with an engraved design and encased in thin sheet gold on which the whole design is stamped. The edge of the mirror protrudes on this side to form a high rim. In the centre of it are traces of a handle in the form of two stumps. The whole back of the mirror is radially divided into eight sections by lines of double strings; in the angle of each section are two petals, the whole forming a large rosette in the middle of the mirror. The rest of each section is filled alternately with zoomorphic designs and mythological motifs (pl. 29). In one of the sections the figure of Cybele, a Near Eastern winged female deity, the Mistress of the Animals, is shown standing in a long dress reaching to her heels, holding the forepaws of two lions, their tails submissively tucked between their legs. In the adjacent section on the right there are figures of a lion and an ox locked in battle, and below this a figure of a wild boar (pl. 31). Next comes a pattern of two confronted winged sphinxes, and below them the same carnivore that was the subject of the solid gold centre-piece of the shield. Still farther to the right is a very life-like lion, standing against a tree. Below it is a figure of a recumbent ram (pl. 32). In the next section two hairy human figures fight a struggling griffin set above an interweave pattern. The sixth section contains a bear with a bird flying above it, and below a running wolf or fox (pl. 33). In the seventh section are two winged sphinxes facing each other and a winged griffin, and in the eighth are two confronted lions closely resembling the design on the lower ends of the Kelermes and Melgunov swords, and a figure of a recumbent goat, behind which the head of a ram

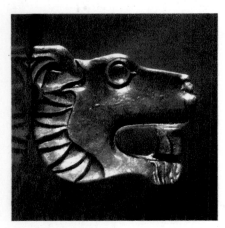

40 BRONZE PLAQUE

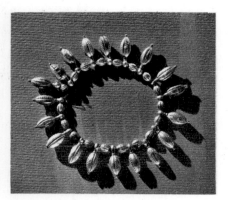

41 NECKLACE OF BEADS. GOLD

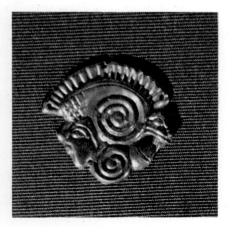

42 GOLD PLAQUE

can be seen (pl. 30). This mirror is one of the most outstanding examples of Graeco-Ionian art, combining religious motifs of the greatest antiquity.

There are also two objects, possibly sections of a throne, consisting of semi-cylindrical gold rods with lion-head terminals (pl. 34, 36, 37, 39). On either side of the rod are two ram-heads with a knob topped with a rosette between them (pl. 38). The cylindrical surface of the rod is divided into triangular and square compartments filled with amber.

A silver rhyton, originally covered in gold leaf and bearing an engraved design in the same East Ionian style as the mirror, was one of the most remarkable vessels found in the Kelermes burials (pl. 20). Unfortunately it is badly broken, but still it is possible to see that the decoration on it was divided into three bands. Best preserved in the upper row are figures of birds (bustards), and two goats walking side by side. In the next row a figure of the goddess Cybele, holding winged griffins in her lowered arms, is partly visible. In the third row, the large figure of a centaur is almost intact.

Two gold cups found, according to Schultz, one inside the other, are in a good state of preservation. The first is hemispherical, made of thick sheet gold with smooth edges and bottom, the rest of its surface being covered with almond-shaped and quadrangular embossing (pl. 46). The second cup is of the same shape and made of thin sheet gold with three rows of stamped patterns on its sides and a rosette on the bottom (pl. 40—45). A succession of fourteen bustards with extended wings make up the upper row. Forming the middle row are four figures of recumbent stags and goats; also two scenes — a lion devouring a stag, and a wolf chasing a she-goat. In the lower row are five figures of recumbent animals: a stag, a boar and goats.

This does not exhaust the list of things discovered in the Kelermes burials by the treasure hunters. There were in addition several bronze cauldrons with handles in the shape of goats (pl. 47), pole-tops (pl. 50, 55; fig. 10), some other broken metal vessels, a silver cup, buckles and fastenings (pl. 52—53), a number of weapons (fragments of swords, spear-heads, pieces of a wooden bow, numerous bronze arrow-heads, and several knives). There were also numerous items of horse harness, such as runners (fig. 13) and gold discs — hemispherical with a loop on the back, or shaped like multi-petalled rosettes with two loops on the back — and gold plates decorated in relief, as well as many beads made of gold, glass and carnelian; gold plaited chains, and gold bridle plates.

To judge by these finds, we may believe Schultz's statement that he excavated four mounds containing male and female burials furnished with a quantity of valuable objects of high artistic merit. However, no records survive as to the presence in the mounds of any accessory human burials, if we except those of some women, or regarding the number of horses found in the barrows.

In the oldest remains of early Scythian culture, such as the Melgunov treasure and the Kelermes mounds, the prevalence of patterns and motifs of west Asiatic origin is

26

very characteristic; this is not surprising, considering the close historical links between the Scyths and other tribes inhabiting the region north of the Black Sea and the Asian countries. At the same time, these finds include objects showing traces of Graeco-Ionian origin which could not have reached the barbarian tribes of the Black Sea region from Asia Minor and Transcaucasia, but must be a result of direct contact between the Scyths and the Greeks within the region itself. This seems the more probable, because, even among articles of the early Scythian period, those representing direct Near Eastern imports (that is, gold cups or semi-cylindrical ornaments from Kelermes, or parts of a throne from the Melgunov treasure) are comparatively few; a combination of styles of varied origin, with definite signs of local manufacture, is characteristic of a number of them. Mingled with motifs and shapes of west Asiatic or Graeco-Ionian origin, the presence of individualistic features attests the evolution of a new artistic style in the area north of the Black Sea. This new style came into being among the Iranian tribes, who included the Scyths, during their migration into Asia, through the borrowing and assimilation of the ancient cultural inheritance of Mesopotamia in its Assyrian-Babylonian phase.

Our present state of knowledge does not permit us to say with certainty which kind of objects characteristic of Scythian culture had been produced locally among the Eurasian steppe tribes, and which of them were borrowed from the Iranians, or created simultaneously by Iranians, Scyths and Sacae of central Asia. The basic elements of weapons and horse trappings were most probably produced by the Eurasian barbarians themselves, since earlier prototypes can be traced in pre-Scythian culture in the same region. For instance, the Scythian light bronze arrow-heads have nothing in common with the arrow-heads used in western Asia during the pre-Scythian period, while leaf-shaped tanged arrow-heads, a prototype of the characteristic Scythian form, occur in the Andronovo and Box grave cultures of the Eurasian Bronze Age. Generally speaking, it was the northern Iranians, the Scythians and the Sacae who created the light armed cavalry that proved so effective against the heavily armoured, cumbersome armies of infantry and war chariots they encountered in western Asia.

Luxury articles, ornaments and works of art, were all largely dependent on Near Eastern tradition. In the animal style, so typical of Scythian art, the figures of animals in the oldest examples are of Near Eastern derivation. The compositions with the tree of life, seen on the gold settings of the swords from both Kelermes and the Melgunov treasure, not only reproduce an ancient Mesopotamian subject but in no way differ stylistically from similar Assyrian and Urartian designs. The same is true of the figures of monsters decorating the scabbards which, though without exact counterparts in ancient Near Eastern art, by their content and style belong to western Asia. Even on the gold casing of the axe from Kelermes, forms of obvious Near Eastern character predominate.

27

43 GOLD PLAQUE

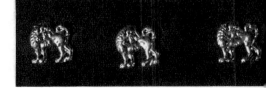

44 GOLD PLAQUES

45 GOLD PLAQUES

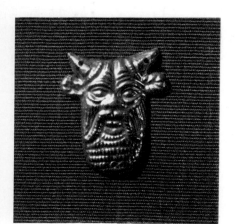

46 GOLD PLAQUE

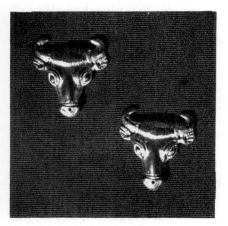

47 GOLD PLAQUES

48 GOLD PLAQUES

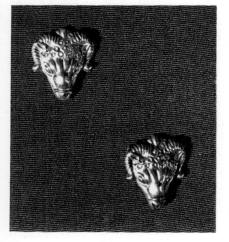

At the same time, in some animal figures displayed on the axe's casing, and especially in the figures of stags on the flanges of the Kelermes and Melgunov sword scabbards, there are prominent stylistic features not in the least akin to western Asiatic art. These features are particularly well exemplified on the shield centre-piece in the shape of a panther from Kelermes, or the figure of a stag made for the same purpose from Kostromskaya. These two designs are characteristic examples of native Scythian art that sprang up as a result of stylistic assimilation of specimens of Near Eastern art.

Scythian art belongs to the so-called zoomorphic style, its subject being mainly animals or their parts. This is very characteristic of many races during the archaic stage of their history. The style of Scythian art is displayed essentially on objects made for everyday use, such as weapons, horse-harness and clothing. Thus, being both applied and decorative, it is remarkable for its realism, and at the same time for its adaptability to limitations imposed by the size and shape of the objects it adorns. It shows a wonderful ability to fill space and a compact exactness of outline. It possesses a remarkable ability to reproduce the characteristic features of an animal by artistic means that are, after all, conventional. A closed outline of the figure, retaining the vividness of the image, leads to simplification and deformation, thus fulfilling the decorative aims. Another characteristic of the Scythian style, namely the custom of turning cylindrical and convex surfaces into inclined planes intersecting each other at sharp arrises, is with good reason attributed to skill in carving wood.

The style of Scythian art was determined by the original material on which it was applied, namely wood and bone. When using bone, the artist was forced to compress his design into the space allowed by the shape of the object being decorated. Initially, Scythian artists expressed themselves in wood and bone, but the objects that have survived are mainly those made of metal. There is no doubt that the original works of Scythian art were first carved in wood, and then in many instances, as is obvious from the Altai barrows finds (where due to perpetual freezing, objects made of organic materials were found in a state of good preservation), encased in gold foil on which the design carved on the wood was impressed. In order to produce a series of these objects, impressions made from the same wooden matrix were filled up with wax or some other rapidly solidifying substance, in order to make moulds for producing similar objects.

Contrary to widespread belief, the majority of subjects and motifs in Scythian art are not of local origin. They are, as may be seen from the Kelermes and the Melgunov groups of objects, borrowed from the countries of the ancient East, although among the Scythians they acquired new specific characteristics. The most frequent subjects in these groups were so much transformed by the Scythian style that their oriental origin can be detected only with difficulty, and then only due to the fact that, in some instances,

typical traces of Assyrian-Babylonian and Urartian art were still retained side by side with features characteristic of Scythian style.

A hoard from Zivie in Iranian Kurdistan of the seventh century BC is of great importance in this connection. It apparently formed part of an Assyrian and, probably, Mannaean-style burial, and among the articles found in it were some very much resembling those of Scythian origin both in the subject-matter and the style of the design. The find shows that Scythian art had begun to take shape among Iranian tribes, on the outskirts of the Assyrian empire, whence it spread both to the Black Sea regions and to Central Asia and Siberia, particularly among a population speaking the same Iranian languages. Only a common origin can explain the striking similarity in art and culture during the Scythian period existing between the Black Sea area and southern Siberia as far as the Altai Mountains.

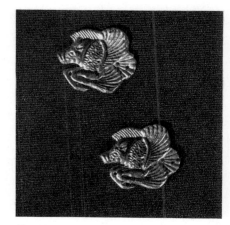

49 GOLD PLAQUES

Greek influence, as we have noted, makes itself felt on Scythian culture in the Black Sea area at a very early period. Greek objects and motifs of Greek origin appear there simultaneously with Scythian culture. Thus in the oldest barrows containing Scythian objects from the beginning of the sixth century BC, such as that on the western shore of the Tsukur estuary on the Taman peninsula, and that at the summit of Mount Temir north-east of Kerch, Greek *oenochoae* have come to light. In the former, a bronze axe was found with a prong at the butt, and a bronze ornament representing two beasts standing upright on their hind legs and confronting each other (fig. 14). In the latter, carved bone objects were found, one in the shape of a bird-head (fig. 15), and the other in the characteristic shape of a curled beast (fig. 16). In the Kelermes barrows the importance of Greek influence is indicated not only by objects produced locally in the Graeco-Ionian style, but also by the extent to which Greek stylistic peculiarities were combined with native motifs. Reflecting the extent to which contacts between the Greek colonies and the natives widened, the quantity of articles of Greek origin found in the Scythian burials increases. This applies even to fifth-century burials on the middle reaches of the Dnieper, far from the Black Sea coast.

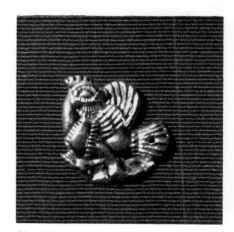

50 GOLD PLAQUE

In the Kuban area there are other barrows which in structure resemble those of Kelermes, for example, the mounds near the villages of Ust-Labinskaya and Voronezhskaya. These had been completely robbed. In the Voronezhskaya barrows there were instances where the corpse was not in a pit but laid in a special wooden structure at ground level. Here horses were buried either in several elongated pits along the sides of the wooden structure, or in a broad trench forming an incomplete circle open on the south side (App. IV). In Barrow 19 there were thirty horse skeletons lying with their heads towards the human burial. The shards of black-figure ware found in the mounds indicate that they date to the sixth century BC, approximately the same date as the Kelermes barrows.

29

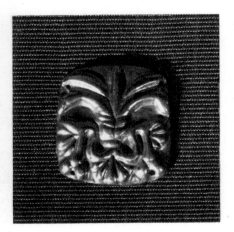

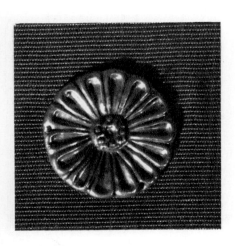

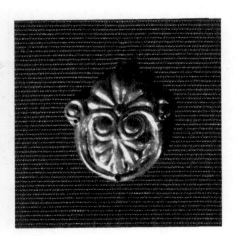

51 GOLD PLAQUES

The famous Ulski barrows are of the same type. One which was particularly remarkable for its numerous horse burials was of enormous size, being 15 m. high. In the centre under the mound were the remains of a wooden structure with four posts at the corners. Between these, six posts were set on either of the longer sides, and four on either of the shorter sides. The bones of eight oxen and of numerous horses were found encircling this structure. The arrangement of the latter was remarkable: groups of eighteen horse skeletons were placed around each of the individual poles, and the same number on either side form posts connected by lintels. In the excavated part of the mound, therefore, there were two sets of lintel-topped posts and six poles on both sides of the central structure. A total of 360 skeletons, not counting those along the sides of the central structure and those which probably are still under the unexcavated part of the mound were discovered. It is highly probable that when laying out the burial they attempted to simulate to a certain extent the actual dwelling of the dead man, around which there would have been tethering posts, represented by the poles and lintelled posts described above. Besides the great number of horse skeletons, the bones of two oxen and asses were found 5.35 m. above the virgin soil. Some horse skeletons arranged around posts were noticed as well.

The contents of the central grave structure in this mound had been robbed; nothing but a slab with a square hole, probably an offering stone, was found. Hardly anything else came from the other mounds of the same group. Nine mounds of different size were excavated, but all of them had been pillaged. Traces of a wooden support for a superstructure to contain the human burial, with surrounding horse skeletons, were found, but the latter were nothing like as numerous as in the first and biggest mound of the group.

Yet the Ulski barrows yielded some important finds, including a gold plaque, probably from a quiver casing, with stamped figures of two griffins attacking a goat and figures of a running stag (Barrow 1, 1898), plaques, intended as dress trimmings, shaped like a recumbent stag and a carnivore of the Kelermes-panther type (Barrow 1, 1908)(fig. 17). There were also numerous gold plaques decorated with a lion and an eagle, and among them some larger ones with the figure of a ram with enormous stylized horns and a panther-like carnivore (Barrow 1, 1909). Especially interesting is a gold hollow finial shaped like a horse's head with little hares at the nostrils, and triangular fields on the forehead and along either side of its mouth, inlaid with sawn amber (fig. 18), recalling the inlaid objects from the Kelermes mounds. Noteworthy, too, is a round gold plaque with up-turned edges and a wooden roundel inside, proving that thin gold plates were frequently laid over wood (Barrow 2, 1909); and two pairs of gold earrings, one pair in the form of a bunch of grapes (Barrow 1, 1909), the other decorated with green enamel and gold pendants (Barrow 4, 1909). Among the horse trappings in the Ulski

30

barrows, which included iron bits, bronze plaques, bells and other objects, silver frontlets shaped as round plates decorated with openwork triangles and secured to bronze roundels, and silver and bronze cheek-pieces, engraved all over (pl. 56), are deserving of mention. The animals shown on these have their outlines formed in part by the shape of the cheek-pieces.

Other finds of note were a beautiful figure of a running stag that served as a cauldron handle (Barrow 2, 1909) (pl. 57) and a whole series of terminals; one an openwork cone ending in a griffin head (Barrow 1, 1908) (pl. 59), three pear-shaped and ending in ox heads surmounted by massive horns (pl. 60), and two in the form of thick cast plaques on a broad socket (pl. 58, 61). The plaque is shaped like a schematic bird head with a hooked beak. The lower edge is decorated with a human eye design worked in relief, above which runs a row of three bird heads also in relief, each smaller than the preceding one. The inner field on one pole-top is plain, while the other is filled with the design of a recumbent goat with its head turned backwards, and above, forming relief bands, another schematic bird head (Barrow 2, 1909).

The wooden structure above ground, so typical of Ulski and some other rich Kuban barrows, can be better judged by the remains in a mound near Kostromskaya village (App. V). A royal burial had taken place there, for which purpose a square wooden chamber had been built on top of an earlier barrow. Four thick logs set vertically into the ground marked the corners, and six smaller posts formed the sides of a square structure, whose walls must have been of basket-work daubed with clay. Four cross-pieces supported a pyramidal arrangement of rafters. Outside, the remains of twenty-two horse skeletons were found, some provided with bits. The wooden structure in the Kostromskaya mound had not rotted away because it was set on fire before being buried, the charred surface of the posts thus preserving them. The burial chamber had been robbed of its contents, but there still remained armour (the upper part of iron scales and the lower part of copper ones), four spear-heads, and two leather quivers with arrows. There was also a big stone slab broken into two, probably of the Ulski and Kelermes type, and shards of earthenware vessels. The most remarkable find in the Kostromskaya barrow was an iron shield decorated with the now famous gold figure of a recumbent stag, which has already been mentioned as a typical example of the Scythian style (pl. 62-64).

The Kostromskaya barrow, as well as the Kelermes finds, belong to the first half of the sixth century BC. The majority of the Ulski barrows are of a later date, namely the second half of the sixth century and the early fifth century BC, but Barrow 1 (1908) might date from the first half of the sixth century BC.

52 PARTS OF A SILVER *RHYTON* WITH GOLD LION-HEAD FINIAL

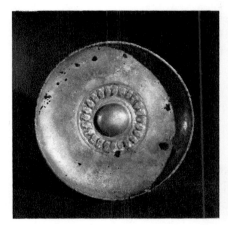

53 *PHIALE* WITH FRIEZE. SILVER

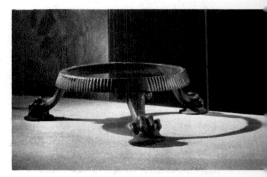

54 VESSEL STAND SUPPORTED ON THREE LEGS. BRONZE

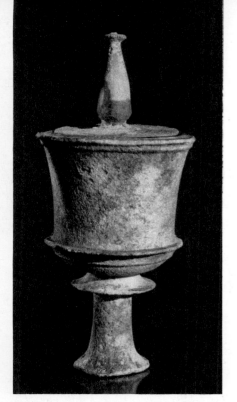

55 GOBLET AND LID. ALABASTER

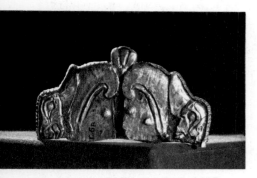

56 CHASED VESSEL HANDLE. GOLD

II FIFTH CENTURY BC

In the steppes north of the Black Sea no barrows so rich as those described have as yet been discovered. Moreover, we do not know how the objects found were arranged in the grave structures from which they came. For example, the ritual disposition of a rich burial of the late sixth or early fifth century BC from the Pointed Barrow near Tomakovka, Dnepropetrovsk region, remains unknown. The cairn, about 5.5 m. high, made of boulders, contained nine crouched skeletons in its excavated part (it was not fully excavated because of the poverty of the finds). In the years following the abortive excavation of 1862, peasants who used the mound as a stone quarry stumbled on a very rich Scythian grave. Unfortunately, the only record of the burial is limited to the group of gold objects found in it, consisting of personal ornaments and weapons. These were a gold torque, a gold crescent-shaped plaque, decorated with triangles of small pellets and light-blue enamel (fig. 19), and parts of a sword. The sword has a gold-plated hilt, with an oval pommel and a heart-shaped guard. The upper end of the scabbard casing is decorated with two symmetrically placed twisted animals, whose long tails terminate in bird heads and an upright row of lion-heads (pl. 65). The gold chape is decorated with triangles, double spirals and almond-shaped depressions inlaid with light-blue enamel (pl. 66). In addition there was a capacious plume-holder, probably intended to hold a large brush attached to a horse's mane, and two hundred bronze arrow-heads. It is evident that these are but a few of the things that had been put in the grave with the corpse; the rest are irretrievably lost, and so this burial, which seems to be one of the oldest barrows of Scythian type in the steppe region of the Dnieper, remains imperfectly understood.

It may be assumed that the burials in plundered barrows near Annovka and Martonosha in the Kherson district were rich. Unfortunately, nothing is known about the grave structure of either. Both have yielded excellent bronzes of purely Ionian type, which probably reached Scythia via Olbia. In a barrow at Martonosha a superb crater came to light, its handles adorned with sculpted figures of Gorgons cast from wax models (pl. 67). A mirror with a handle in the shape of a nude figure of Aphrodite with raised hands supporting the mirror disc was found near Annovka (pl. 69). It is probable that the beautiful mirror, with the handle in the form of a goddess in a clinging garment and holding a siren in her right hand, which was found in a robbed mound near Kherson, reached Scythia by the same route. Above the figure's head is an elaborate composition consisting of two lions devouring an ox, which formed the junction between the statuette and the disc of the mirror. Below this, on the shoulders of the female figure, are two jackals (pl. 68). All these finds testify to the existence of close connections between Olbia and the natives as early as the sixth century BC.

The absence of any record of the ritual arrangement of finds gives a special interest to the two barrows, Baby and Raskopana, investigated by D.I.Evarnitsky in the same region near the village of Mikhailovo-Apostolovo in 1897. These revealed that the typical graves of the Dnieper area, consisting of an underground chamber (known here from the remarkable monuments of the fourth to third centuries BC, which are rightly associated with the Royal Scyths) had existed from an earlier date.

Tombs in these barrows belonging to the first half of the fifth century were constructed in a similar way. Under a mound of earth, which in one case was 3.5 m. and in another 5 m. high, there was a semi-cylindrical pit with a stepped ramp on the straight side. Large stones had been piled over it. The floor lay at a depth of 5 m. in one case, and 5.7 m. in another. In the semicircular walls of the pit were underground chambers at floor level, in which the corpses and funeral accessories had been placed.

The graves had been so damaged and plundered that except for scattered bones, and bulky or valueless articles, or a few objects that the robbers failed to notice, little remained. In the Baby barrow were found fragments of a large bronze hydria and a bronze cup, a solid bronze lamp with four wicks, a large gold plaque decorated with two heads of wild boars (pl. 71), a square gold plaque decorated with the figure of a recumbent stag, a triangular plaque with a representation of a horse's leg (fig. 20), small plaques showing a hare and a lion, and some other small plaques, pendants and beads. In the Raskopana barrow there was a splendid oval-shaped cauldron on a tall base with handles, and decorated with three bands set in relief showing stylized ox-heads alternating with concentric circles, palmettes and triangles (fig. 21). There were also weapons (arrowheads and spear-heads), a bronze dish, parts of a bronze vessel, iron knives with bone handles, amphorae, fragments of a black glazed vessel and some other objects.

The core of both barrows, as well as their earth filling, contained horse, ox, sheep, dog and bird bones. In the Raskopana mound itself were two horse skeletons and a skeleton of a dog, while in the earth filling the pit seventeen horse skulls and odd bones of oxen and rams were found.

The barrows of the northern Crimea from the fifth century BC were no better studied than those of the Dnieper. Of the former, those worth mentioning are near Ak-Mechet (the Karamerkit barrow), the Golden Barrow near Simferopol, and another in the same region opened in 1895 by Y. A. Kulakovsky and known by the name of its discoverer. The method of interment in the Ak-Mechet barrow is not recorded. From it there came a gold plaque shaped like a stylized bird head (pl. 70), and three plaques decorated with recumbent stags (pl. 72). In the Golden Barrow, as in the Pointed Barrow, there were several burials with contracted skeletons. The Scythian tomb consisted of a shaft dug through the mound of an older barrow. With the human skeleton were the remains of iron scale armour and parts of an ornamented bronze belt, two cast figures of an eagle

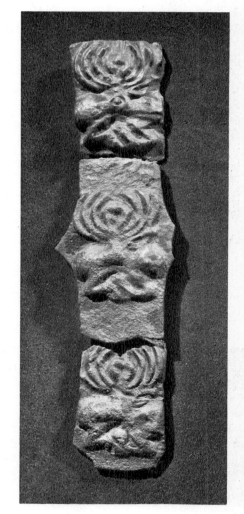

57 BRONZE PLAQUE

58 GOLD *RHYTON*

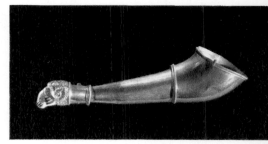

33

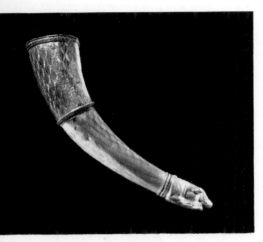

59 GOLD *RHYTON*

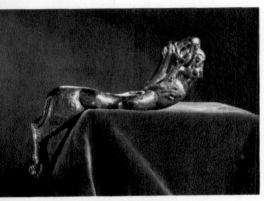

60 BRONZE CHEEK-PIECE

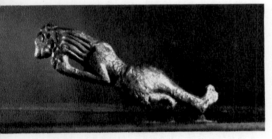

61 BRONZE CHEEK-PIECE

(pl. 74), two griffin-heads with cramps on the back, forty bronze buttons, three large gold buttons (fig. 22), and twenty-five tiny buttons also of gold. The skeleton had a gold torque on its neck, and at the belt there was an iron sword in a leather scabbard the tip of which was encased in gold leaf inlaid with coloured enamel (fig. 23). There were also six bronze plume-holders. To the left of the skeleton was a bronze figurine of a carnivore, its body encased in sheet gold with almond-shaped sockets for coloured inlay (pl. 75). Apparently the figure had decorated a quiver lid, sections of which in the form of fragments of silver leaf, together with parts of a wooden bow and 180 bronze arrow-heads, were found near by. In the grave there was also an earthenware one-handled jug with a rounded body and a narrow neck. Both the barrows can be dated to about the second quarter of the fifth century BC.

Under the earth mound of the somewhat later Kulakovsky barrow a shaft grave was found covered with timber and a cairn of stones. Near the right hand of the skeleton, which was lying on its back, its head facing east, two bronze plaques were discovered. One of them is shaped like a twisted wild beast with an extraordinarily elongated body and neck; the long ear and snout suggest a wolf. Its shoulder is stylized and turned into the figure of a recumbent goat with, beneath it, an elk's head, while the paws and tail contain bird heads. Another bird's head is displayed on the thigh (pl. 78). The elaborate workmanship, distorted proportions and stylization make the design essentially different from the earlier examples of the same type of motif and mark a transition to a new stylistic treatment which became fully developed by the end of the fifth century BC.

The second plaque is also a closed figure, but of another kind (fig. 24). In this instance, the creature's body curves in the contrary direction, its front leg drawn up close to it; the back leg is turned inwards, once again curving in the opposite direction from the body, but with the paw touching its muzzle. On the shoulder there is the figure of an elk. The twisted form of the figure was a convention employed in Scythian art to express violent movement. In addition there were found with the skeleton: part of a bronze cheek-piece with a horse-head terminal, a whetstone, an iron spear-head, an iron sword and a quiver with numerous bronze and bone arrow-heads.

As one can see from the examples given, the Dnieper steppe barrows and the Crimean barrows differ in structure. While those along the Dnieper customarily contained graves of subterranean type, the Crimean grave took the form of a rectangular shaft. It seems probable that the two kinds of burial customs reflect ethnographic differences between the nomads of the two areas, and this would bear out what Herodotus said about the existence of two kinds of nomadic Scyths in the Black Sea area, the Royal Scyths and the Nomad Scyths, separated from each other by the River Gerrhus, near which (on the lower Dnieper) the cemetery of the Scythian kings (the Royal Scyths) was situated.

34

Among these fifth-century burials, as well as among some others found in a poorer state of preservation, there are none that can compare with the extremely rich barrows of the Kuban group. The characteristic of most Scythian burials — that they were inserted into the barrows of an earlier period, dating back to the Bronze Age — is very evident in the case of both the Golden and the Pointed Barrow.

The scarcity of finds in barrows of the Black Sea area of the fifth to fourth centuries BC, when compared with the Kuban barrows, cannot be wholly accounted for by inadequate field work, nor is it the result of chance. Investigations have been carried on here for a long time and the number of excavated barrows is most impressive. We must look elsewhere for an explanation — probably in the new relationships among the various tribes inhabiting the Black Sea area, which later found expression in the formation of a great political unity headed by the Royal Scyths, whose chiefs accumulated great riches. This could not have been a quick process. It took a long time for the Scyths who returned from Asia to subdue other Scythian and non-Scythian tribes and gain the hegemony described by Herodotus. Consequently we cannot assume the sudden appearance of dynasties of Scythian kings who could afford to adorn the burials of their dead with the luxury characteristic of a later period, and which at an earlier date had shown itself among the barbarians of the Kuban valley.

The Zhurovka Barrows

Nevertheless, Scythian culture spread in the area north of the Black Sea as it did along the Kuban, and from the Scythians it penetrated the territories of the Thracians on the west shore of the Black Sea (and into central Europe), forming a basis for the emergence of an independent Thracian culture. Scythian culture extended also to the wooded steppes of the middle Dnieper, where sedentary tribes of farmers had settled with their own chiefs. The numerous barrows from this area provide evidence of similar funeral rites and goods of the same type, although these are of course much poorer than the contents of the royal barrows of the Kuban valley.

Early Scythian burials on the right bank of the Dnieper, datable from the finds of imported Greek objects, have been discovered in the vicinity of the village of Zhurovka in the Chigirin region near Kiev. In this barrow group is a fully developed type of tomb of peculiar construction — similar to that observed in other places but nowhere else so numerous and distinct (although that may be partly due to the thorough scientific excavations in this area). Large shafts with stout oak posts at the corners, and not infrequently in the middle of each side, house the burials. Similar posts, occasionally in pairs, were set in the centre of the larger pits. The walls of the shaft between the posts are usually lined with wooden boards or logs set upright, their ends embedded in the ground, which necessitated shallow trenches dug in the floor against the walls.

35

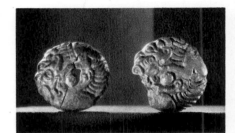

62 ROUND PLAQUES. BRONZE

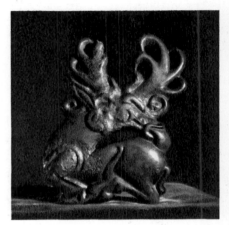

63 BRIDLE PLAQUE. BRONZE

64 BRIDLE PLAQUE. BRONZE

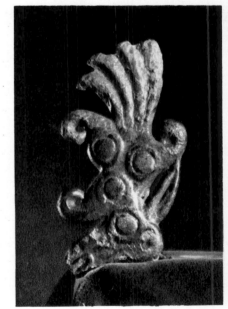

The posts supported the roofing, which is either a flat ceiling of beams or made of rafters meeting in an apex over the middle of the chamber. The tomb was entered by way of a sloping ramp or down steps, the walls being sometimes lined with wood, and in some instances completely or partly roofed (App. VI). The floor of the chamber may be covered with wooden boards; traces of clay rendering have been observed on the walls, and in some cases even instances of painting. The walls of the chambers were sometimes lined with textiles, hooks being inserted in the walls or, more often, into the posts for hanging clothing or bridles. In many of these chambers there were two corpses — a man and a woman, the latter evidently a wife or a concubine who accompanied the man to the next world. In the entrance would be two or three horses. The dead were supplied with numerous and varied objects but, unfortunately, most of the graves had been plundered.

Some of the mounds of the Zhurovka group opened by grave robbers contained, besides sixth-century vessels from Samos, magnificent specimens of early Scythian art. These include a horseshoe-shaped object, having phallic terminals with a contracted carnivore in the middle (pl. 77); a figure of the same creature standing on a mount shaped like a clawed foot (fig. 25); a recumbent elk, its head turned back and likewise mounted on a pedestal shaped like a bird's leg (pl. 76); a carnivore's head in profile with jaws open; and lastly, a bird in profile with extended wings and tail, very much like the bird on the gold plaque from the Golden Barrow in the Crimea. All these are cast in bronze and display the most characteristic features of Scythian stylization.

Several barrows of the same group were opened by A.A.Bobrinsky. The oldest, Barrow 407, dating from the sixth century BC, contained bone cheek-pieces (fig. 26), and bone runners for reins shaped like bird heads. Beside a female skeleton were found bronze earrings shaped like bent nails with broad heads, a bronze nail-shaped pin and a bronze mirror with a stud at the back fitting into a wooden case. In the other part of the chamber a gold plaque shaped like a recumbent stag was discovered (pl. 79), and two iron pole-tops lying between the skeletons of a man and a woman.

Other noteworthy finds in the Zhurovka barrows include, in Barrow 400 (second quarter of the fifth century BC): bronze cheek-pieces in the shape of horses' bent hooves; a bronze pendant shaped like a tiny dagger, its hilt in the form of a lion head (fig. 27); a bronze plaque of a lion head in profile; a large bronze buckle with two elk heads seen in profile (fig. 28). There was also a gold plaque showing a stag with its head turned backwards and extended antlers (fig. 29).

Barrow 401, of the same date as the last-named, contained: a plaque of a recumbent carnivore with the head projecting *en face*, the tail terminating in the head of a bird and the legs ending in paws with exaggeratedly large claws (fig. 30); two plaques of a lion's head with jaws open (pl. 81), similar to the one found in Barrow 400 but turned in the

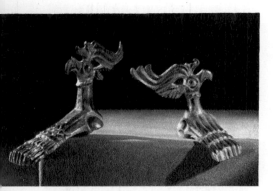

65 HORSE FRONTLETS. BRONZE

66 BRIDLE PLAQUES. BRONZE

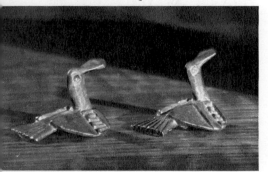

opposite direction, and one of an elk head (pl. 83); a solid bronze stag's head (pl. 80); a bronze pendant shaped like a sitting lion; a plaque of a griffin's head, and another of a bird's head with a long beak partly broken off; as well as a long bridle frontlet with the figure of a bird in the middle, a recumbent stag at the top end, and two bird-heads at the lower end (fig. 31). There were, in addition, a gold plaque with the figure of a recumbent stag and a triangular plaque having small holes along its edges with little golden nails to fit. It had probably originally been nailed to a wooden vessel. On the plaque are displayed the head of a goat or stag with a long straight horn with stylized bird-heads on the sides. In the horse burials in the entrance there was, among other things, a bronze plaque in the shape of a griffin head with a palmette behind (pl. 82).

The other barrows contained objects more or less of the same kind: Barrow 403, a plaque of a stag; Barrow 404, a beautiful mirror with a handle in the shape of an Ionic capital; Barrow 402, tiny gold plates depicting griffin heads and a long gold plaque decorated with a series of double spirals. The objects of Greek origin in the barrows enable us to date them to the fifth century BC. On the whole, objects imported from Greece are not numerous in the Zhurovka burials, but there were a few black-glazed vessels, a small red-figure kylix with an inscription, an alabaster box, amphorae, a bronze scoop and strainers with handles with swan-head terminals.

The Hermitage collection houses only a limited number of objects from the wooded steppe of Scythia; there are not enough of them to trace local variations between the different tribes. But even the data available are sufficient to reveal important differences in the construction of the graves between the steppe and the wooded-steppe inhabitants of Scythia, as well as the remarkable similarity of their respective cultures. The burials of the wooded-steppe belt are inferior in richness and splendour to the mounds of the steppe, yet the social position and wealth of the dead are just as striking. Here too a buried chieftain shares his grave with his wife or concubine, sometimes his servant, and also his horses, though there are fewer of these than in the burials of the Kuban chiefs. Moreover, in the graves of the rich we find, together with objects of local manufacture, Greek imports, and instances of Greek-influenced native art.

Outstanding examples of this stylistic borrowing are mirrors of Greek type, but with additions not normally associated with Greece, for the most part from Olbia. The edge of the mirror's disc is raised in a high rim, and the fluted handle is decorated at one or both ends with zoomorphic designs, especially ram-heads (fig. 33). Mirrors of this type were in common use and penetrated as far as the south Ural area. Cruciform plaques, used most probably for quiver attachments, may be regarded as typical objects of Olbian manufacture (fig. 34). It is possible that many other objects, in which animal motifs, so characteristic of barbarian art, were combined with classical plant motifs like palmettes and rosettes, may have come from Olbia. The Olbian workshops also produced

37

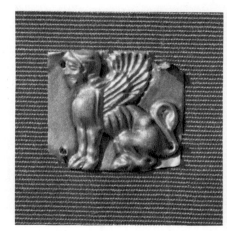

67 SQUARE PLAQUE. GOLD

68 ROUND PLAQUES. GOLD

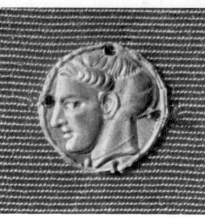

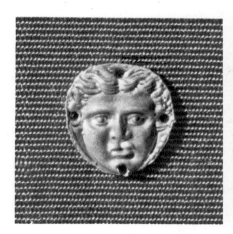

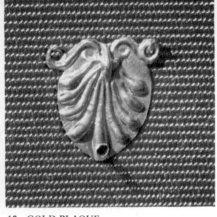

69 GOLD PLAQUE

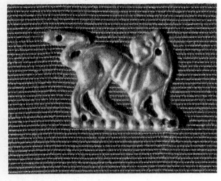

70 GOLD PLAQUE

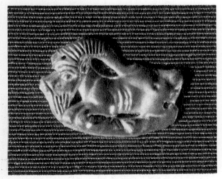

71 GOLD PLAQUE

72 TRIANGULAR PLAQUE. GOLD

jewellery, including various pieces decorated with granulations, Ionian-type necklaces formed of separately strung pieces, earrings with bird-shaped pendants (pl. 86), pendants in the form of discs ornamented with granulation and filigree, having on one side a lion head also with granulation, and on the other a ram's head or a small boss resembling a nail-head (pl. 84). To this category belong sword hilts and scabbards like those found in the Pointed Barrow.

It is natural that the Greek influence should have been strongest among the immediate neighbours of the Greek colonies. The native aristocracy, closely connected by trade with Greek cities, assimilated many elements of classical culture. This is evident from the urban cemeteries that have been excavated, for these show that nomads lived in the Greek cities. On their outskirts are large barrows, the funeral rites of which display a mixture of Greek and barbarian elements, although the offerings are mostly objects of Greek workmanship.

The barrows in the vicinity of Nymphaeum on the Kerch Peninsula may serve as an example of this kind of burial in the fifth century BC. In one of these barrows (24, cist 19) three vessels were found in the earth filling. The neck of one of them had been sealed with lime; in it were the charred bones of various animals. There were also two clay statuettes of bearded satyrs. The barrow cist, 3.2 m. long, 1.7 m. wide and 1.2 m. deep, had been let into the ground and covered with stone slabs; a heap of stones had then been piled over it. Almost all the space in the tomb was taken up by a carved wooden sarcophagus inlaid with a frieze of palmettes, large rosettes and a twenty-pointed star. In the tomb was the skeleton of a man, about whose skull lay sixteen gold plaques representing a seated sphinx, a Gorgon's head, a ram's head, a lion's head, a flying bird, and rosettes (fig. 35). Around the skeleton's neck was a solid gold torque; a silver *phiale* lay on his chest; on his finger was a ring with a revolving stone, on one side of which a cow suckling a calf was engraved (fig. 36) and on the other a winged disc — the Greek representation of an Egyptian motif. Beside the skeleton were found a coat of scale armour with bronze and iron scales, several swords and daggers, bronze arrow-heads, and a gold plume-holder. At its feet stood a beautiful bronze candelabrum with three feet shaped like lion-paws, and with a figure of a nude youth standing on its Ionic capital (pl. 87). Beside it were a bronze vessel, two black glazed kylices, a scoop with a handle ending in two swan-heads, a strainer with a siren at the base of the handle and a swan's head at the end, an alabastron, a red-figure scyphus, three amphorae and a bronze mirror with handle. On each side of the grave were two horse skeletons, making eight in all. Parts of their bridles were found on some of them, including two cheek-pieces terminating in an animal's ears, several cheek-pieces with ends shaped like hooves, others with ends bent in opposite directions, yet another shaped like a bird's head (pl. 91), an ear-shaped plaque with a palmette as its base, others in the shape of

38

a boar's head (pl. 93), or a bird's head (pl. 92), or a figure of a bird, as well as a number of plain round plates with loops.

In another mound (Barrow 17) a similar burial was found. As in the grave described above, a skeleton with a gold necklace on its chest was found in a wooden sarcophagus. The necklace was made of plaques decorated with filigree, rosettes and pendants (pl. 90). The skeleton still wore on the left hand a gold ring decorated with the figure of winged Nike (fig. 37), and lying on it were eight gold earrings in the shape of tiny bread rolls (pl. 98), and a variety of gold plaques. Among the forms these take are: an embossed human and lion's head (pl. 94); a seated sphinx (pl. 99); a standing sphinx (pl. 95); a recumbent stag (pl. 100); a fish; an unidentified creature; an elk or goat (pl. 102); a Medusa head (pl. 104); heads of monkeys (pl. 97); cocks (pl. 106); a flying eagle (fig. 38); a winged beast of prey (pl. 101); a recumbent lion (fig. 39); discs showing seated, confronted sphinxes with a lion lying beneath them, jaws wide open (pl. 96). Around the skeleton lay a Greek helmet, greaves, scale armour, arrow-heads, remains of swords, daggers and spear-heads. At its feet were a scoop with a handle terminating in a swan's head, a strainer, two black glazed vessels, a bronze mirror, an alabaster box, a bone spindle, and a sponge. In the same grave were bridle parts including cheek-pieces and plaques. Near the grave were some horse skeletons without any objects on them.

Among the Nymphaeum barrows is one mound with its human burial plundered but with four intact horse burials, among which parts of a bridle were found including bronze plaques shaped like lion-heads (fig. 40). The burials with objects of Scytho-Greek character consistent with Scytho-Greek ritual which occur on the outskirts of many of the Greek colonial cities, even in the town cemeteries, belong not only to people of wealth and position, but also to the ordinary tribesmen who happened for some reason to be included among the inhabitants of the towns.

The Seven Brothers Barrows

The Seven Brothers Barrows on the lower reaches of the Kuban are in many respects similar to those at Nymphaeum, although they are not associated with a Greek town. Probably interred there were members of a local royal dynasty who, though markedly hellenized, retained a strong link with their native background.

The first, the fifth and the seventh mounds had been pillaged. In the first mound, 15 m. high and one of the biggest in the group, only a log-roofed chamber with plastered stone walls remained. In the fifth and the seventh mounds only horse burials were examined. The tomb in the second and largest mound, 18 m. high with a vault of adobe bricks, was in a good state of preservation (App. VII). Much of it was filled with the skeletons of thirteen horses, but the human skeleton was lying on a separate ledge in a corner. It wore leather armour with iron and bronze scales, some covered with gold

73 OPENWORK PLATE. BRONZE

74 OPENWORK PLATE. BRONZE

leaf, and the breast-plate was decorated with a splendid silver ornament. This takes the form of an embossed design of a deer suckling a fawn with, below, a downward-facing bird whose spread wings and tail are covered with gold leaf (pl. 113). There were three gold torques on the dead man's neck; one a smooth tube *(grivna)*, another of strung gold cylindrical fluted sections, and the third of small gold ovals alternating with almond-shaped pendants (fig. 41). About the skeleton lay a great number of gold ornamental plaques that had been sewn to the clothing. These included human heads in profile (pl. 109), the forepart of a reclining ox (pl. 112), a kneeling nude youth bearing fruit in his hands, symbolizing a god (pl. 110), a helmeted head of Athena behind which appears a lion's head (fig. 42), an owl (fig. 43), a standing lion with head turned back (fig. 44), a leaping lion with jaws open and tongue thrust out (fig. 111), a Medusa head (fig. 45), the head of a bearded Silenus or Pan with horns and beast's ears (fig. 46), the head of an ox (fig. 47), a ram's head (fig. 48), the figure of a winged sphinx (pl. 108), the protome of a winged boar (fig. 49), a recumbent stag with his head turned back (pl. 107), a recumbent ibex, a standing panther, a hen (fig. 50), as well as a number of rosettes (fig. 51). Lying near the body were a sword, spears, arrow-heads, and a large silver rhyton terminating in a lion's head (fig. 52), a silver *phiale* with a circle of bearded Sileni (fig. 53), a bronze cup, a strainer terminating in a swan's head, two scoops, a large bronze vessel supported on a stand with three lion-paws (fig. 54) and two handles shaped like lions and snakes, fragments of a silver kylix with engraved figures partly gilded, an alabaster goblet (fig. 55), two black glazed vases, and two fragments of the sheet-gold casing of a wooden vessel — one part with the design of a winged leopard tearing a mountain goat, and the other, which covered the handle, of two confronted eagle heads (fig. 56).

With the thirteen horse skeletons were metal parts of bridles, among them bronze cheek-pieces of very varied shapes, such as the protome of a horse at one end and a hoof at the other (pl. 125), a deer's leg and a deer's ear, a horse's leg and some beak-shaped figures. In addition there were bridle plaques, frontlets in the form of a stag's head (pl. 114) or plaques having relief designs of recumbent stags with branching antlers (fig. 57), plaques in the form of a bird's head with a volute-shaped beak and palmette-shaped crest (pl. 115), and of two confronted recumbent stags with their horns represented symmetrically, and much besides. In the mound five large bronze bells came to light.

Another burial of about the same date, or perhaps a little earlier, was found in the fourth mound (13 m. high). It had been partly pillaged. The nature of the burial structure remains obscure. There must have been a shaft with walls of adobe brick of the kind described above. With the skeleton were three *rhyta:* a large one of silver decorated with a winged goat (pl. 117, 119), and two of gold, one terminating in a ram's

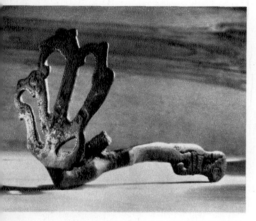

75 CHEEK-PIECE WITH AN OPENWORK
PLATE. BRONZE

76 OPENWORK PLAQUE. BRONZE

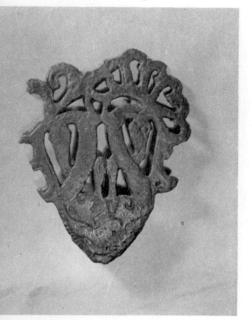

head (fig. 58) and the other in the protome of a dog (fig. 59). Near by lay five triangular gold plaques with a design of an eagle attacking a lamb on two of them (pl. 118), and that of a winged lion tearing a goat (pl. 116, 122), a lion attacking a stag (pl. 120), and a dragon (pl. 121) on the others. The dragon has large teeth and ears, wings terminating in a bird's head with voluted beak, and a tail which also ends in a bird's head. These plaques had served as plating for wooden parts of the *rhyta*. In addition there were seven amulets including a tooth on gold mounting, a gold bracelet shaped like a snake (pl. 133), a small silver cup and a kylix with an engraving on the bottom.

Next to the skeleton was a special boarded-off compartment, where weapons and other equipment had been placed; this contained the remains of a leather jerkin with bronze scales sewn over it, convex round plates and long plates ornamenting the sleeves. At the collar was a crescent-shaped plaque, on the chest a large bronze Gorgon head. Other items that came to light included a bronze candelabrum, a bronze cauldron on an iron tripod, a bronze dish, the handle of a mirror (possibly a ladle) shaped like a human figure standing on a ram's head and carrying two rams in his upraised hands (Hermes Criophoros) (pl. 124), a fragment of a bronze vessel, a cup of red clay, three black glazed vessels, three amphorae and a painted *lecythos*.

The horses had been placed in a special large grave covered with timber. Besides the four horse skeletons, there were parts of bridles, cheek-pieces of various shapes, such as a bent stag's leg, a beast of prey with its rump twisted round (fig. 61) and a stylized bird's leg. Among the bridle accessories we may note plaques in the form of a curled-up lion (fig. 62), a recumbent lion with another carnivore sinking its teeth deep into the lion's back (pl. 126), recumbent stags (fig. 63, pl. 128, 130), a boar's head (pl. 127), other animal heads (fig. 64) and small sitting birds (fig. 66). Of special interest are the frontlets with projecting antlered bird-heads (fig. 65, pl. 129).

In the sixth barrow a large tomb had been left intact. Its walls were faced with adobe brick and it was roofed with wooden beams. Inside, it was divided into three parts by walls, that at the narrow north end being in its turn subdivided into two. Let into the floor of the larger part was a cist of stone slabs in which a carved wooden sarcophagus had been set. The adjoining compartments contained funeral equipment, and in the one farthest from the sarcophagus seven horses had been laid.

On the dead man's skeleton were remains of fur-trimmed clothing and scale armour, an iron spear-head and bronze arrow-heads. The skeleton was adorned with beads, two gold buckles, a gold ring with the design of a leopard devouring a stag (pl. 132), and another, undecorated ring. The clothing was decorated with gold plates showing a sitting sphinx (fig. 67), profile and facing female heads (fig. 68), and Medusa heads. In the same compartment were a rock crystal intaglio representing a boar (pl. 134) and three small smooth pots.

41

77 PLAQUES IN THE FORM OF BIRDS. GOLD

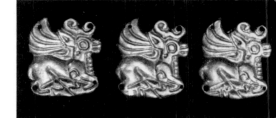

78 PLAQUES IN THE FORM OF STAGS. GOLD

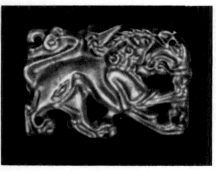

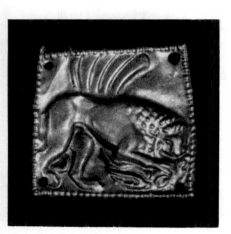

In the adjoining and smallest compartment were two clay amphorae, a red-figure vase and a plain bronze mirror with a wooden handle. In the middle compartment were bronze and clay vessels, a plaited basket, a box faced with bone plates, and a needle-case of bone containing iron needles. Finally, in the horse compartment were iron bridles with cheek-pieces and bronze buckles.

The earliest of the burials in the fourth barrow, judging by the silver-gilt kylix with the figure of a seated Nike, and equally by other pure Greek objects, may be dated back to the second quarter of the fifth century BC. The second and the sixth burials belong to the middle and second half of the same century, the sixth apparently being somewhat later than the second burial. In the fifth and the seventh barrows only horse burials survived. In the first of these the human grave was not excavated, as it was obvious that it had been robbed. The horse grave consisted of a pit lined with brick walls and roofed with wooden beams. In it were bridle sets similar to those found in the second mound. In the horse burial of the seventh mound four bronze S-shaped cheek-pieces were found. The central burial cist was made of stone slabs and divided into two, and contained the remains of iron scale armour.

The burial in the third mound was the latest. The central stone cist covered with three stone slabs contained the rifled remains of a human burial and several horse skeletons. In addition there was a special burial of five horses beside it. In the human grave were found: an iron sword-hilt shaped like an eagle-griffin head plated with gold (pl. 137); a gold ring with the engraving of a bear on a chalcedony intaglio (pl. 131); plaques in different shapes, including palmettes (fig. 69), a standing lion (fig. 70), a female head, a recumbent goat (fig. 71), bunches of grapes, embossed triangles (fig. 72) and rosettes; a broken silver vessel; amphora shards; an alabaster casket and other items. An entirely new style of decorating horse harness appears here, particularly in the cheek-pieces with openwork ornamental plaques at the ends in the form of birds with exaggeratedly hooked beaks and claws (pl. 135), or stylized antlers (fig. 75). Then there are also openwork plaques: one of a stylized animal head with ornamentally treated antlers (fig. 74), and another of two animal heads on long necks bent backwards (pl. 136). This barrow dates to the beginning of the fourth century BC.

The Elizavetinskaya Barrows

The same kind of development as seen above may be traced in the Elizavetinskaya barrows on the middle reaches of the Kuban, where, in spite of the greater distance from the Greek towns, elements of Hellenic origin are also found in great quantity. The barrows had been plundered, but by comparing the data obtained when excavating the barrows it is possible to form a general idea of the funeral rites and accessories peculiar to burials of this group.

Beneath the mound, in all the barrows, there was a broad pit similar to those in many other Kuban barrows (the ones at Kelermes, for instance). However, inside the shaft in the majority of the Elizavetinskaya burials there was no wooden construction on posts (as at Kelermes) but a stone vault with timber roofing. As the main burial in every mound had been completely rifled, it is quite impossible to judge its nature.

'Everywhere', wrote Veselovsky, when describing the first Elizavetinskaya mound he excavated in 1913, 'there were buried horses, with iron bits and bronze cheek-pieces in most cases . . . In all we counted up to two hundred. Some of them were above the old ground level; those at the edge of the burial chamber had fallen into it together with earth. At one point there were three horses lying radially around a wooden post, their heads towards it.'[1] The description vividly recalls the great barrows of the Ulski group, as well as that part of Herodotus's *History* where he states that strangled retainers were mounted on horse carcases tethered to special posts or horse-ties. There is no doubt that a careful study of the Elizavetinskaya barrow would have revealed the general system according to which the horse skeletons were placed. Unfortunately, the archaeologist in charge did not interest himself in this.

Veselovsky's information concerning human burials in the mound is even scantier. He says: 'We also came across disturbed human skeletons with which there were beads and bronze wire bracelets.'[2] That they belonged to accompanying burials is proved by the evidence from another barrow of the same group opened in 1914/15. He writes: 'In various parts of the grave we came across horses, nearly all of them disturbed.'[3] However, the number of horses was apparently not so great as in the first mound. As for human burials, they seem to have been found in a better state of preservation, and are more fully described. 'Outside the vault, on its south-east side, there were five female skeletons in a common grave; all the skeletons were found lying on their backs with their legs and arms extended, their heads facing east; they wore bronze wire bracelets, and rings and earrings of the same kind.'[4] West of the vault was a disturbed skeleton that had been dressed in bronze armour, the lower part of which consisted of separate curved strips. 'On the breast of the armour there were three smooth gold plates which may have formed a star shape . . . North of the skeleton there was an iron sword, and beyond, two female skeletons with their heads directed westward, which also wore bronze bracelets and beads.'[5] Thus the mound contained eight burials besides the main interment, which had evidently been within the stone-vaulted chamber. Only one was a male burial, all the rest were female.

Accompanying burials also occurred in a barrow opened up in 1914 (App. VIII). Here the vault covered almost the whole of the burial pit. A ramp down a passage roofed with wood led into it, in the same way as in the barrow dug in 1913. Inside the entry passage were the remains of a wagon with three pairs of harnessed horses. Veselovsky

82 GOLD BRACELETS

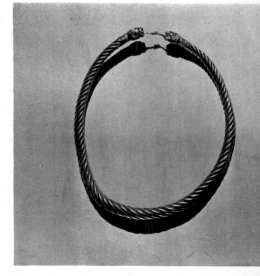

83 TORQUE WITH LION-HEAD
FINIALS. GOLD

84 GOLD PLATE

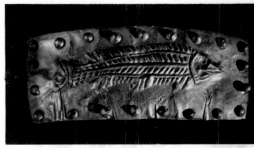

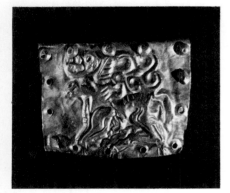

85 RECTANGULAR PLAQUE. GOLD

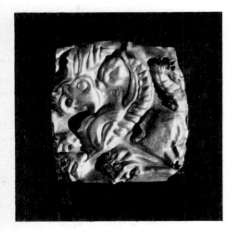

86 SQUARE PLAQUE. GOLD

worked out that there had been two wagons in the passage, but of the second — turned with its horses to face the vault — only two wheels remained, for the other two wheels had been smashed by robbers and thrust, together with the horses, into the vaulted tomb. The horses had iron bits, bronze cheek-pieces and other bridle decorations. On the west side of the passage there were ten more horse skeletons lying on virgin soil close to the edge of the tomb, and on the east side four human skeletons. All the skeletons were placed facing northwards, towards the chief burial. The skeletons had beads at their necks. In the north wall of the tomb, in a special recess behind the vault, was a human skeleton in heavy armour, with a long sword by its right hip. By analogy with the barrow excavated in 1914/15, where the skeleton of a man in armour was also found close to the tomb, one may assume that all the rest of the burials found in 1914 were female — a supposition which the beads found with them seems to confirm. If this is the case, one should consider the presence of a large number of accompanying female burials to be a typical feature of the Elizavetinskaya barrows, and it may possibly be a characteristic feature of ancient Kuban barrows in general. In some mounds these burials were associated with a great number of buried horses.

The fourth Elizavetinskaya barrow, excavated in 1917, had a structure much resembling the stone-vaulted tombs already described, differing from them only in that the stone walls of the pit shaft formed a kind of passage with wooden roofing around the tomb. In the passage was a medley of human and horse bones.

Of the things found in the Elizavetinskaya burials one should mention the remains of funeral wagons found in two of the barrows. In the one dug in 1914 it was evident that the funeral wagon had been painted, for traces of blue, yellow and white paint were still visible. The wagon had four wheels, each 75 cm. in diameter, with twelve spokes and iron tyres. The gap between the front and rear wheels was 70 cm. The front board of the wagon was decorated with bone inlay. The horses were harnessed on either side of a wooden shaft, the end of which was plated with iron.

Among other things found in the barrow dug in 1913 the Panathenaic amphora is most remarkable (pl. 140, 141). Painted on one side is Athena, and on the other a scene including two nude men sparring. Such amphorae, filled with expensive olive oil, used to be given as prizes to winners of Panathenaic contests. This does not mean, of course, that the barbarian chieftain buried in the Elizavetinskaya mound had participated in sports only open to Greeks; the amphora was most likely a purchase. It belongs to the last quarter of the fifth century BC, and thus helps in dating the burial in which it was found to the end of the same century. In the same barrow were wooden and bronze parts of a large *gorytus* (bow case and quiver) now fully restored, scale armour and a sword, which were lying together on a stone slab that might be compared with the offering stones that came from the Kostromskaya, Ulski and Kelermes barrows. In

a barrow dug in 1914/15 there was a remarkable bronze breast-plate bearing a design of a Medusa head (pl. 144). It too belongs to the end of the fifth century BC. From the 1914 excavations a number of small gold plaques, displaying a Medusa head, palmettes and lotus, were collected.

Harness fittings, distinguished by most original semi-vegetable and semi-animal forms, are a very individual feature of the finds from the Elizavetinskaya burials investigated during 1916/17. Openwork bridle plaques and cheek-piece terminals display fantastic interlacing ornamental figures of animals and horns that look very much like plant shoots (fig. 73, 75, 76; pl. 138, 139, 142, 143). At the base of these ornamental designs one may occasionally distinguish figures of animals or parts of animals (for example, two heraldic-looking confronted stags, the head of a stag with branching antlers, a bird head with long beak), but frequently they are so stylized that it is impossible to say what they represent. These finds from the Elizavetinskaya barrows are very similar to corresponding objects from the later burials of the Seven Brothers barrows and, like them, date from the beginning of the fourth century BC.

It is not only the richness of the contents of the Kuban barrows that arrests our attention, however, but also the nature of the funeral rites with their numerous horse burials, funeral wagons, and the human sacrifices accompanying the main interment. It is remarkable that among the victims of sacrifice women predominated, and their position in the grave next to the horses can be taken as a clear indication that these were not concubines such as are frequently found in tombs of rich men, but female servants, probably slaves, who performed household duties. In two of the Elizavetinskaya graves there were also accompanying male burials, one in each, placed just outside the wall of the main tomb, and also undoubtedly those of persons of subordinate rank — warriors, or possibly sword-bearers. This more or less corroborates Herodotus' description of contemporary funeral rites of the barbarians of the Black Sea region. It follows that the Scyths who lived in the Dnieper basin may have practised similar rites, although until now this has not received archaeological confirmation. This leads us to the classical fourth-century Scythian burial, of which those at Solokha and Chertomlyk offer such superb examples.

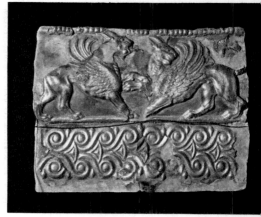

87 DETAIL OF *GORYTUS* CASING
SHOWN IN PLATE 160

III SOLOKHA AND CHERTOMLYK

Solokha

One of the very rare intact Scythian burials was found in the Solokha barrow, twenty-one kilometres south of Nikopol (App. IX). It was a vast mound, 18 m. high, erected in two stages and containing two burials. The central one consisted of a shallow rectangular shaft, with two side chambers dug out on its two longer sides. The floor of the chamber was 2 m. below the bottom of the entry shaft. This burial had been rifled.

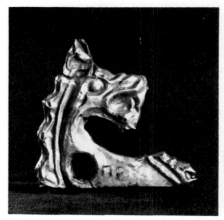

88 HORSE FRONTLET. BRONZE, GOLD

45

In one of the chambers a few remains of the burial accessories were found, including gold cruciform plaques, or plaques in the form of human heads, sirens or birds (fig. 77), a gold needle, gold plating for wooden cups, a large amphora with a long-handled bronze scoop hung on its neck, a silver kylix with a Greek inscription *ALKO* (which vaguely recalls the name of one of the Scythian kings mentioned by Herodotus). There were also bronze arrow-heads and ox bones. In the other chamber, undisturbed by the plunderers, were the cumbersome and less valuable household utensils: a large bronze cauldron with bones of sheep and oxen, a grill on wheels that probably served to pass round roast meat at table, a wooden scoop, a pointed rod for getting meat out of a cauldron, three amphorae and a gilded bronze vessel. There was also a small wooden table with turned columns along the side.

As in other cases, close to the shaft and the chambers an intact horse burial was found. It was divided into two by a wall of adobe brick and contained two horse skeletons with almost identical gold bridle decorations. These had been fixed to carved wooden forms and consisted of a frontlet shaped like a double fish, the embossed design on which included a smaller fish and two pairs of birds, and pairs of cheek-pieces shaped like stylized pointed ears (pl. 146).

The second grave, containing a human burial, was unusually situated near the edge of the barrow, and probably for this reason remained unnoticed by the robbers. It also consisted of a deep shaft and compartments linked to each other by a long passage. In the chamber were three recesses of different sizes (App. X), the largest containing the skeleton of the principal interment. Numerous gold plaques of griffins, lions, recumbent stags (fig. 78, 79, 80), Scythians drinking out of horns (fig. 81) and embossed triangles were collected about the skeleton's legs; the plaques had been sewn on his trousers. At his feet lay a knife with a bone haft. On the right of the skeleton was a sword in a gold-plated scabbard, ornamented with animal figures (pl. 145); the heart-shaped hilt is decorated with heads of boars of heraldic appearance, and the pommel with volutes in the shape of bird heads. The hilt is decorated in the same manner as that of the sword from Tomakovka — namely with cross-hatching and two bands of animal figures extending along its broad sides. The scabbard is carved wood sheathed in gold showing figures of lions attacking stags. In this scene, repeated twice along the scabbard, the stag is represented by only a head with branching antlers. One scene is separated from the other by a band of interlace design. The lower part of the scabbard is filled with two figures of carnivores, and the circular chape is ornamented with a stylized lion head. The Solokha scabbard differs from others in that it has not one but two protruding side-plates for attachment, both of which display figures of lions.

On the right arm of the skeleton were three gold bracelets, on the left two (fig. 82). Around the neck there was a gold torque with lion-head finials inlaid with coloured

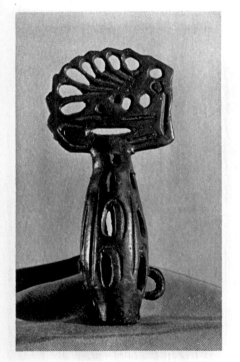

89 OPENWORK POLE-TOP WITH TWO
LOOPS. BRONZE

46

enamel (fig. 83). At the head lay a Greek bronze helmet (pl. 149), and not far from it was the famous gold comb (pl. 147—8, 150). The upper part of the comb is decorated with a group of Scyths in combat and a frieze of five recumbent lions. The group consists of three warriors. One mounted warrior is aiming his spear at another, who protects himself with a shield. His wounded steed is lying at the feet of the rider. A third warrior, on foot and sword in hand, is hurrying to help the rider. The first two warriors are probably Scythian chieftains. Their attire and weapons are partly Scythian and partly Greek. Their trousers and soft boots fastened around with leather straps are Scythian, but the rider has Greek greaves, and both of them have Greek helmets on. Both wear armour. The one on horseback wears scale armour and the dismounted one has plate armour on his trunk with long semicircular metal scales at the bottom. The third warrior is bare-headed and dressed in an ordinary Scythian caftan decorated with sewn-on plaques, like the trousers of the second warrior. The rider is holding a short spear with a broad leaf-shaped head; the two other warriors are armed with short swords. All of them have light shields variously shaped. The warriors on foot hold their shields with their left hands by a handle fixed in the middle of the back of the shield. The rider, who is holding the reins in his left hand, has his shield hung on his left shoulder. Two of the warriors have a *gorytus* fastened to their belts at the left hip, and one an *akinakes* sheath. Most of the details of clothing and weapons displayed in the scene fully correspond to the objects found in Scythian burials. The horses are very characteristic, small and long-tailed with closely cropped manes. The rider has abruptly reined in his horse which rears on its hind legs. The other horse, which is wounded in the neck, is lying on its back with its legs bent. Blood is flowing from the wound. As to horse harness, the bits with figured cheek-pieces attached bear a close resemblance to the usual Scythian types.

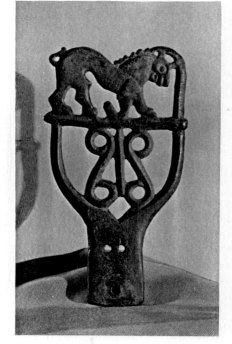

90 POLE-TOP IN THE FORM OF A FRAME. BRONZE

Along the right arm of the skeleton lay a six-spiked mace, and beyond it six silver vessels. These imitated local styles but were evidently made by Greek craftsmen. Three were decorated with figures. The largest is spherical with a cut-off upper segment, and a low ring-like stand. It has two perforated lugs by which it was hung. Along the upper edge it is encircled with a garland of ivy, and the lower part of it is demarcated by a narrow band of interweave with vertical grooving below it. The middle part of the vessel bears a frieze displaying scenes of Scyths hunting lions, assisted by dogs (pl. 155). On one side of the vessel a lion is shown pierced by a dart, rising on its haunches and clutching with its forepaws at the leg of a horse. The mounted hunter has raised his spear to stab the lion. Under the legs of the horse a dog can be seen cowering with its tail between its legs (pl. 155). Another rider who approaches the lion from behind is taking aim at it with his bow. Under the legs of his steed there is also a dog, but this is bravely rushing at the lion with its tail up. On the other side of the vessel two

47

Scythians strike down a fantastic horned lioness (pl. 154). Rising on its hind legs, the beast is about to attack one of the hunters, who is aiming his spear at it. Another hunter is about to shoot an arrow at it. Under one of the handles of the vessel is a pair of lions with their heads in close contact, and, under the other, two confronted beasts with heads turned back and curved tails. The handles are decorated with two ram heads, turned in opposite directions, with a three-petalled flower between them.

In the vividly realistic scenes displayed on the vessel, the type of ideal Scyth, created by Greek art and similar to the one seen on the comb, is repeated; in this case a beardless young man with his head uncovered, showing his long hair. The Scyths are dressed in their usual short caftans and wide trousers decorated with sewn-on plaques, and soft boots fastened round the ankle with a leather strap. They are armed with javelins or spears with long narrow heads, and with bows and arrows. The horses are of the same breed as those depicted on the comb, the bridles and bits are shown decorated with round plates, and the bits have curved cheek-pieces. Soft saddles, or rather shabracks, are decorated along the edge with plaques, like those not uncommonly found with the horse skeletons in the graves. Their hunting dogs are of two breeds: one has a long narrow muzzle and smooth coat, the other a squatter muzzle. There are collars on the dogs' necks. All the figures and ornamental parts of the vessel were gilt on a silver-white background. It is one of the most beautiful examples of Greek chasing, remarkable not only for its exquisite perfection of composition but also for the wonderful skill with which it was embossed.

A second vessel, spherical in shape, with a short neck and slightly everted mouth, is covered with a relief design (pl. 151). It repeats the shape of a common local earthenware vessel engraved with geometrical design filled with a white paste. Two confronted winged sphinxes are to be seen, one on either side of a lotus. The frieze containing the picture is demarcated by narrow bands, the upper at the base of the vessel's neck, and the lower in a zigzag pattern separating it from the base of the pot.

A third vessel, shaped like a cup, is covered with engraved figures of groups of women with flowers and musical instruments (pl. 156). A woman with a harp is seated, while another dances. There is also a figure of an antelope. The remaining silver vessels are smooth — two of them like the first of those described above (with the hunting scenes), and one like the second (with the sphinxes). There were also a Greek black glazed kylix and a wooden basin (a prototype of metal vessels with lugs) plated with gold bearing a stamped design of fish (fig. 84), and one plaque with the figure of a stag (fig. 85).

Near the head of the skeleton were decorative plaques showing a goat or an elk (fig. 86), and a necklace of little cut gold cylinders alternating with almond-shaped pendants and terminating in a rosette. Also near the skeleton were bronze arrow-heads, a second iron sword, remains of a belt, iron scale armour and a knife with a bone handle.

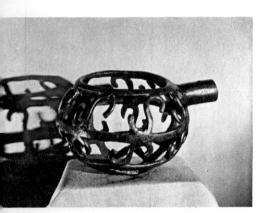

91 BRONZE BRAZIER

48

In the side wall of the recess a small hiding-place was found, evidently designed to contain the most valuable belongings of the deceased, namely a gold *phiale* and a *gorytus* mounted in silver and gold and decorated with battle scenes. There were 180 arrows with bronze arrow-heads in the *gorytus*. The *phiale* has its whole outer face covered with embossed designs running in three rows; in each row the same composition is repeated several times (pl. 157—9). In the upper row two lions devour an ungulate animal, in the middle row a lion and a lioness attack a fallow-deer, and in the lower row a lion seizes a stag. On the outer rim of the vessel a Greek inscription made in dotted lines can be distinguished, the lettering being reversed. It is supposed to read *ΕΛΕΥΘΕΡΙΑ ΗΕΡΜΟΝ ΑΝΤΙΣΘΕΝΕΙ*. Also, there is in smaller letters the word *ΛΟΧΟ*, meaning 'ambush' or 'detachment'. Neither inscription has any connection with the last owner of this Greek *phiale*.

The *gorytus* (only fragments of thin, partly gilt, silver plating remain) was worked in relief with a supporting plaster backing. It was of the usual Scythian shape and bore the usual ornamentation, divided into three parts (pl. 160, 161). In the central and wider part there is a scene showing a fight between Scyths mounted and on foot. On the left a young half-nude warrior is fighting a bearded horseman, who has reared up his horse and is about to thrust his spear at his adversary. The young warrior defending himself with his shield has raised his axe above his head. He has a *gorytus* containing a bow fastened at his left hip. On the right a young warrior, holding a long sword in his right hand, seizes with his left hand the hair of his bearded enemy. His enemy has just dismounted from his wounded horse, shown in the background fallen on its bent fore-

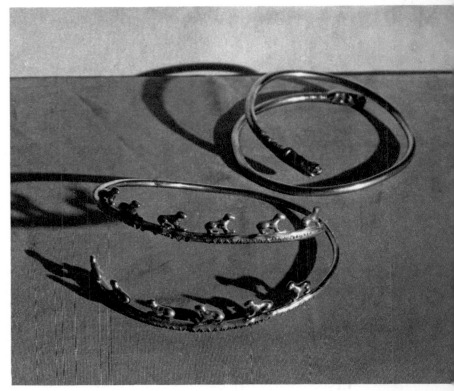

92 TWO TORQUES. GOLD

49

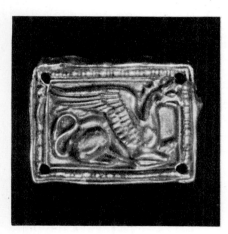

93 RECTANGULAR PLAQUE. GOLD

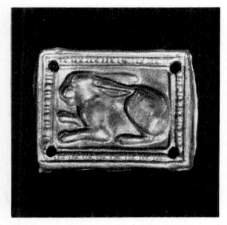

94 RECTANGULAR PLAQUE. GOLD

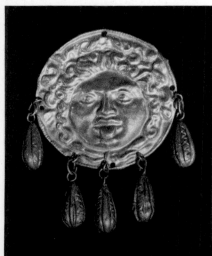

95 ROUND PLAQUE. GOLD

legs. He is struggling with one hand to free his hair, while with the other he is drawing his sword from the scabbard at his belt. Behind the horse one can see another young warrior protected by his shield with his spear aimed for a blow. In the upper band, above the battle scene, a griffin and a lion attack a stag. The rectangular projection in the upper part of the *gorytus* is divided into two parts; one can see figures of two monsters in one part, and decorative volutes in the other (fig. 87).

Along the north wall of the chamber, with head towards the main interment, was another skeleton — probably that of a sword-bearer. On its right was a sword, and the remains of scale armour among the bones: three spear-heads and arrow-heads lay on the left. Near the place where the burial recess joined the passage was a third skeleton of a youthful retainer. There were bronze arrow-heads near its left hand, and two iron spear-heads at its feet. Not far from the skeleton were rams' knuckle-bones, evidently used for a game.

In the second recess, next to the one used for the burial, were three cauldrons for cooking meat, containing horse, cow and sheep bones. In the largest cauldron was an iron rod with a pointed end used to get the meat out of the cauldron, and a bronze ladle. In the same recess were also a large bronze basin, a silver *rhyton* rim, a bronze strainer used in wine-making, with a handle shaped like a swan's head, and long triangular plating from wooden vessels. In the third recess were ten Greek amphorae which had probably contained wine and oil. The youth that lay not far from it had evidently acted as a cup-bearer.

Near the side, as well as the principal burial, there was a special grave for five horses with another burial for the groom at its edge. The harness accessories were not as luxurious as in the main burial. They comprised carnivores' heads in gold-plated bronze (fig. 88) which decorated the thong junctions of bridles, cheek-pieces shaped like stylized animal legs or those of a wild beast, numerous crescents, bells, pendants, plaques, brush-holders, buckles and bits with cheek-pieces. Only a few arrow-heads were found with the groom's skeleton.

Chertomlyk

The famous Chertomlyk barrow is another of the few Scythian monuments that virtually escaped plundering. It lies north-west of Nikopol. The mound reaches a height of 19 m. — that is about as high as a five-storey house — while its circumference at the base is a third of a kilometre (330 m.). The edge of the mound is marked out with large stones. Its excavation, which made the reputation of I.E.Zabelin, lasted for two seasons, as did that at Solokha, but it was limited to digging a wide trench transversely across the mound, which left a considerable part unexplored.

50

Already near the summit of the mound various parts of bridles began to appear, such as bits and cheek-pieces, and at a depth of 6.5 m. a mass of bits with cheek-pieces, frontlets, buttons, plaques, bells and other horse harness came to light. Some of the cheek-pieces were made of gold. The deposit contained no less than 250 bridles. In addition there were several pole-tops with figures of animals and birds (fig. 89,90), an iron openwork brazier with a socket for the handle (fig. 91), a bronze torque in the form of a smooth ring, and over 260 bronze arrow-heads. At the level of the natural virgin soil outlines of several pits were discernible, the central pit being conspicuous by its size (App. XI). It was filled in with stones. It proved to be 11 m. deep and gradually widened to give a floor space of 6.4 m. by 4.4 m. at the bottom. Its excavation presented exceptional difficulties both in disposing of the stone and soil filling and from the danger of trench collapse. At the bottom of the shaft traces of decayed wood and reed were noticed in the middle, and traces of colouring on the ground and corroded iron cramps and nails along the walls. Could it have been the remains of a bier? At the corners of the shaft four cave-like chambers which had been hollowed out of the subsoil, measuring 5 m. long, 3.5 m. wide and slightly over 2 m. high, were found.

In the south-west chamber were two skeletons side by side. One wore a rubbed gold torque decorated with twelve figures of lions (fig. 92), while about its skull were twenty-nine rectangular gold plaques bearing a design of a griffin (fig. 93), that had decorated its headdress. This might have been a hood. Under the chin, where it had been tied, were two plaques: one of them was rectangular with a design of two flowers, the other was round and displayed a Medusa head. There were wide gold bracelets on the arms and plain rings on the fingers. At the left side of the skeleton was a sword, the hilt gold-plated and the scabbard with a plain gold chape; a horse-whip with a gold spiral band wound round the handle; a knife and a pile of bronze arrow-heads with the remains of a leather quiver. At the pelvis were bronze scales from the belt, and on the shins bronze greaves. At the left of the skull were fragments of a bronze cup and a silver ewer, a few spear-heads and another pile of arrow-heads with the remains of a quiver. The other skeleton also wore a cast gold torque with lion terminals (fig. 92), a silver bracelet on its right arm, a gold ring on its finger and a bronze belt at its waist. At its left side was an entirely corroded sword, and fragments of a knife as well as a quiver with arrows. Near both of them were rusty nails and small cramps.

The next (north-west) chamber contained a female burial. The skeleton lay on the remains of a decayed wooden couch which was over 2 m. long and 1.5 m. wide and bore traces of dark blue, light blue, green and yellow paint. On the forehead of the skeleton were a gold band decorated with a plant design, forty-nine plaques shaped like flowers and rosettes, and seven tiny buttons, also of gold; on the sides of the skull there were two gold earrings decorated with pendants on chains (fig. 96). Around the head

51

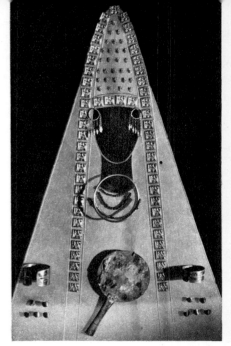

96 RECONSTRUCTION OF A 'QUEEN'S' FUNERAL ADORNMENTS

97 SQUARE PLAQUE. ELECTRUM

98 RING WITH BEZEL

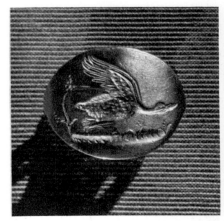

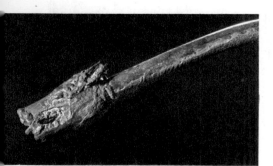

and the body were fifty-seven rectangular plaques that had adorned a purple shroud. On them were figures of goddesses with a Scythian on the one side and an altar on the other (fig. 97).[6] There was a solid gold torque with lion finials round the neck. On the arms were broad gold bracelets with a rib down the middle, and on each finger a ring, one with a figure of a flying duck (fig. 98). Near the right hand was a bronze mirror with a bone handle (fig. 96).

In the same chamber on the floor near the couch was another skeleton, that of a youth, with its head towards the first one. On its arms were a bronze and an iron bracelet, at its side a knife, and somewhat lower a small pile of arrow-heads. To the left of it was an earthenware amphora. There were thirteen amphorae of the same kind near the north wall of the chamber. By the west wall stood the famous partly gilt silver amphora showing scenes of Scythians breaking-in horses (pl. 162—76), and a large silver (also partly gilt) dish with figured handles (pl. 177—9), on which was a silver scoop, the handle of which had a dog-head finial (fig. 99).

The silver wine amphora is 70 cm. high, and has a maximum diameter of 39 cm. In shape it resembles Samos amphorae of the sixth century BC. In its neck is a strainer for straining wine as it was poured in, and in the lower part of its body are three bung-holes also fitted with strainers on the inside. These bung-holes are shaped like a horse's head in one instance (pl. 171), and in the two others like lion heads (pl. 172, 173). They were stopped with bungs fastened on chains. The body of the vessel is ornamented with a luxuriant design worked in relief, high on the exterior curve but gradually lowering on the receding face, where it turns into engraving. The decoration consists of a plant design with serrated leaves, palmettes and flowers. In the upper part of the vessel, on the flourishes of the stems or on the flowers on either side of the palmettes displayed in the centre of the front and the back surfaces, are two pairs of birds in profile with raised wings, remarkable for their elaborate detail. Below, on one side there is the same bird and on the other a crane. The relief horse head on the forward face of the vessel is surrounded by a radiant corona and two raised wings, the feathers of which are worked in as elaborate detail as those of the birds mentioned above. The upper part of the vessel is encircled with a frieze in high relief. Each figure in it has been cast separately and then soldered to the surface of the vessel. Two grazing horses in the middle of the reverse side, facing in opposite directions, divide the frieze in two (pl. 168, 176). Each section opens with a scene of a Scythian lassoing a galloping horse as, crouching on the ground, he checks its attempted flight (pl. 166). On one side a Scythian is hobbling a saddled horse that stands quietly (pl. 175); on the other a Scythian, holding his horse by the tether, is bending its foreleg (pl. 167), probably to make it lie down. In the centre of the front side of the vessel three Scyths, having lassoed a horse, are trying to make it lie on the ground; a fourth, his caftan having slipped from his right shoulder, stands apart,

52

drobably about to start breaking-in a wild horse (pl. 174). The Scyths are dressed in the same way as depicted on objects from Solokha. They wear short narrow caftans, wide trousers and soft footwear fastened with leather straps, and are bare-headed. Their hair is long; the older ones are bearded, and the younger clean-shaven. On the shoulder of the vessel are two groups of griffins devouring a stag, worked in relief (pl. 169, 170). Both decoration and frieze are gilded in contrast to the silver background of the amphora. It is an outstanding piece of craftsmanship, the work of a master of the first order.

In the third (south-east) chamber stood a small bronze cauldron and five amphorae, in front of which was a badly preserved dog's skeleton. There was, in addition, a pile of bronze arrow-heads with traces of leather quivers and five knives with bone handles. In the corner were rows of arrows against the wall, some of them intact, with shafts about 70 cm. long. There were 350 of them. At the same places remains of what had probably been a carpet were found, together with numerous head ornaments, gold plaques, buttons, bands, cylinders, pendants and other trimmings for clothing which had probably fallen from iron hooks along the wall and in the vault of the chamber.

In the next (north-west) chamber six amphorae stood along the walls. In the middle a bronze mirror with an iron handle, a silver spoon, and bone plates from a casket were discovered, while at the entrance there was the skeleton of a man with a plain bronze torque around its neck, with a gold pendant from an earring by its head and a gold spiral ring on one of the fingers of the right hand. At its left side was a knife with a bone handle and sixty-seven bronze arrow-heads with traces of a leather quiver. About the head a few gold and bone objects were discovered. These included gold plaques, pole-tops, spiral bands, trimmings and fragments of bone. All over the floor of the chamber were masses of gold plaques, pendants, beads, cylinders, tiny buttons and other accessories for decorating clothing. In all, about 2,500 pieces were collected from the floor. The most frequently depicted figures on the plaques were a bearded human head (fig. 100), a mythical animal called hippocampus (fig. 101), besides the hare (fig. 94), Hercules strangling a lion (fig. 103), a griffin, a Gorgon's head, little embossed triangles (fig. 104b), two flowers (fig. 104a), rosettes (fig. 104c), a Scythian fighting a griffin (fig. 102), a lion seizing a stag (fig. 105), and a helmeted Athena (fig. 106). There were a few plaques with figures of a recumbent ox (fig. 107) and a lion struggling with a sphinx. Parts of headdresses like those found in the preceding chamber, with gold openwork bands and pendants, are of particular interest. They are decorated with a plant design and representations of beasts fighting monsters. These abundant adornments had been attached to clothing that had once hung on special iron hooks, in the same way as in the chamber described above. The hooks were found in the clay. A number of powdery lumps of decayed textile confirm this. A silver spoon and two pendants shaped like sitting sphinxes were also found there (fig. 108).

53

101 RECTANGULAR PLAQUE. GOLD

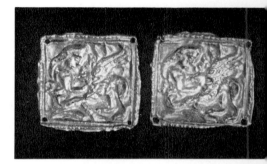

102 SQUARE PLAQUES. GOLD

103 ROUND PLAQUE. GOLD

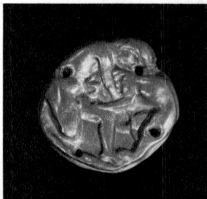

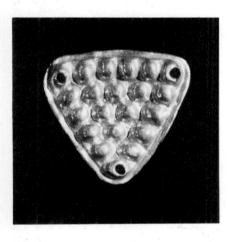

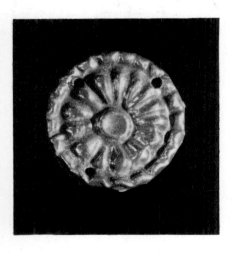

Beside the north-western chamber, where the female in rich attire and her attendant had been buried and where the famous silver vase was discovered, a large oval underground chamber filled with the collapsed ceiling and earth was found; its purpose remains uncertain. Some believe it to be a secondary burial, like the one in the Solokha barrow. Others think that it was the main part of the tomb described above and had been connected with the adjacent 'queen's tomb'. The second supposition is a more likely one.

During the excavations it was noticed that only the upper part of the chamber was filled with the black earth of the barrow mound from the collapse of the tomb's roof. From 2.5 m. down to floor level it was filled with natural clay from the collapsed roof. The floor of the cellar was level with the bottom of the main grave containing the four underground chambers at its corners. It was 7.82 m. long, 4.25 m. wide, broadening at its western end to 6.4 m. Its height, judging from the layer of black earth inside the cave, had been not less than 2.5 m. There had been three recesses in the chamber wall.

The main burial had evidently been robbed, access being gained by digging a narrow tunnel from the edge to the centre of the barrow. Its scattered and cracked bones were found near the west wall, where the chamber broadens towards the south. At this point traces of wood, probably the remains of the bier, were observed at floor level. It was 2.5 m. long and over 2 m. wide and had stood against the west wall of the chamber, so that the corpse must have lain there with its head pointing either south or north, but not west, as was usual in Scythian burials.

Near this place a number of different gold articles were collected, including a ring showing an ox (fig. 110), another showing a dog (fig. 111), a wire ring, a plain sword chape, some openwork plaques of various shapes displaying plant ornament and animal figures. Similar plaques were collected in the chambers at the side of the access shaft. Other finds included edging bands, little tubes joined together, cruciform plaques composed of five roundels, rosettes, roundels, beads (all of gold), little bone buttons covered with gold leaf, a silver buckle, a few fragments of silver plating and some bronze arrowheads. Some articles, apparently dropped by the robbers, were near the entrance to the tunnel. Several openwork gold plaques, a fragment of a tubular border, a gold pendant in the shape of a human head, a gold bead, a gold button and a little bone tube plated with silver, were picked up there.

By the northern wall of the chamber stood two bronze cauldrons covered with soot. The larger of the two contained horse bones, a skull, six ribs and leg bones, and was decorated with six figures of goats around the rim (fig. 112), acting as handles. The other was somewhat smaller and had two handles, and its sides, like those of the larger one, were divided by relief strips into rhomboid and triangular figures (fig. 113). It contained bones of a colt and also an iron scoop on a long handle. Fragments of a Greek

black glazed cup lay on the floor of the chamber. By the east wall, near the entrance to the 'queen's chamber', a bronze lamp with holders for six wicks was found (pl. 180), an indispensable item in the darkness of underground tombs.

The most valuable objects in the main Chertomlyk burial chamber were found in the secret recesses mentioned above. In the one on the west wall near the bier of the main interment were a bronze pail and many gold plaques and buttons in a layer of decayed substance that seems to have been the remains of leather or thick cloth. Among the finds were 503 triangular embossed plaques, 103 plaques displaying rosettes, seventy plaques with the head of Dionysus (fig. 115), and twenty rectangular plaques of a goddess holding a mirror and a Scythian standing (fig. 114). The second recess in the north wall, near the north-western corner of the chamber, contained a gilded bronze cup, a leather quiver full of arrows, a sword with a gold-plated hilt, a gold chape and two iron knives with bone handles. Lastly, in the third recess in the south wall, was the gold mounting of a *gorytus* displaying intricate scenes of Greek mythology (pl. 181, 182), arranged in two rows between an ornamental plant design and figures of animals. A rectangular projection in the upper part of the *gorytus* shows a griffin struggling with a panther. There was also the gold casing of a scabbard displaying two confronted griffins at the upper end, and a multi-figured battle scene, Greeks fighting barbarians, occupying the rest of the space (pl. 183, 185). On the side projection for fastening the sword there is the figure of a griffin devouring a stag's head. Both objects are similar in style and craftsmanship. There were also two swords with gold hilts. One of these terminates in two magnificently sculptured ram heads, the hilt being embossed along its length with a scene of horsemen hunting goats (pl. 184). On the second hilt, as well as on most of the other swords found in Chertomlyk, the figures of animals are rather crudely done (fig. 118). Three more swords were thrust into the recess wall. Their hilts are also mounted in gold which is covered with a crude schematic animal design. The following objects were found in the same recess: a pear-shaped gold plaque that had a decorated quiver, displaying two figures of griffins and palmettes (fig. 116), a whetstone with a gold terminal (fig. 117), parts of a bronze decorated belt, several knives and arrowheads, several plaques (large and small), tiny buttons, beads, tubes and other miscellaneous trimmings.

In the rubble not far from the underground entry, human bones came to light, most likely those of a robber crushed by a collapse of the roof. Skeletons of tomb robbers crushed by sudden falls are known on other sites. To judge by these, and by the precautions taken by the builders of the tombs to conceal the valuable belongings accompanying the buried men, we may conclude that the barrows were often robbed by the contemporaries of those who erected them. The tomb robbers were perfectly familiar with the way the tombs were planned, so they skilfully directed their burrow straight

55

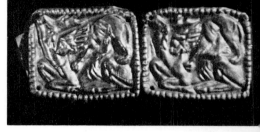

105 GOLD PLAQUES

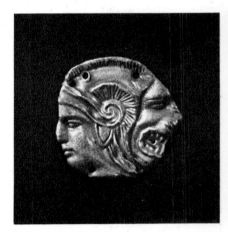

106 GOLD PLAQUE

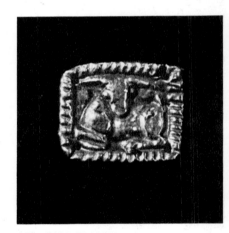

107 GOLD PLAQUE

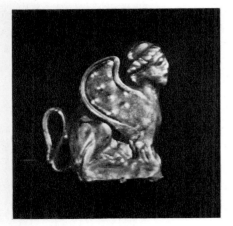

108 FIGURINE OF SPHINX. ELECTRUM, SILVER

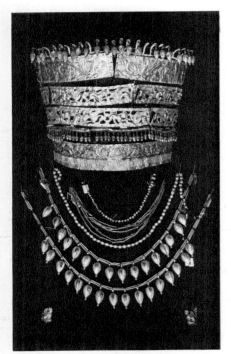

109 PART OF A FEMALE HEADDRESS. GOLD

to the interment chamber, digging over a distance of scores of metres to reach it. Such burrows are usually circular in section and up to one metre in diameter; they had to be dug in a lying or crouching position, the earth being carried out in bags or baskets. It is clear that such a tunnel could only be dug through undisturbed ground and clay, and not in the heaped-up earth of the mound. The contents of the Chertomlyk mound remained as they were found, only because a roof fall cut short the stay of the robbers in the chamber into which they had already penetrated. It was useless to attempt to dig out the fallen earth, for it would have continued to slide and pour in. The plundering of Scythian barrows, like that of the Egyptian pyramids, shows that love of gold caused men to risk roof falls, the terrible punishment which awaited a thief caught desecrating a tomb, and to suppress their terror of the dead. There are curious cases recorded of skeletons in robbed barrows being found with the bones of their legs and arms broken; this was probably done by the robbers, who wished to protect themselves from the revenge of the offended spirit of the dead man.

At Chertomlyk as at Solokha, under the mound and not far west of the human burial, there were horse burials, three large square pits roofed with logs, containing eleven horses. In the first pit, the southernmost burial, were three horse skeletons; in the other two, four in each. Five of the horses had bridle and saddle fittings of gold, six of silver. The bridles were decorated with a massive frontlet in the form of a sculptured figure of an animal, the cheek-pieces showing designs of birds, and there were two buttons or plaques with loops (fig. 119). Four shaped plates, four buttons or plaques with loops, an iron buckle and a silver ring possibly from the saddle-girth (fig. 120) are all that remains of a saddle. With two of the horses which had silver trappings there were also bronze decorations of oval and moon-shaped plaques with bells that hung over the horse's chest. In the southern burial, where only three horses were found, was an extra bronze bridle set which may have belonged to a horse the skeleton of which was found at ground level under the western edge of the mound. The animal must have escaped from the tomb when on the point of death.

Two graves near the horses contained single human skeletons, evidently grooms, for they lay with their heads pointing towards the horses. In one, the following grave goods came to light: a bronze torque covered with gold leaf around the corpse's neck, a gold earring with a pendant in the shape of a double-faced human head, and a spiral gold wire ring. To the right of the skeleton was a spear-head and a dart-head, at the belt a knife, and not far away a pile of bronze arrow-heads with traces of a leather quiver. With the second skeleton were a solid gold torque, a pile of bronze arrow-heads and three bone buttons. There was no 'groom' with the third horse burial.

A stylistic analysis of the designs on the comb and the silver vessels found there allows us to date the Solokha barrow to about the end of the fifth, or the beginning

of the fourth century BC. In them one still observes the austere style of the Parthenon without the tendency to feeble prettiness so characteristic of Greek art of the fourth century BC. The lions devouring animals on the Solokha *phiale* are so close to similar designs on coins of Achanta, near Chalcedon, of the second third of the fifth century BC, that one cannot help suggesting that they not only belong to a similar period but also that the craftsman who produced them was of northern Greek, or of Thracian-Macedonian origin. The silver vase and the dish of quite exceptional size from Chertomlyk should be dated to the second quarter of the fourth century BC. The very delicate treatment of details in the Chertomlyk vase calls to mind the style of a Chios engraver, Dexamen, and its luxuriant plant ornament links it to the Samos school of art. Taken all in all the Chertomlyk burial is no doubt later than the first third of the fourth century BC and should be placed rather in the middle of the century. In this respect the *gorytus* and the scabbard plating are very revealing in the tenseness of the figures and detailed subdivision. Both objects come from the same workshop that undertook mass production of this kind. At the present time three more *goryti*, similar to the one from Chertomlyk, have been found in the region north of the Black Sea: in Ilyintsy, Melitopol, and at Elizavetovskaya in the lower Don region (in the Five Brothers barrow group). The Achaemenian sword hilt displaying hunting scenes and terminating in ram heads is possibly older than the other objects found in the Chertomlyk barrow.

IV FOURTH CENTURY BC

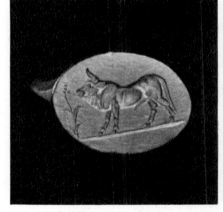

110 RING WITH BEZEL. GOLD

Barrows like those at Solokha and Chertomlyk are known in the lower reaches of the Dnieper in fairly large numbers, both on the left bank in the vicinity of Melitopol and on the right bank, particularly between Nikopol and Dnepropetrovsk. Between Kakhov and Melitopol there are, near the village of Nizniye Serogozy, the Deev and Oguz barrows and, closer to the river, those of Mordvinov, Lemeshev and Little Lepatikha. Farther north, near the villages of Great Belozerka and Great Znamenka, not counting Solokha, there are the Verkhni Rogachik, Tsimbalka and Chmyrev barrows. Further-more, in the Melitopol district, the Shulgovka barrow merits attention. On the right bank of the Dnieper, apart from the Pointed Tomakovskaya and Chertomlyk barrows, the Geremes, Krasnokutsk and Alexandropol barrows are well known. Besides the rich 'royal' burials there were burials of lesser people, built after the style of the 'royal' burials but more modest in funeral offerings.

111 RING WITH BEZEL. GOLD

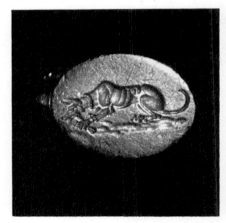

An undisturbed burial of the same date as Chertomlyk was found in the Deev barrow. Under the mound, robbers had found the central burial which had already been rifled in antiquity. It was a grave of the usual type, a rectangular shaft connected with the burial chamber by means of a short passage. In the excavation only two gold plaques were found, but some years later a chance collapse of the chamber wall revealed another

57

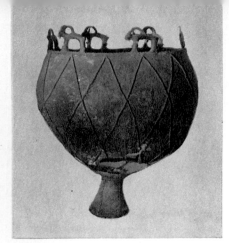

112 BRONZE CAULDRON

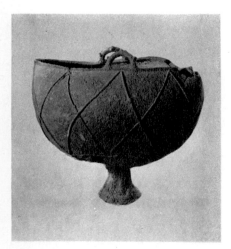

113 BRONZE CAULDRON

adjacent chamber containing a rich undisturbed female burial. Unfortunately, the burial was found by local peasants, who gathered up most of the valuable pieces. A good part of them reached the Imperial Archaeological Commission and the Hermitage at St Petersburg. Renewed excavation showed that this burial was secondary and had been inserted through the body of the mound. The tomb was constructed in the same way as the first one, with a shaft and small underground chamber linked by a short passage. The most remarkable discoveries were parts of a decorated headdress of a type different from that found in the Chertomlyk female burial, but similar to that in the side chambers of the same burial. It is rather like a *kokoshnik* (a Russian female peasant's headdress) decorated with gold bands and almond-shaped pendants (fig. 121). Probably belonging to the same headdress are twenty-four gold plaques shaped like figures of dancing maenads, some of whom hold swords, others *thyrsi*. The following objects were also found: a pair of gold earrings shaped like sphinxes set on pedestals from which six little ducks hang on chains (fig. 122); a gold necklace made of plaques shaped like ducks, flowers and double hemispheres; a long string of little gold tubes with acorn-shaped pendants; a pair of gold bracelets, gold rings with plain bezels and several kinds of plaques, among them those with a woman's head, the head of a bearded Silenus, and the head of a satyr.

In most of the Scythian barrows in the Dnieper steppe area human burials have been plundered, but horse burials with valuable decorations remain intact. Of these we may mention Great Tsimbalka, where there were six horse burials, of which two had bridles with gold decorations. Two long frontlet plates on a carved wooden base were the finest pieces. One shows the figure of a goddess whose body below the waistline consists of serpentine monsters, two of them with heads of lion-griffins which the goddess is holding by the horns, and below them, two more with heads of eagle-griffins. Lower, the trunk turns into a palmette and terminates in two intertwined snakes. From the headdress of the goddess rise two shoots which support a palmette (pl. 186). The second plate, of cruder workmanship, is decorated with a design of two confronted lions standing on their hind legs and plant motifs (pl. 187). Two pairs of cheek-pieces shaped like leaves or ears terminate in fish-heads with open jaws lined with teeth (pl. 186, 187).

The Geremes barrow on the right bank of the Dnieper was incompletely excavated, but it contained a grave of uncertain construction. It is famous for the large gold plate with an extremely crude design (pl. 188), which was found on the floor of an underground chamber among scattered human bones and bronze and iron objects.

In another barrow, at Krasnokutsk, two piles of fragments of a funeral wagon and horse harness were found under the mound. There were about seventy iron bits, eight hub bands and many fragments of tyres, besides iron strips and nails that had held the body of the wagon together. There were also ten gilded bronze pole-tops showing

a hippocampus seizing an animal (fig. 123), a winged griffin (fig. 124), the figure of
a bird with spread wings (fig. 125), and numerous bronze plaques and harness bells.
Under the mound was a horse burial in a shaft roofed with wood, containing four horse
skeletons in bridles with silver plates *(phalerae)*. Among these were a frontlet with the
head of a griffin (fig. 126), four plaques with horse heads arranged in a swastika design
(fig. 127), two plaques decorated with eight-ray stars, two large openwork plaques with
designs of two animal heads rising from a palmette (fig. 128) and rectangular plates
bearing engraved griffin heads (fig. 129).

The Alexandropol Barrow

The Alexandropol barrow, also often known as the Meadow Tomb, is one of the most
recent monuments of the Black Sea steppe. It is situated north of Chertomlyk, approxi-
mately halfway between Nikopol and Dneprodzerzhinsk, some 65—70 kilometres from
the Dnieper. It was one of the most magnificent mounds in the Black Sea steppe, with
a vertical height of 21 m. and a circumference of 320 m. Around the edge of the mound
was a circle of huge stones, and a broad ditch interrupted by two causeways on the
eastern and western sides ran round the outside of it (App. I).

In 1851 a chance find among the rocks at the southern edge of the mound prompted
the first excavation. The find consisted of two crude iron plaques in gold and silver leaf,
representing an oriental winged goddess holding two beasts (fig. 130); two bronze pole-
tops with the figure of the same goddess with her hands on her hips (pl. 189); a bronze
pole-top shaped like a trident, its prongs ending in bird heads with bells in their beaks
(pl. 191); two hooks terminating in a typical recumbent stag, and other objects. The
excavation, started in the following year, yielded various objects found in different parts
of the mound. These included bronze and silver plaques, animal figures, little bells,
bronze tubes, arrow-heads and the figure of a dog engraved on shelly limestone.[7]

The excavation of 1853 revealed two large groups of objects in the mound, as well as
horse, bull and sheep bones, arrow-heads and spear-heads. The western group comprised
remains of a wagon, fragments of tyres, four pole-tops, two with the bird at the top and
two others showing a griffin in a square frame with two bells suspended below it
(pl. 190), five plates made of silver sheets shaped like plants with silver roundels hanging
from each branch, three bronze sheets with the design of a winged unicorn, and a great
number of other bronze plates, little bells, harness bells and tubes that were probably
used as wagon decorations. In the north part of the barrow were found a thick iron ring
encased in gold, some silver ringlets, a silver spoon with the handle ending in a goose
head, a gold crescent, a horseshoe-shaped object with two horse heads in the middle
of the curve, a hollow gold figure of a boar and five other gold ornaments, among them
one with a design of a lizard. All these ornaments have holes for nails. This and the

59

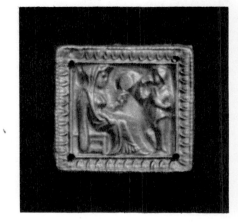

114 GOLD PLAQUE

115 GOLD PLAQUE

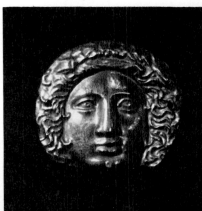

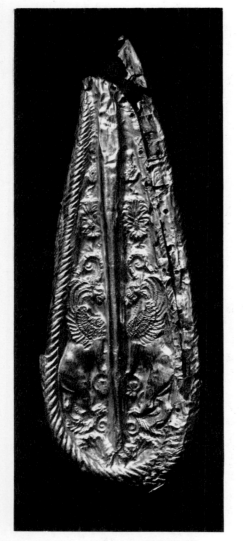

116 DETAIL OF THE MOUNTING OF
GORYTUS SHOWN IN PLATE 181.
GOLD

presence of numerous gold nails and wooden remains are evidence that they had served to decorate wooden objects — probably including wooden vessels.

In 1855/6 the barrow was fully opened (App. XIII). Below the mound on the exposed surface three access shafts down into the underground burial chambers and a special pit for a saddled horse near the central human grave were found. The horse was buried in a posture resembling the favourite attitude of animals in Scythian art. Its legs were pressed up against its body and its head thrust forward, resting on a special shelf in the side of the shaft. The grave was roofed with logs. The horse's bridle was decorated with four gold relief plaques representing an ox, a lion, a bird and a hippocampus; its forehead was adorned with a roundel taking the form of a sculptured horse head (fig. 132) fixed on a strap; the iron bits were decorated at the ends with gold rosettes; about the horse's neck were five bronze plaques, six spherical bells, and five half-moon pendants, eight silver beads hanging down on chains, four buttons, and a silver ring with two plume-holders. The remains of the saddle, consisting of the solid gold plaques that had adorned it, were on the horse's back. A bronze-plated wooden quiver containing forty-five arrows was fastened at the right side of the saddle.

The entrance shaft leading to the central tomb was 7.6 m. deep, connected by an underground passage with a semi-cylindrical roof to a spacious chamber, where two human skulls and the odds and ends of the plundered funeral remains were found. The same chamber could be entered by another underground passage leading there from a large rectangular pit in the eastern part of the mound. In the rubble filling the pit a few small ornaments and numerous iron cramps and hooks were found on the floor. The first half of this passage lead from the pit and was full of horse skeletons. They had been buried under a roof fall and so left undisturbed, but the others had been disturbed by the tomb robbers.

In all there were no less than fourteen horses. Numerous and rich ornaments were found on the undisturbed skeletons. Thus one of them had a silver plate decorated to represent locks of curly hair and, below, a gold frontlet showing a griffin head, and beside each eye was a gold plaque of a recumbent lion and, nearby, plume-holders. At the strap junctions of the bridle at the mouth and ears were four gold plaques with a design of a human head surrounded by seven ox heads, and the straps were adorned with alternating gold and silver ornamental plaques decorated with the figure of a mounted Scyth hunting a hare. Gold plaques with eyelets on them were fitted to the frontlets. Another horse had not only bridle but also collar decorations, a third had five silver patterned plaques, six gold beads, and bells with chains and crescents at the neck. Finally, among the plaques belonging to a fourth horse were four bridle plaques showing designs of a galloping horseman, two of a griffin standing on its hind legs, and a round plate with an Athena head on its forehead, and, on the nose-piece, an oval plate with

a full-length figure of Athena with an owl at her feet. The terminals of the bits were decorated with two round plates showing female heads, and eleven bells and two brush-holders were suspended from the bridle. The collar was decorated with openwork plaques ornamented with figures of griffins attacking a deer and a wild boar (fig. 131). At the ends of the collar were broad semi-oval openwork plaques with the figures of two griffins standing on their hind legs (fig. 133), and another griffin and a hippocampus attacking a panther (fig. 134). Deep in the passage among the disturbed horse bones a large number of horse ornaments were collected. Worthy of mention are seven panther figures cut out of thin gold sheet (pl. 192); a number of plaques with central rosettes and four boar heads round them; a gilded bronze plaque showing a half-length figure of Artemis holding a quiver and a couple of gold plaques shaped like Gorgon heads. At the end of the passage, at the entrance to the burial chamber, an intact human skeleton lay transversely across it, wearing two silver earrings, a bronze spiral torque and an iron bracelet on the right arm. A bronze basin containing a bronze vase was found near by.

The central chamber of the Alexandropol barrow had been used twice for burial. The first time the corpse was brought into the chamber through a short passage. Some time later another corpse had been placed near the first, but as the mound of the barrow had been thrown up, a new entrance had to be dug a long way from the chamber in the filling, and consequently a long underground passage was required. This was later used for burying attendants and horses accompanying the second corpse.

A second tomb had been let into the north-eastern side of the barrow. This also consisted of a shaft of considerable size, a passage and a circular chamber. In the entrance pit remains of an iron-bound wagon, and numerous openwork gold plaques, buttons and beads that had decorated it, were found. On the floor of the chamber a human skeleton was lying with its head pointing to the north-west. Gold plaques, buttons, little tubes and light blue perforated beads were found about the skeleton. At the head a decomposed cloth with small silver decorations was found, and a silver spindle. To the left of the skeleton lay two earthenware amphorae.

Both the tombs had been entered by means of underground tunnels and the robbers must have had to work quite hard before they reached the coveted treasure. In the north-western part of the barrow two underground passages were discovered. They ran parallel and went as deep as 8.5 m., down to the water-table, and reached 38 m. in length. Realizing that they had taken the wrong direction, the robbers had then given up digging these tunnels and started another from the shaft of the second chamber on the north-east side of the mound. Their tunnel being parallel to the passage connecting the entry shaft and the burial chamber, they got into the chamber, but not satisfied with the modest contents of the female burial, they made for the central part of the mound in search of the principal burial. Having cut through the virgin soil under the mound beyond its

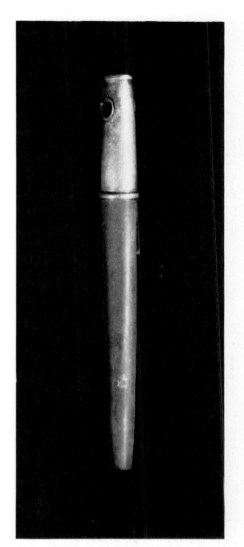

117 WHETSTONE WITH A GOLD
 TERMINAL

61

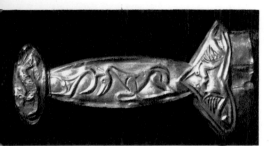

118 CASING FOR SWORD-HILT. GOLD

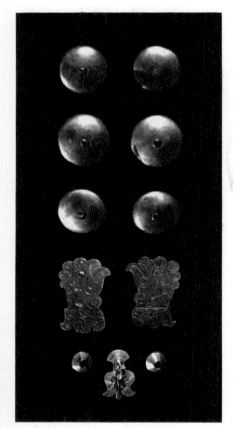

119 BRIDLE TRAPPINGS. GOLD

centre, they turned their tunnel almost through a right-angle to the south-east. Then they gave up, probably losing hope of finding another grave in the same direction, unaware that they were not more than 6.5 m. from it. The length of this tunnel is no less than 52 m. Not satisfied, the robbers made yet another tunnel. They started from the passage they had dug close to the circular chamber of the female burial. They stumbled on the long passage with the horse burials, and having stripped the horses that had not been made inaccessible by roof falls, started to ransack the chamber containing the two corpses. Its entrance had been blocked by a roof fall. Thanks to this, the servant burial situated at the entrance remained intact. Now they had to make a by-pass to gain access to the southern part of the chamber. Another tunnel of the same kind was found on the opposite — that is, the western — side of the chamber. It had probably been dug to penetrate the north part of the chamber, the centre of which must already have been filled by the collapsed roof. In the underground passage, by means of which the robbers penetrated the burial chambers, gold plaques, buttons, pendants and some other small things were found, lost by them on the way out. In other parts of their passages bones of animals, probably from the meat they ate when working, and sooty vessels that they had used as lamps, were found.

The great quantity and value of the objects found in tombs already pillaged in the Alexandropol barrow indicates that the original contents were inferior neither to Chertomlyk nor Solokha. The form of burial does not differ from the older 'royal' graves of the Dnieper area of Scythia. However, the style of decoration does differ, showing a preponderance of ornamental over representational elements. The accent is on flat surfaces and schematic designs. The purely Greek designs, such as the Athena head on a horse frontlet, belonging in its style to the period about 300 BC, provide a basis for dating. Shards of late Greek red-figure pottery found in the burial confirm this dating.

These are the main burials of the Dnieper steppe of the fifth to the third centuries BC. The ritual arrangement of the finds and the grave goods have much in common. With rare exceptions, one encounters a consistent tomb plan in the form of an underground chamber — a plan quite alien to the other regions over which Scythian culture extended. This gives some ground for supposing it to be an ethnographic peculiarity of the Royal Scyths, the tribe that enjoyed a hegemony in the region north of the Black Sea. Special horse graves accompanied all the rich burials, and not infrequently the remains of a wagon, most probably the one in which the corpse was brought to the place of burial, were found. Almost always with the wagon were characteristic pole-tops like those found in the Kuban area and the middle reaches of the Dnieper, although their connection with wagons is not proved. In the Dnieper barrows there are not as many horses as in the Kuban ones, although there are numerous bridles, which might have been

regarded as a substitute for the horses themselves. Rich burials of the Dnieper area are characterized by a considerable number of human sacrifices accompanying the main interment. In this respect they correspond to the description of the funeral ceremony of a Scythian king given by Herodotus. Together with the corpse of the wealthy man, his concubine and attendants, including a sword-bearer, a cup-bearer and grooms, were buried. These accompanying burials were often furnished, like the principal corpse, with rich adornments and weapons. Dog burials are sometimes found. In Chertomlyk a dog was found lying at the entrance to the chamber, obviously as a guard for it. Tombs that had not been robbed show a surprising quantity of objects of great value buried with the dead. Not only was the corpse decked in its finest clothes, but in several cases special chambers in the shaft were filled with clothing and weapons and supplies of wine and food that would be needed in the next world.

Crimean Barrows

The Crimean barrows of the fourth century BC are of interest mainly because of the form of grave structure, which differs considerably from that both in the Dnieper and the Kuban barrows. For instance in the Talayevsky barrow near Simferopol, dug by N.I.Veselovsky in 1891, the interment had been made in a shaft covered by a timber roof set beneath a cairn of stones. The walls of the grave were faced with stone. The following things were found with the skeleton: a gold torque with lion-head terminals (fig. 135), a spiral ring also of gold, and a silver ring. The corpse had worn a coat of bronze scale armour, and to his right and left were spears, darts and arrows. In the grave there were, in addition, a bronze helmet, an iron axe with a wooden handle bound with

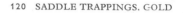
120 SADDLE TRAPPINGS. GOLD

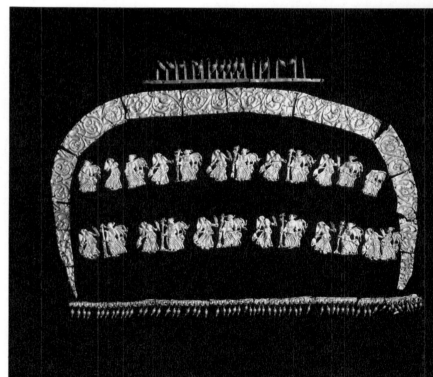
121 PARTS OF A HEADDRESS. GOLD

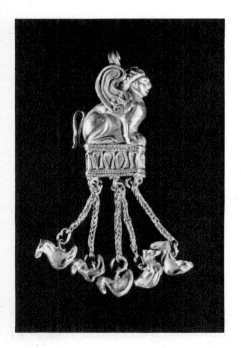

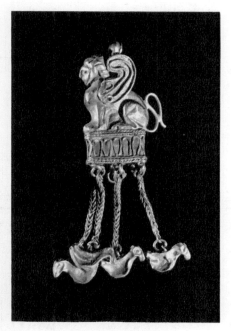

122 PAIR OF PENDANTS. GOLD

a gold band, a whetstone mounted in gold, a *rhyton* made of deer horn and mounted in silver, three amphorae and other small objects.

The barrows at Dort Oba (Four Barrows), dug by Veselovsky in 1892, contained a similar kind of tomb. Masonry rose above the edge of the shaft to form a dome-like vault within the body of the mound. The grave shaft was of some depth, its sides faced not with stone but with vertical tree-trunks covered-over with felt. In the corners and along the sides of the shaft there were further traces of posts, whose purpose was uncertain. Possibly they are connected in some way with the round bronze plaques fitted with rings and showing traces of wood, which were found in the upper part of the mound. The corpse had been placed in a special hollow in the bottom of the grave along its north side. A coat of iron scale armour was found near its head, and its headdress was decorated with gold plaques, secured by silver nails with gold heads. Triangular and diamond-shaped plaques sewn onto the clothing had decorated the upper part of the costume down to the waistline; 533 pieces were collected in all. Near the pelvis a leather *gorytus* was found. Plated with gold, it is decorated with the figure of an eagle holding a hare in its beak. A frieze of other animals decorates its longer side (pl. 193, 194). The quiver was full of arrows. A gold plate bearing the design of a griffin (pl. 193) and a gold roundel with figures of some horned animals were also discovered. On the left side of the skeleton lay an iron sword, and on its right a bronze ring. Other finds included five amphorae, bones of a sacrificial ox piled into a heap with an iron knife near them, spear-heads, shreds of leather and arrows with bronze heads.

A second barrow in this group contained a quadrilateral grave in a shaft faced with stone and covered by timber. A woman's skeleton was found in a sitting position in the grave. In addition to pots and bones of food offerings with an iron knife beside them, finds comprised a bone spindle, a silver ring, bag-shaped gold earrings with a griffin head on one end (fig. 135), beads and gold plaques which had been dress trimmings. Amongst the plaques were two in the shape of a recumbent lion (fig. 136), nine sphinxes (fig. 137) and eighteen griffins (fig. 138).

The Crimean shaft graves perhaps correspond more closely than others to the description of a Scythian king's funeral given by Herodotus, although they contain no burials either of attendants or horses, and are not as rich as the 'royal' barrows of the lower Dnieper area.

As one can see in the instances cited, the quantity of objects of Greek origin in the richer Scythian barrows goes on increasing all the time. Among such articles, together with things connected with Greek life, other objects appear to have been made in Greek workshops especially to meet the demands and tastes of the Black Sea barbarians. Such articles are of special interest when they bear representations either of the barbarians themselves or their deities, like the Solokha gold comb or the Chertomlyk vase. These

came from Thrace, the resemblance of the names Spartacus and Paerisadis to Thracian names lending weight to this view, and that Spartacus was a commander of Thracian mercenaries in the service of the Greek rulers from whom, supported by his troops, he usurped power. In support of this, the widespread stone tombs with corbelled roofs (false vault) which are found in the eastern Crimea and on the Taman peninsula, have been compared to tombs in Thrace. In funeral rites also there is much in common between the two areas.

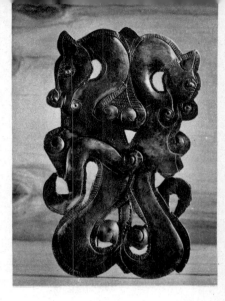

128 OPENWORK PLAQUE. SILVER

This might indeed be one way of solving the problem of the Bosporan barrows. However, another supposition is more probable: that the Bosporan barrows do not owe their existence to Thracians but to the native tribal chieftains. It is known that the Scythians had very close relations with the Thracians long before, that Scythian and Thracian royal families had intermarried and often bore identical names; and besides, among tribes under Scythian sway there were Thracian tribes, who had retained their tribal identity. Moreover, there are good grounds for supposing that the Cimmerians, who ruled in the Black Sea before the Scyths arrived, had Thracian affinities and that they to some extent survived when the Scyths came. Among the latter were the Tauri, who inhabited the mountainous parts of the Crimea. Cimmerians could have remained around the straits of Kerch, where the memory of them was especially persistent — for example the straits of Kerch were known as the Cimmerian Bosporus or the Cimmerian crossing, and some other place names referred to the Cimmerians. So the Bosporan dynasty of Spartacids might have been of native Cimmerian, not Thracian origin, since by the time of its appearance Cimmerians, Maeotae and other non-Iranian tribes of the Black Sea area all shared the same culture with the Scythians, and their ethnographic peculiarities are almost indistinguishable.

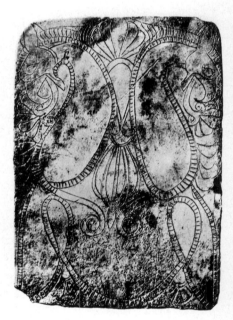

129 RECTANGULAR PLATE. SILVER

Classical influence made itself felt upon the native population from the time when the Greeks first appeared on the north coast of the Black Sea. Burials with indications of local funeral rites in the vicinity of the Greek cities are known from the fifth century BC, as we have seen in the case of the Nymphaeum barrows, but particularly frequent and clear evidence of the mixing of Greek and Scythian culture emerges in the fourth to the third centuries BC. Any account of this must begin with the famous burial in the Kul Oba barrows, in which the native basis of the ritual arrangement of the tomb is obvious.

130 IRON PLAQUE

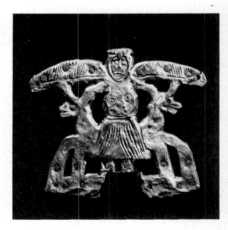

The grave at Kul Oba near Kerch was a large stone tomb with a corbelled roof (App. XIV). The greater part of the tomb was occupied by a painted wooden sarcophagus (fig. 139) divided lengthwise into two parts. One of these contained a male skeleton in a peaked hood *(bashlyk)* of thin felt decorated with two bands of beaten gold with relief designs. There were five plaques decorated with scenes, one showing two Scyths drinking brotherhood (pl. 204), and others showing a Scythian with a *gorytus*

and a goblet (pl. 203). At the neck of the skeleton was a large gold torque terminating in sculptured figures of mounted Scyths (pl. 202). On the right forearm was a bracelet decorated with rosettes and mythological scenes (pl. 206), on both wrists were solid bracelets with sphinx finials (pl. 200, 205). In the other compartment of the sarcophagus lay the dead man's weapons: an iron sword, its hilt mounted in gold decorated with two animals, the gold plating of the scabbard with a hippocampus in relief on the fastening plate and, along the sheath itself (pl. 208), figures of animals consisting of a griffin and a lion tearing a stag (pl. 209) and a leopard attacking a hind or a goat. At the end of the scabbard is a lion's mask, and a little above it an inscription in Greek which reads *ΠΟΡΝΑΧΟ*, the name of the owner or of the craftsman who made it. In the same place were a gold band, the binding of a whip handle, a hone mounted in gold (pl. 212), one

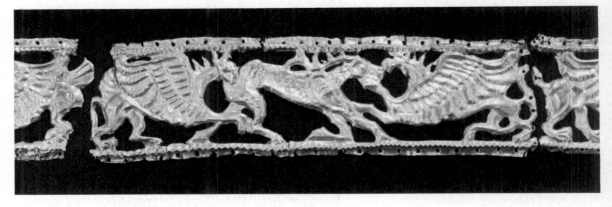

131 OPENWORK PLAQUES. GOLD

greave of bronze-gilt (the other was found above the head of the skeleton) and a solid gold *phiale* decorated with dolphins and fishes, Gorgon heads, Sileni, boars or panthers, and ornamental volutes (pl. 207, 210).

Beside the sarcophagus of the principal burial was set a couch with a female skeleton. The dead woman had an electrum diadem on her head, decorated with enamel rosettes of different colours at the ends, and in front, seated women and griffins. Electrum bands (fig. 199) completed the diadem, the broader bearing relief designs, the narrower with pendants attached by hooks and the third with smaller pendants attached to its lower edge. Around the neck was a necklace of plaited gold wire decorated at the ends with figures of recumbent goats (fig. 140) as terminals. On the skeleton were two large round gold pendants showing Athena wearing a helmet decorated with a sphinx, a pair of winged horses, an owl, a snake, and completed with numerous pendants shaped like amphorae (pl. 214, 215). Two round pendants, decorated with ornamented rosettes and pendants in the form of crescents terminating with rosettes, a palmette at their centres, and amphora-shaped terminals suspended on plaited chains (pl. 221—3), all of them of the finest craftsmanship, should also be mentioned. The famous electrum vase

depicting Scythians was found here: it is probable that the corpse had held it in its hands (pl. 226—9).

The Kul Oba vase differs from others of the same kind by its shape: it has a rather high straight rim and a stand in the form of a ring at the base. The body of the vase is divided by an ornamental band of guilloche into two parts, the lower of which is fluted to represent long narrow petals of a rosette, the upper, with Scythian scenes, is separated into four groups. One group represents two Scyths conversing (pl. 228). One of them sits on a small mound, his head leaning against a spear which he is holding with both hands in front of him, and there is a band or diadem round his long-haired bare head. His companion is squatting before him. The latter wears a *bashlyk* on his head, and is armed with a spear and a shield. There is also another Scyth by himself, who is adjusting

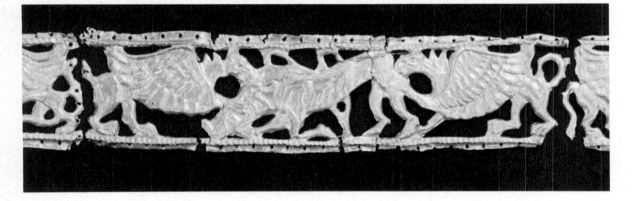

a bow-string (pl. 232). The next scene consists of two bareheaded crouching Scythians, one with his finger in the other's mouth, probably treating an aching tooth (pl. 233). The last scene shows a Scyth wearing a *bashlyk*, dressing the wounded leg of his companion (pl. 229). In all these scenes the Scyths are depicted in their ordinary clothing, adorned with sewn-on plaques and patterns, with *goryti* fastened to the belt at the left hip and with the other weapons mentioned. Under the feet of the human figures one can see the grass and flowers, as on the Voronezh vessel.

On the arms of the female skeleton were broad gold bracelets decorated with designs of griffins devouring a stag (pl. 236—8). Not far from the skeleton, a silver spindle and a mirror, its handle encased in gold and decorated with a griffin chasing a stag, were found (pl. 213).

At the head of these two skeletons and at right-angles to them, along the south wall of the tomb, lay the skeleton of a servant. Beside him were six knives with bone handles, one of which was mounted in gold and decorated with beasts of prey (pl. 211). In the south-west corner of the chamber, by the head of the servant, in a special hollow in the floor, were horse bones, a helmet and greaves. Utensils were placed along the west wall.

69

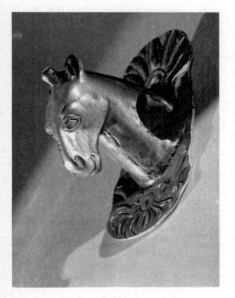

132 BRIDLE FRONTLET. GOLD

133 OPENWORK PLAQUE. GOLD

134 OPENWORK PLAQUE. GOLD

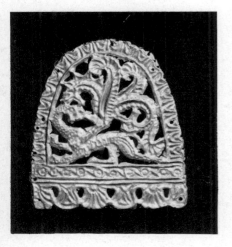

These included four amphorae, a big bronze cauldron containing sheep bones, a silver-gilt basin with four silver vessels in it, including a plain round-bottomed vessel, a plain cup and two *rhyta*, one of which terminates in the protome of a ram (pl. 250), the other in a lion's head (pl. 251). Beside it was a similar dish also containing four vessels, two round ones bearing designs of struggling beasts worked in relief (pl. 242—6), one with ducks pecking at fish (pl. 239, 240) and the fourth a cup with a lid and the name *HERMES* inscribed on it. Two iron spear-heads were found near these vessels. Along the north wall of the tomb to the right of the entrance some other vessels were found: a bronze cauldron with sheep bones, a hydria ornamented at the base of the handle, an amphora and a bronze plate.

All over the tomb numerous gold buttons and stamped plaques for sewing onto clothing and covers were found. Among them were rosettes, Medusa masks, heads of maenads, little human heads in profile and full face (pl. 219), Athena heads, Hercules struggling with a lion (pl. 218), a youth on one knee with fruit in his hands (pl. 220), Scyths shooting arrows (pl. 224), a recumbent lion (pl. 248), griffins (fig. 225), figures of hippocampi (pl. 256), a bird with a fish in its claws (pl. 231), the forepart of a winged boar (pl. 217), a winged goddess with the lower part of her body shaped like griffins and snakes (pl. 230), a Scythian hunting a hare (pl. 253), a winged horse (pl. 252), two dancing women (pl. 234), a goddess with a mirror and a Scyth confronting her (pl. 235), Scyths drinking brotherhood (pl. 204), a jumping hare (pl. 217), a mounted Scyth (pl. 255), etc. In the vault were numerous arrow-heads and darts, some gold flagons, and thin ivory panels with engraved designs, perhaps from a lyre or some other musical instrument or, more probably, from a sarcophagus (pl. 257 to 261). A gold wire pin terminating in the form of a bird deserves mention (pl. 249).

The thieves, who entered the tomb at night during the excavation, moved the huge flagstones of the floor and claimed they found another grave with a skeleton in it under the floor at the entrance in the north-west corner. Around its neck it had a bronze torque plated with gold, with lion-head terminals finished with enamel (pl. 263). A solid gold boss, shaped like a recumbent stag with designs of a griffin with a hare and a lion on its body and dogs under its neck, is supposed to have been found in the same place (pl. 264, 265). On the stag's neck there is an inscription: ΠΑΙ (pl. 263). This boss supplies important evidence of the changing relationship of the successors of barbarian Scythian chiefs to classical Greek society. It carries the already ancient type of shield decoration, as it is found in superb sixth-century examples at Kostromskaya and Keler-mes. The plaque is invaluable both because it so clearly illustrates the relationship which had grown up over the centuries between the local Greeks and the Scythians and also because of the light which it throws on the position which the descendants of the early barbarian chieftains had come to occupy in an alien, slave-owning urban community.

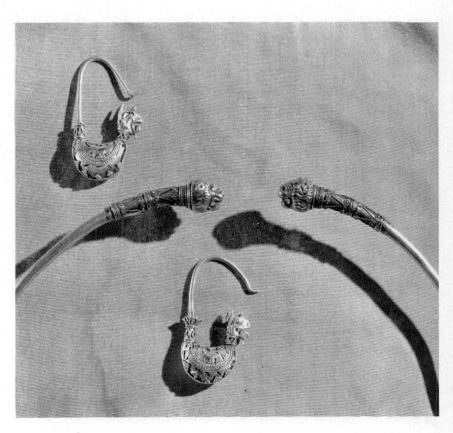

The plaque reproduces a shield ornament which had by then become archaic, but which is known to us in its original splendour through the sixth-century BC versions recovered from the Kostromskaya and Kelermes barrows. Their form had come to be regarded as traditional by a specific section of local barbarian society who considered it to be, so to speak, the crest of a certain barbarian dynasty. However, the task of reproducing this ornament proved too much for the Kul Oba craftsman, and he was so far from a real understanding of the Scythian style that he could only reproduce some of its peculiarities in a distorted form. The figure of the deer has a dead, lifeless outline; its strongly flattened antlers blend into its body; the back sags in a posture very uncharacteristic of a deer. The treatment of surfaces degenerates into meaningless geometricity; the additional animals, normal in Scythian art, seem to have been added as an afterthought here and there on the body. It is interesting that the craftsman of the Kul Oba boss, seeking to imitate the Scythian style in the additional animals, has rejected stylization and remained completely faithful to the forms of Greek art.

Whether this boss came from another burial under the corbelled tomb, or whether there was a cache for the most valuable of the funeral accessories, is uncertain. However, this find is not sufficient ground for dividing the Kul Oba finds into two chronological groups as some scholars have suggested. Here, as at Chertomlyk, the objects do not lend themselves to such a division, and, taken all in all, they may be dated to about the same time as Chertomlyk or even a little earlier — that is, the beginning of the fourth century BC.

136 GOLD PLAQUE

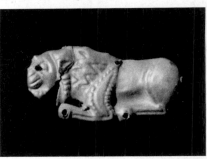

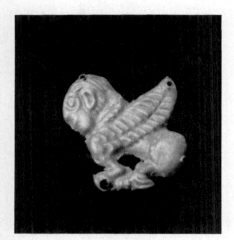

137 GOLD PLAQUE

There is much in common between the Chertomlyk and Kul Oba burials. In both, for instance, identical gold plaques, which seem to have been made with the same matrix, were found: the design shows a goddess and a Scythian drinking from a horn. There were also similar plaques with the figure of Hercules strangling a lion, or with an Athena head backed by a lion's muzzle, and many others. In addition, it is obvious that the ritual arrangement of the Kul Oba barrow corresponds with the rich Scythian barrows both in its contents and manner of burial. Here also the dead man is accompanied by his concubine and an attendant, besides his weapons, utensils, clothing and adornments, while food was also placed in the grave. Further work on this incompletely excavated mound will probably bring horse burials to light, perhaps even with grooms as at Chertomlyk. The feature peculiar to Kul Oba, and to many other Bosporan mounds, is the corbelled stone roof of the tomb, instead of the underground chamber characteristic of the Dnieper steppe, the shaft graves of the Crimean tombs, or the wooden post structure in the Kuban region (although, already as early as the fifth century BC, the latter were giving way to stone or sun-dried brick chambers with a flat log roof).

The Mounds of the Kerch Peninsula

On the Kerch peninsula there are a number of barrows which contain burials combining Greek and native elements both in respect of burial customs and grave goods. The majority were rifled in antiquity. Of the few which remain intact we may mention the Kekuvatsky barrow, where the corpse had been laid in a rich sarcophagus decorated with appliqué gold figures of griffins attacking various animals. On the skull was a fine gold wreath of olive branches with berries (pl. 268, 269), on one finger a ring with splendid figures of four recumbent lions placed side by side (fig. 141). In each hand the corpse had held a bundle of arrows with bronze gilt arrow-heads. At its feet were a Greek helmet with side-plates to protect the cheeks, a pair of bronze greaves, a hone and a sword with a gold-plated hilt bearing a zoomorphic design of the kind that decorates the swords from Chertomlyk or the mirror handle from Kul Oba (pl. 270). A red-figure *pelice* of the beginning of the fourth century BC was found in the same tomb.

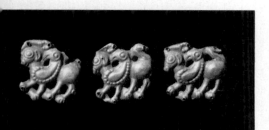

138 GOLD PLAQUES

The barrow on Cape Ak Burun is an example of a new type of burial distinguished by an even greater number of Greek elements. The funeral rites here were Greek, for the dead body was cremated; the construction of the tomb with its tile roofing is purely Greek. However, the grave goods are still wholly Scythian. Besides a coat of scale armour, a sword, a spear, a dart, arrow-heads and a solid brush-holder, there was a gold wreath (pl. 271) and a unique gold helmet or, more likely, the top of a luxurious fur-lined cap, semi-oval in shape and displaying an openwork design (pl. 272). A Panathenaic

amphora and a gold coin of Alexander the Great found in the tomb date it to the fourth century BC.

A female burial in the Pavlovsky barrow on the promontory formed by the Yuz Oba range, on which the most famous Bosporan barrows are situated, is usefully compared to the burials of the Kul Oba and the Kekuvatsky type. The barrow is remarkable in the first place for its construction: it is an enormous mound of earth nearly 13 m. high, its base encircled with a sort of defensive wall made of large dressed stones. The rock-hewn tomb which lay in the middle of the mound was covered with a corbelled roof and entered by a long passage *(dromos)*. The burial was found intact. Almost the whole chamber was occupied by a carved and painted sarcophagus with little Ionic columns at the corners. In it lay the skeleton of a woman richly attired. On her head was a gold band *(stlengis)*, gold earrings in the shape of flying Nikes (pl. 273), and a superb necklace around the neck (pl. 277). On the fingers of the left hand were three gold rings, one of which has a revolving bezel displaying a design of two female dancers on one of its sides (pl. 274), and a hippocampus on the other (pl. 275). Near the same hand was a large round mirror of bronze gilt. Low leather shoes were preserved on the feet, and shreds of cloth decorated with ornaments and scenes still adhered to the bones. At the head of the skeleton were a little basket and a painted casket, at each foot a sponge, and next to them two alabaster boxes. Nine additional alabaster boxes were found in the tomb outside the sarcophagus, and with them three more vases, among them a red-figure *pelice* with a picture from the Eleusinian cycle, datable to about 380—360 BC (pl. 278). A silver Panticapaean coin was also found in the grave.

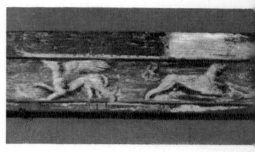

139 DETAIL OF PAINTED PLANK OF SARCOPHAGUS. WOOD

We do not pretend to be able to analyze here the way in which the natives of the Bosporus were Hellenized. We can, however, observe that features which did not conflict with native customs and views were adopted first. It is not difficult to detect the old native practice in a Greek disguise. This is best illustrated in the oldest Bosporan barrows of the fifth and early fourth centuries BC, in which the native character of tomb construction and grave furniture still more or less survive, although certain elements bear the marks of Greek craftsmanship or even of direct Greek origin. Later, a still closer relationship developed in which Hellenic influence penetrated appreciably deeper. The most remarkable monument of the unification of Hellenic and Scythian elements is the Great Bliznitsa barrow on the Taman peninsula.

140 DECORATED TORQUE. ELECTRUM

The Great Bliznitsa Barrow

This vast mound on the Taman peninsula was excavated over a number of seasons (App. XII, XV). The tombs found in it belong to roughly the same period and, as suggested by some scholars (Stephani, Rostovtsev), contained members of the same family. It is a reasonable assumption; the custom of turning a barrow into a family

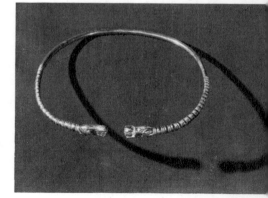

141 GOLD RING

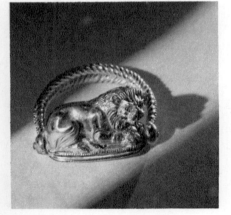

142 GOLD RING

tomb was fairly widespread, particularly in the case of later Bosporan barrows, and something analogous is discernible in the steppe. In the latter case several rich burials were commonly made under one mound; sometimes male and female burials are found together. In those instances when a rich female interment appears as a secondary burial to a mound with a central male burial, there can be no doubt that a widow's body had been added to the tomb of her wealthy husband.

In the Great Bliznitsa barrow there were at least three independent female burials (App. XVII). In the one known as the tomb of a priestess of Demeter there was a clearly expressed connection between the corpse and the Eleusinian rites. It was in a square tomb, with a corbelled roof constructed of soil and lay under the western part of the mound. It could be reached only through a short passage made by two parallel walls not covered by a roof. The tomb proved to be fairly intact and contained a very rich female burial with two sets of adornments, differing from each other in degree of luxury but similar in ritual significance. To the first set there belonged a luxuriant headdress — a *calathos* shaped like a small basket splayed at the top, which symbolized fertility (pl. 284, 285). This kind of headdress was worn by the priestesses and maidens who performed sacred dances in honour of Demeter, Dionysus, Artemis and other deities of fertility. The gold *calathos* from Great Bliznitsa is covered with a design of young barbarians struggling with griffins. These young men wear the conventional Phrygian dress in which the Greeks usually depicted barbarians (pl. 291—94). Ornaments fixed to the headdress over the temples are in the form of discs showing Nereids riding on dolphins accompanied by Delphic hippocampi (pl. 296, 300). On both pendants it is probably Thetis herself who is depicted bringing Achilles the set or armour forged for him by Hephaestus. A coat of armour is shown on one of the pendants and a pair of greaves on the other. It should be noted that the goddess is wearing a *calathos*, from which a veil falls over her back. The same kind of veil had been most probably worn by the woman buried in Great Bliznitsa. Four rows of amphora-like pendants hung from the discs on plaited chains. Evidently it is to the same group that a magnificent gold necklace belongs, formed of a plaited wire strip hung with numerous pendants resembling the pendants of the forehead ornaments. The necklace has lion-head terminals (pl. 305).

The second set consists of a gold head-band, the external surface of which is embossed in imitation of locks of wavy hair, the end of every lock terminating in a seated Nike (pl. 307). This kind of band, the *stlengis*, used to be worn somewhat above the forehead, so that its ends reached the ears. It was fixed to the hair by means of strings inserted into loops at the ends and in the middle of the band. Ear and temple pendants of a smaller size and of the finest jeweller's workmanship belong to the same headdress (pl. 304). They are also disc-shaped, filled with ornamental spherules and filigree with

74

a rosette in the middle; a pendant is suspended from this in the form of a little padlock with amphora-like pendants on chains. The necklace of the second set also consists of a plaited band of thin gold wires, but it is narrower than the first and with slighter pendants. Its ends are decorated with plaques bearing palmettes (pl. 306).

Solid gold bracelets terminating in figures of leaping lions (pl. 279) were found on the skeleton's arms. There were four gold rings on the fingers. Two of these have revolving bezels with designs in relief on one side — in one case a recumbent lion (fig. 142); in the other a scarab (fig. 144); on the back of the bezel are figures in intaglio of Artemis on the first ring (fig. 143), and Aphrodite with Eros on the second (pl. 280). The two remaining rings have simple flat bezels with designs of Aphrodite with Eros on one (pl. 283), and an imaginary creature on the other (pl. 282). The creature is a woman with a lyre in her hands, her body gradually changing into that of a grasshopper terminating in a griffin head. 'The grasshopper, who makes the fields lively and was hence named by the ancients the Muse of the field, was closely associated with Demeter and Kore, the goddesses of agriculture, whose priestess the woman or maiden, of whom we are speaking here, had been.'[8]

A large number of gold plaques from clothing were collected from about the skeleton. Quadrangular plaques displaying busts of Demeter (fig. 145), Kore (Persephone) (fig. 146) and Hercules (fig. 147) — all characters of the Eleusinian agricultural cult — are most remarkable. No less interesting are plaques showing dancing girls and youths like those found in Attic vase painting. The girls wear a *calathos* and a short skirt (pl. 266, 267). Some of the larger plaques had probably formed part of the first outfit, while the smaller ones belonged to the less luxurious outfit. The plaques with Gorgon head (fig. 148), rosette-shape (fig. 149), as well as those in the form of a bust of a woman wearing a *calathos* on her head, with wings instead of arms and wing-like volutes in place of legs, are also of several sizes (pl. 308). In addition, there are plaques of a helmeted Athena head, of a Helios head, of a Pegasus protome (fig. 150), of a bovine head, of a stag's head, of walking griffins and sphinxes, of embossed triangles, and lastly of five roundels joined in a cross. Some plaques with loops on the back belong to the same costume; some of them are rosettes of flowers, ivy leaves and violets, some of other plants. Lastly one should mention some gold beads of most delicate goldsmith's work with an inlay of blue enamel, which is also made use of in decorating many other parts of the finery described above. There was also a bronze case for a mirror displaying the figures of Aphrodite and Eros (pl. 297) and a painted red-figure *pelice*.

The peculiar feature of this female burial is the presence in it of parts of four rich horse caparisons, evidently belonging to one team of horses. They comprised bronze cheek-pieces with a hoof at one end and a stylized stag head in a rectangular frame at the other, turned back at right angles (fig. 151), round and elongated plaques which

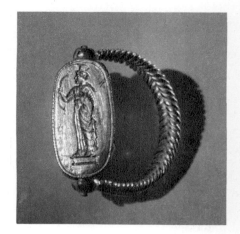

143 OTHER SIDE OF RING SHOWN IN FIG. 142

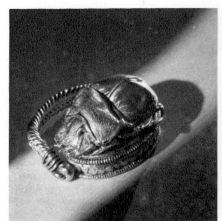

144 RING WITH A SCARAB. GOLD

75

suggest that they were likely to form segments of a large circle, plaques *(phalerae)*, decorated with the figures of Poseidon wrestling with a giant and of Greeks fighting a mounted Amazon (pl. 298), bronze crescents, bells and some other objects.

The spread of the Eleusinian cult to the Greek colonies north of the Black Sea is attested by a number of direct statements both by classical authors and in inscriptions. A central place in these was occupied by Demeter and Persephone, mother and daughter, the reproductive and regenerative powers of the earth. Demeter was revered primarily as the goddess of agriculture, but both of them were symbols of the life cycle generally. The abduction of Persephone by the god of the nether regions, her return to the surface of the earth every spring and her descent to the underworld every autumn, symbolized not only seasonal changes but also the human life cycle itself. In the Eleusinian mysteries the rape of Persephone, the search for her daughter by Demeter and the return of Persephone were acted out liturgically.

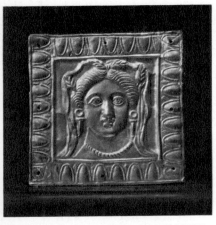

It is probable that the woman buried at Great Bliznitsa was a priestess of one of the Taman temples dedicated to a mother-goddess, whose rites were associated with the Eleusinian mysteries. It is no accident that among her adornments, side by side with characters from Greek mythology, there are figures of that Scythian goddess, half woman, half snake, whom Herodotus described and who is surely portrayed in the horse frontlet from the Tsimbalka barrow. Perhaps the presence of horse harness in the woman's tomb at Great Bliznitsa is to be attributed to her priestly rank, for even in Scythian burials harness is never included in the offerings accompanying female burials. It is known that in the Eleusinian mysteries Persephone returned in a wagon drawn by horses, so the horse harness might have been placed in the burial as a cult accessory. The absence of horse burials around the tomb lends the suggestion even greater validity.

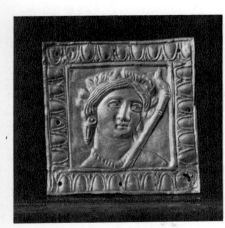

The second woman's burial at Great Bliznitsa much resembled the first. It was also in a stone vault (No. 4, 1868), set in the mound but not at the old ground level. The objects found in it were not so valuable, but their nature reveals that their owner was connected with the Eleusinian mysteries. Again there were two sets of adornments, one finer than the other. The first set included a *calathos*, the surviving section of which consists of an ornamented gold band, which had formed the border of the headdress to which were fastened gold plaques with flying Nikes (pl. 287), naked youths (satyrs) and maenads wearing long dresses, shown in attitudes of frenzied dance (pl. 290, 310, 311). The youths and some of the maenads hold discs, probably tambourines; in the hands of maenads there are *thyrsi* decorated with ribbons; one has a knife in one hand and in the other a half-dismembered lamb (pl. 289). Two are shown seated, one on a griffin (pl. 288), the other on a panther (pl. 286) holding a *cantharos*.

The second set belongs to the *stlengis* type (pl. 315), the same as in the first burial. It consists of a broad band decorated to resemble locks of hair with a rosette in each

lock; fastened on the sides are two triangular plates also fashioned like curly locks. In addition, there were ear pendants, very similar to those of the second (smaller) pair of pendants in the first burial, and three necklaces. The most remarkable of these is a crescent-shaped openwork necklace, bordered with intertwined cords, the tapering ends of which terminate in lion heads (pl. 295). The inner field of the plaque is filled with a relief design showing sheep and goats grazing, with figures of a dog and a hare at each end. The second necklace consists of beads with amphora-shaped pendants alternating with amulets in the shape of heads of satyrs, Sileni, Helios, rams; figures of a frog and a bee, and knuckle-bones. In addition, there was a bracelet shaped like a spiral ribbon with figures of recumbent lions at the ends (fig. 152), two rings with chalcedony stones, one showing a carved recumbent lion (pl. 314), the other an intaglio figure of an oriental deity striking down a lion, a gold ring showing a seated woman playing with a dog (pl. 281), two spiral rings with snake heads, sixteen gold plaques in the shape of a winged female wearing a *calathos* similar to those found in the first burial, seven plaques of a little bird in flight, over a hundred triangles filled with granules, twelve plaques with loops on the back shaped like lotus flowers, twenty rhomboid plates with a design of an Athena head like those on the forehead pendants at Kul Oba, twelve round plaques with a design of a Nereid riding a hippocampus, twenty plaques with a bust of Pegasus, eight rosettes inlaid with enamel, and nine sculptured griffin heads that had decorated the sarcophagus (pl. 312). Also included were a bronze mirror with a design of two struggling Eroses (pl. 299), several bronze vessels, two bone statuettes of women, the head of the Egyptian deity Bes, a small amphora made of smalt, and, in particular, a collection of terracottas, quite exceptional both in quantity and expressiveness. There are three dozen of them, including a standing Hercules holding an amphora (fig. 153), the well-known teacher and pupil, a boxer, a drunken Silenus, a Silenus with a bunch of grapes in his hand, an actor in a torn cloak, two wrestlers, a pregnant woman, a drunken old woman, and a pig. All of them are vivid and realistic, even if inclined to caricature. To such statuettes was ascribed apotropaic power, and on this account they were placed in the graves. A large number of earthenware vessels were also found, including a hydria and an alabastron.

Besides these two burials, quite exceptional in their grave goods, two more intact tombs were found in Great Bliznitsa. One in the south-eastern side of the mound, built as a stone chamber roofed with timber, contained the third female burial in the barrow. In the remains of a wooden coffin containing the skeleton were found an exquisite gold wreath, a pair of gold earrings and a necklace (pl. 309), a couple of bracelets with ram-head finials (pl. 313), seven terracotta figures (fig. 153), some *lecythoi*, little cups, alabastrons, a bone spindle and a bronze mirror. At the feet of the skeleton was a painted vase and an oval-shaped stele resting against the right side of the coffin.

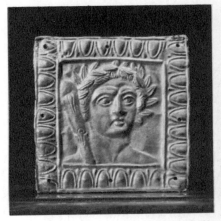

147 PLAQUE WITH HEAD OF HERCULES. GOLD

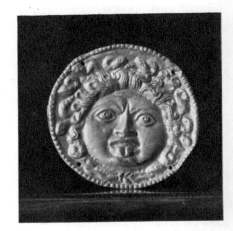

148 PLAQUE WITH A GORGON HEAD. GOLD

77

149 PLAQUES IN THE FORM OF
ROSETTES. GOLD

Another burial, that of a man, was in a square stone tomb with a corbelled roof in the body of the barrow near the tomb of the first priestess. Here fragments of a wooden sarcophagus, covered with ivory inlay carrying engraved designs (pl. 301—3) similar in technique to those at Kul Oba, were found. Around the skeleton were a gilded bronze helmet shaped like a Phrygian cap, a gold laurel-wreath, fragments of armour, a sword, knives and spears, and arrow-heads. On the fingers of the corpse were two solid gold rings, the design on one of which shows a *rhyton* terminating in a griffin, similar to that found in the Seven Brothers barrows. Numerous gold plaques that had been sewn on for decoration were collected, representing Medusa heads, heads of Athena, the head of a satyr, a winged female figure terminating in volutes, like those in the other burials in this barrow and, lastly, palmettes.

In the immediate vicinity of the first priestess's tomb there was one further burial chamber, which had been robbed of its contents, although the chamber itself remained undamaged. This chamber is remarkable for its paintings, in particular on the pyramidal cap-stone. Demeter is depicted half-length but full face, with earrings in her ears and a necklace around her bare neck (App. XVI). The goddess holds a veil over her abundant hair which is decorated with a wreath of flowers. In her right hand she holds a plant with flowers and long leaves. Although the burial had been ransacked, the painting is sufficient to show that the buried person had some connection with the Eleusinian mysteries.

One should mention that during excavation in the western part of the mound, not far from the first chamber, a kind of burnt area, a layer of ashes, burnt earth and char-coal, was noticed in the mound. A number of objects were found in it, including parts of a gold laurel-wreath, a gold ring with a scarab, a gold figurine of a dancing woman wearing a *calathos* and a short tunic (the figurine is part of a forehead pendant), a great number of gold plaques, beads, a bronze mirror, a little bronze spoon, a mass of bronze nails and little bone ornaments. It is possible that a body had been cremated there, and, to judge by the objects, it had been that of a woman. It is dated by a gold statue of Alexander the Great, found with the other objects, and to judge by this and the strati-graphic evidence, this was one of the very latest, if not the last, burial at Great Bliznitsa.

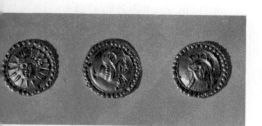

150 ROUND PLAQUES. GOLD

Pyres and the remains of funeral feasts found in various places under one barrow mound are of great interest. One such cremation was found just below the cremated woman described above, and is connected with the burial of Demeter's priestess. Similar traces of a pyre were found near the neighbouring painted chamber. Both pyres had been constructed in a similar way within a rectangular wall of sun-baked bricks. As-sociated with both were funnel-shaped pits. In one case the pits had been covered by a slab with a hole in it that could be closed by a semicircular stone to which a clamp was fixed; in the other, an actual altar had been erected over the pit with an aperture

right through the middle of it (App. XIX). Evidently such altars were used for libations, which were made to the gods of the underworld. Slabs with a perforation or cavity discovered in most of the oldest Kuban barrows (as at Kelermes, Ulski and Kostromskaya) probably served the same purpose.

All the burials at Great Bliznitsa contain to a greater or lesser degree evidence of the Eleusinian cult. This led Stephani to suggest that all the corpses belonged to one family, who were particular devotees of the cult and may even have played an important part in it. There is little doubt that this supposition is well founded. In fact, all the burials discovered in the barrow belong to roughly the same period — that is, the middle and the second half of the fourth century BC — and in all of them some connection with the Eleusinian cult is reasonably clear. One should also remember that the cult was wide-spread — if not in its complete form, at least in its different elements. For instance, basing our knowledge on the finds made in Great Bliznitsa, we may confidently assume that the female burial in the Pavlovsky barrow was also connected with the cult; there are equally strong grounds for saying the same of some Scythian barrows of the Dnieper group, specifically the Deev and the Ryzhanovsky barrows, with their adornments and accessories of a ritual nature. Among plaques belonging to the costumes found in these burials were some decorated with figures of dancing women, and the headdress was not unlike a *calathos*. The Scythians had worshipped goddesses of their own for centuries, and this probably accounts for the popularity of cults associated with Demeter, Artemis and Aphrodite, worshipped by the Greeks in the colonies north of the Black Sea. There are also stories recorded by Herodotus of early attempts by Scythian kings to introduce the Greek cults into Scythia, or at all events of their devotion to mystical cults. The archaeological evidence for the popularity of these cults outside the Greek towns and their immediate territories is not therefore altogether surprising. It may be assumed that the Scyths took over from the Greeks certain rites associated with goddess worship which they then used in the worship of their own Scythian deities. Perhaps they even entirely modified their own cult in an attempt to copy the Greeks.

151 TWO-HOLED CHEEK-PIECE.
BRONZE

152 SPIRAL BRACELET. GOLD

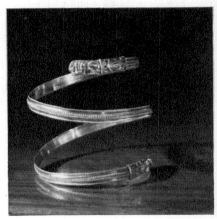

Karagodeuashkh

The Scythian period in the Kuban area closes with a most remarkable burial at Karagodeuashkh, which corresponds both in time and in importance to the Alexandropol barrow in the Dnieper area. Karagodeuashkh is situated near the village of Krymskaya in the lower reaches and south of the River Kuban. There was a large stone construction in the mound consisting of four consecutive chambers, althogether 20.5 m. in length. The walls were built of thick, smoothly dressed mortared blocks, plastered inside. The roof construction is uncertain; it appears to have consisted of wooden beams covered or piled over with rocks. The entry was at the narrow west end. The upper stones by

79

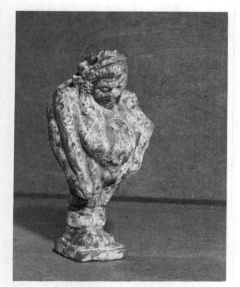

153 STATUETTE OF HERCULES. CLAY

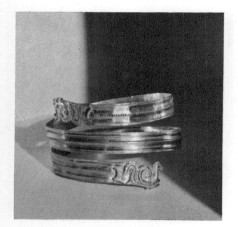

154 SPIRAL BRACELET. GOLD

155 ROUND MEDALLION. GOLD

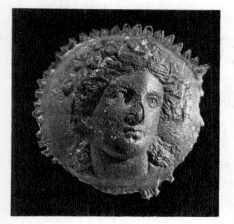

the door jambs were decorated with a cornice, on top of which a stone lintel almost 3 m. long spanned the doorway, while a similar slab served as a threshold.

In the first chamber as one enters were parts of a wagon and bones of two or three horses bearing traces of burning. Part of the chamber was filled with ash, charcoal and bones of domestic animals. Whether the funeral pyre had been inside the chamber, or whether it was above and fell in with the burnt roof, is uncertain. Along the left wall lay the skeleton of a young woman amid the remains of a wooden sarcophagus. Near the skull was a thin triangular gold diadem displaying three bands of remarkable figures (pl. 318). In the lowest and widest band a goddess is shown seated in the centre, wearing a tall conical headdress covered by a long veil hanging down the sides, the border of which is decorated with what are evidently sewn-on plaques. Two shrouded figures are standing behind and on either side of the seated woman, presumably a goddess, while two more figures stand in front and offer her a *rhyton* and a spherical vessel with a splayed rim. Below is a frieze of alternating masks and ox heads; above, a narrow band with a design of two recumbent griffins on either side of a small vase. The next row shows a chariot drawn by two horses, seen from the front with an upright human figure in it. Lastly, at the top is an apparently female figure with a veil over the lower part of her face. The diadem was worn by the corpse in the same way as it is depicted on the head of the goddess in the lower part of the plaque (pl. 320). Around the skull were other decorations from the headdress including sixteen gold openwork plaques in the form of doves and fifty round plaques with Medusa heads. Near the forehead was a pair of gold earrings with pendants. Around the neck was a solid gold torque and a rich gold necklace composed of ribbed beads and shaped plaques with rosettes in the centre (pl. 319), each link supporting an almond-shaped pendant with a little ball at the top. In the centre of the necklace, above one of the pendants, is an ox head. Close by lay a gold chain with a lion head at one end, and a plaited necklace with delicate heart-shaped pendants. On the arms were solid gold bracelets terminating in hippocampi (fig. 154). On one of the fingers of the right hand was a gold ring, on the bezel of which was the figure of a woman playing the lyre (pl. 316).

In the right-hand rear corner of the chamber was a large earthenware amphora, and near it a silver vessel, a bronze spoon and a little earthenware cup. There were also nearly one hundred and fifty beads of glass, stone and paste, also three glass medallions mounted in silver. On one of them is the design of a lion; on another that of a human head (fig. 155), and on the third the design of a warrior.

The second chamber, distinguished by its careful architectural finish, proved to be absolutely empty. The plastered walls of the third chamber were decorated with frescoes along the upper and lower edges and around the doors. On the south wall a design displaying a grazing stag with branched antlers could be distinguished, but it soon

disappeared when the plaster peeled off. In this chamber remains of horses with bronze harness adornments were found.

Finally, in the fourth chamber, the walls of which also had been frescoed to judge by the traces, lay the skeleton of the principal burial near the left wall among the rotted timbers and nails of a sarcophagus. Gold plaques with palmettes and hippocampi that had probably decorated the headdress were found about the skull, and on the neck of the skeleton was a solid gold torque having figures of lions devouring boars as its terminals. Beside the skeleton lay a short sword with a gold hilt, a hone, a *gorytus* encased in silver showing scenes of war, containing fifty arrows. On the other side of the skeleton was a second quiver of arrows (over a hundred) covered with gold plaques decorated with geometric zoomorphic figures, twelve spear-heads and triangular gold plates that had probably covered a wooden vessel. By the opposite wall were two cauldrons, two bronze jugs and a little pottery lamp. An amphora stood in the corner and near it a huge dish with two silver *rhyta* placed on it (fig. 156). The gilt rim of one of them is ornamented with scenes of beasts fighting (pl. 317), the other with palmettes, and the lower parts of both are fitted with finials shaped like rams' heads. Near by stood two silver vessels and the remains of a bronze shield on which was another *rhyton* decorated with a design of two horsemen and a frieze of flying birds (fig. 157). There was also a pole-top shaped like a ram's head. With these objects was a silver ladle and a silver strainer, both with handles in the shape of swan heads.

Among objects whose position in the barrow was uncertain were three triangular gold plates of varying size which had probably fitted on to wooden vessels. On one of these, stylized bird heads are shown on either side of a vertical rib, while another has five granulated triangles as ornamentation, and a third a ring with three loops around it. The bronze bridle plaques deserve mention, among which one frontlet is shaped like a griffin's head and others like extremely schematic animals.

The most interesting finds from Karagodeuashkh, after the triangular diadem with the goddess, are the *rhyta*. One of these, as has just been mentioned, is decorated with a design of two horsemen; they are riding towards each other, and while one of them has his hand raised in a gesture of adoration, the other is holding in one hand either a rod or a spear, and in the other a *rhyton*. Both horsemen are bareheaded and dressed in Scythian costume. Under the hooves of their horses lie two headless corpses, also in Scythian attire (App. XXII). The scene as a whole is undoubtedly of a ritual nature and probably represents authority being conferred on a king by a god. This is similar to the famous relief from Naqsh-i-Rustam, where the conferment of royal authority on Ardashir I by the god Ormazd is represented in the same way.

The burial at Karagodeuashkh, by the stylized nature of the art and the pottery found in it, can be dated to the end of the fourth century BC. This brings to an end a sequence

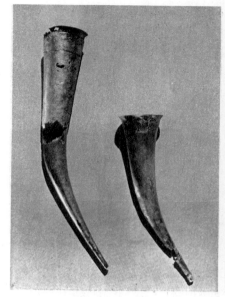

156 TWO SILVER *RHYTA*

157 DETAIL OF A SILVER *RHYTON*

of Scythian type monuments that started with Kelermes. Already local traditions have been obscured by forms derived from the neighbouring semi-Greek Bosporus, but they have not yet completely vanished. They are still present in the ritual arrangement of grave goods, and even in the style of decoration, particularly on the horse harness.

A find at the village of Merdzhana near Anapa belongs to a rather later period. It is a gold plaque, apparently from a *rhyton*, depicting a ritual scene of a goddess seated full face on a high-backed throne and holding a rounded vessel in her right hand (pl. 331). On her right is a tree, symbolizing the fact that she is a fertility goddess. On the left of the goddess is a stake with a horse's skull impaled on it, showing that horses were sacrificed to her. On the same side a bearded horseman wearing a cloak, with his head turned full face, is approaching the goddess; he holds a *rhyton* in his raised right hand. In its general subject the scene is similar to many votive pictures of the goddess, but there are essential differences in detail. Thus the costume depicted on the plaque from Merdzhana was not usually worn by Scyths, particularly the horseman in a cloak. It also differs in style from the Graeco-Scythian manner of depicting Scyths, but bears all the signs of local craftsmanship in its clumsy primitive forms. It reminds us of a battle scene from the Geremes mound and of an obscure but probably ritual composition from the Oguz barrow.

The Mounds of the Lower Don
The barrows of the lower reaches of the Don, which form a specific group, are probably attributable to the Sarmatians or Sauromatae who, according to Herodotus, lived along this river. The burials in the enormous barrow cemetery at Elizavetovskaya in the estuary of the Don near Tanais yielded many finds of great interest. The method of construction of the tombs differs markedly from both that employed in the lower Dnieper steppe and that used in the Kuban valley. There are neither underground chambers nor catacombs. Instead, the graves consist of a large pit with reeds lining the walls and forming the roof. In one of the big barrows of the Five Brothers group, which has its base faced with masonry, a stone cist was found, containing numerous bridles which strikingly resemble finds in the Dnieper barrows. In a subsequent investigation in 1960 an intact human burial was found accompanied by numerous gold ornaments similar to those from Chertomlyk. There was gold plating for a *gorytus* and a sword mounted in gold, both made from the same matrices as corresponding objects from Chertomlyk.

In graves under other barrows Greek pottery has been found in abundance, including amphorae, black glazed and red-figure vases. The normal Scythian weapons were fully represented, as well as some Greek arms, such as a helmet and a round bronze shield with a diameter of 50 cm. There were cauldrons, but few gold ornaments owing to the

fact that the tombs had been ransacked. However, a gold torque, a gold binding for a whip handle, a gold plate decorated with a stag from the *gorytus* (pl. 322), and gold plaques to sew on to clothing remained. There was also a *rhyton* finial decorated with a bird holding a fish in its claws (pl. 321).

The most interesting of the grave goods in the Don barrows are swords. One found in 1901 (the so-called Ushakovsky sword) had a scabbard encased in gold decorated with a boar pursued by two lions, the rump of one being turned upside-down. This is a form of stylization that is commonly encountered in Scythian art (pl. 329). On the projection for buckling on the sword another lion is shown (pl. 330). Two more swords were found during the excavations by A. A. Miller. One of them has a hilt and a gold-plated scabbard decorated with stylized animals: two griffins attacking a stag on the scabbard, and on the fastening plate a recumbent stag with head raised. It resembles the Chertomlyk swords both in form and style. The other sword is of much cruder workmanship (pl. 323); its iron hilt ends in a ring, and its gold-plated scabbard has an unusually long attachment plate decorated with a deer's head having many-tined stylized antlers ending in a palmette (pl. 324). On the scabbard casing is the figure of a griffin with a bird's tail holding a snake in its claws (pl. 325). The barrows of the lower reaches of the Don can be broadly dated from the fifth to the fourth centuries BC.

By the time Scythian art in the Black Sea region had completely degenerated, stifled by motifs and shapes of Greek origin, in Siberia the animal style still flourished, retaining its representational realism and its full emotional vitality. In the East it spread to the borders of Mongolia and northern China, and its echoes borne by the Sarmatians penetrated back to the shores of the Black Sea. The heritage of this artistic style made itself felt in the works of the Asiatic nomads who entered the European steppes in the post-Hun period. Unfortunately, to pursue this interesting development further would take us beyond the limits set by our present subject.

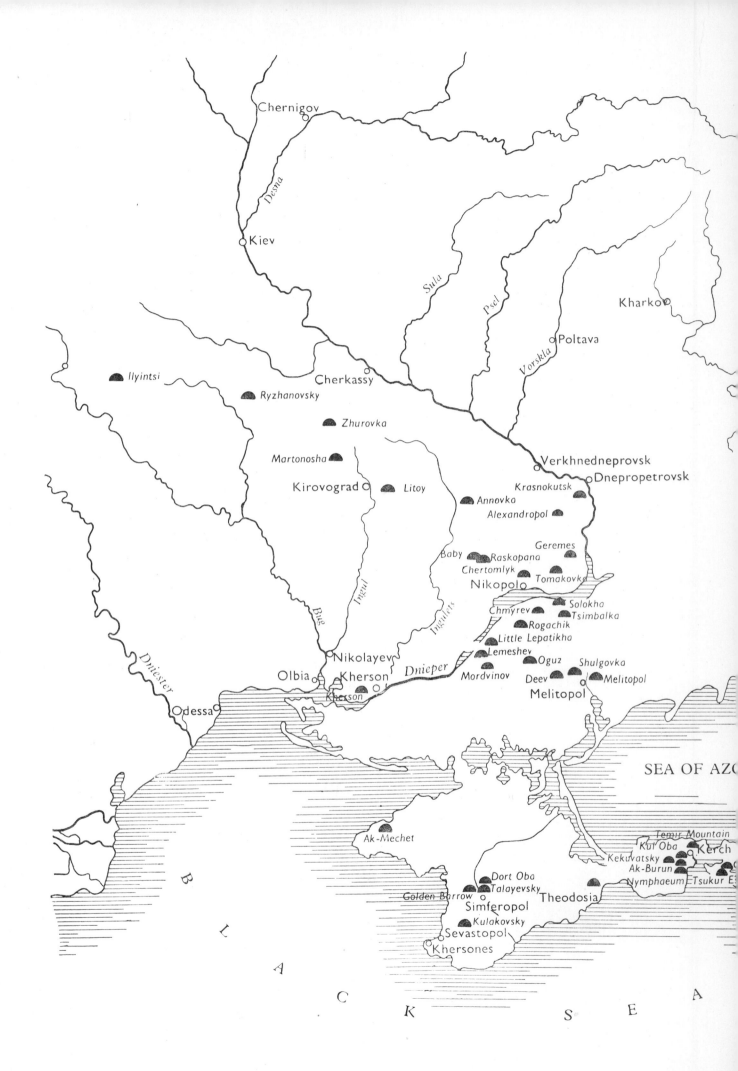

Chernigov

Desna

Kiev

Sula

Psel

Kharkov

Vorskla

Poltava

Ilyintsi

Cherkassy

Ryzhanovsky

Zhurovka

Martonosha

Verkhnedneprovsk

Kirovograd Litoy

Krasnokutsk

Dnepropetrovsk

Annovka

Alexandropol

Geremes

Baby Raskopana

Chertomlyk Tomakovka

Nikopol

Solokha

Chmyrev Tsimbalka

Rogachik

Little Lepatikha

Lemeshev

Oguz Shulgovka

Mordvinov Deev Melitopol

Nikolayev

Dnieper

Bug

Ingul

Ingulets

Olbia Kherson

Kherson

Melitopol

Odessa

SEA OF AZO

Dniester

Temir Mountain

Ak-Mechet

Kul' Oba Kerch

Kekuvatsky

Ak-Burun

Nymphaeum Tsukur E

Dort Oba

Talayevsky

Golden Barrow

Theodosia

Simferopol

Kulakovsky

Sevastopol

Khersones

B

L

A

C

K

S

E

A

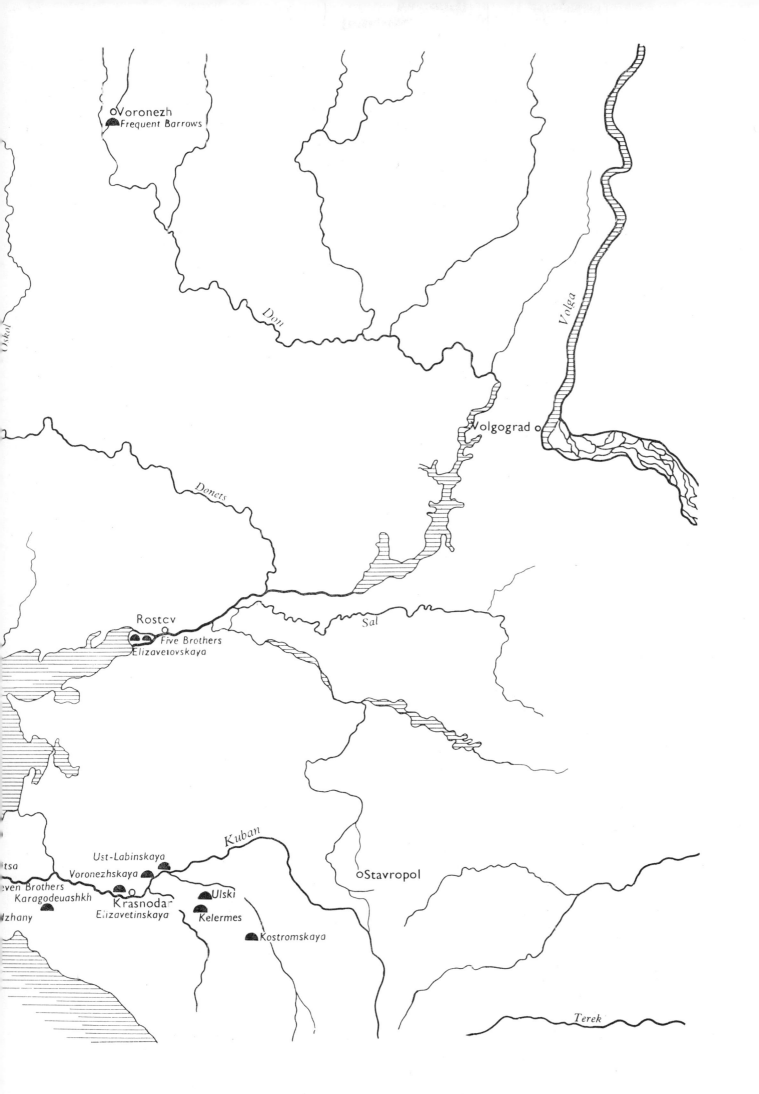

oVoronezh
Frequent Barrows

Don

Volga

Oskol

Donets

Volgograd o

Rostov
Five Brothers
Elizavetovskaya

Sal

Kuban

Ust-Labinskaya
Voronezhskaya
tsa
even Brothers
Karagodeuashkh
Krasnodar
Ulski
Elizavetinskaya
Kelermes
Kostromskaya
Izhany

oStavropol

Terek

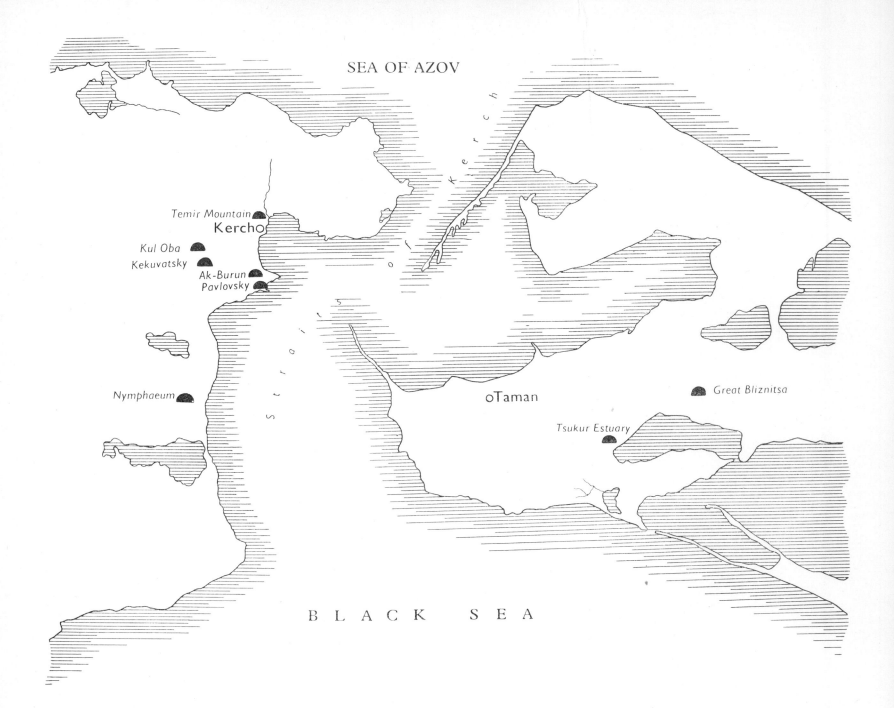

SEA OF AZOV

Temir Mountain
Kercho
Kul Oba
Kekuvatsky
Ak-Burun
Pavlovsky

Nymphaeum

oTaman

Great Bliznitsa

Tsukur Estuary

Strait of Kerch

BLACK SEA

NOTES

1 *OAK*, 1913—15, p. 151.

2 *Ibid.*, p. 151.

3 *Ibid.*, p. 157.

4 *Ibid.*, p. 156.

5 *Ibid.*, p. 157.

6 According to Borovka, this type of plaque corresponds with the number given by Zabelin. Plaques depicting a goddess with a mirror and a Scythian drinking from a horn were probably found elsewhere, namely in the main chamber among the ornaments of the 'king'. See G. I. Borovka, 'Zhenskiye golovnye ubory chertomlytskogo kurgana', *IRAIMK*, I, pp. 172—3; M. I. Rostovtsev, 'Ellino-skifsky golovnoy ubor', *IAK*, 63, p. 81.

7 The objects from this barrow were moved to the Ukraine and destroyed in the Second World War. Only a few genuine pieces and electro-copies survive at the Hermitage.

8 L. Stephani, *Grobnitsa zhritsy Demetry*. St Petersburg, 1873, p. 16.

THE PLATES

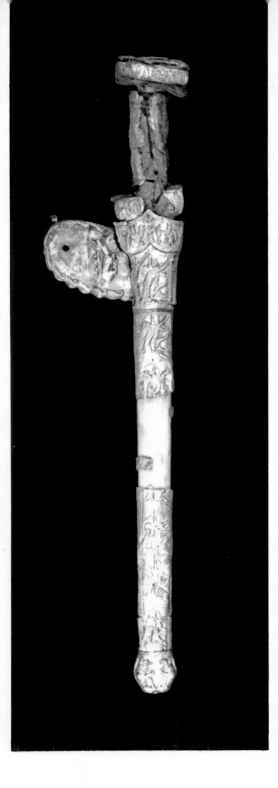

1 Hilt and scabbard of a sword with similar designs embossed on either side of the casing. Scabbard top ornamented with lotus blossoms and buds; shoots of a sacred tree decorate the hilt. The cross is decorated with two confronted figures of recumbent goats, heads turned backwards. On the heart-shaped upper end of the scabbard two gods flank a sacred tree. On the two wide sides of the sheath are eight profile figures of imaginary animals. Along the edge is a plaited border. The head is filled with the figures of two confronted lions. The attached projection on the upper part of the scabbard has a rounded end and undulating edges with a circular hole, and the profile figure of a recumbent stag is outlined with a border of schematic bird heads. Sheet gold. Melgunov Treasure.

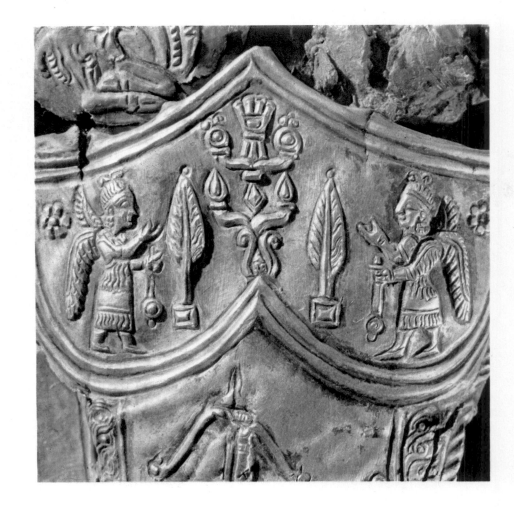

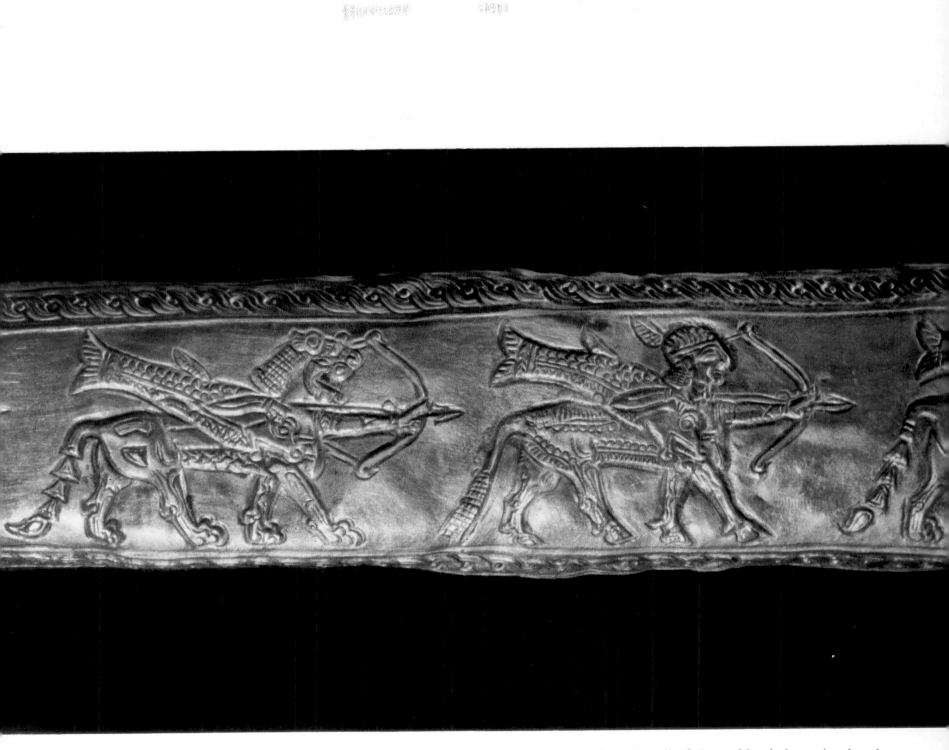

3 Fantastic animal archers. Detail of the scabbard shown in plate 1.

2 Two gods, each facing a sacred tree.
Detail of the upper part of the scabbard
shown in plate 1.

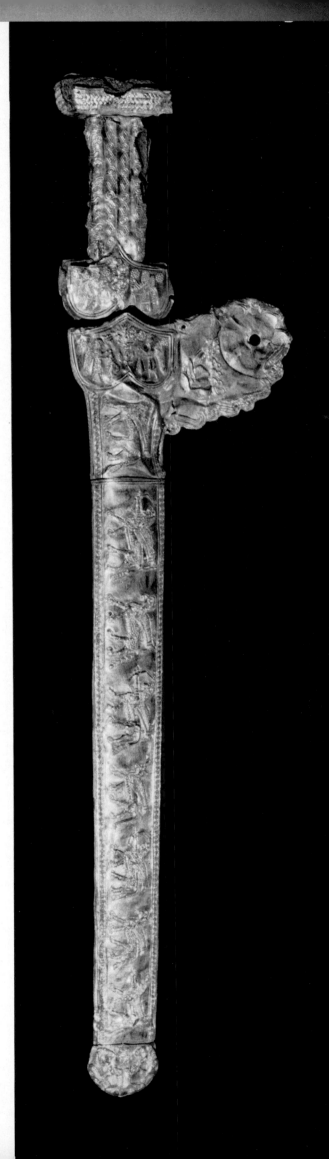

6 Iron sword in scabbard. Hilt and scabbard are embossed in sheet gold with relief designs of ritual scenes, animals and mythical creatures, repeated on both sides. Profile figure of a recumbent stag on the projection for fastening. Kelermes.

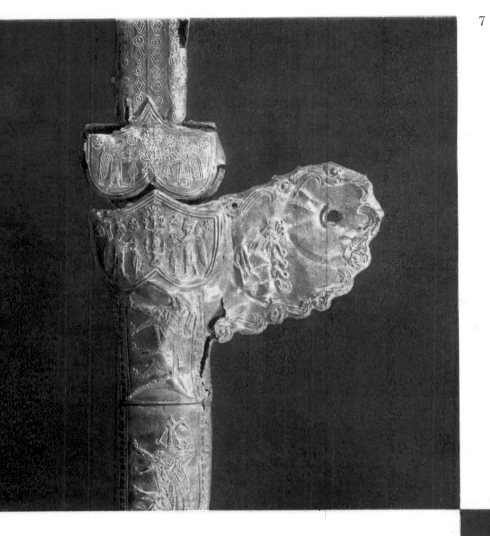

7 Embossed design of a ritual scene, mythical creatures and a recumbent stag on the projection surrounded by schematic bird heads. Detail of the lower portion of the hilt and the upper portion of the scabbard shown in plate 6.

8 Embossed design of imaginary creatures. Detail of the scabbard shown in plate 6.

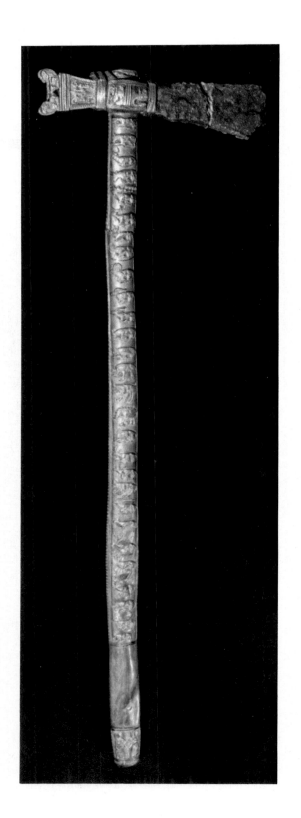

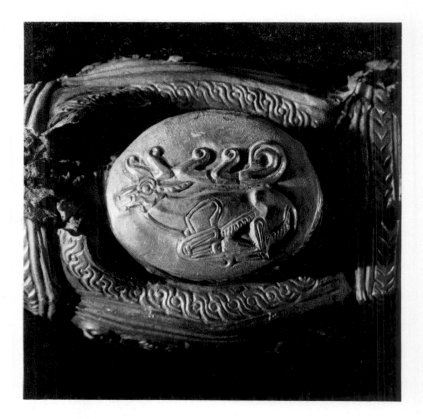

10 Recumbent stag. Top of handle of hatchet shown in plate 9.

◄ 9 Ceremonial hatchet. Butt, shaft-hole and handle mounted in sheet gold with an embossed design of ritual scenes, a man in a tall headdress and various beasts. Two sculptured figurines of recumbent goats on butt, and on either side of the handle twenty-nine animal figures. Kelermes.

11 Two boars. Bottom of handle of hatchet shown in plate 9.

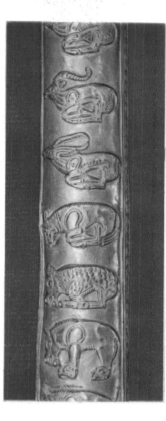

12 Animals. Detail of handle
of hatchet shown in plate 9.

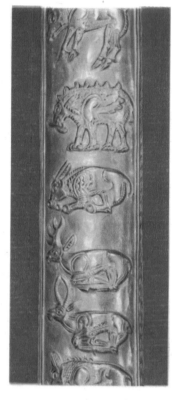

14 Handle of hatchet.
Detail of plate 9.

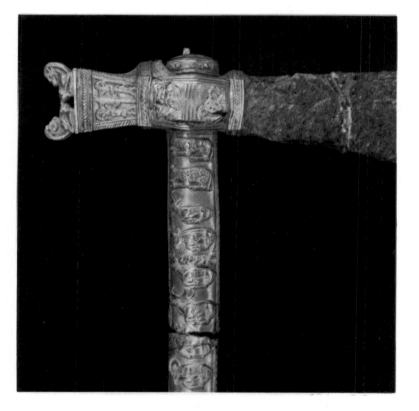

13 Animals. Detail of handle and head of hatchet shown in
plate 9.

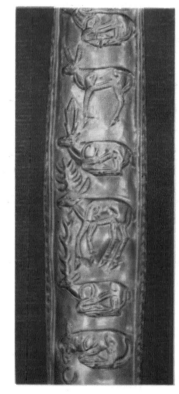

15 Handle of hatchet.
Detail of plate 9.

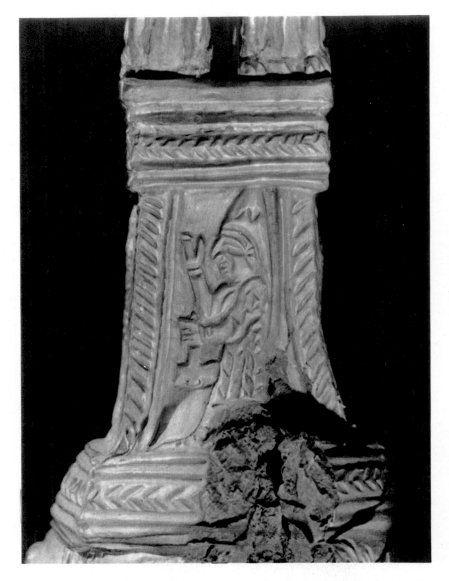

16 Human figure near hatchet butt. Detail of plate 9.

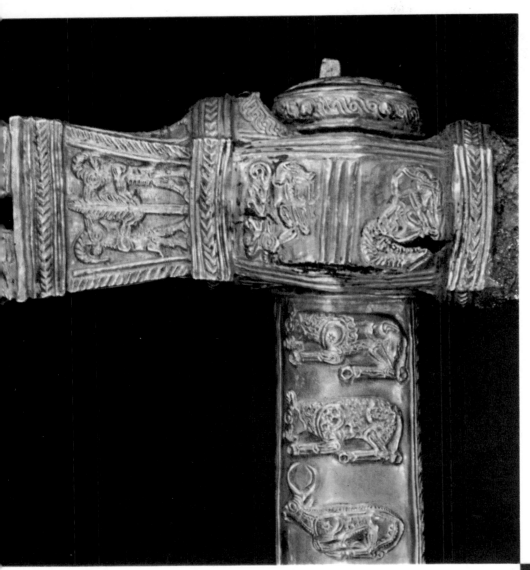

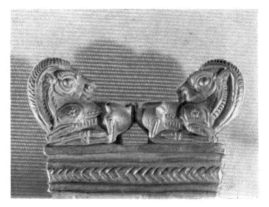

18 Figures of recumbent goats on butt
end of hatchet. Detail of plate 9.

17 Relief design of animals. Detail of plate 9.

19 Figures of goats standing on their hind legs on either side of
a sacred tree. Lower part of hatchet handle shown in plate 9.

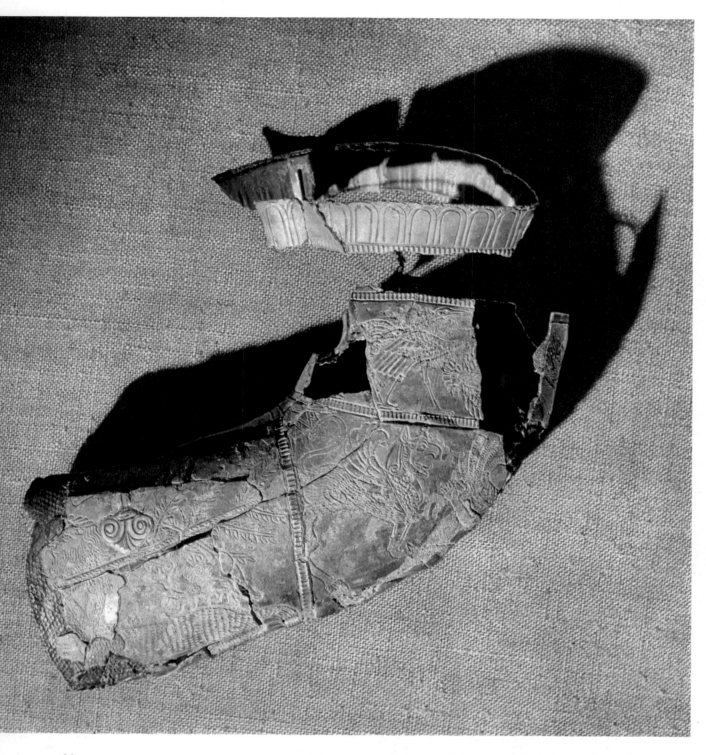

20 Fragments of *rhyton* with engraved design. Silver. Kelermes.

21 Rectangular plate from casing of a *gorytus*, divided into ▶
 twenty-four rectangles with a recumbent stag in each. Along the
 edges run rows of standing panthers. Gold. Kelermes.

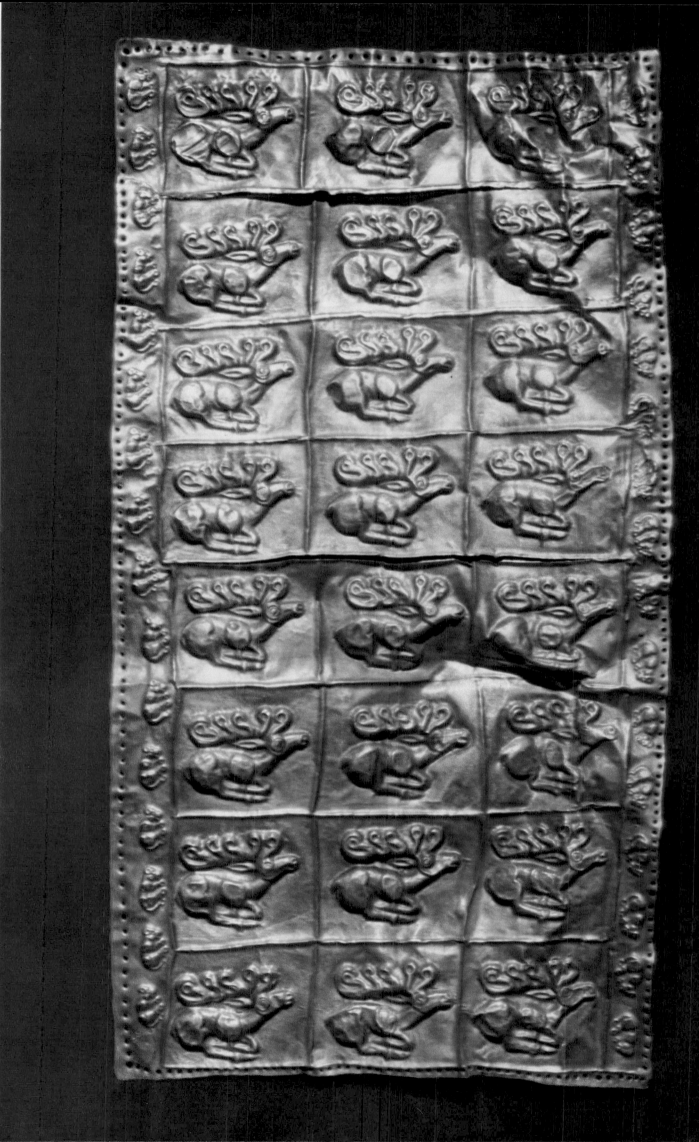

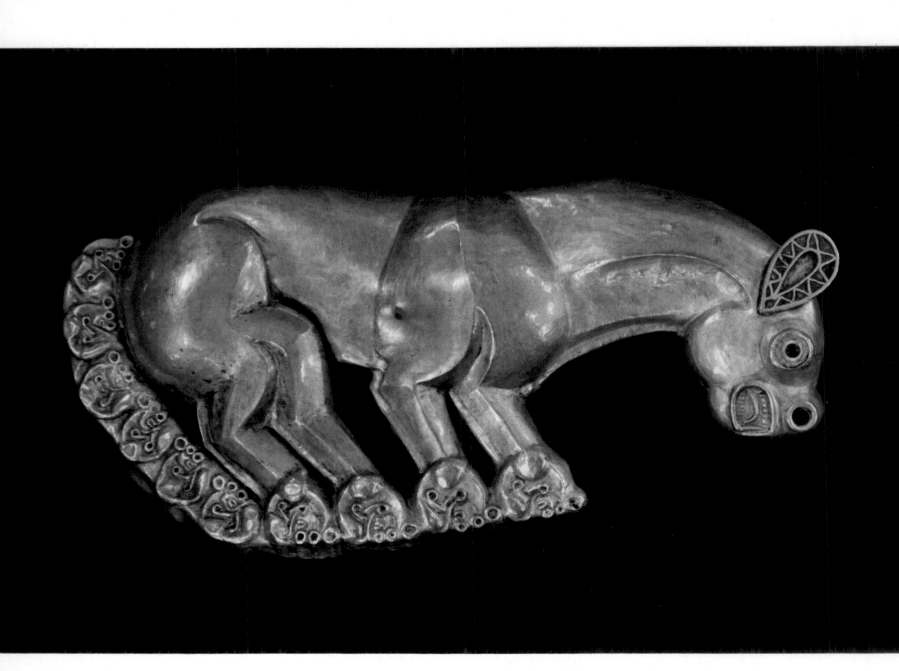

22 Centre-piece of a shield in the shape of a panther walking with head lowered and teeth bared. On its paws and along its tail are tiny figures of a twisted beast. Gold. Ear, eye and nose inlaid with coloured enamel. Kelermes.

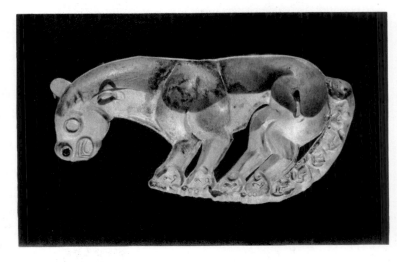

23 The back of the shield centre-piece shown in plate 22.

24 Panther's head. Detail of the shield centre-piece shown in plate 22. ▶

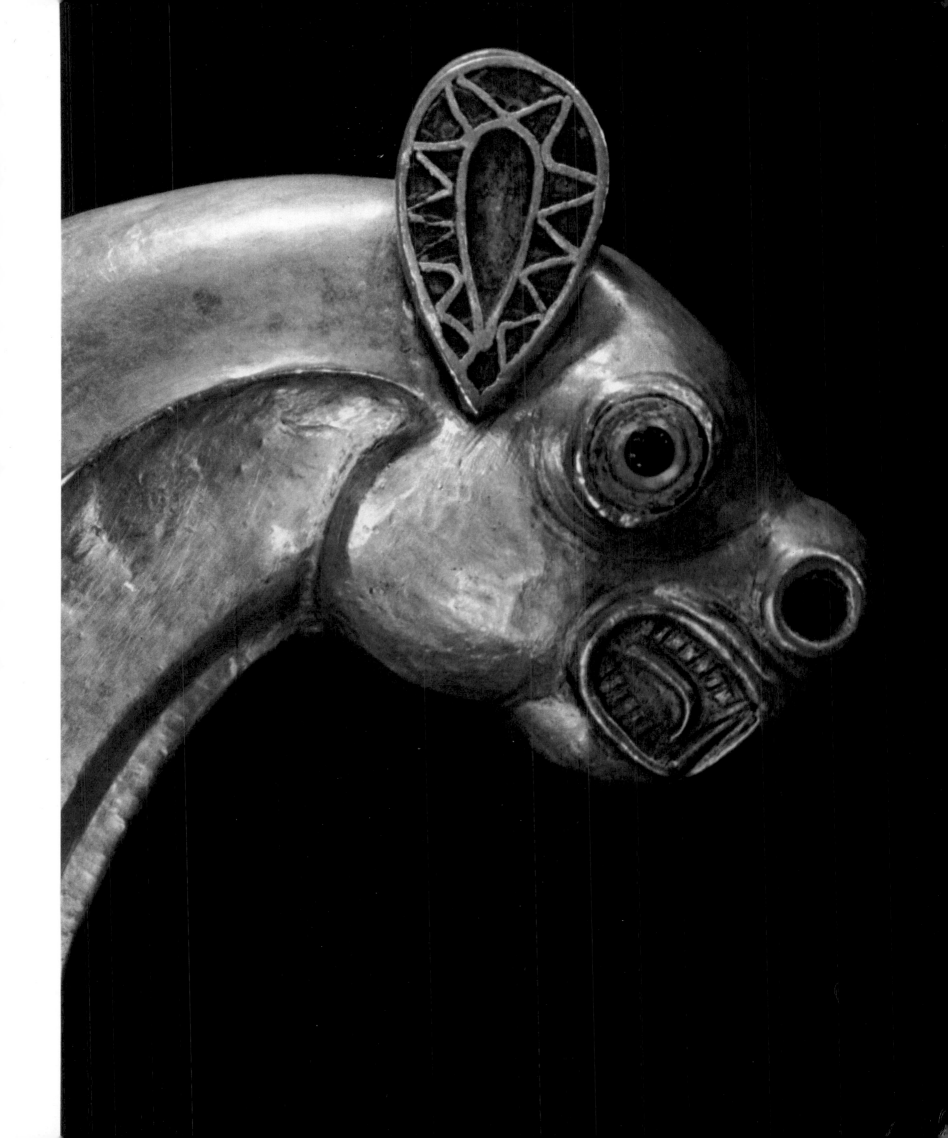

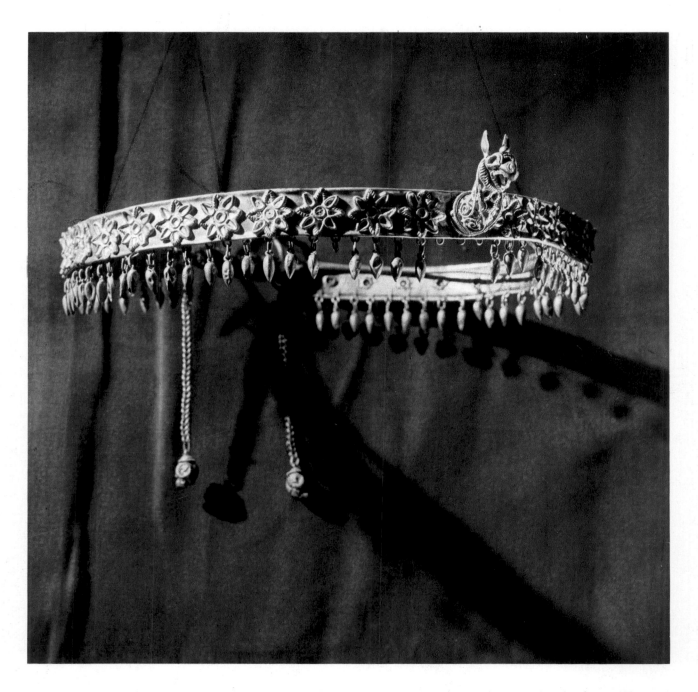

25 Diadem or headband ornamented with eight-petal rosettes, the sculptured head of a griffin and drop-like pendants, with two pendants shaped as ram heads hanging on long chains at either end. Gold, with traces of enamel. Kelermes.

26 Griffin's head, with hollows for enamel inlay on the neck. Detail of the diadem shown in plate 25.

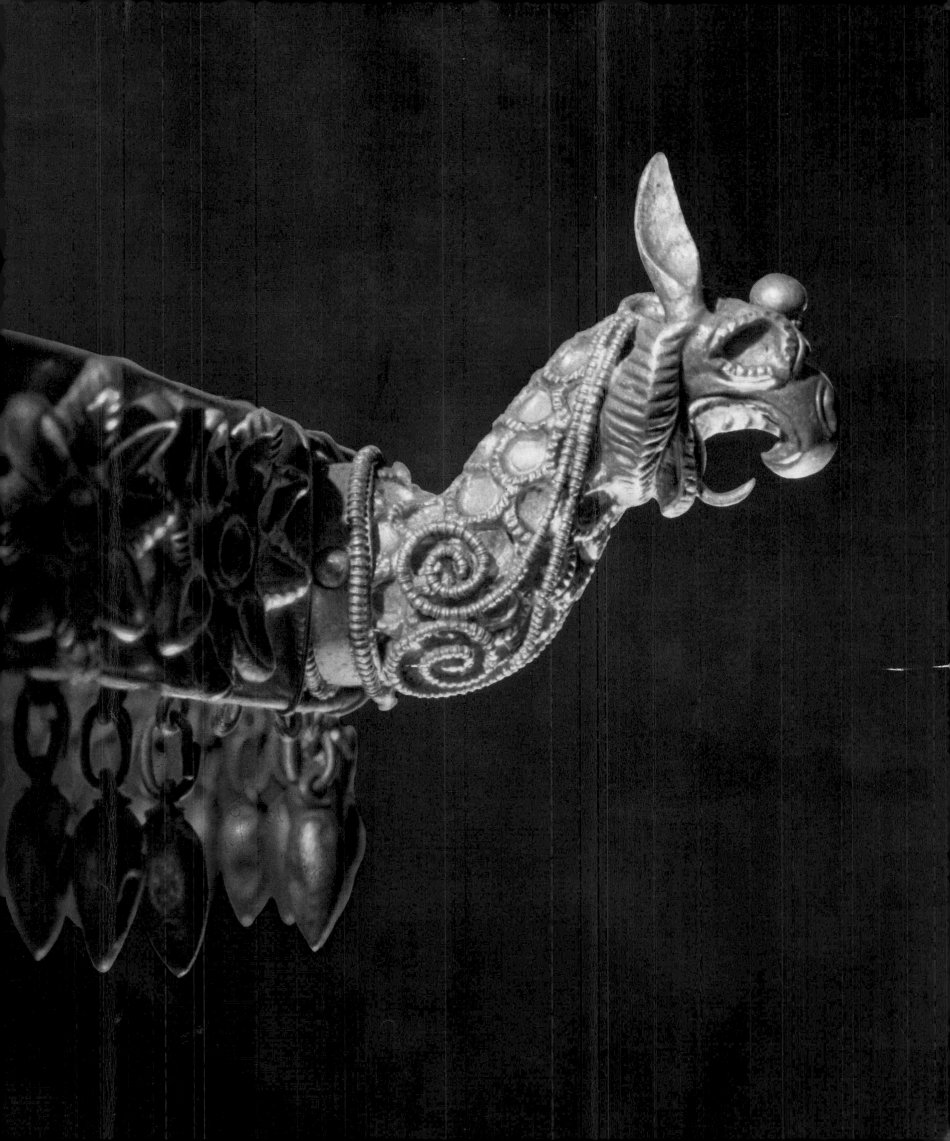

28 Diadem in the shape of a broad band orna-
mented with flowers and rosettes alternating with
figures of birds. There is an amber inlay in the
central rosette. The band has wire loops at the
ends. Gold. Kelermes.

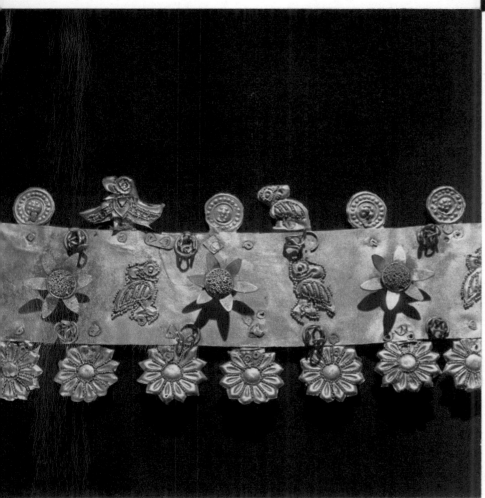

27 Diadem. Detail of plate 28. Note that the birds,
shown in profile, are picked out in tiny grains of
gold.

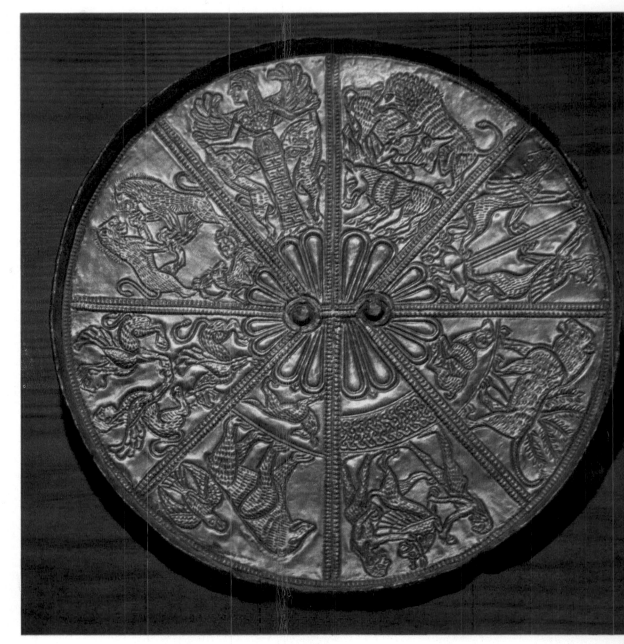

29 The back of a round silver mirror with raised edge and the ends of a two-pronged handle in the centre. The design has been impressed on the gold leaf which covers the whole of this side. Kelermes.

30 Two sections of the back of the round silver mirror shown in plate 29. One depicts confronted sphinxes and a griffin, the other confronted lions with a goat below facing a ram's head.

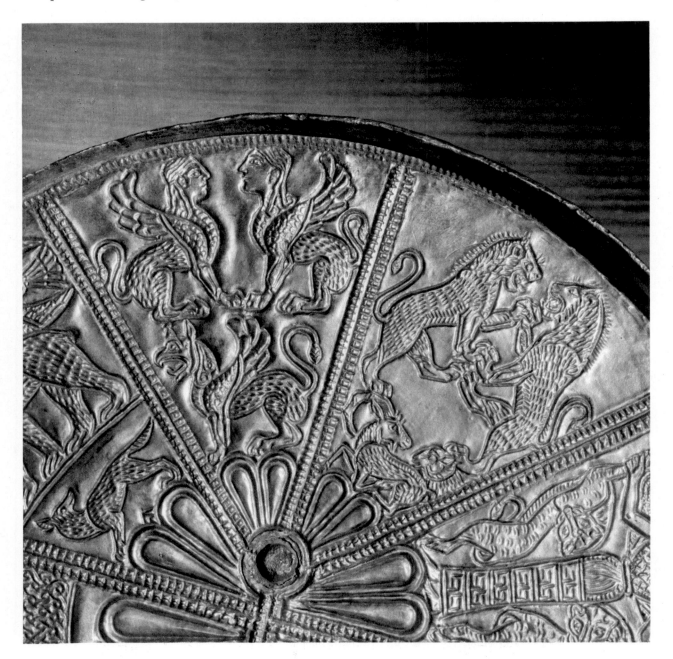

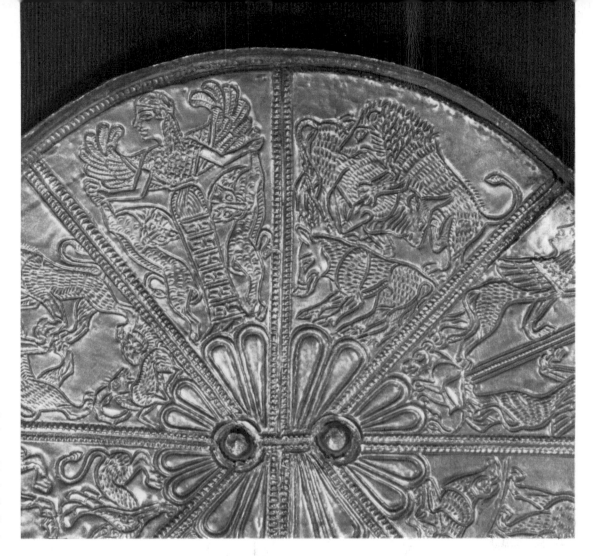

31 Two sections of the back of the round silver mirror shown in plate 29. One depicts Cybele holding two lions, the other a lion and an ox locked in combat, with the figure of a boar below them.

32 Two sections of the back of the round silver mirror shown in plate 29. One depicts two confronted sphinxes rampant with the figure of a panther below them, the other a lion set against a tree with a ram below it.

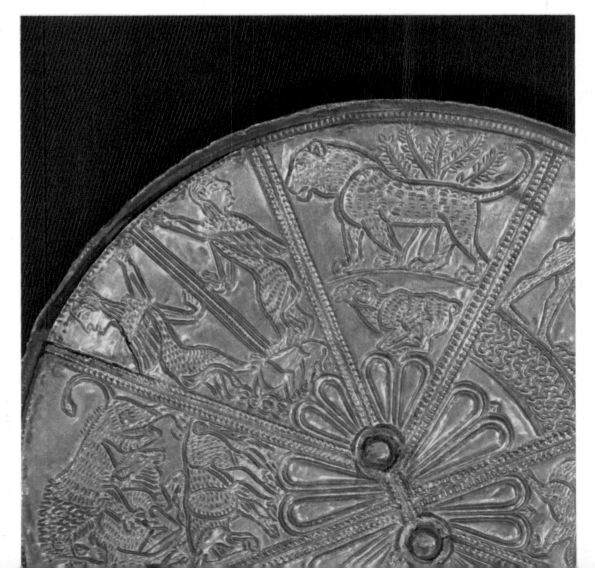

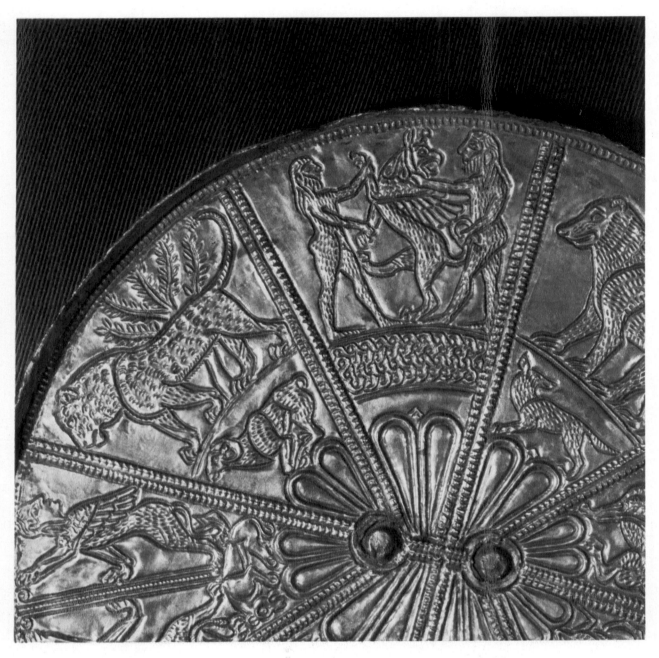

33 Sections of the back of the round silver mirror shown in plate 29. One depicts a lion set against a tree with a ram below it, another two hairy human figures fighting a griffin, with an ornamental field below. In the third sector there is a bear, with a wolf or fox below it.

34 Semi-cylindrical hollow object of uncertain purpose (part of a throne?) with lion-head terminals and a pair of ram heads on each side with an ovoid knob between them. The semi-cylindrical surface is divided into rectangles and triangles to form fields for amber inlay. Parts of the heads and knobs are granulated and inlaid with amber. Gold and amber. Kelermes.

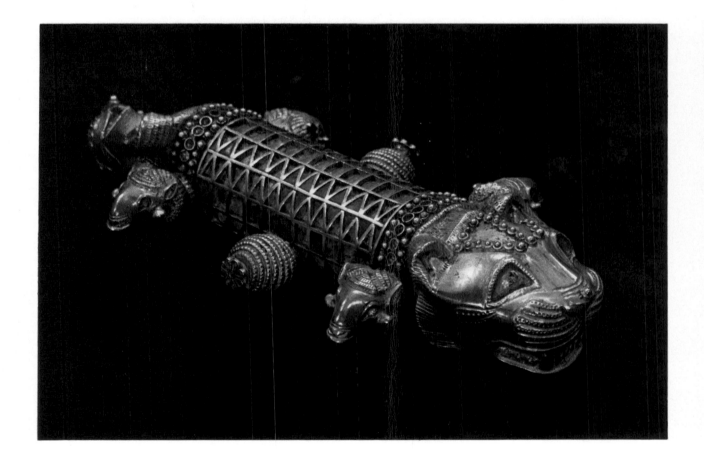

35 Mirror, its handle decorated with figure of a twisted beast worked on relief. Bronze. Kelermes.

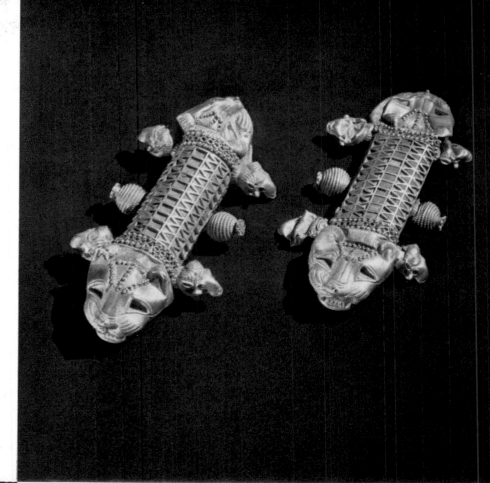

36 Two semi-cylindrical objects, purpose uncertain, as shown in plate 34.

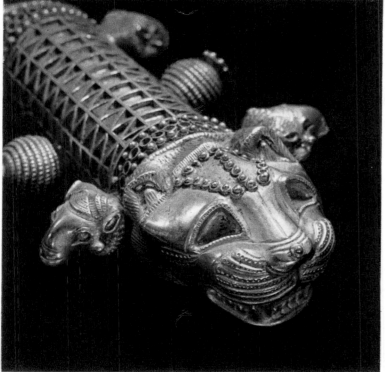

37 Lion head. Detail of plate 34.

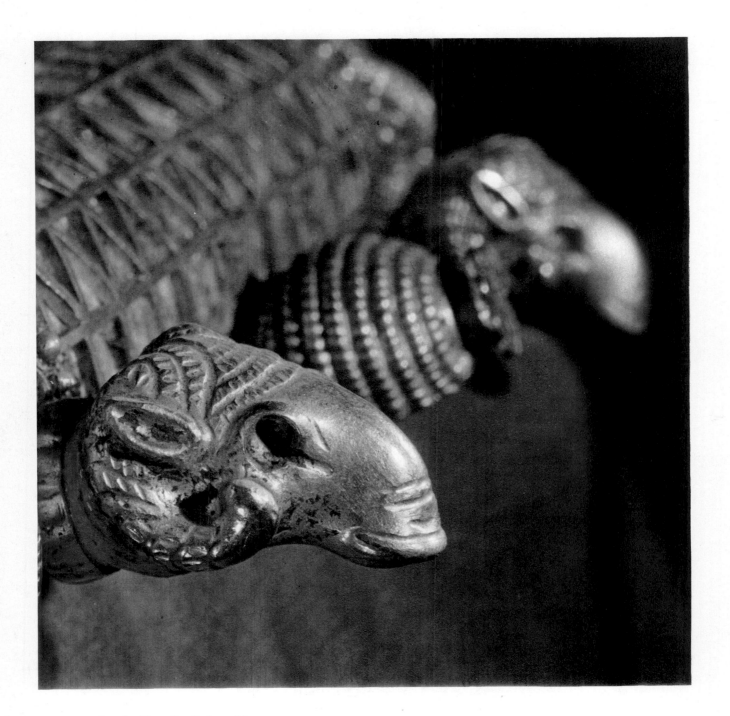

38　Ram heads. Detail of plate 34.

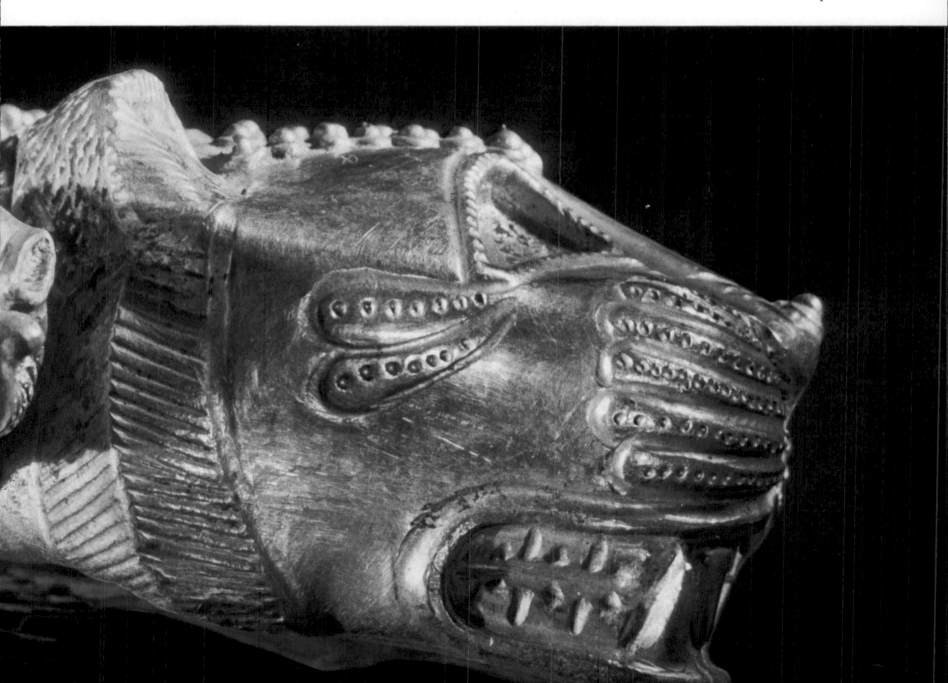

39　Lion head. Detail of plate 34.

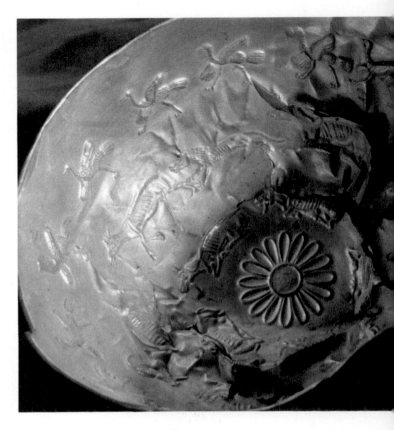

40 Cup embossed on the sides with the figures of birds and animals and on the bottom with a rosette. Detail. Gold. Kelermes.

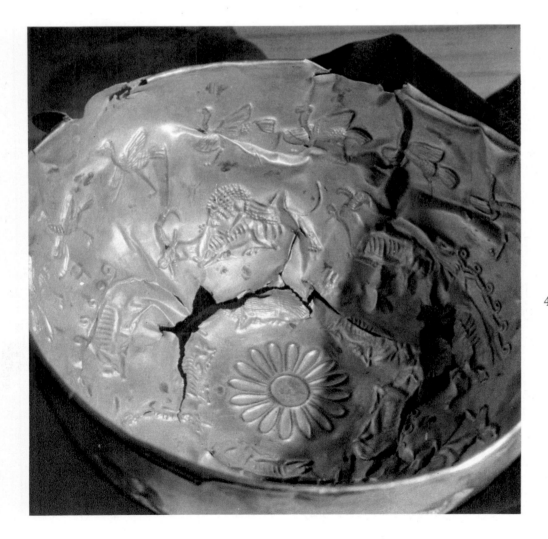

41 Another view of the cup shown in plate 40.

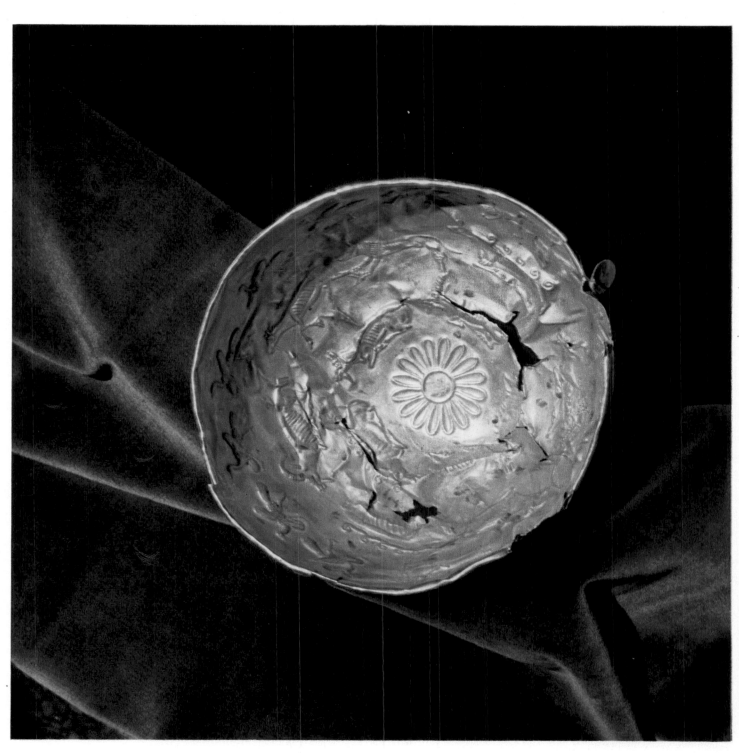

42 The gold cup shown in plate 40 viewed from above.

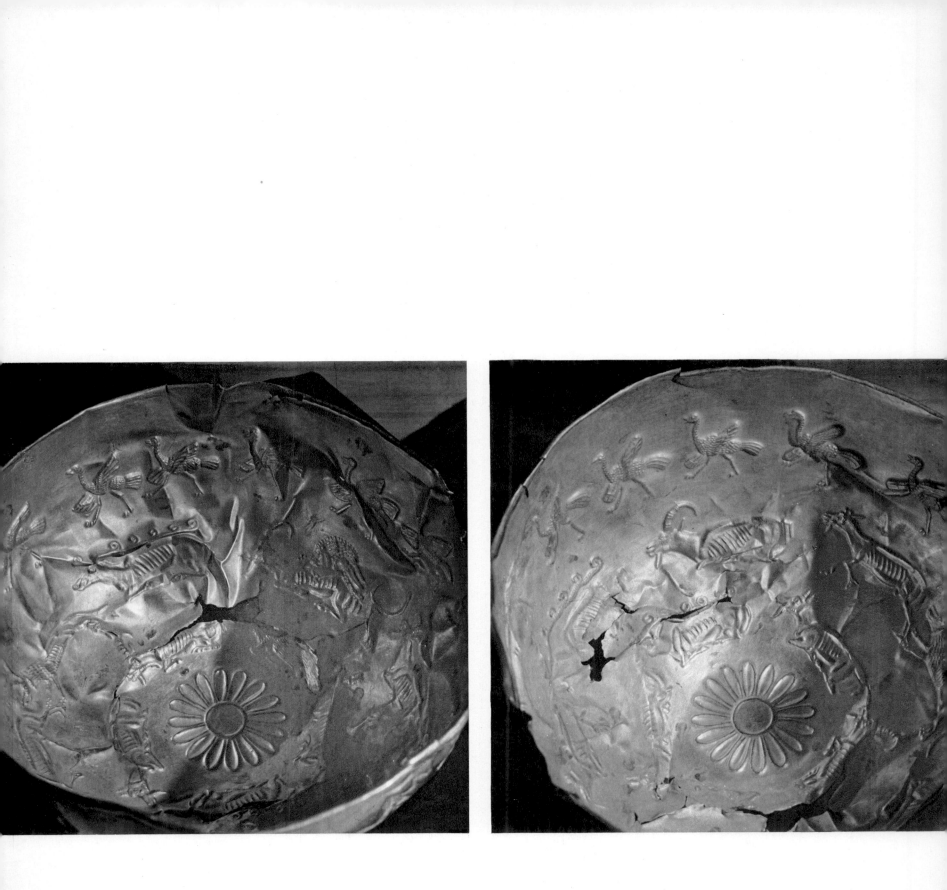

43, 44 Two more views of the cup shown in plate 40.

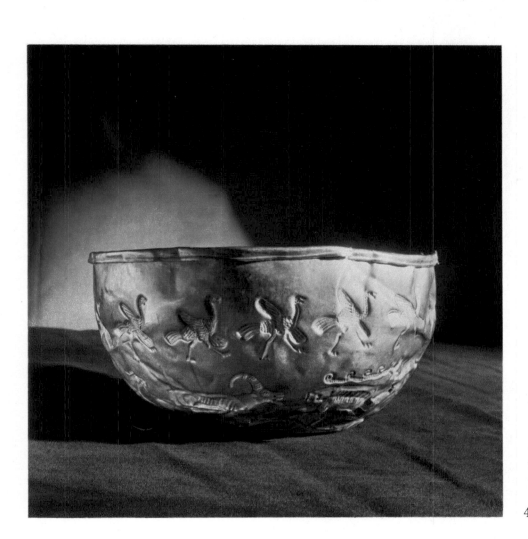

45 Side view of the cup shown in plate 40.

46 Hemispherical cup, its sides covered with almond-shaped and quadrangular embossing. Gold. Kelermes.

48 Helmet with rounded top strengthened with a rib ending in a short point in front, where it is shaped to form eye apertures. At the lower edges of the sides is a border pierced with a row of holes for fixing cheek-pieces and back-piece. Bronze. Kelermes.

47 Hemispherical cauldron on a conical foot with rhomboid ornament on the sides, and handles on the rim in the form of goats. Bronze. Kelermes.

49 Round plate embossed with a spiral ornament. Gold. Kelermes.

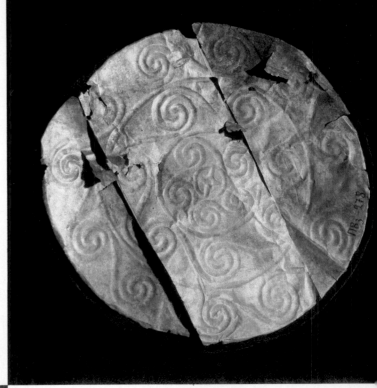

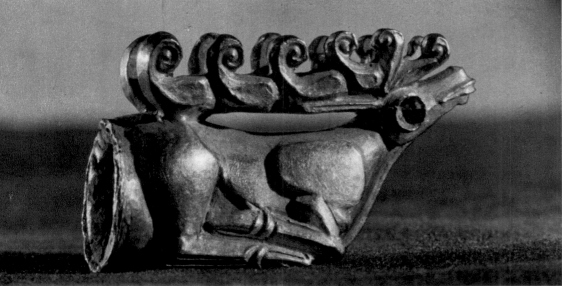

50 Hollow finial in the form of a recumbent stag with head raised. Gold. Kelermes.

51 Round plaque with embossed design of a recumbent horse, with cord ornament around the edge. Gold. Kelermes.

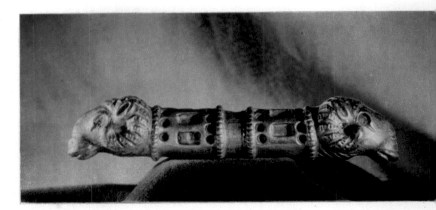

52 Buckle runner shaped as cylindrical rod with depressions for inlay of light blue enamel and amber, terminating in sculptured ram heads. Gold. Kelermes.

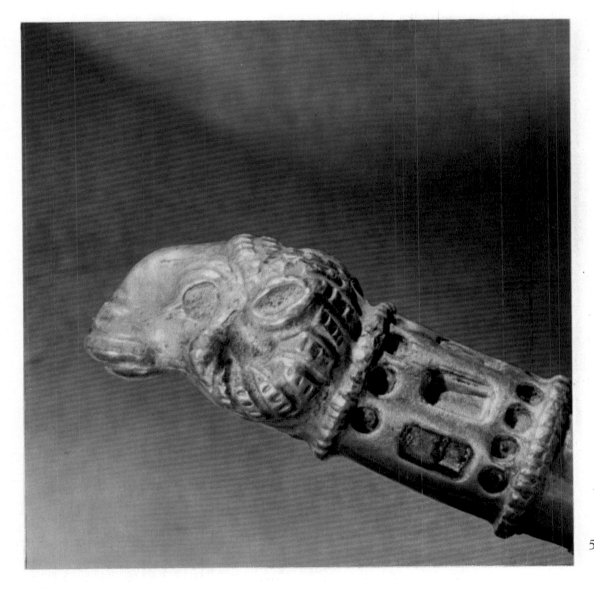

53 Ram-head terminal. Detail of plate 52.

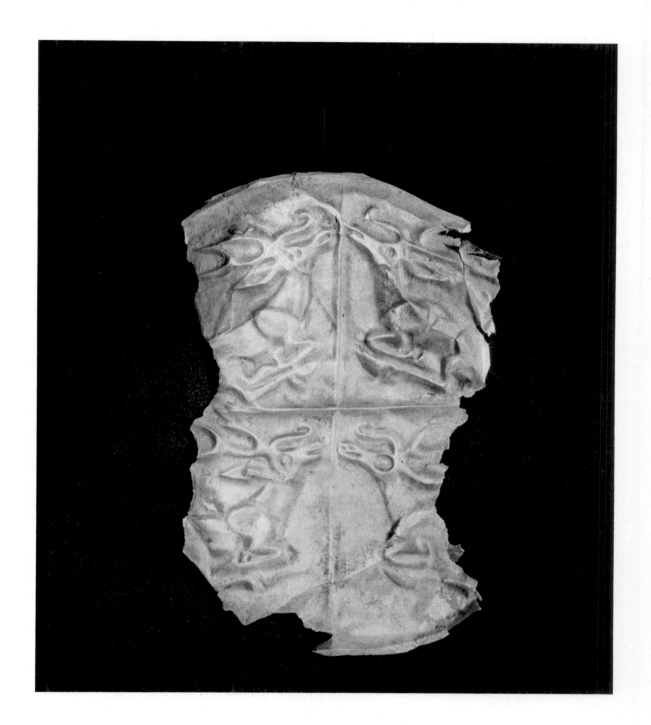

54 A broken circular plaque divided by ridges into four sections, with the figure of a recumbent
 stag in each. Gold. Kelermes.

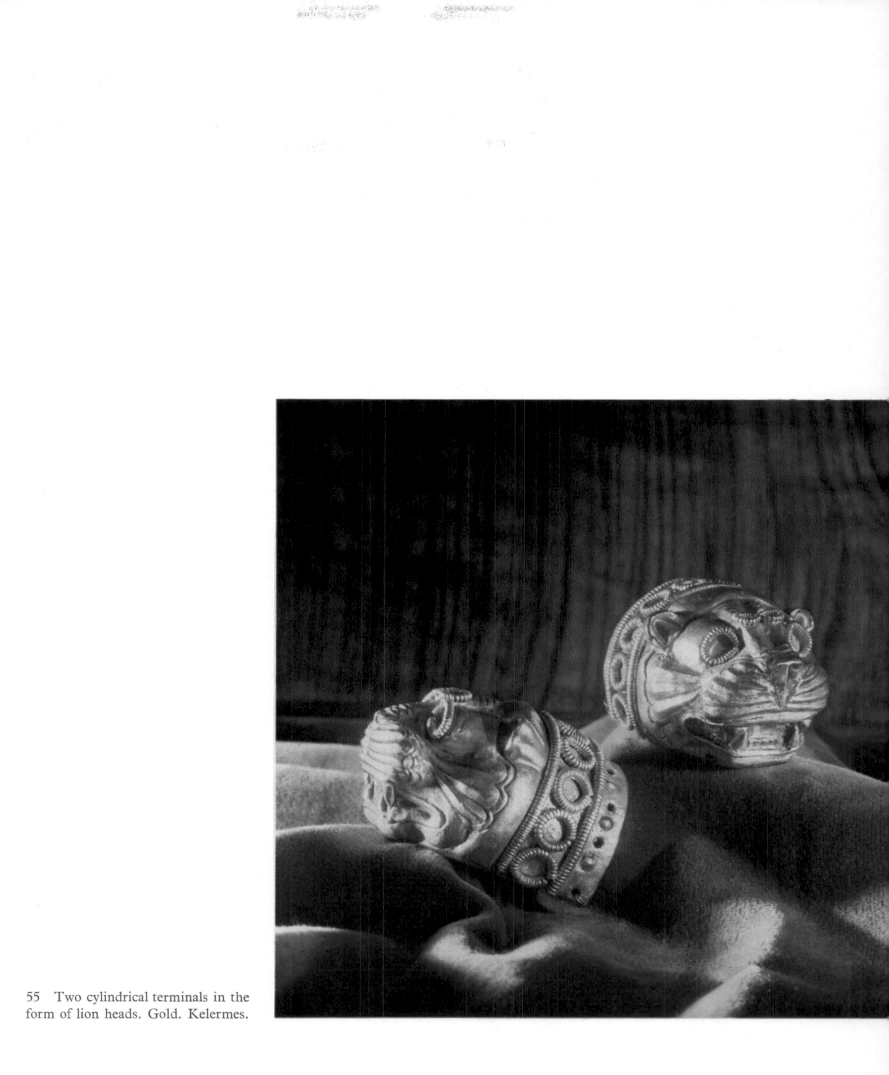

55 Two cylindrical terminals in the form of lion heads. Gold. Kelermes.

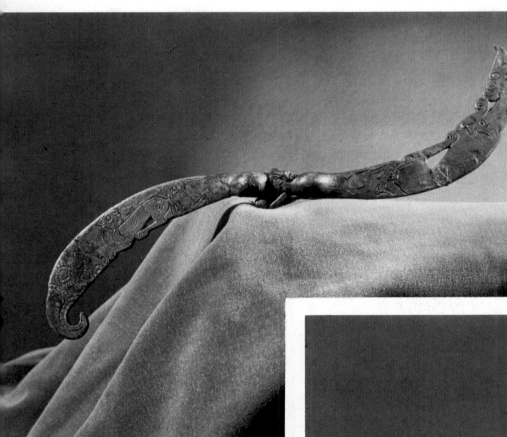

56 Cheek-pieces with double perforation, having flat sickle-shaped terminals partly cut out with a recumbent carnivore at one end and a bird head at the other. The details of the figures are engraved. Behind the bird head is a recumbent beast with head turned back, and behind the animal at the other end there is a stag. Silver. Ulski.

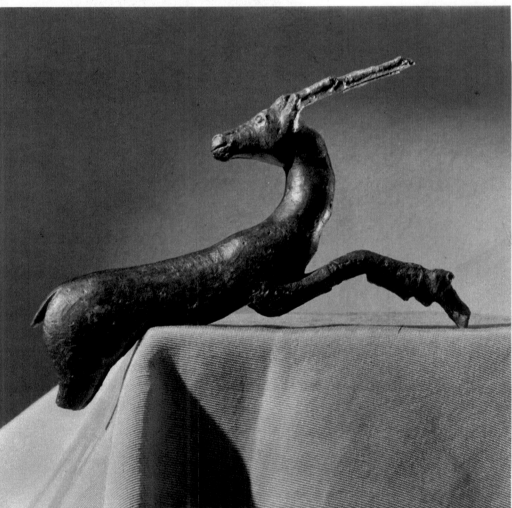

57 Figure of a running stag with head turned back. Originally this was a cauldron handle. Bronze. Ulski.

58 Flat pole-top shaped like a schematic bird head with human eyes and a curved beak. ▶ At the base and on the beak are loops hung with conical bells (two loops are intact, one is broken off). Above the eye the head is edged with three schematic bird heads. The beak is filled with relief lines repeating its shape. A round hole in the plate at the base of the beak is surrounded by lines forming a schematic bird head. On the plate below it is the figure of a recumbent goat with its head turned back. Bronze. Ulski.

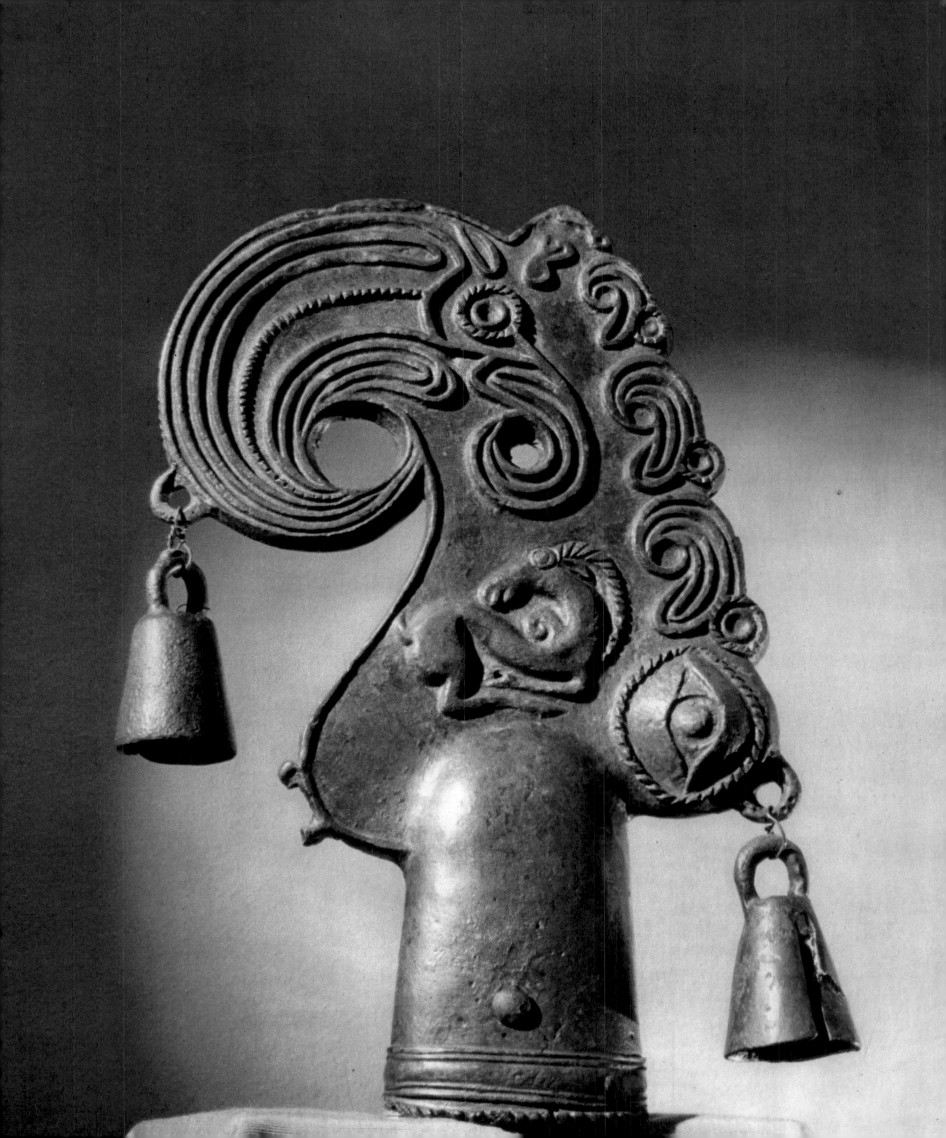

59 Conical cut-out pole-top crowned with a flat schematized griffin head with ram's horns. Bronze. Ulski.

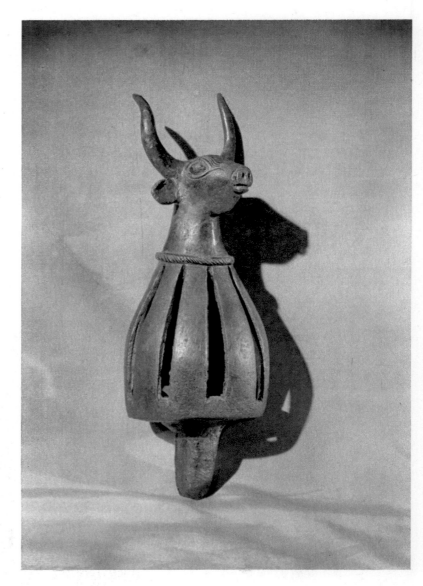

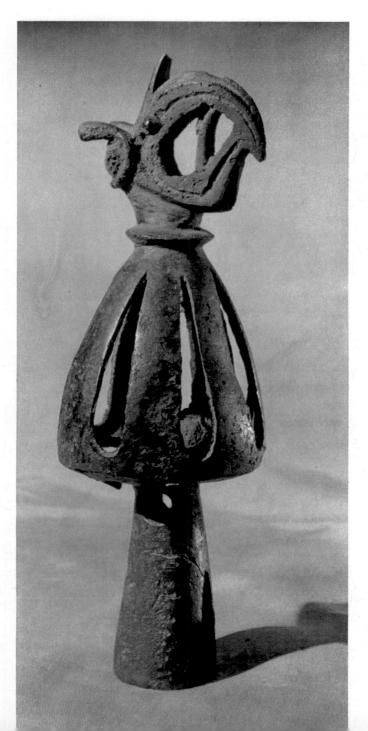

60 Pear-shaped openwork pole-top terminating in an ox head. There are two little balls inside. Bronze. Ulski.

61 Flat pole-top in the shape of a schematic bird head hung with ▶ three little bells. Bronze. Ulski.

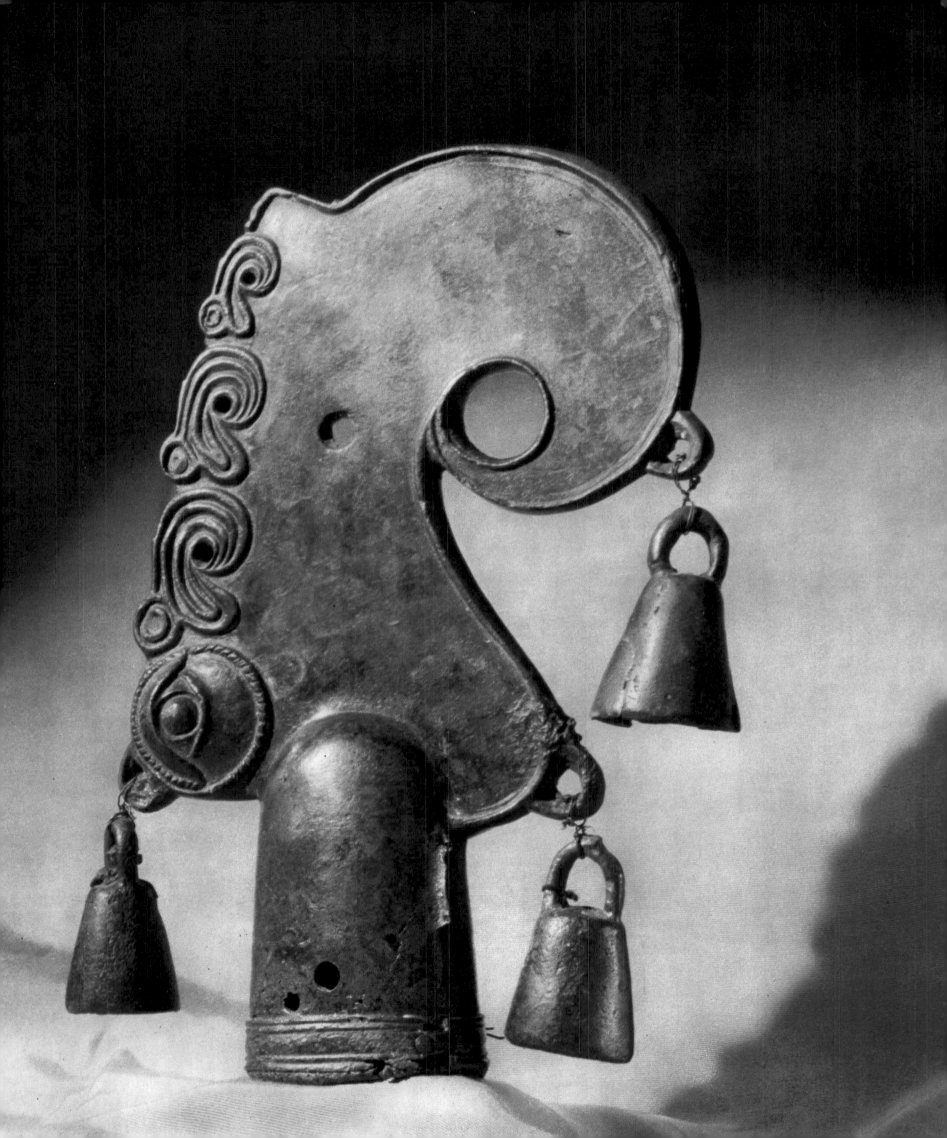

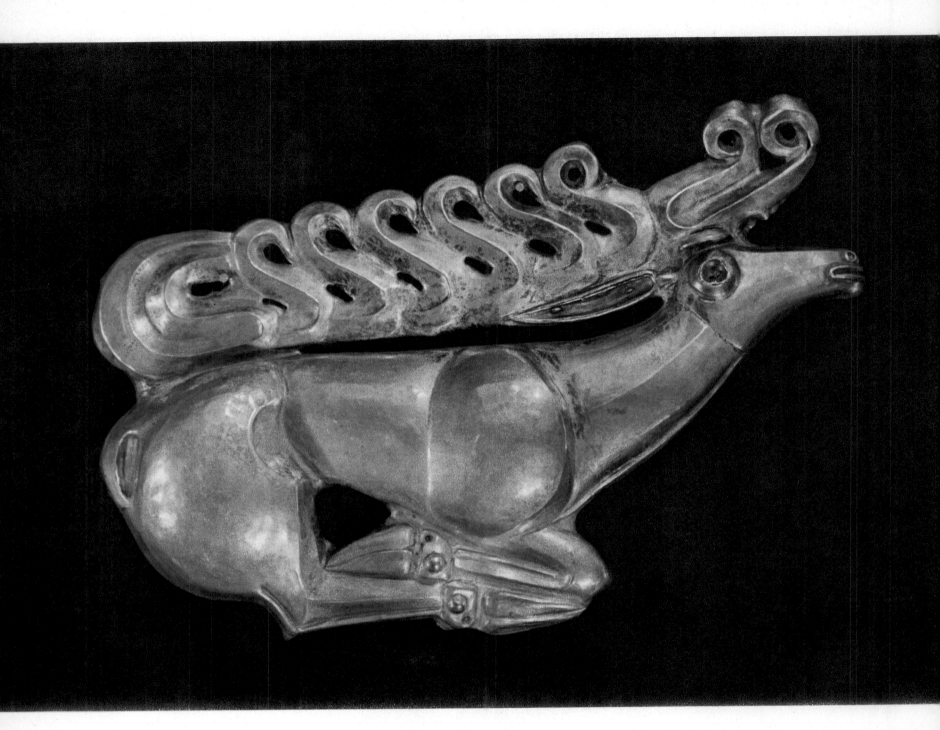

62 Figure of a recumbent stag. Shield centre-piece. Gold. Kostromskaya.

64 Forepart of the stag shown in plate 62. ▶

63 Reverse side of the shield centre-piece shown in plate 62.

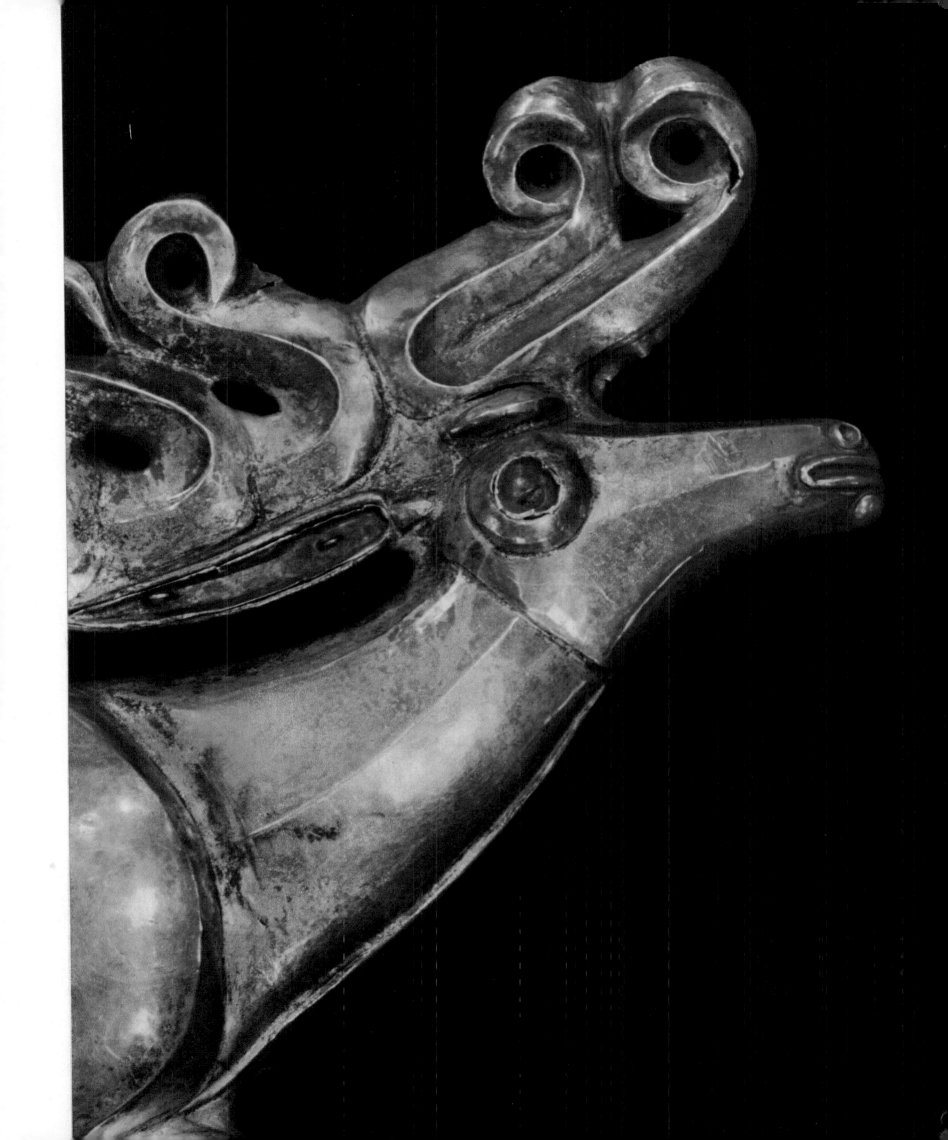

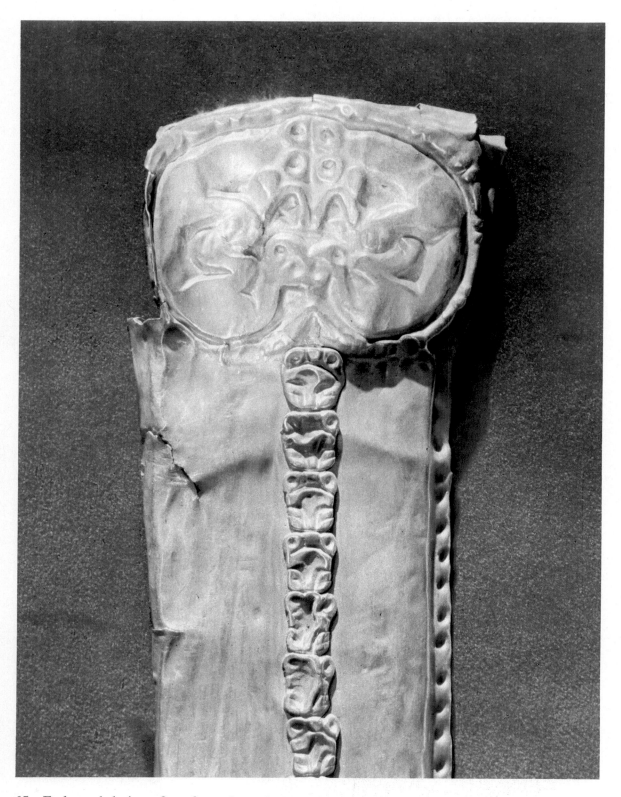

65 Embossed design of confronted carnivores with an edging of ten facing lion heads. Upper part of the scabbard shown in plate 66. The Pointed Barrow.

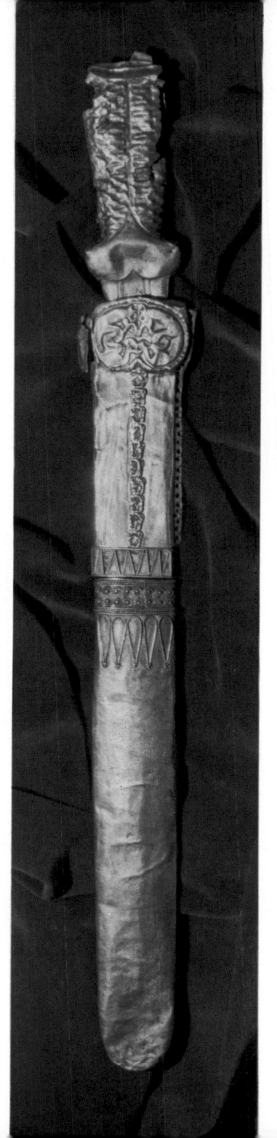

66 Sword, with decorated hilt, an oval
pommel and heart-shaped guard.
The scabbard is decorated with
rows of triangles, double spirals and
almond-shaped depressions inlaid
with blue enamel. Gold. The
Pointed Barrow.

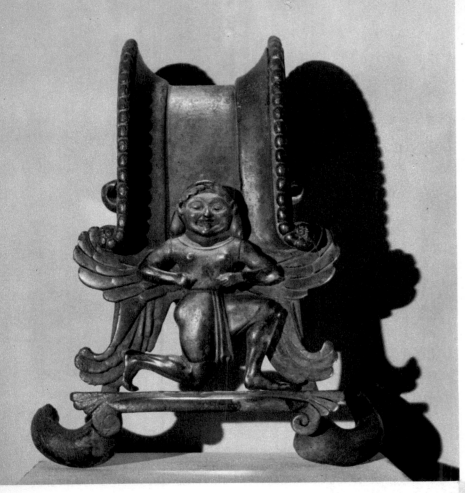

67 Handle of a *crater*, with volutes and the figure of a Gorgon. Bronze. Martonosha.

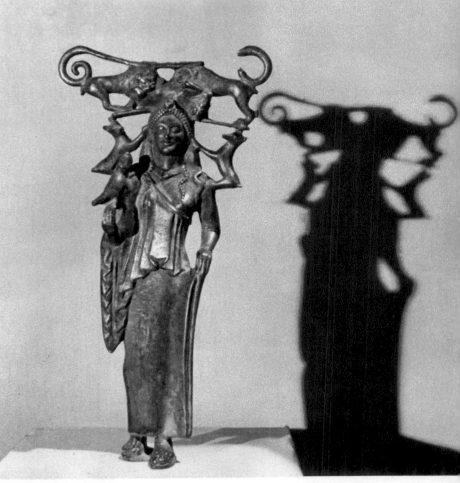

68 Mirror-handle in the form of a goddess with a siren in her right hand and two carnivores on her shoulders. Above the head of the goddess is a light openwork design showing two lions devouring an ox. Bronze. Kherson.

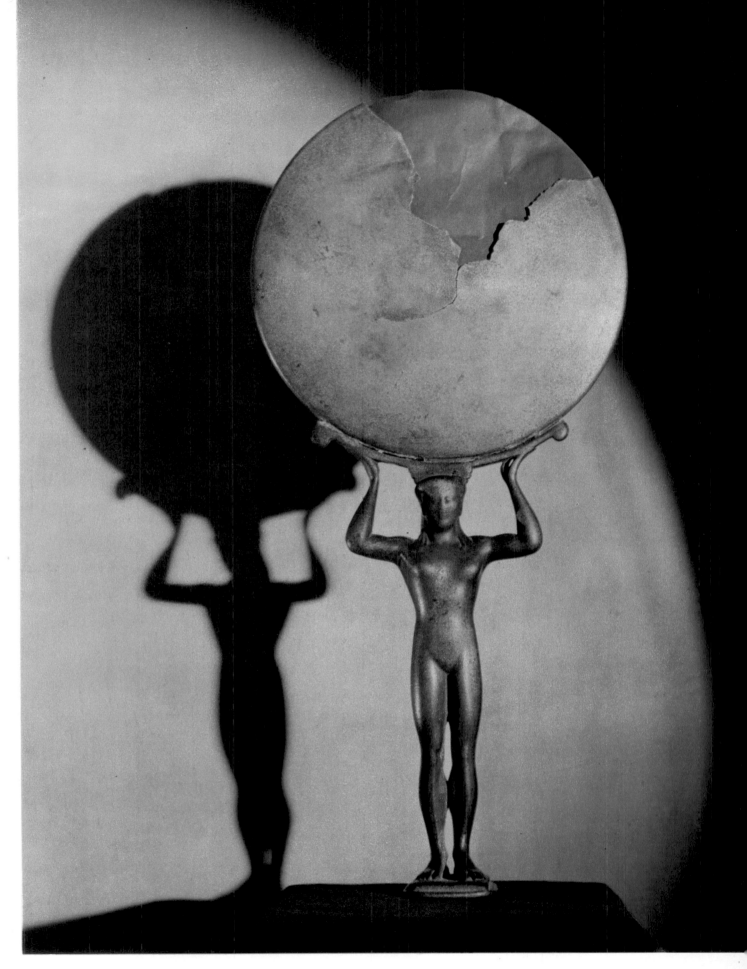

69 Mirror with handle in
the form of a figure of
Aphrodite, her arms raised.
Bronze. Annovka.

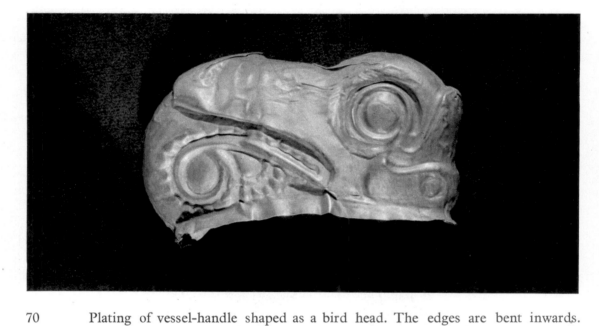

70 Plating of vessel-handle shaped as a bird head. The edges are bent inwards.
Gold. Ak-Mechet.

71 Mounting, embossed with design of two confronted boar heads. The upper edge
is bent back. Gold. Baby.

72 Mounting, with embossed design of a recumbent stag, its head raised. The upper
edge is bent back. Gold. Ak-Mechet.

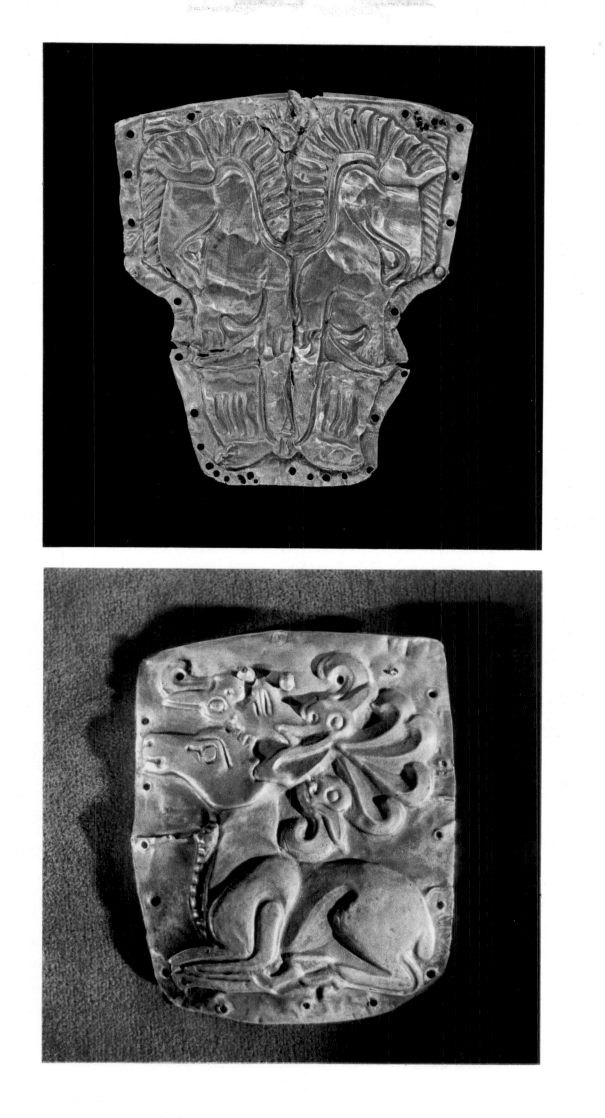

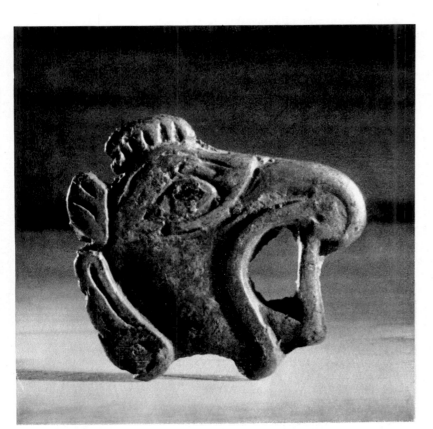

73 Belt plaque in the form of an embossed griffin head. There is a loop on the reverse side. Bronze. The Golden Barrow.

74 Belt plaque in the form of an embossed figure of a bird. There is a loop on the back. Bronze. The Golden Barrow.

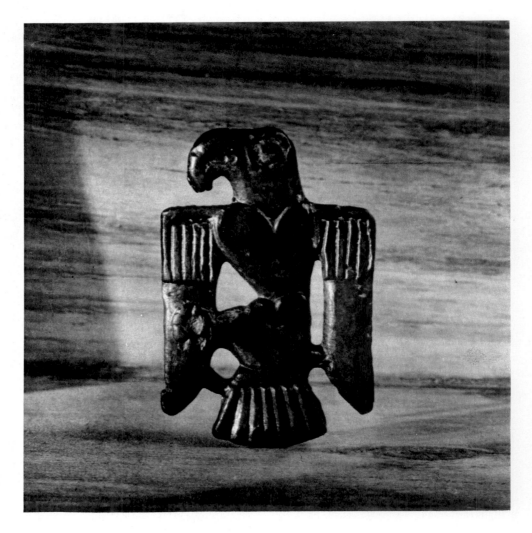

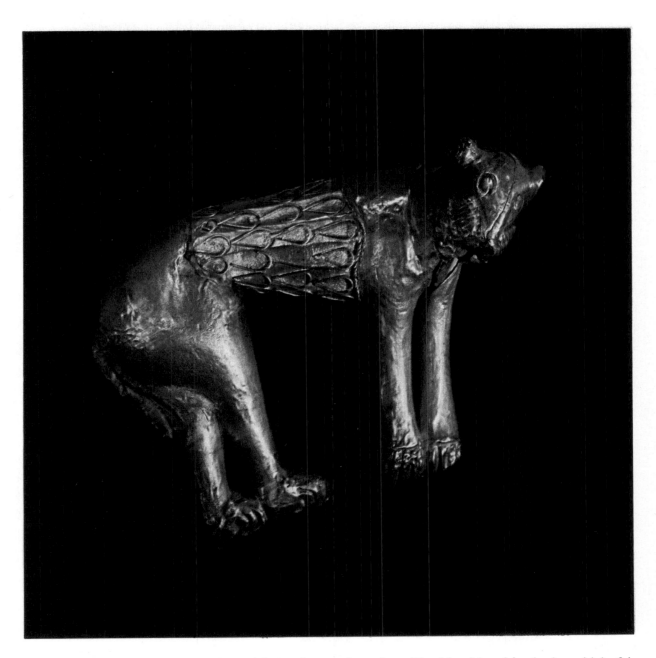

75 Embossed figure of a panther with head turned *en face*. To this side of its body gold leaf is applied with almond-shaped filigree to hold coloured inlay. There is a solid loop on the back. Bronze and gold. The Golden Barrow.

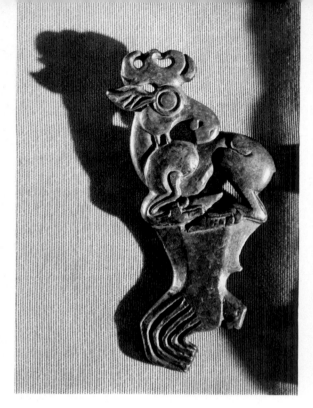

76 Plaque. Relief figure of a recumbent elk on a pedestal shaped like a bird's leg. There are two loops on the back. Bronze. Zhurovka.

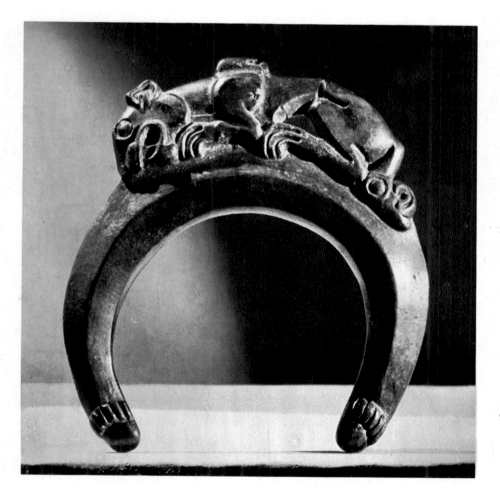

77 Plaque, shaped like a panther lying on a horseshoe-shaped object with phallic terminals. There is a loop on the back. Bronze. Zhurovka.

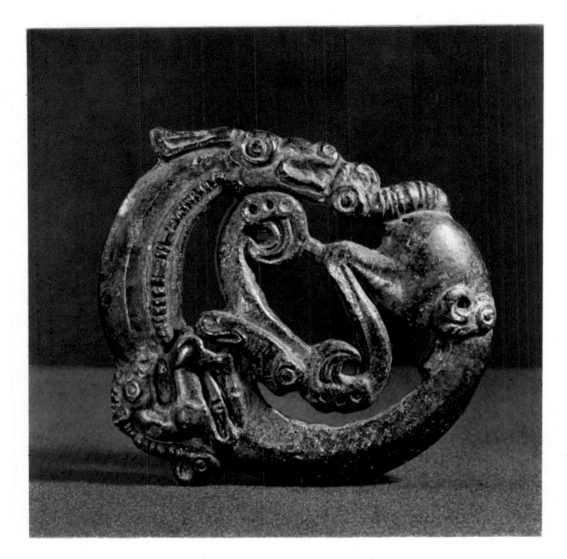

78 Openwork plaque shaped like a carnivore twisted into a ring. There is a loop on the back. Bronze. Kulakovsky.

79 Plaque in the form of an embossed figure of a recumbent stag. Gold. Zhurovka.

80 Bridle frontlet in the shape of a stag head. A palmette on the plate. Bronze. Zhurovka.

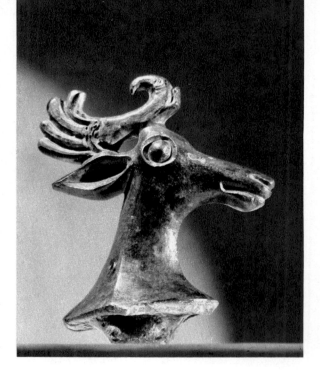

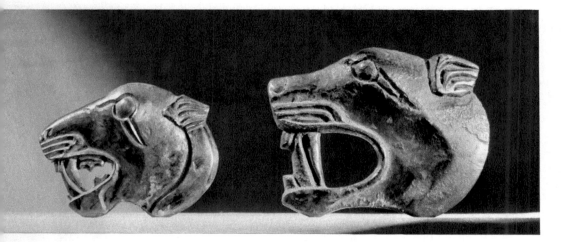

81 Bridle plaques in the shape of a beast's head (probably a lion) seen in profile. There is a loop on the back. Bronze. Zhurovka.

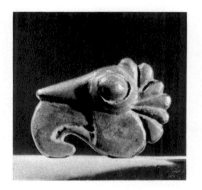

82 Bridle plaque in the shape of a bird of prey seen in profile, with a palmette behind. Bronze. Zhurovka.

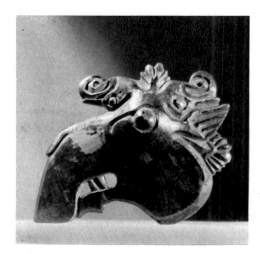

83 Bridle plaque in the shape of an elk head seen in profile. There is a loop on the back. Bronze. Zhurovka.

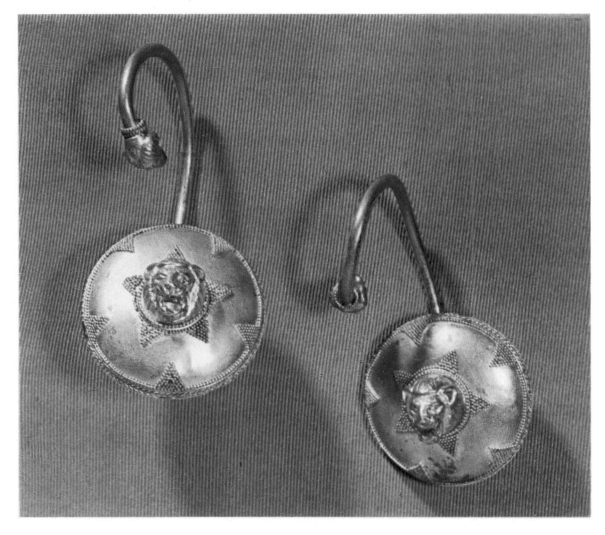

84 Pair of pendants, each ornamented with a lion head in the centre. Gold. Olbia.

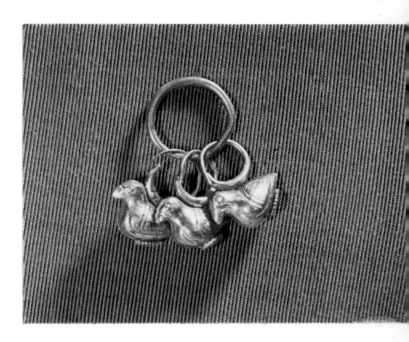

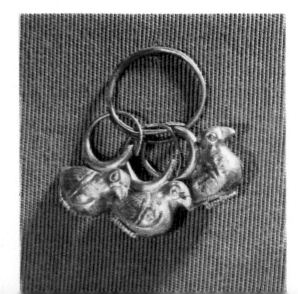

85, 86 Pair of earrings with pendants shaped like birds. Gold. Olbia.

87 Candelabrum with three feet shaped like lion paws. It is crowned with an Ionic capital and the figure of a nude youth. Bronze. Nymphaeum.

88 Rear view of the youth on the candelabrum shown in plate 87.

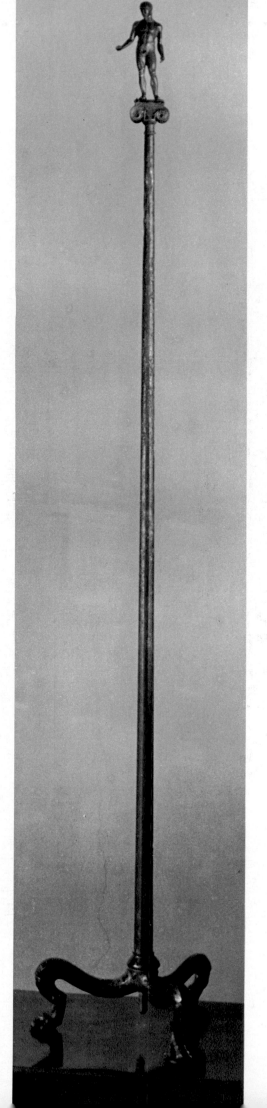

89 Front view of the youth on the candelabrum shown on plate 87.

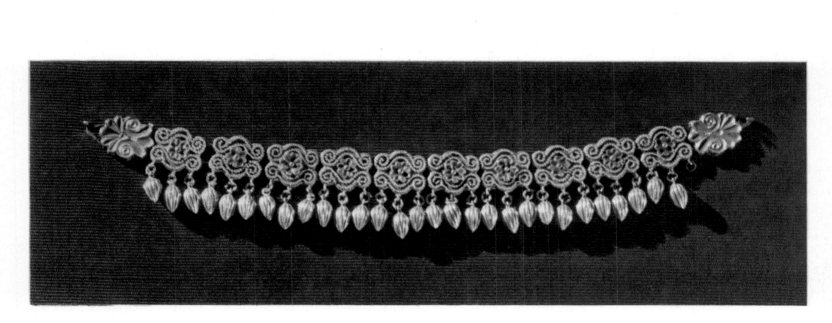

90 Necklace, made up of twelve links in the form of rosettes orna-
mented with light blue enamel set between double spirals and
having three acorn-shaped pendants attached to each unit. The
ends are shaped as palmettes. Gold and enamel. Nymphaeum.

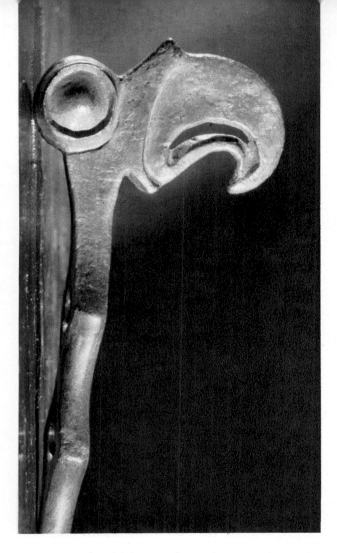

91 Part of a double-perforated cheek-piece with the head of a bird of prey at the end. Bronze. Nymphaeum.

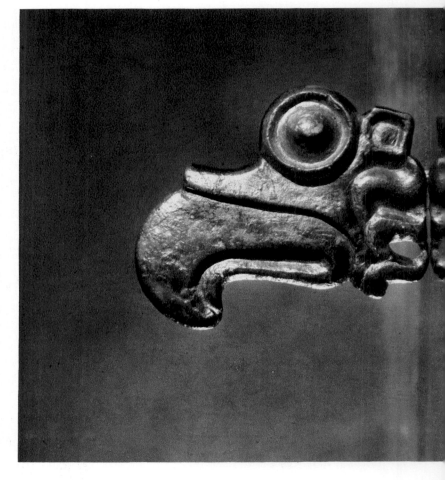

92 Bridle plaque in the shape of a bird head with hooked beak and eye protruding upwards. There is a loop on the back. Bronze. Nymphaeum.

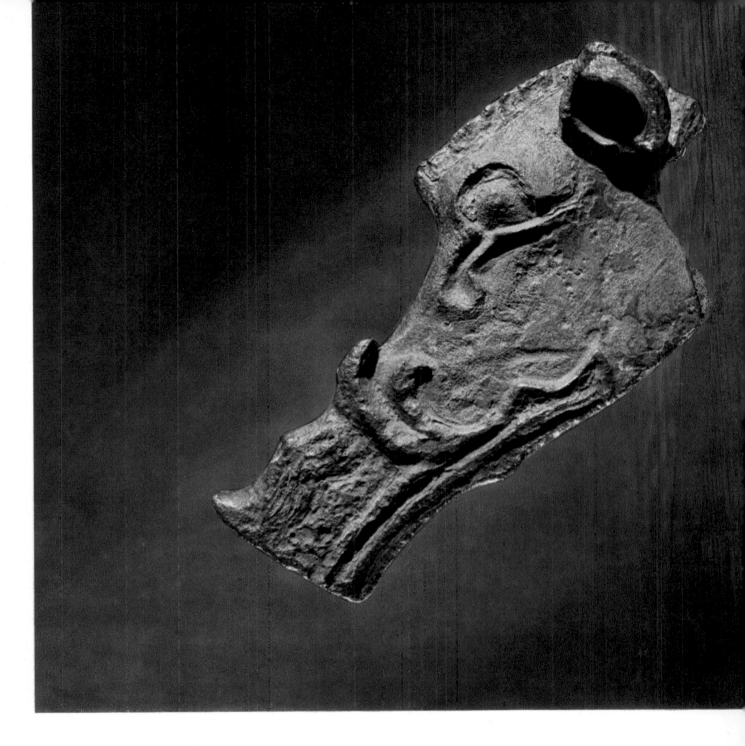

93 Embossed bridle plaque in the form of a boar head, seen in profile. There is a loop on the back. Bronze. Nymphaeum.

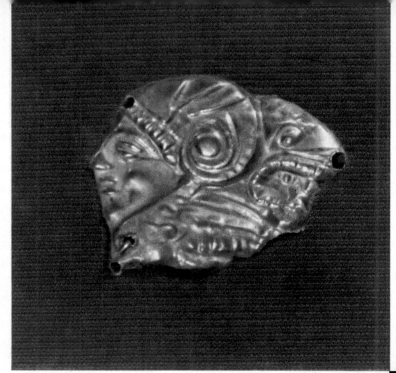

97 Embossed ornament of a monkey head seen full face. Gold. Nymphaeum.

98 Boat-shaped earring with ribbing at the fixed end of the bow and with a little pyramid of granulation at the lock. Gold. Nymphaeum.

99 Embossed ornament of a sphinx, in profile, seated on its haunches. The wings are shown as scaled and ribbed. Gold. Nymphaeum.

100 Embossed ornament of a recumbent stag seen in profile. Gold. Nymphaeum.

101 Embossed ornament of a winged lion with its head turned back. At the end of a tail is a bird head. Gold. Nymphaeum.

94 Embossed ornament showing a lion head and a human head facing in opposite directions, with a fish below. Gold. Nymphaeum.

95 Embossed decorative figure of sphinx. Gold. Nymphaeum.

96 Square embossed ornament with turned-up edges and a design of two confronted sphinxes rampant in the upper part, and a recumbent lion below. Gold. Nymphaeum.

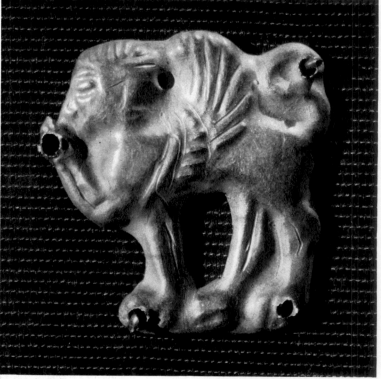

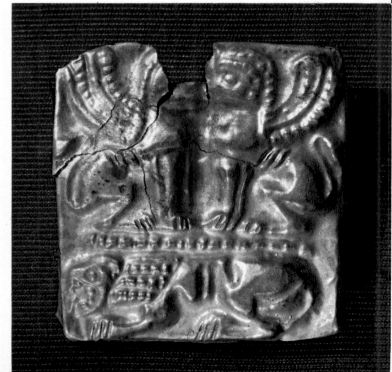

102 Embossed ornament. A recumbent figure of an elk, seen in profile, with head turned backwards and with an angular horn extending to its rump and terminating in a beast head. Gold. Nymphaeum.

103 Embossed ornament. A Gorgon mask with snakes instead of hair. Gold. Nymphaeum.

104 Embossed ornament. A mask of Medusa. Gold. Nymphaeum.

105 Embossed ornament. A recumbent elk with hornless head turned backwards. Gold. Nymphaeum.

106 Embossed ornament. A cock seen in profile. Gold. Nymphaeum.

97

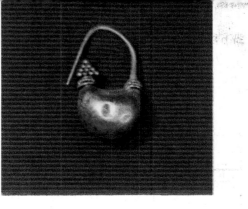

98

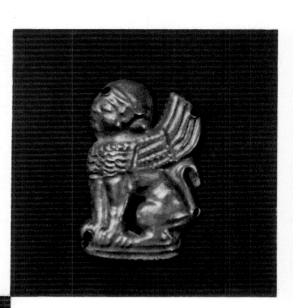

99

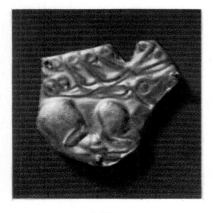

100

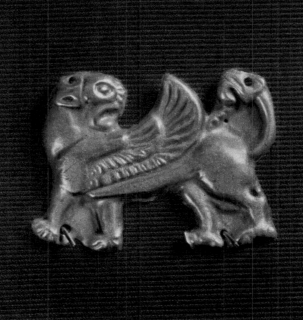

101

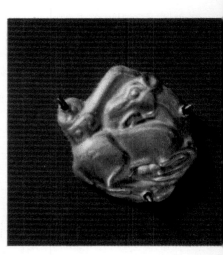

102

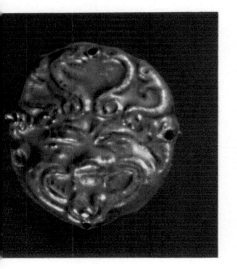

103

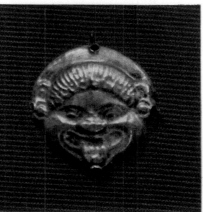

104

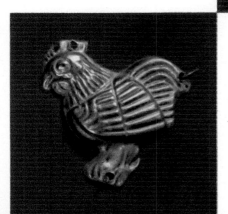

106

105

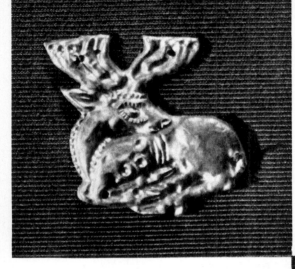

108 Embossed ornament of a sphinx, seen in profile, sitting on its haunches with a curved wing directed upwards. Gold. Seven Brothers.

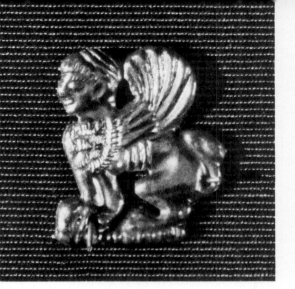

107 Embossed ornament of a recumbent stag, seen in profile, its head turned backwards and with symmetrically spread antlers. Gold. Seven Brothers.

113 Embossed pectoral shaped as a profile figure of a deer with legs apart, the turned-back head bearing symmetrically spread antlers. Between the legs is a fawn with forelegs bent and head lifted. Below, the design is completed with a bird, its head down and wings spread, the tail forming a palmette. Silver with gold plating. Seven Brothers.

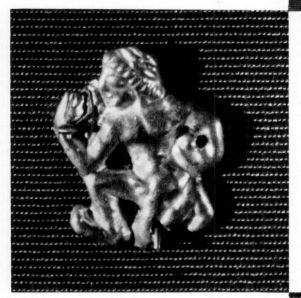

109 Embossed ornament of human heads in profile, with bands over the hair and wearing necklaces. Gold. Seven Brothers.

112 Embossed ornament of the head and shoulders of a recumbent ox. Gold. Seven Brothers.

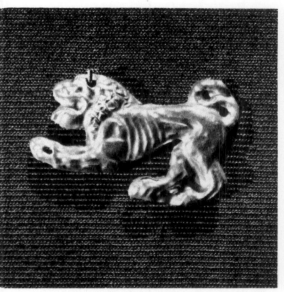

110 Embossed ornament of a kneeling youth, bearing fruit in both hands. Gold. Seven Brothers.

111 Embossed ornament of a leaping lion seen in profile. The tail is raised and curved into a loop. Gold. Seven Brothers.

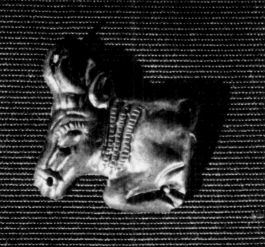

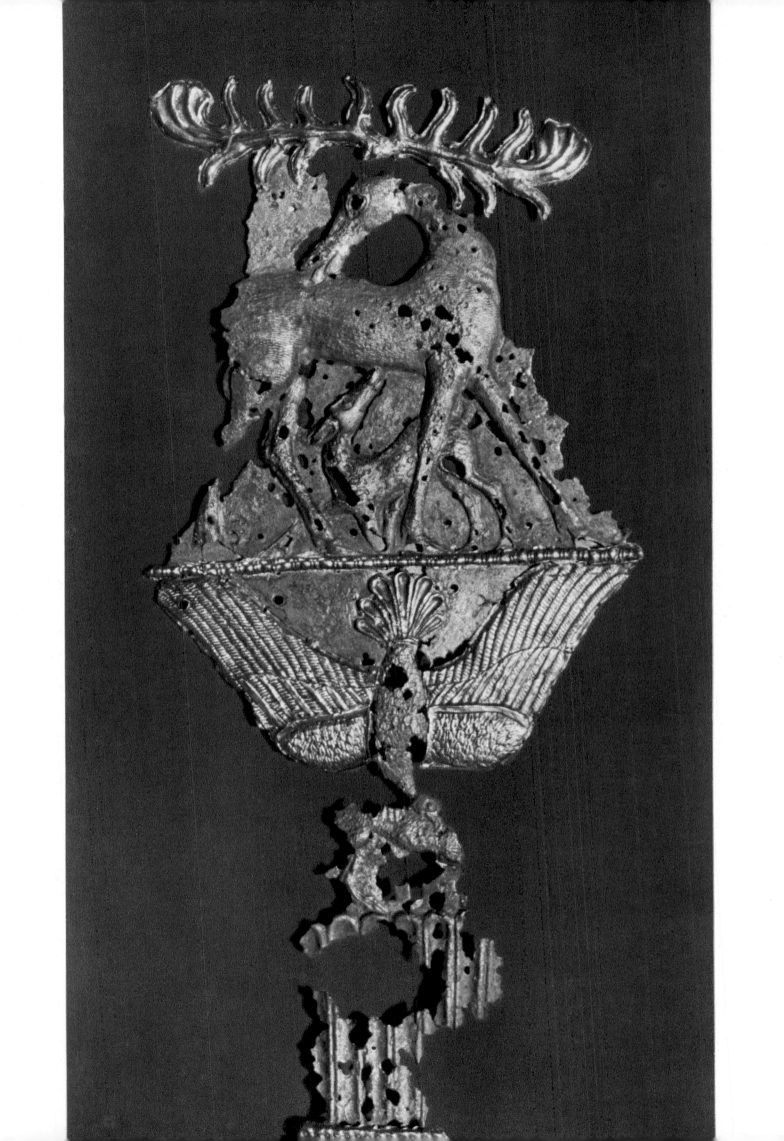

115 Bridle plate in the shape of a relief profile head of a bird with voluted beak, a large round eye, and, behind it, a palmette. There is a loop on the reverse side. Bronze. Seven Brothers.

114 Two frontlets from a bridle in the shape of stag heads with large curved antlers with tines. Bronze. Seven Brothers.

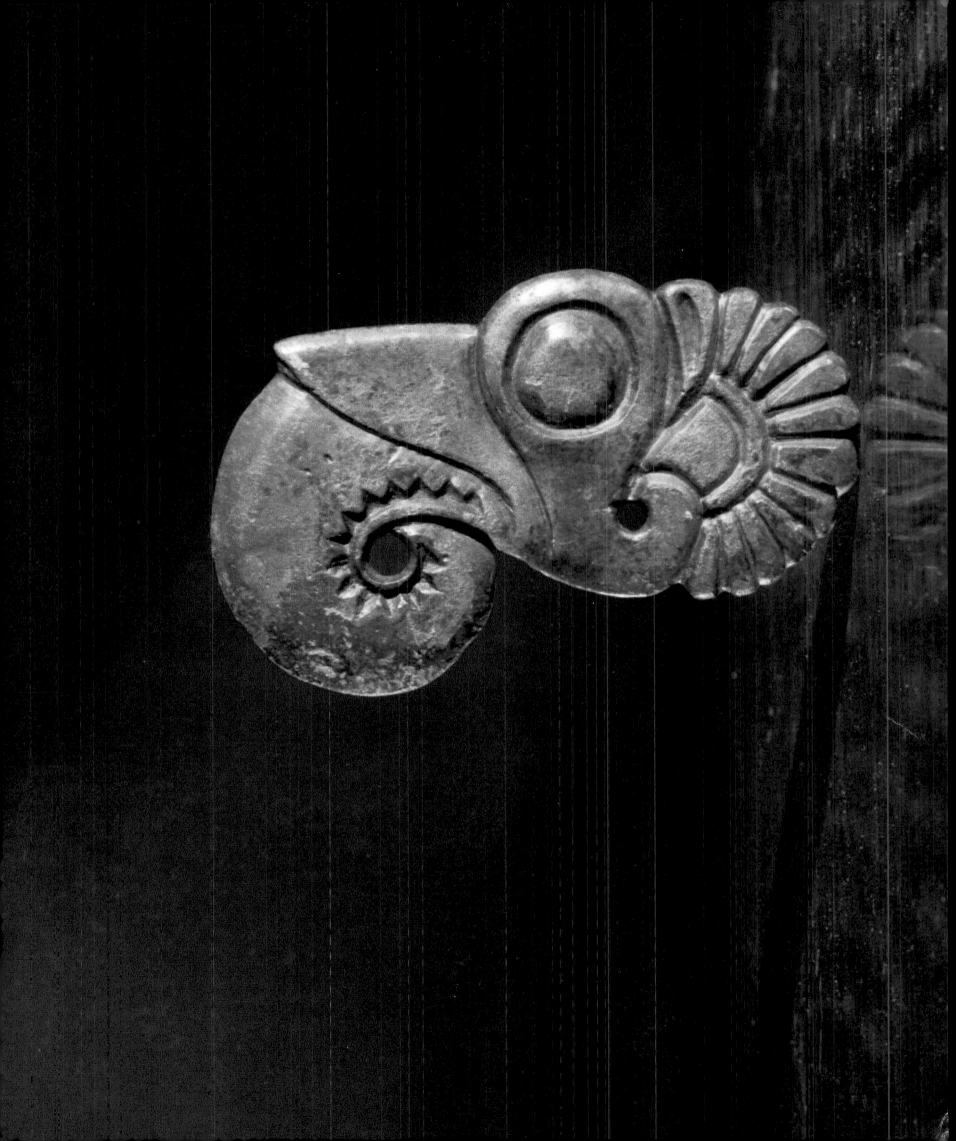

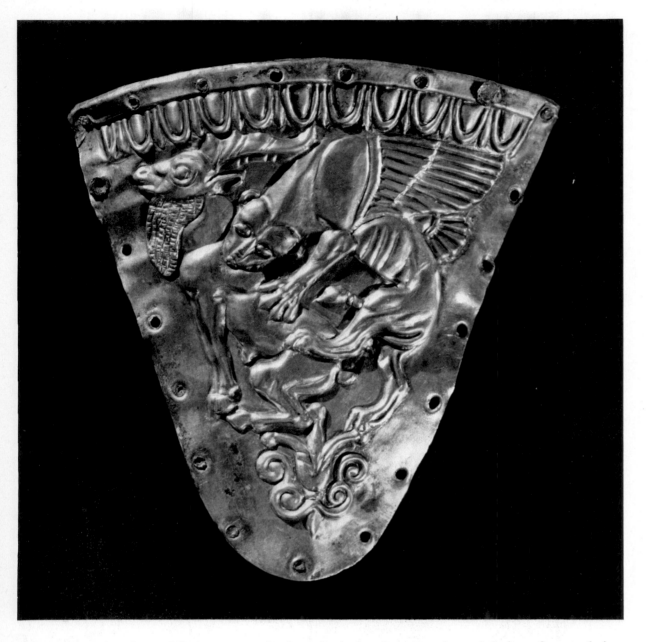

116 Triangular plate, with the upper edge bent back, bearing an embossed design of a goat being devoured by a lion-griffin. There is an egg-and-dart design along the upper edge, a lotus blossom with four volutes at the bottom. Gold. Seven Brothers.

117 *Rhyton*, the lower part of which is in the shape of a capricorn with broad wings, their rounded ends bent forward. The outer edges of the wings, the ends of the longer feathers and the capricorn's side-whiskers had been covered with gold plates secured with little nails. Along the upper edge of the *rhyton* runs a frieze of plaiting, lotuses and palmettes. There is a band of granulation set in notched wire at the junction with the finial. Silver, traces of gold mounting. Seven Brothers.

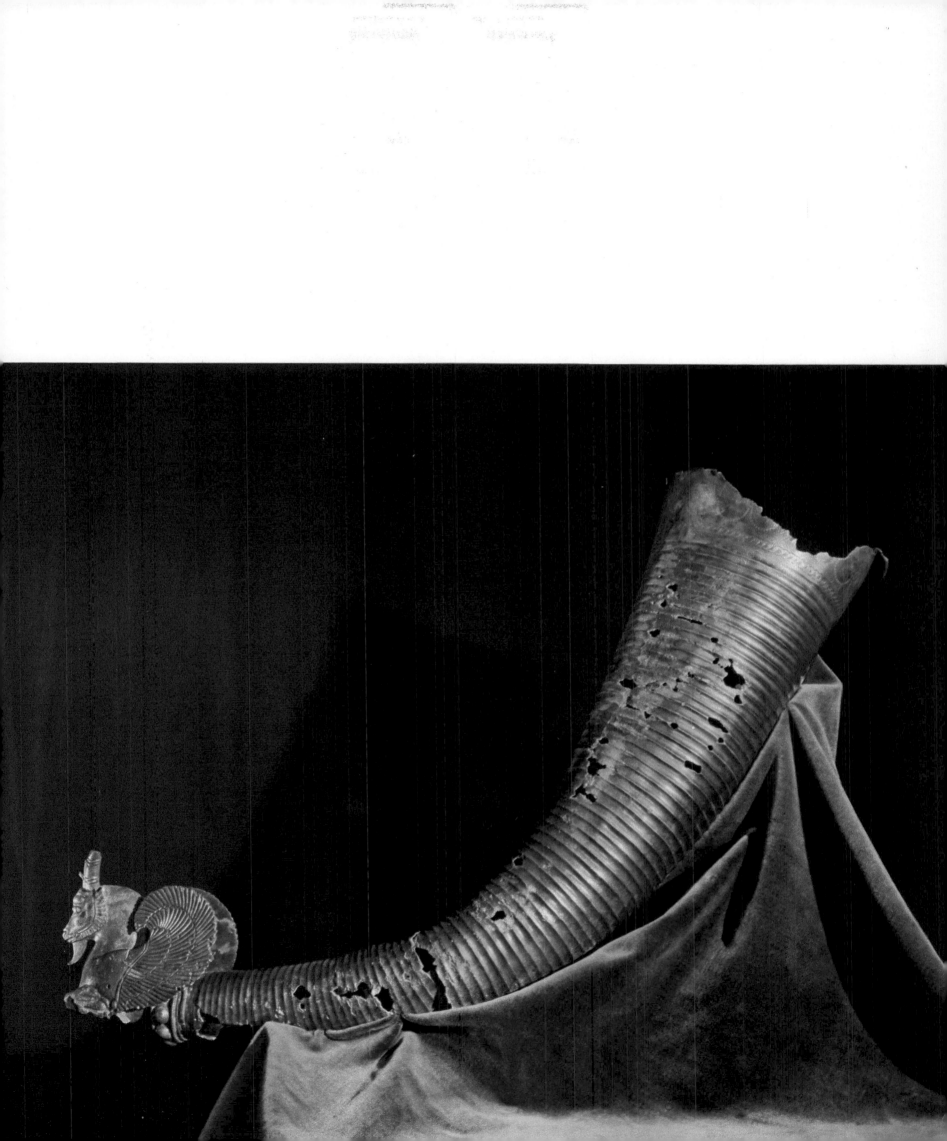

118 Triangular plate with the embossed figure of an eagle attacking a lamb, an egg-and-dart band along the upper edge, on the right a three-petal palmette, below a seven-petal palmette with a stem ending in volutes. Gold. Seven Brothers.

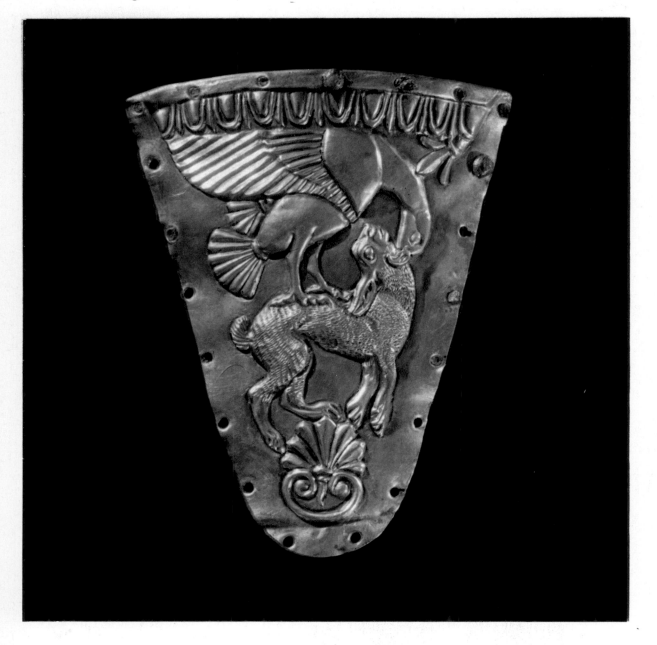

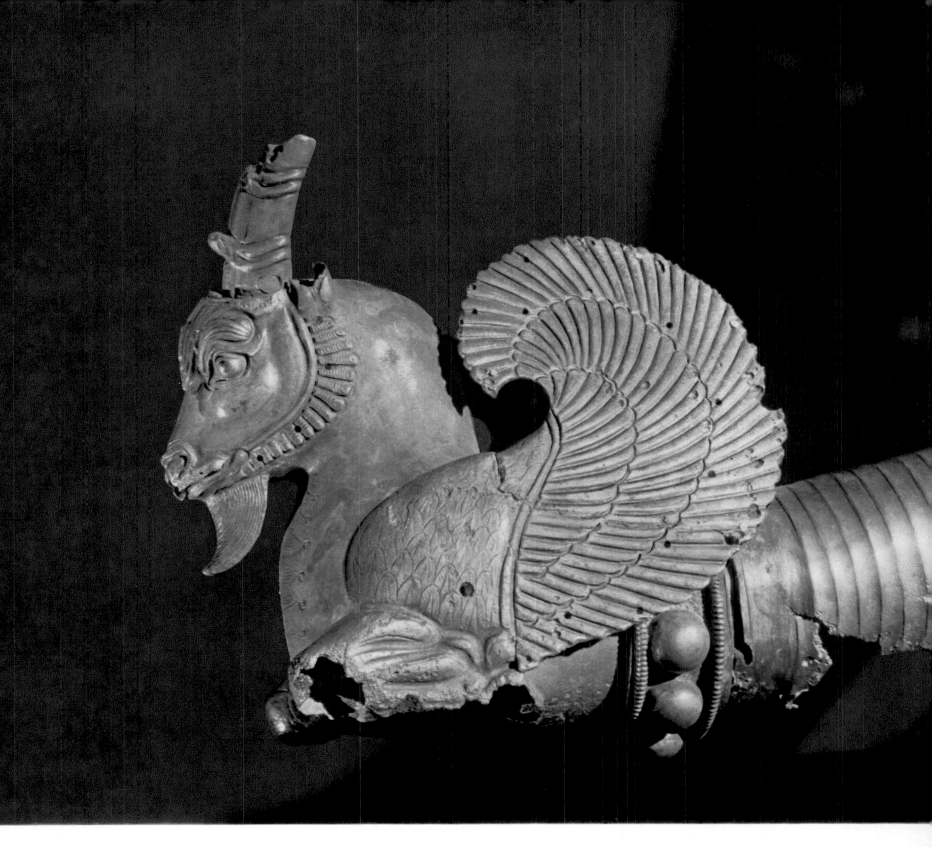

119 Silver *rhyton*. Detail of plate 117. Finial shaped as protome of a capricorn. Seven Brothers.

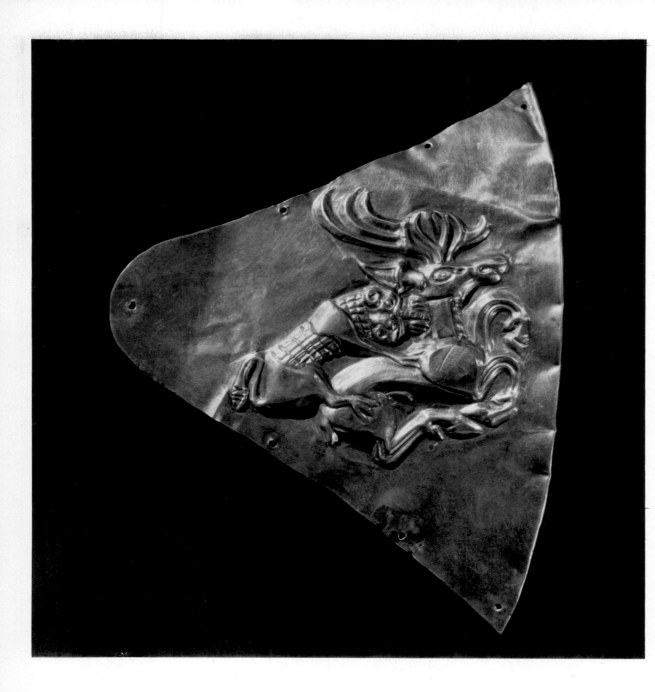

120 Triangular plate with embossed figures of a lion attacking a stag. Gold. Seven Brothers.

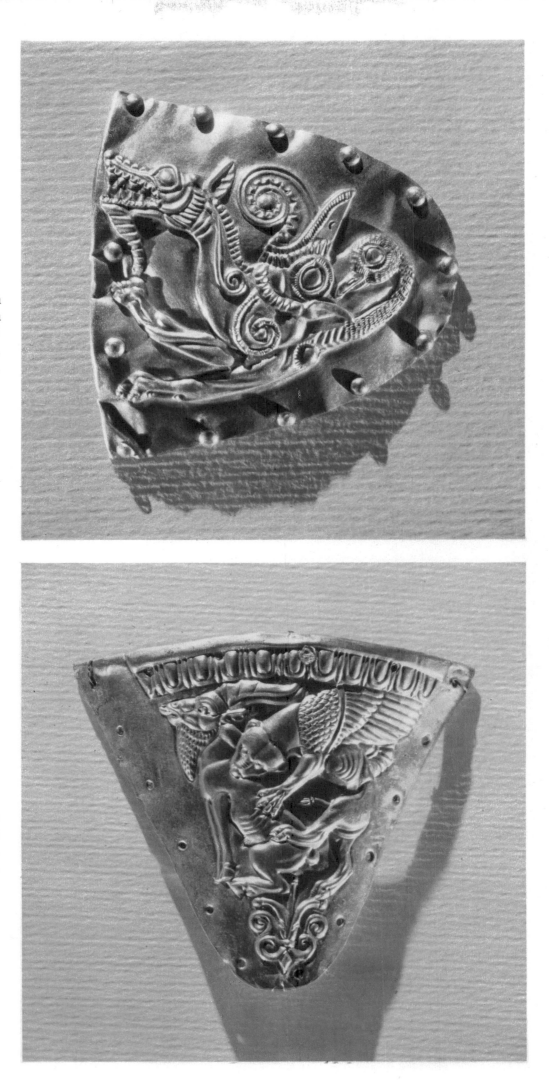

121　Triangular plate with the embossed figure of a mythical beast *(senmurve)* seen in profile. Gold. Seven Brothers.

122　Triangular plate with the embossed figure of a goat seized by a lion-griffin. Gold. Seven Brothers.

124 Mirror-handle in the form of a nude youth with two rams in his raised hands. Bronze. Seven Brothers.

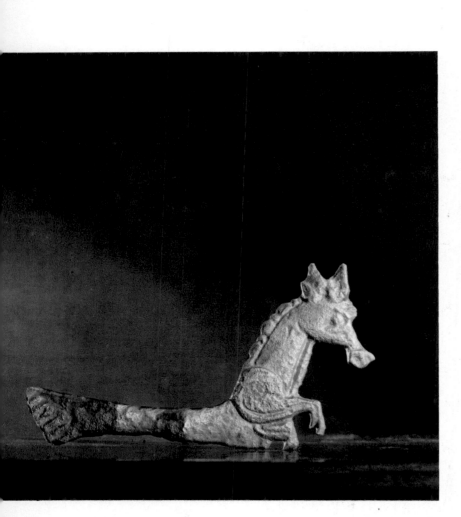

123 Part of a cheek-piece shaped like the forequarters of a horse. Bronze. Seven Brothers.

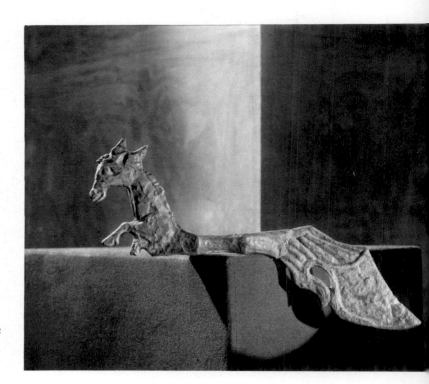

125 Double-perforated cheek-piece with a flattened figure of the forequarters of a horse at one end and a hoof at the other. Bronze. Seven Brothers.

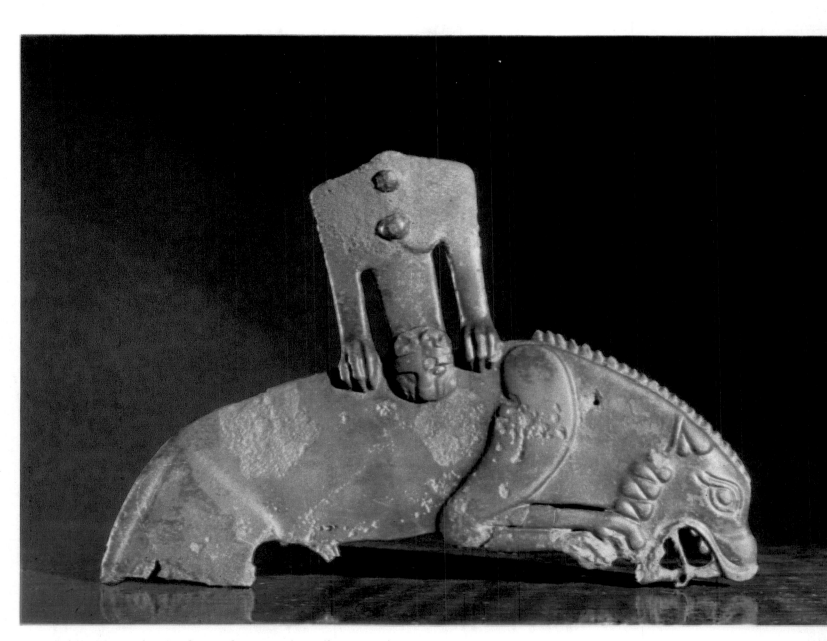

126 Bridle plaque in the form of a recumbent lion seen in
 profile, and frontal view of the protome of a beast biting
 its back. Bronze. Seven Brothers.

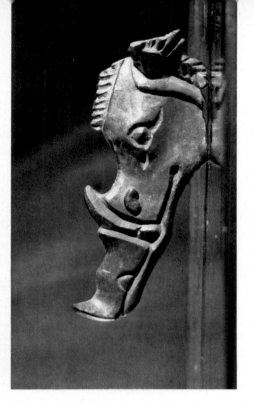

127 Bridle plaque in the form of
a boar head seen in profile.
Bronze. Seven Brothers.

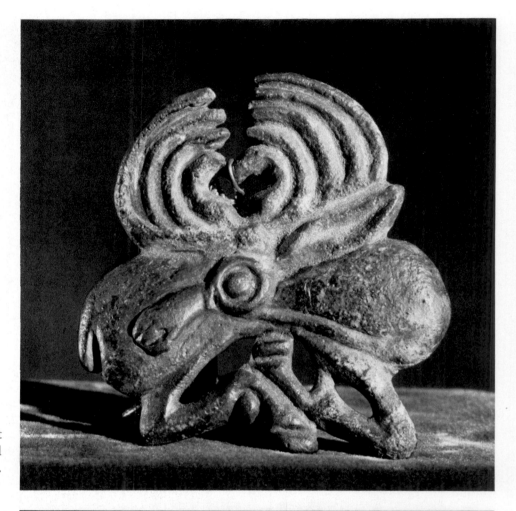

128 Bridle plaque in the form of a recumbent
stag with head turned backwards and crowned
with symmetrically spread antlers. Bronze.
Seven Brothers.

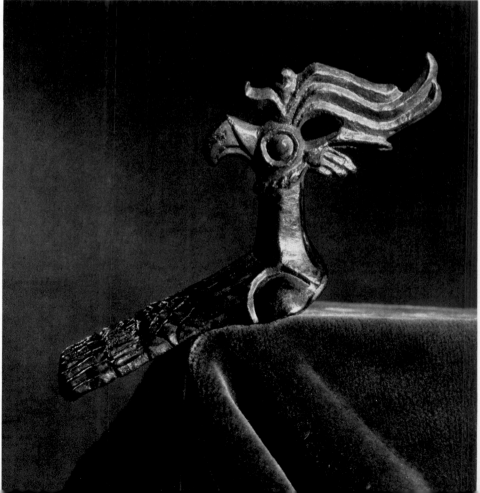

129 Bridle frontlet in the form of a bird-stag.
Bronze. Seven Brothers.

130 Bridle plaque in the form of a recumbent stag with head turned backwards, crowned with symmetrically spread palmette-like antlers. Bronze. Seven Brothers.

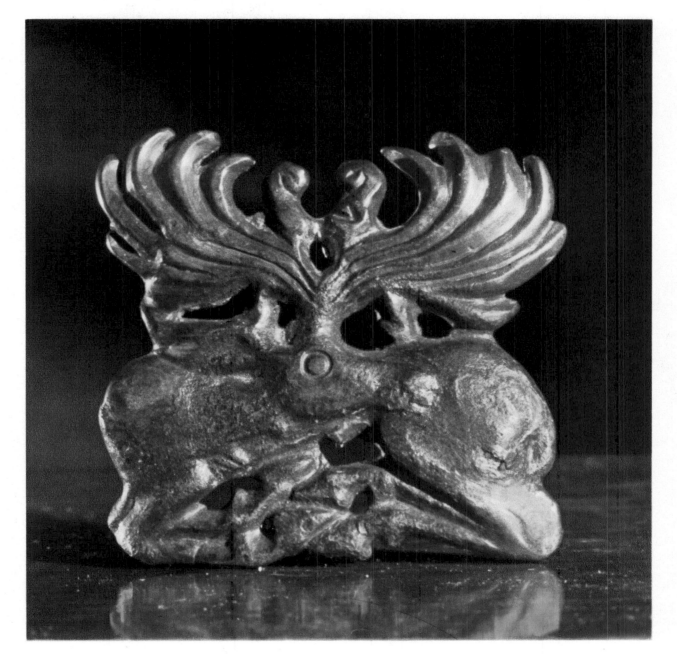

131 Ring with a profile figure of a walking bear on the shield. Electrum, chalcedony, and gold. Seven Brothers.

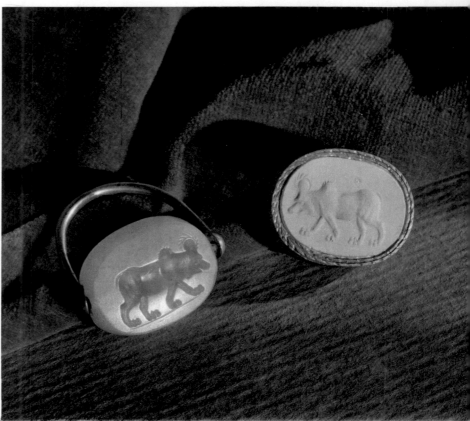

132 Ring with a figure of a leopard devouring a stag. Gold. Seven Brothers.

133 Bracelet of plaited wire decorated at either end with snake heads. Gold. Seven Brothers.

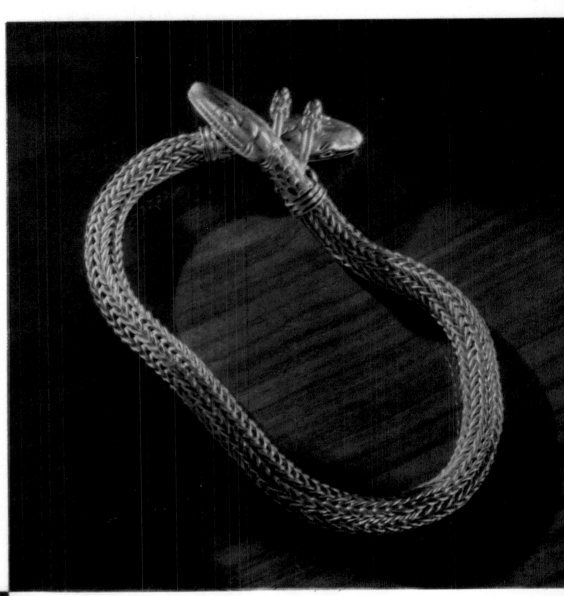

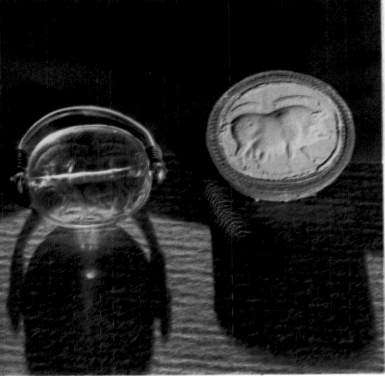

134 Ring with the figure of a boar on the bezel. Gold. Seven Brothers.

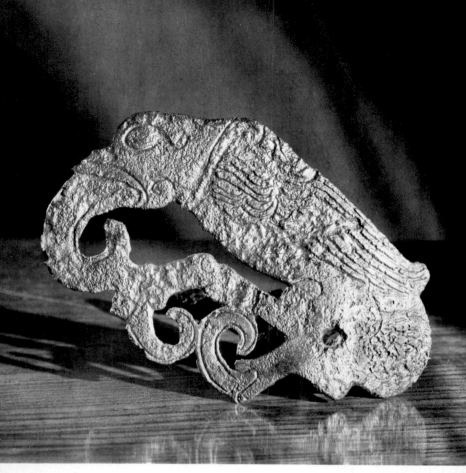

135 Plaque from the end of cheek-piece, shaped like a sitting bird with twisted spirals formed by exaggerated long beak and claws. The tail is like a palmette. Bronze. Seven Brothers.

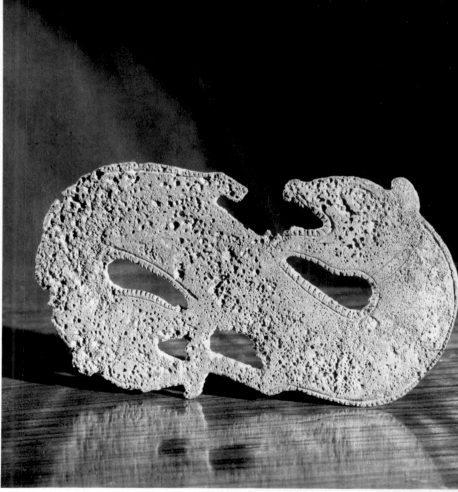

136 Ornamental plaque in the form of two animal heads on long curved necks, turned back from opposite directions to face inwards. Bronze. Seven Brothers.

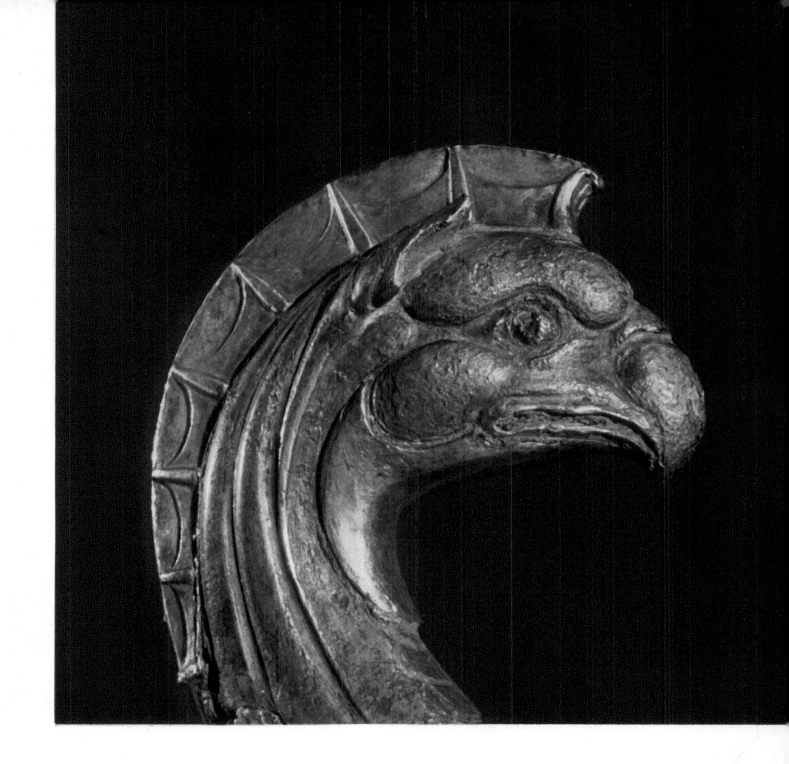

137 Sword pommel shaped as an eagle-griffin head. Iron, silver. Seven Brothers.

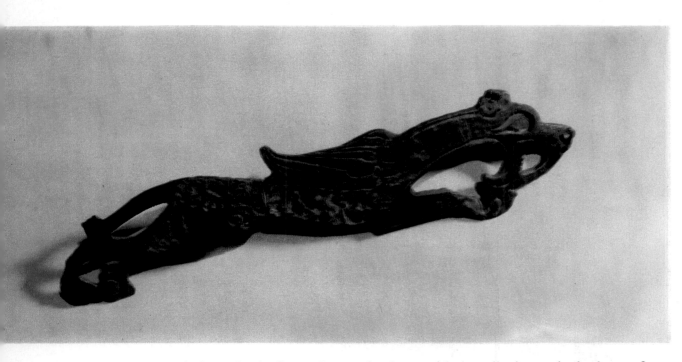

138 Ornamental plaque in the form of a running beast with a small wing on its back seen from the side. There is a loop on the other side. Bronze. Elizavetinskaya Barrow.

139 Plaque in the form of a running beast with its mouth open and its head, crowned with antlers, turned backwards. There is a loop on the back. Bronze. Elizavetinskaya Barrow.

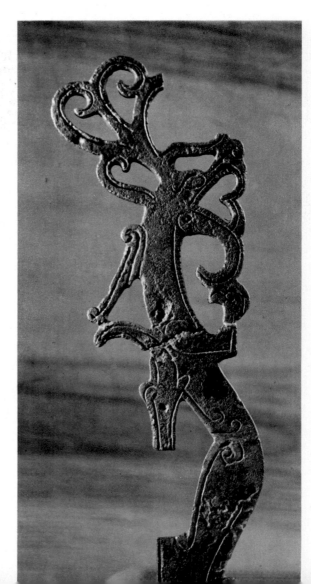

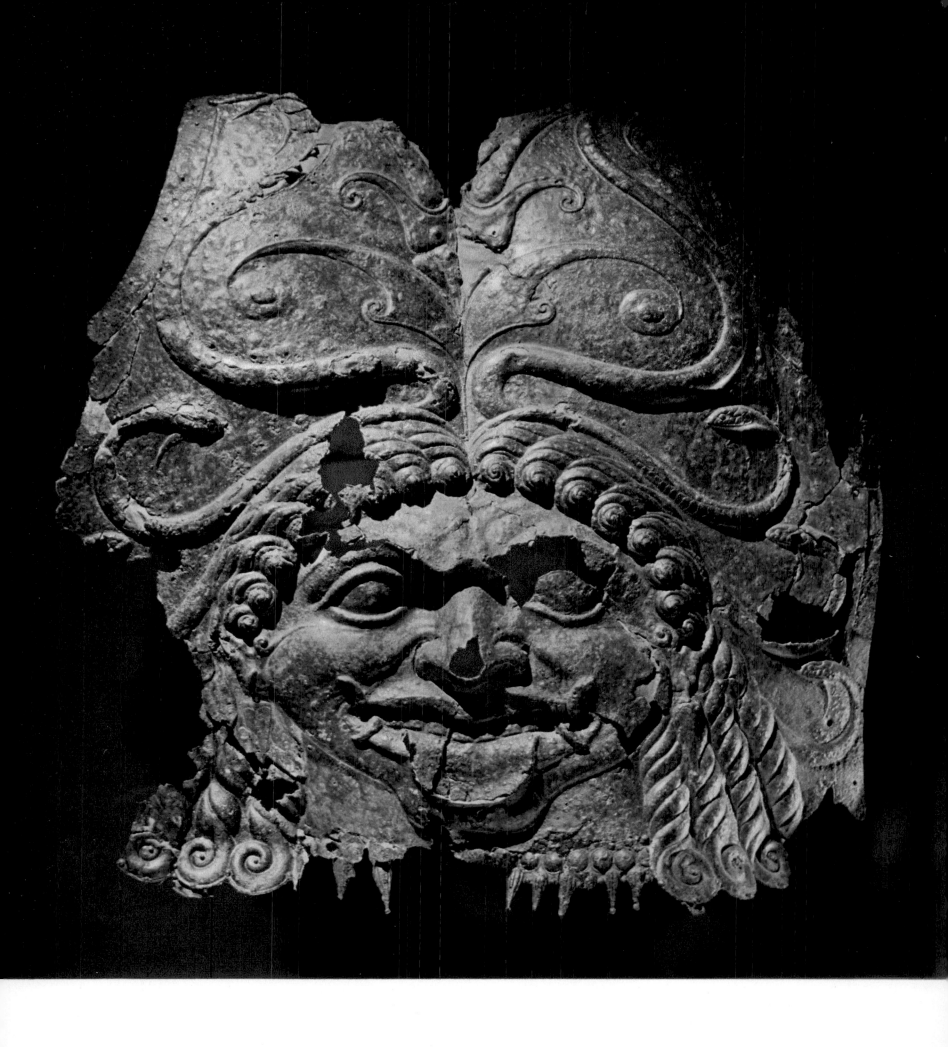

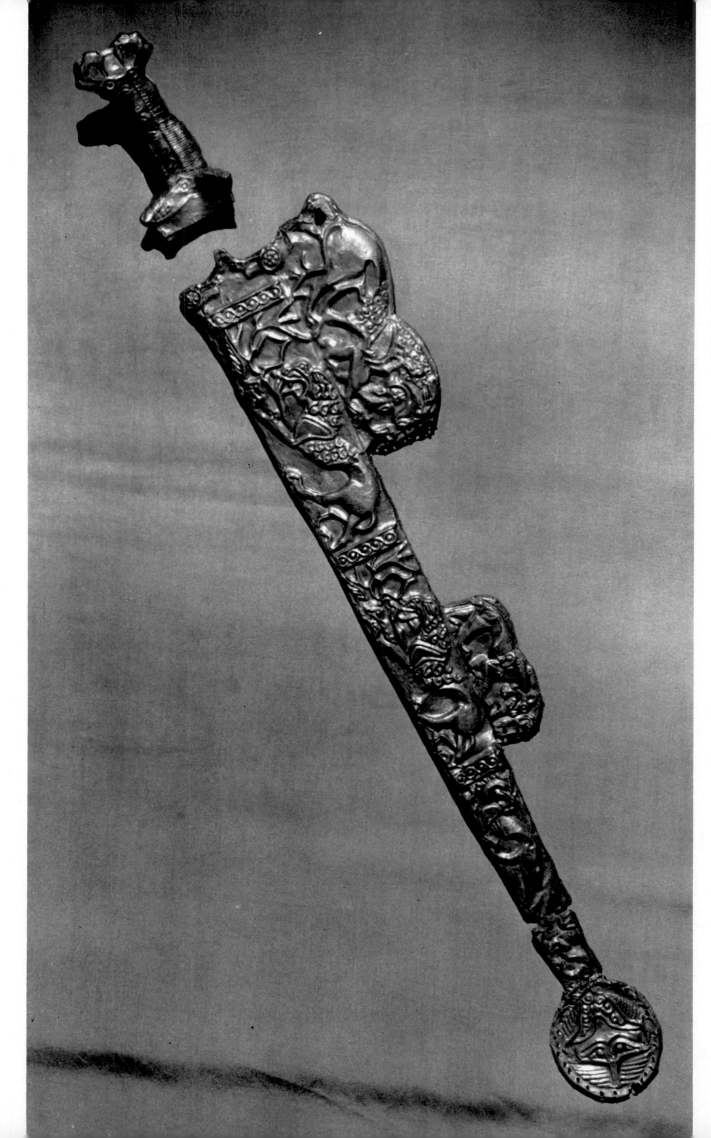

145
The hilt and
scabbard of a
sword with two
projections for
securing it
to a belt. The
hilt is of iron
encased in gold
leaf decorated
at the top with
bird heads. The
gold plating of
the scabbard
and the flaps are
covered with a
design of lions
worked in relief.
Solokha.

146
Bridle frontlet in
the shape of a
double fish
and two
cheek-pieces
shaped as ears.
Gold. Solokha.

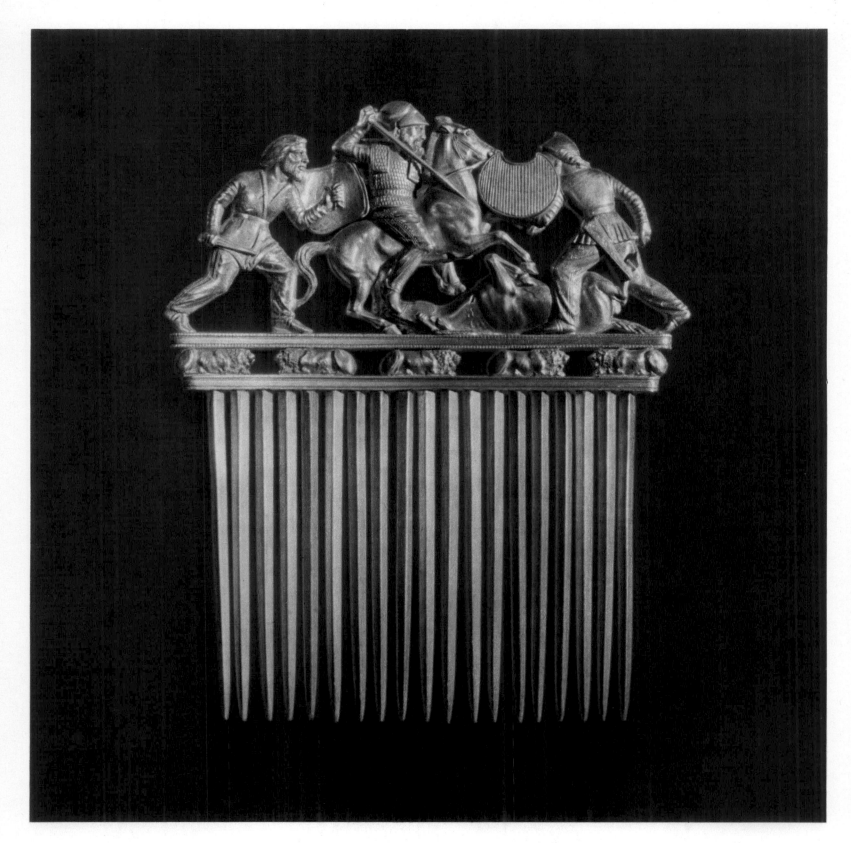

147 Comb ornamented with a group of Scyths in combat, one on horse-back and two on foot; a dead horse belonging to one of the latter lies beneath the mounted warrior. Gold. Solokha.

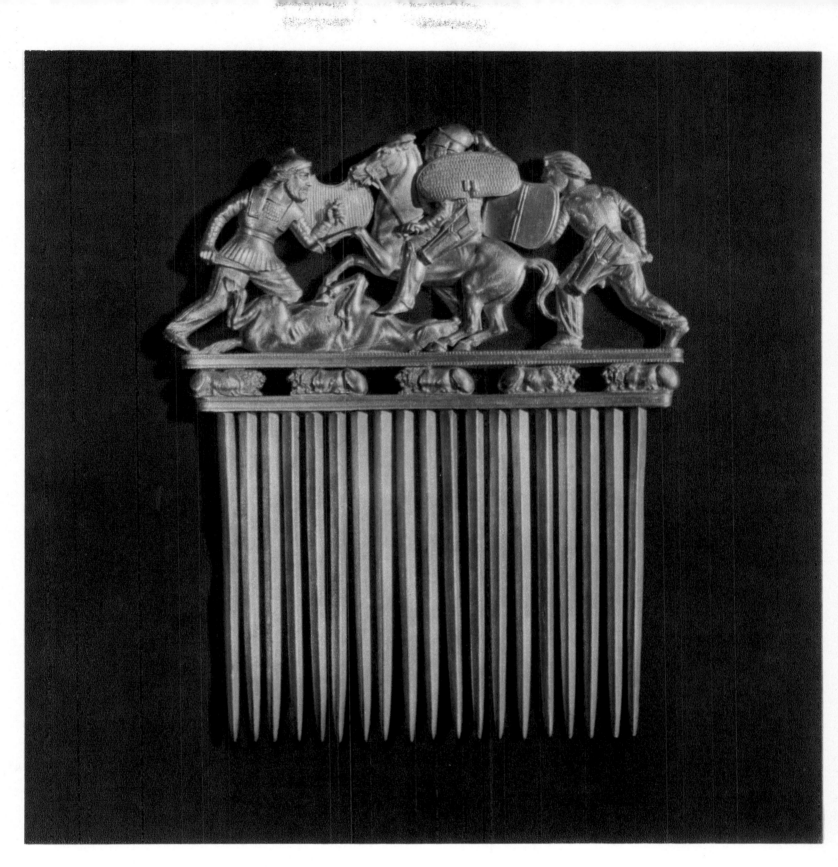

148 Reverse side of the comb shown in plate 147.

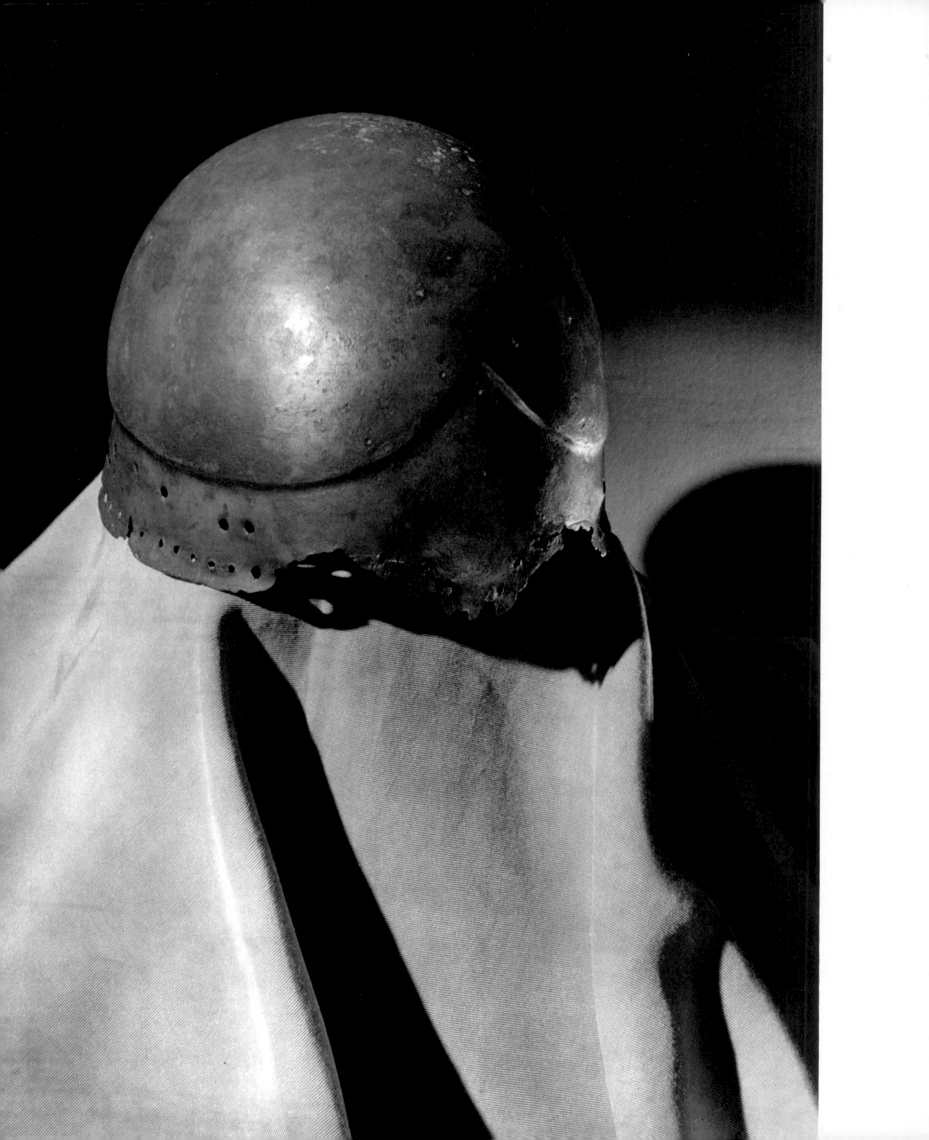

149 Hemispherical helmet with the upper portion raised to represent a sort of hair-style with a parting in the centre. In front are bow-shaped openings for the eyes. The edge of the helmet is pierced with little holes for fixing the lining and cheek-pieces. Bronze. Solokha.

150 Warriors in combat. Detail of comb shown in plate 148.

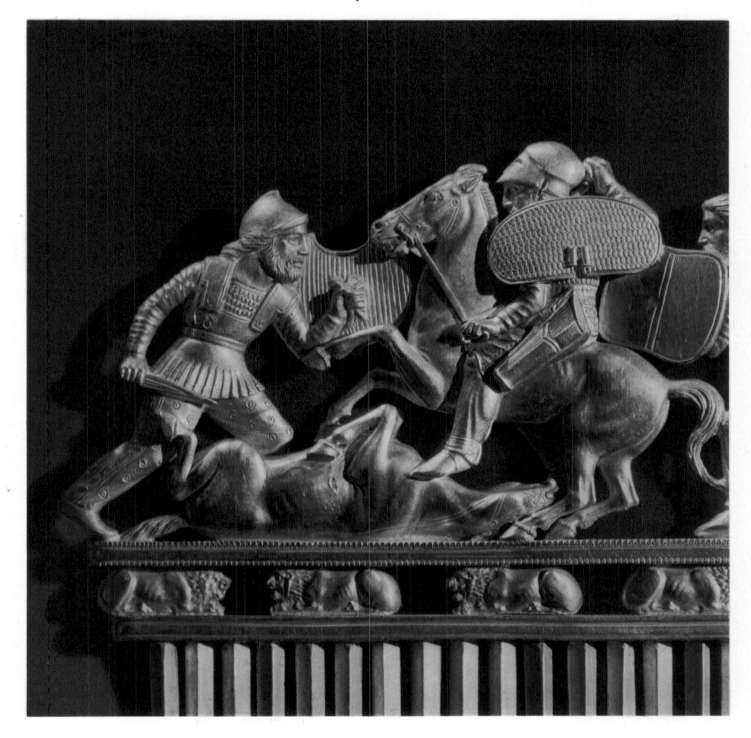

151 Spherical cup with a low cylindrical neck and everted rim decorated in relief
with sphinxes and, below, with a rosette of sharp angular leaves. Silver,
engraved and gilded. Solokha.

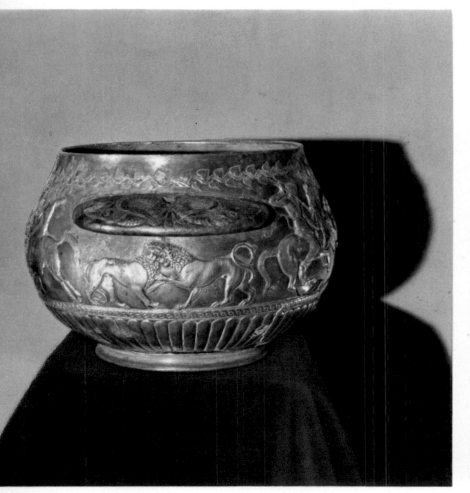 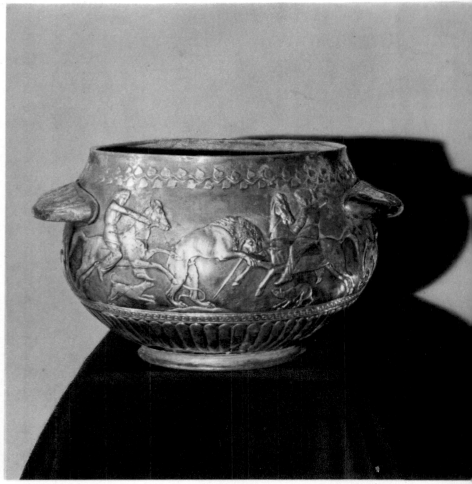

152 Hemispherical vessel with slight shoulder and two solid horizontal lugs or handles ornamented with two ram heads; on the sides are scenes, worked in relief, of mounted Scyths hunting. Along the upper rim runs a design of ivy leaves. Silver and silver-gilt, engraved. Solokha.

153 The hemispherical vessel shown in plate 152, seen from the other side.

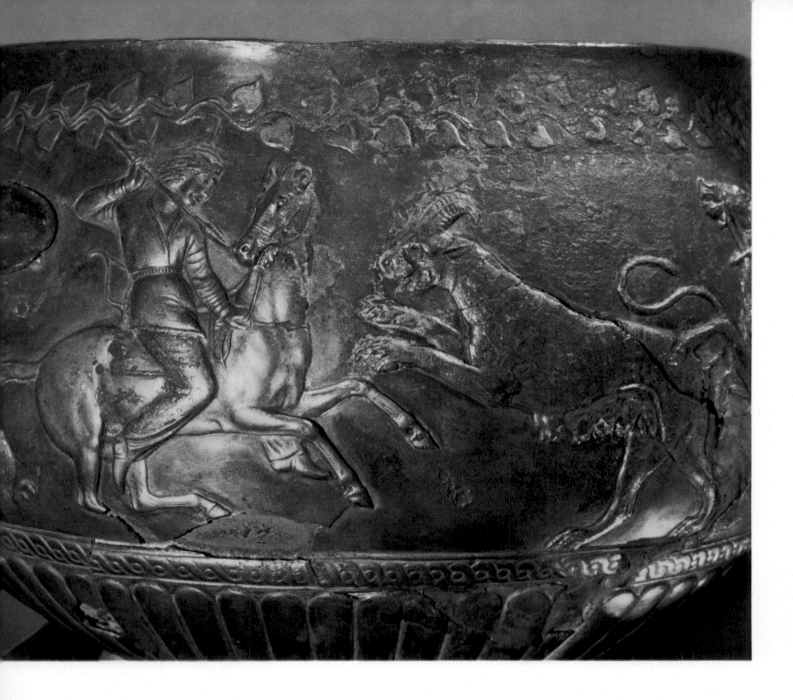

154 Hunting scene of Scyth fighting fantastic horned beast. Detail from vessel shown in plate 152.

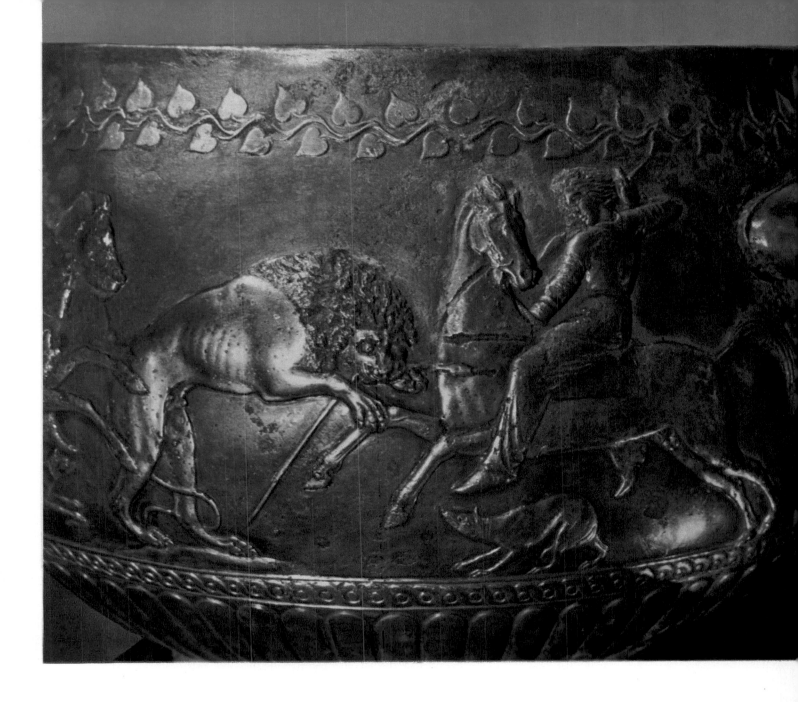

155 Mounted Scyth spearing a lion. Detail from vessel shown in plate 152.

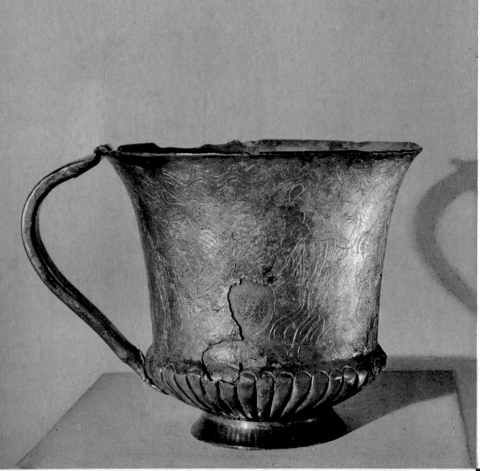

156 Cup on a ring stand, with bow-shaped handle and a keel separating the slightly splayed upper edge from the lower part. The bottom is decorated with a rosette of petals and the sides are engraved with designs of female figures, and there is a garland of ivy along the upper rim. Silver, engraved, silver-gilt. Solokha.

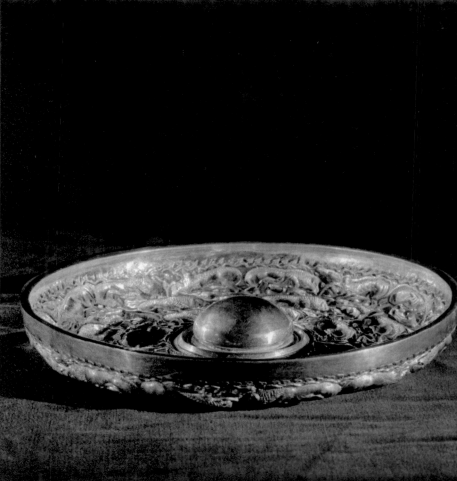

157 *Phiale* with low edges covered with embossed designs of scenes of animals fighting. Hemispherical boss in the centre. Gold. Solokha.

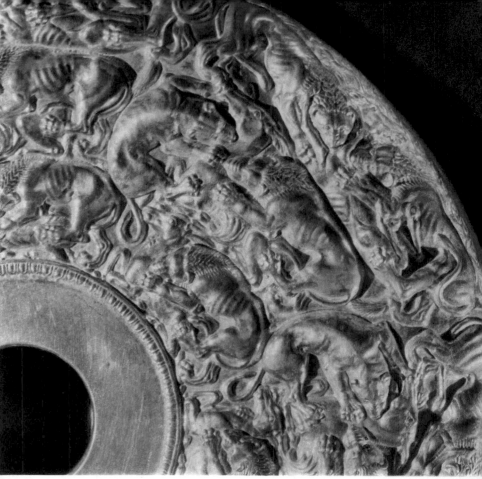

159 Animals seen in relief. Detail of the *phiale* shown in plate 157.

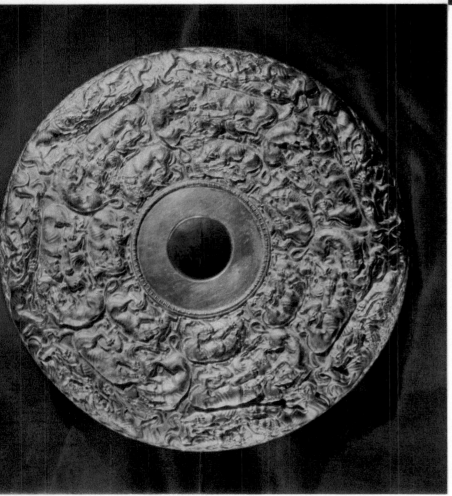

158 The *phiale* shown in plate 157 seen from below.

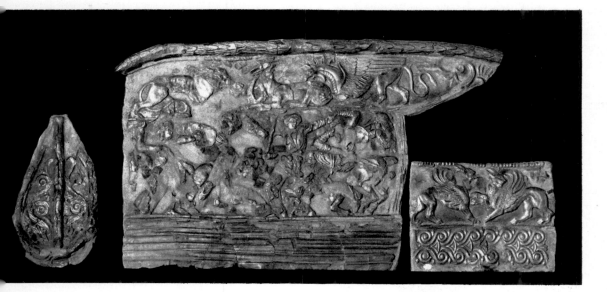

160 Bottom and upper plating of a *gorytus* with an embossed design. In the middle register, scenes of barbarians fighting on horse-back and on foot; along the upper register, a lion and a griffin attacking a stag and, on the quadrangular projection, two griffins and ornament. Gypsum, silver, silver-gilt. Solokha.

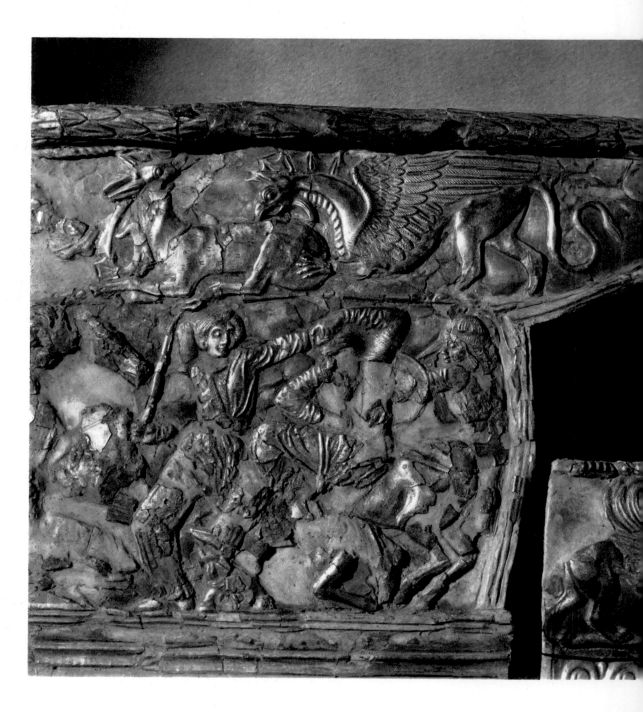

161 Barbarians fighting. Detail of plate 160.

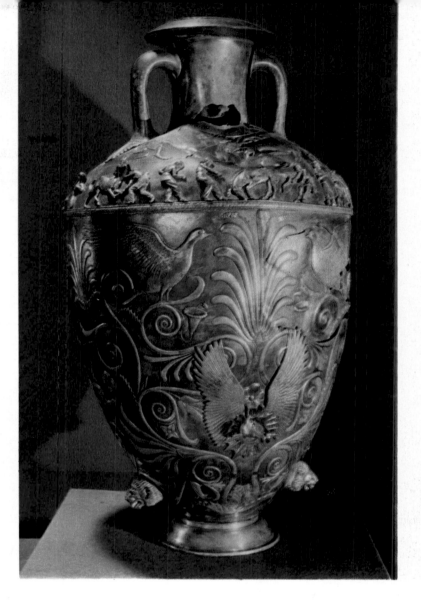

162 Egg-shaped amphora supported on a foot. The amphora has a cylindrical neck and a wide everted rim, with two sharply curved handles descending from the upper part of the neck to the shoulders. In the lower part of the body are three bung-holes; one of them is in the form of a horse head, the two others are lion heads. The whole of the body of the amphora is covered with designs; above the shoulder are scenes of griffins devouring a stag, with a frieze below depicting various incidents of Scythians breaking-in horses. On the sides are palmettes and curving shoots, with profile figures of birds with raised wings standing on them. Silver-gilt, sculptured, relief and engraving. Chertomlyk.

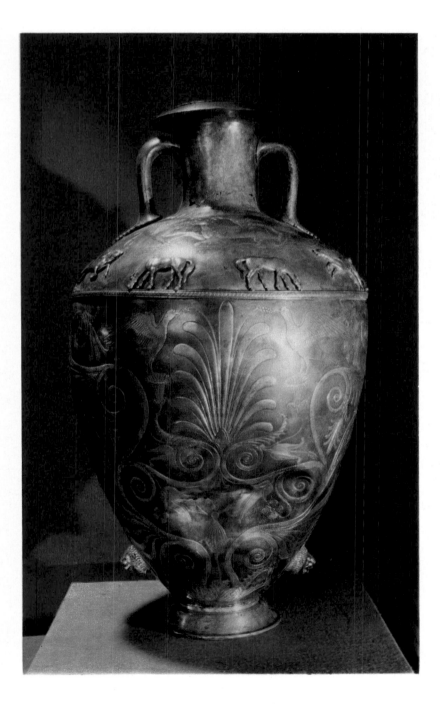

163 The amphora shown in plate 162 seen from the other side.

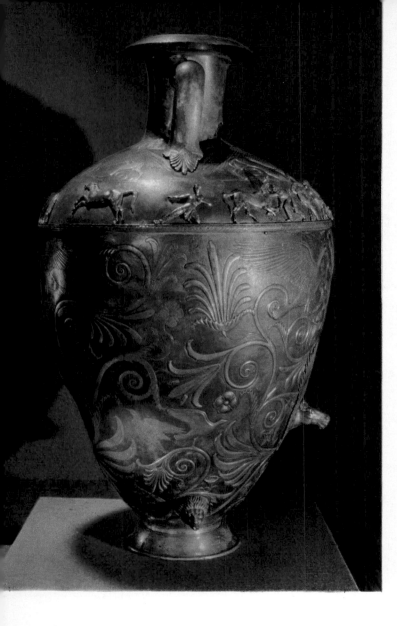

164 Side view of the amphora shown in plate 162.

165 Side view of the amphora shown in plate 162.

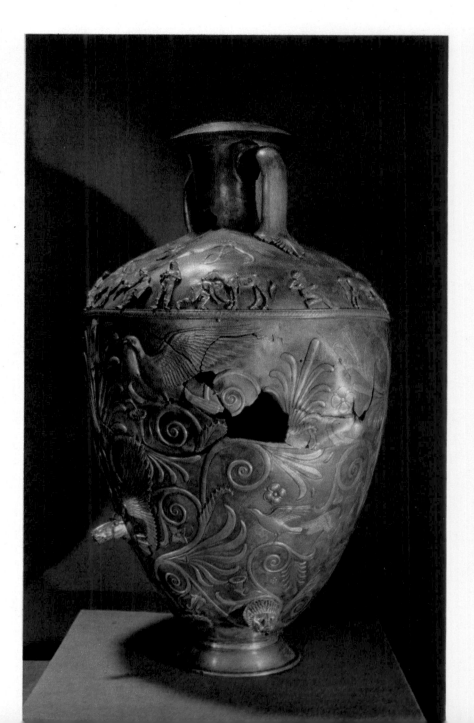

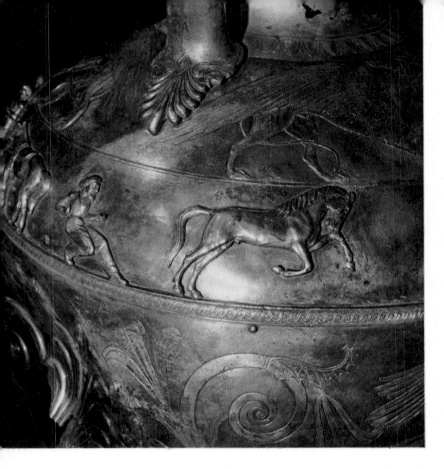

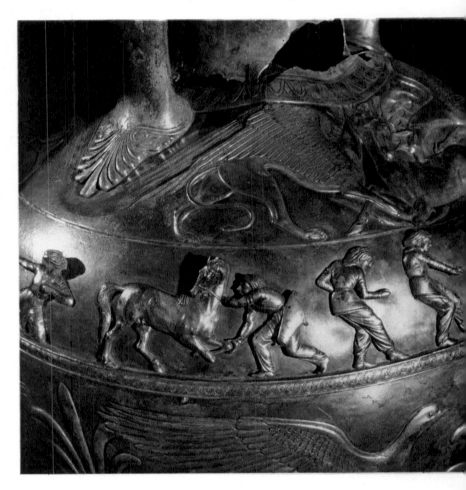

167 A Scythian bending the foreleg of a horse. Detail of the shoulder of the amphora shown in plate 162.

166 Scyths breaking-in horses. Detail of the shoulder of the amphora shown in plate 162.

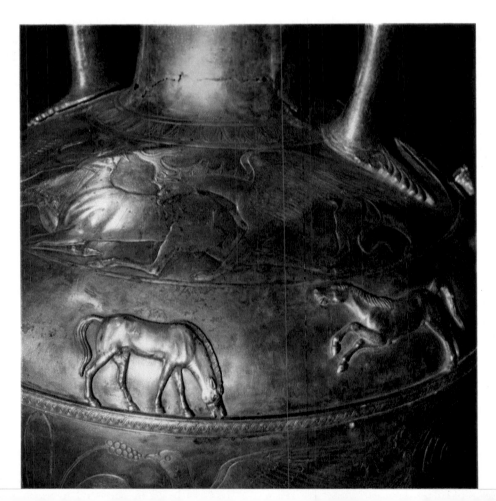

168 Two horses. Detail of the shoulder of the amphora shown in plate 162.

171 Bung-hole shaped like a horse head with wings, wrought in relief and with engraved designs on either side. Detail of amphora shown in plate 162.

172 Bung-hole shaped like a lion head. Side view. Detail of amphora shown in plate 162.

173 Bung-hole shaped like a lion head. Front view. Detail of amphora shown in plate 162.

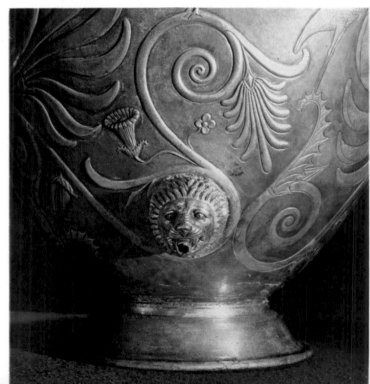

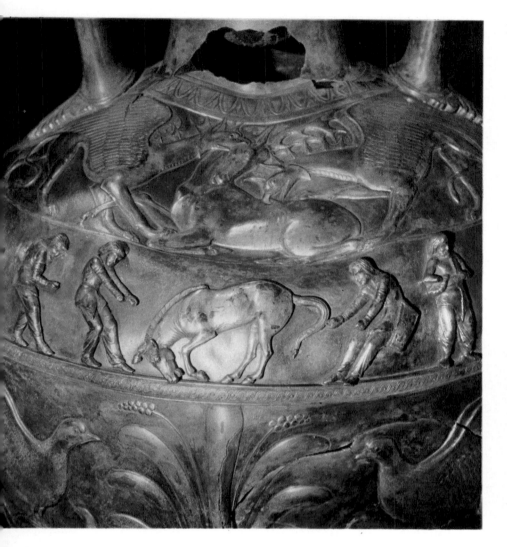

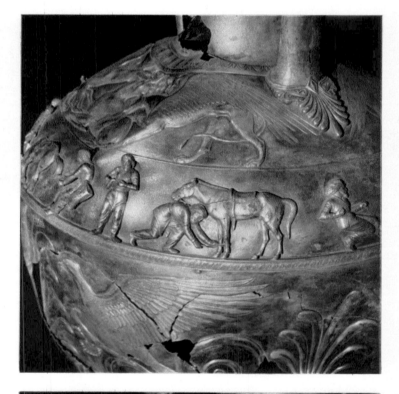

174 Scyths throwing a lassoed horse to the ground. Detail from the frieze on the amphora shown in plate 162.

175 A Scyth hobbles a saddled horse. Detail from the frieze on the amphora shown in plate 162.

176 A galloping horse and a grazing horse. Detail from the frieze on the amphora shown in plate 162.

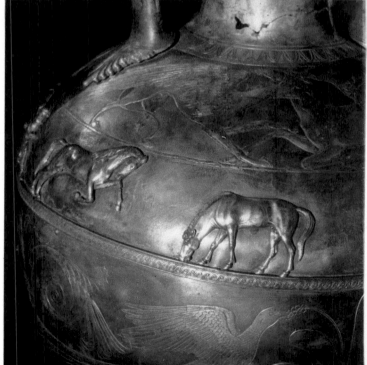

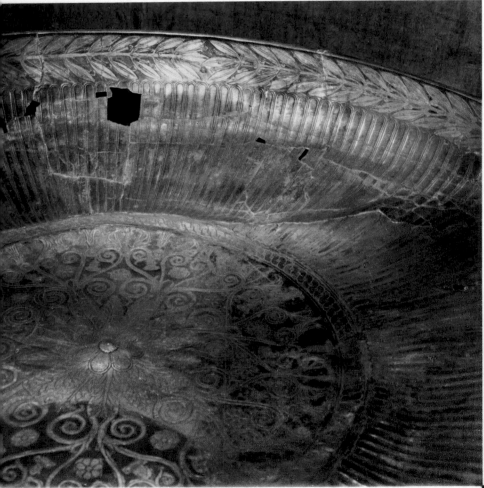

177 Silver dish. Detail of plate 179. Decoration on bottom and sides. Chertomlyk.

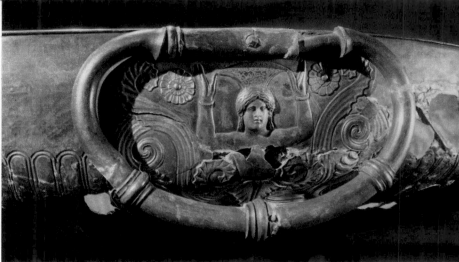

178 Side handle, with a caryatid worked in relief and surrounded by trailing plant motifs. Detail from the silver dish shown in plate 179.

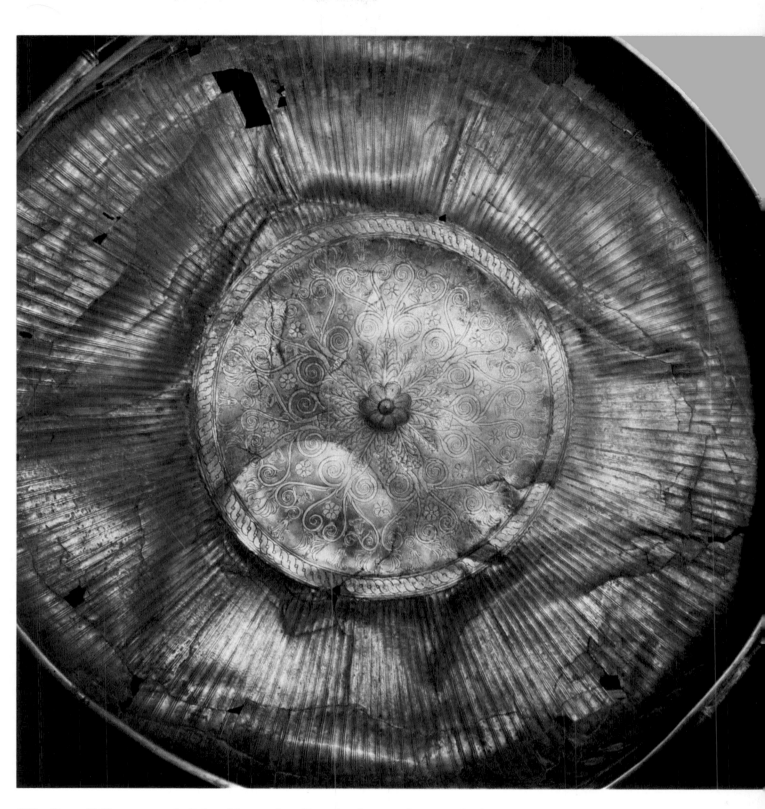

179 Beautifully engraved dish with two handles, the figure of a caryatid in relief under each, and orna-
mented with plant motifs on sides and bottom. Silver, engraved, silver-gilt. Chertomlyk.

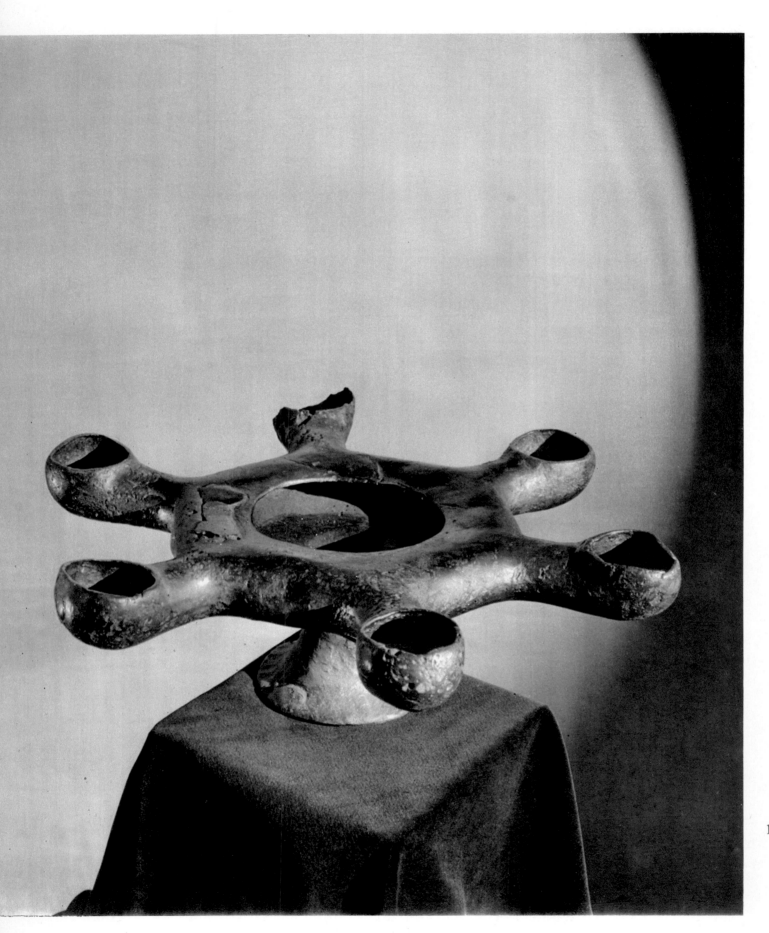

180 Lamp, with holders for six wicks, supported on a conical stand. Bronze. Chertomlyk.

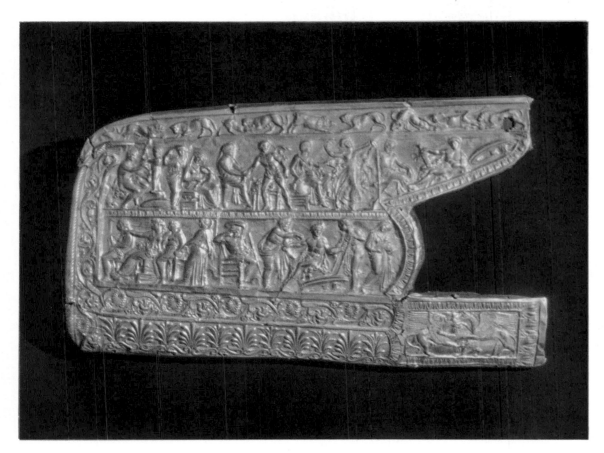

181 The mounting of a *gorytus* ornamented with figures of beasts along the edges, and mythological scenes in the centre portion, which is divided into two friezes, all worked in relief. Gold. Chertomlyk.

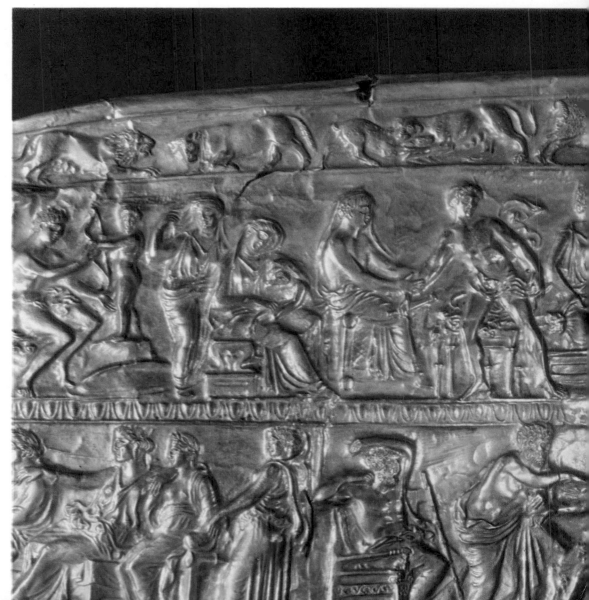

182 Mythological scenes. Detail of the *gorytus* shown in plate 181.

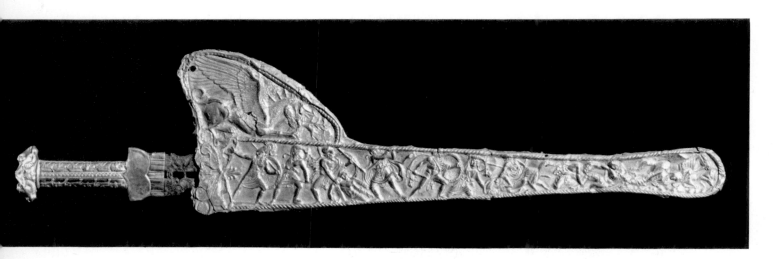

183 Sword with hilt and scabbard plated in gold and decorated with figures of fighting beasts and Greek warriors in combat. Iron, gold. Chertomlyk.

184 Hilt of sword shown in plate 183. It is decorated with figures of horsemen hunting goats. The pommel is formed by the heads of two rams facing outwards. Gold.

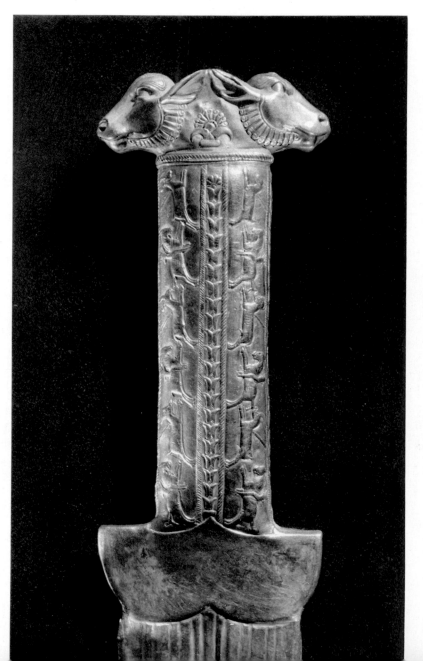

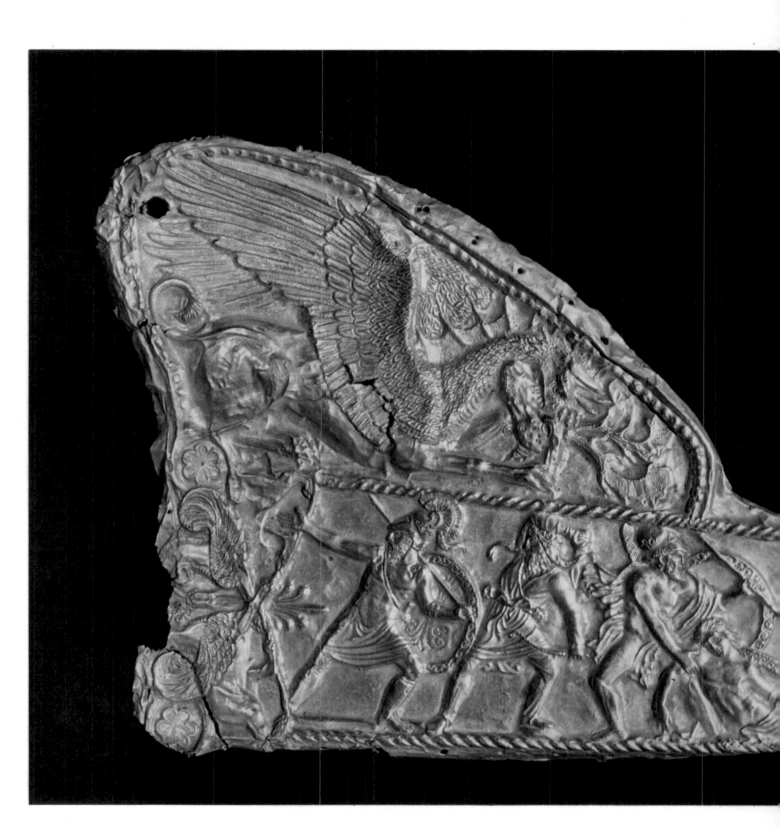

185 Greek warriors fighting, and a griffin attacking a stag. Detail of the scabbard shown in plate 183.

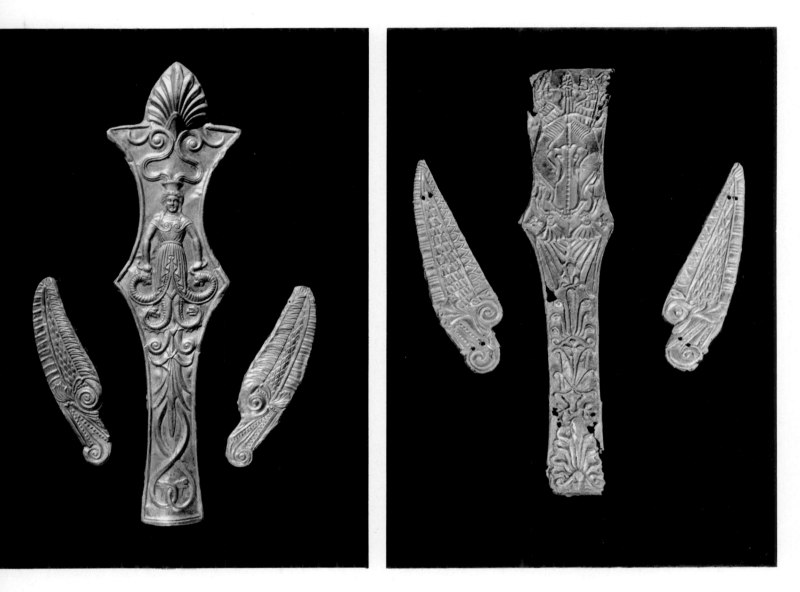

186 Bridle decorations. An elongated plate from a frontlet (with edge bent over) showing the figure of a woman (front view) wearing a *calathos*; the lower part of the body turning into volutes terminating in beasts' heads. The woman with her arms held beside her holds the upper pair of heads by the horns. Two other plates, the casing of cheek-pieces, have the conventionalized ear shape and are treated as dolphins with scaly body and toothy jaws. Gold. Great Tsimbalka.

187 Bridle decorations. An elongated frontlet plate with edge bent over and relief figures of two confronted lions rampant in the upper portion, and plant ornament (palmettes) in the lower one; also two cheek-pieces in the form of ears, decorated like dolphins, with scaly bodies and toothy jaws. Gold. Great Tsimbalka.

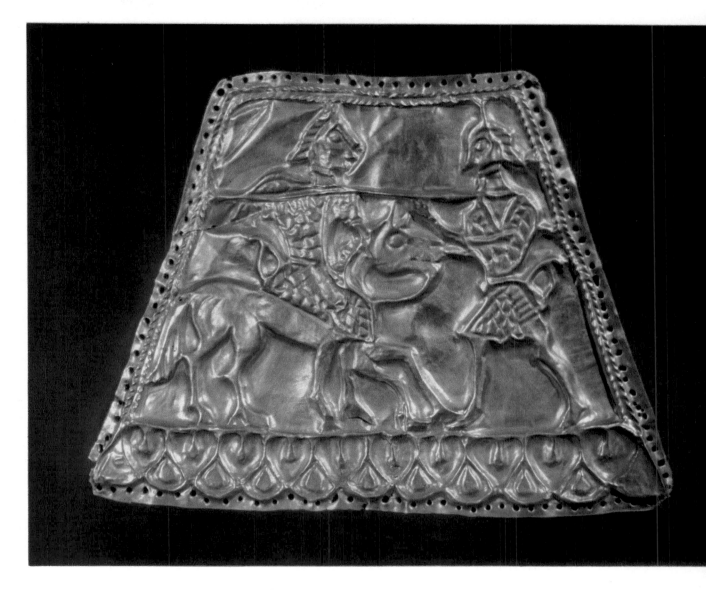

188 Trapezoidal plate. The embossed design shows a struggle between a horseman and a foot warrior surrounded by an ornamental frame. Gold. Geremes.

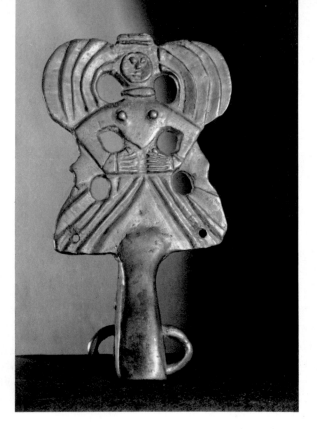

190 Flattened openwork pole-top decorated with the figure of a walking griffin in a rectangular frame with two little bells hung from it. The socket is pyramidal with two loops. Bronze. Alexandropol Barrow.

189 Flattened openwork pole-top shaped as a winged female figure with hands on her hips. The lower part forms a tetrahedral pyramid. The back is plain. Bronze. Alexandropol Barrow.

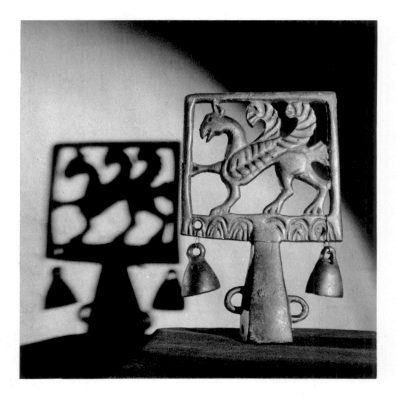

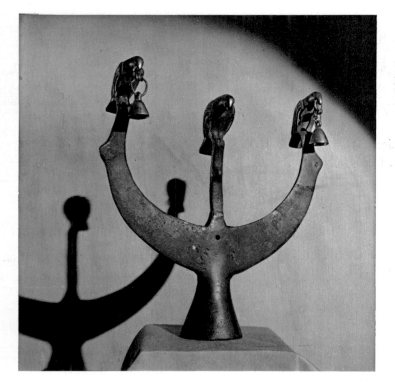

191 Pole-top shaped as a trident with figures of seated birds on each prong holding bells in their beaks. Conical socket. Bronze. Alexandropol Barrow.

192 Plaque shaped as the profile figure of a carnivore. Gold. Alexandropol Barrow.

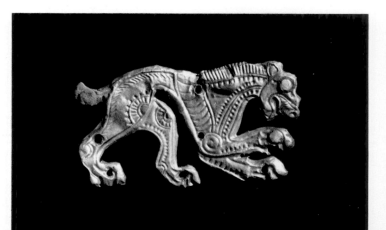

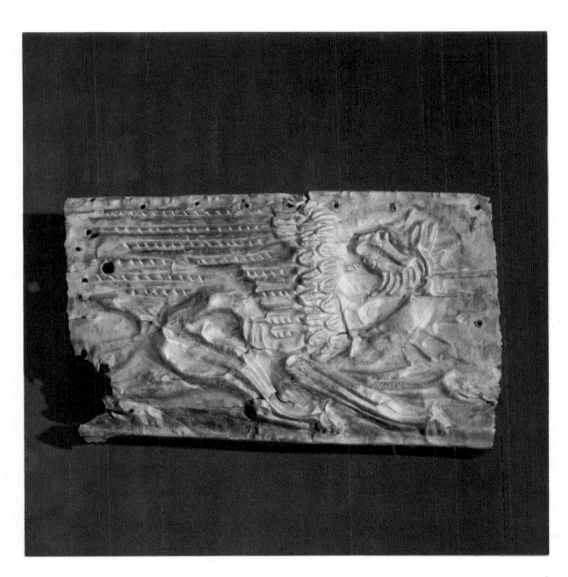

193 A winged griffin. Detail of the *gorytus* plating shown in plate 194.

194 Mounting of a *gorytus* bearing a design in relief. In the centre is a bird with folded wings holding a hare in its beak. A number of animals decorate the side with the triangular projection, and there is an ornamental band along the opposite side. A rectangular plate, which covered another projection in the upper part of the *gorytus*, is decorated with the figure of a griffin. The circular plate served as a casing for the bottom and is decorated with a lion mask. The edges of the plating are turned up. Gold. Dort Oba.

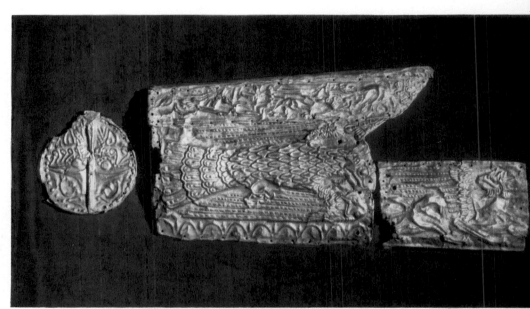

197 Sword, its hilt decorated
with schematized figures of
animals worked in relief.
Iron, gold. Frequent Barrows.

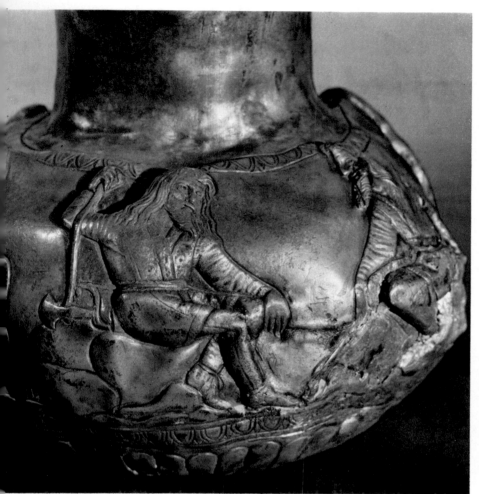

195 Relief design
showing a seated
Scyth resting one
hand on an axe.
Detail from the silver
vessel shown in
plate 198. Frequent
Barrows.

196 Relief design
showing two seated
Scyths facing one
another; one holds
a bow in his
outstretched hand.
Detail from the
silver vessel shown
in plate 198.

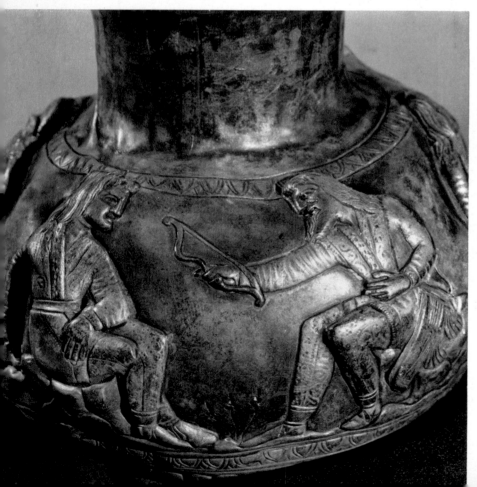

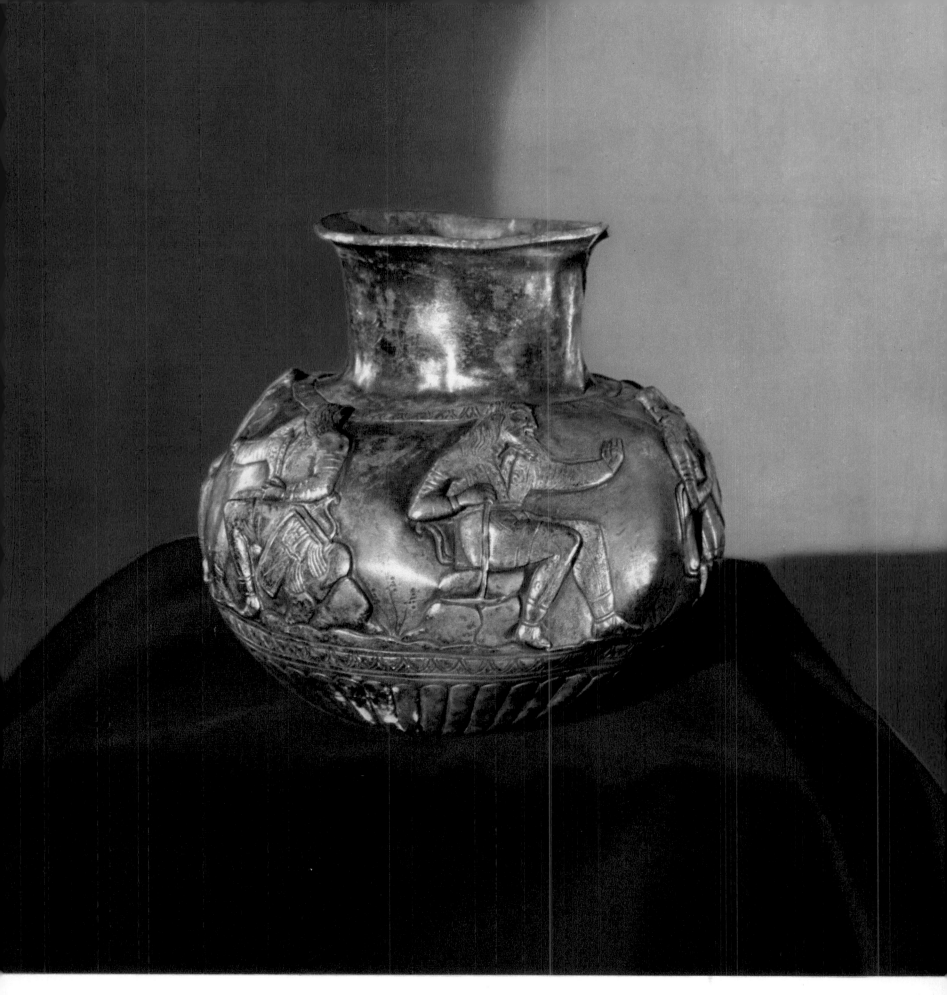

198　Spherical cup with a cylindrical neck and slightly everted rim, decorated around the sides with figures of Scyths in relief and, below, a multi-petalled rosette. Silver. Frequent Barrows.

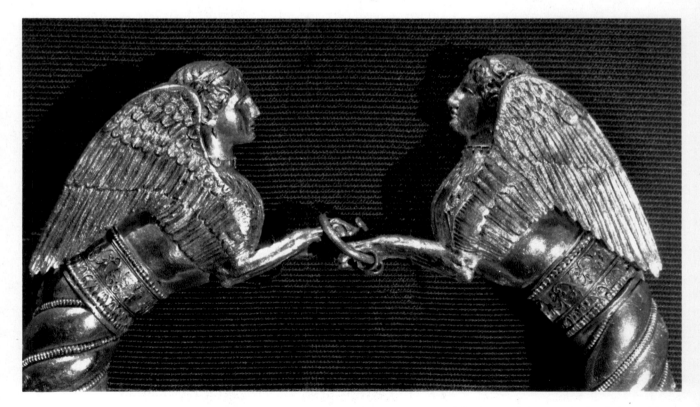

199 Parts of a headdress. One wide band with ornament in relief, another narrow one with pendants on hooks, and a third with tiny ornaments attached to a rim. Gold, electrum. Kul Oba.

201 Torque of thick plaited wire with sculptural figures of Scythian horsemen as finials. Gold, enamel. Kul Oba. ▶

202 Mounted Scyths. Detail of torque ▶ shown in plate 201.

200 Two sphinxes. Detail of the bracelet shown in plate 205.

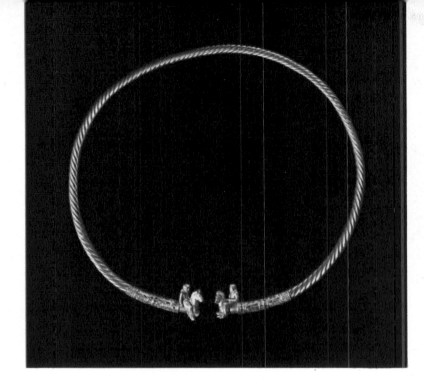

204 Plaque in the shape of a Scyth with a goblet in his right hand and a quiver at his left hip. Gold. Kul Oba.

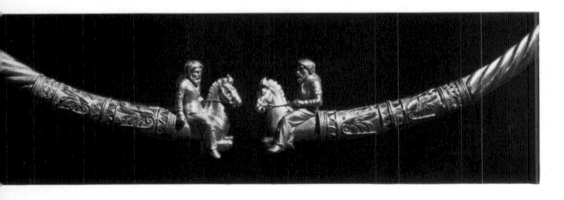

205 Bracelet of twisted gold terminating in figures of sphinxes. Gold, bronze, enamel. Kul Oba.

203 Plaque in the shape of two Scyths drinking brotherhood from a *rhyton*. Gold. Kul Oba.

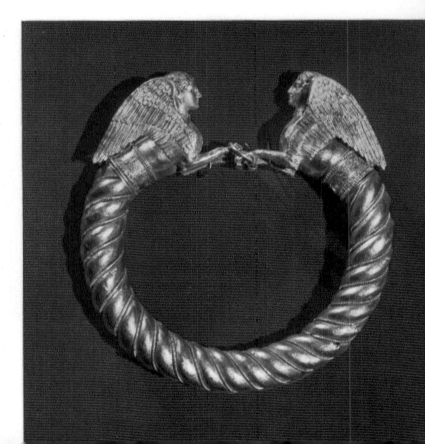

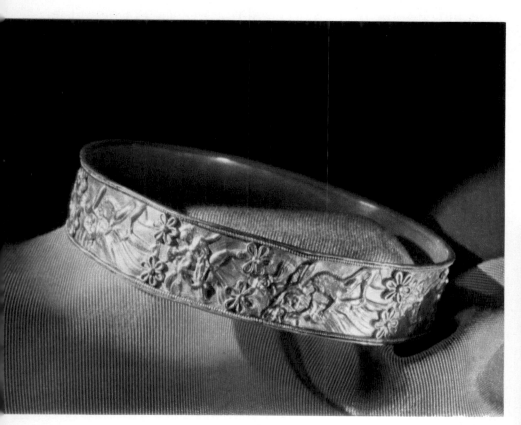

206 Laminated bracelet with rosettes and mythological scenes in relief. Gold. Kul Oba.

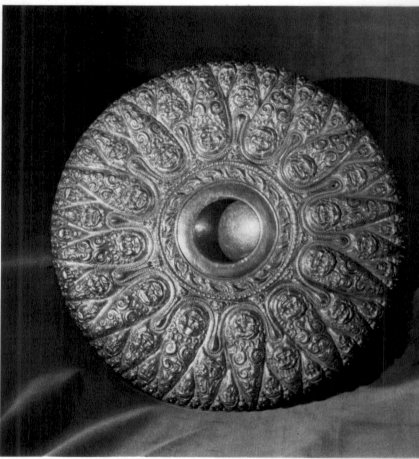

207 *Phiale*, chased in relief and treated as a multi-petalled rosette, each petal being filled with figures of Gorgon heads, Sileni, boars or panthers and ornamental volutes. Around the *omphalos* a band with a design of dolphins and fish. Gold. Kul Oba.

208 Sword, with gold-plated hilt and scabbard, bearing scenes of struggling beasts and, on the projection, a hippocampus. Iron, gold. Kul Oba.

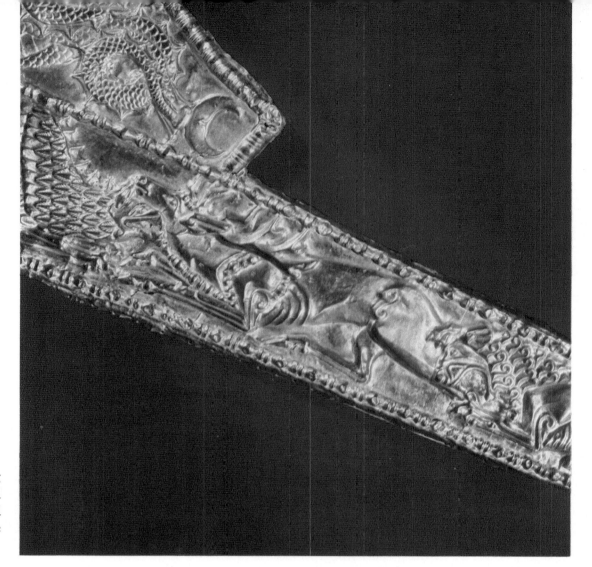

209 Griffins attacking a stag. Detail of the scabbard shown in plate 208.

210 Gorgon heads. Detail from the *phiale* shown in plate 207. Kul Oba.

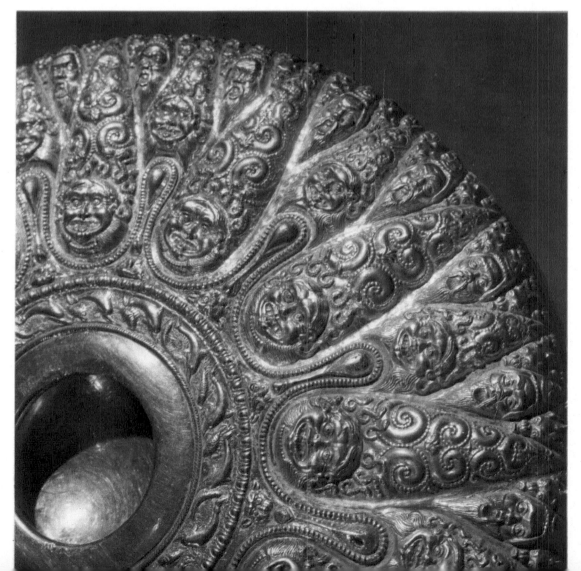

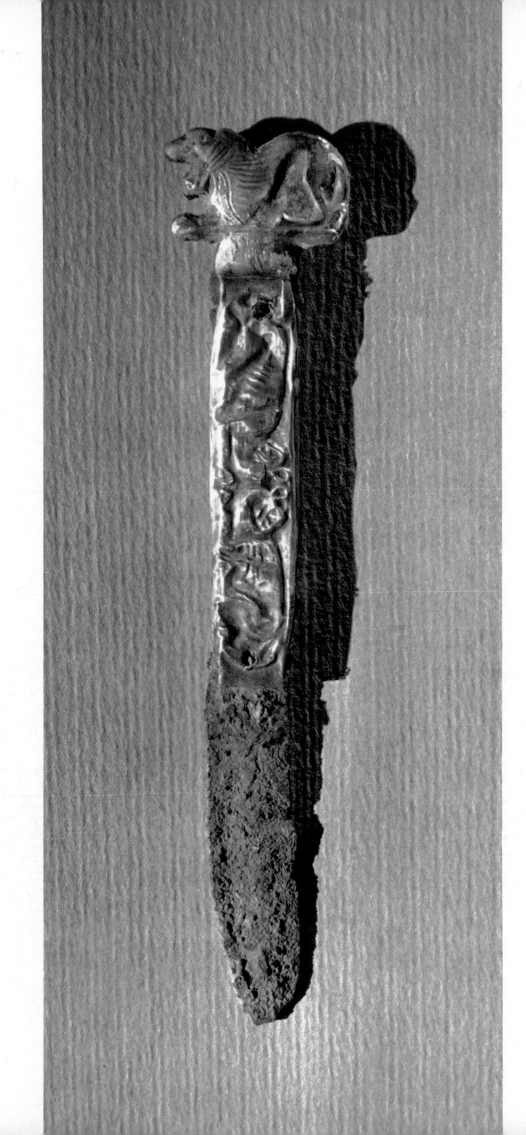

211 Knife handle encased in gold, adorned with a design of lion figures worked in relief. Iron, gold. Kul Oba.

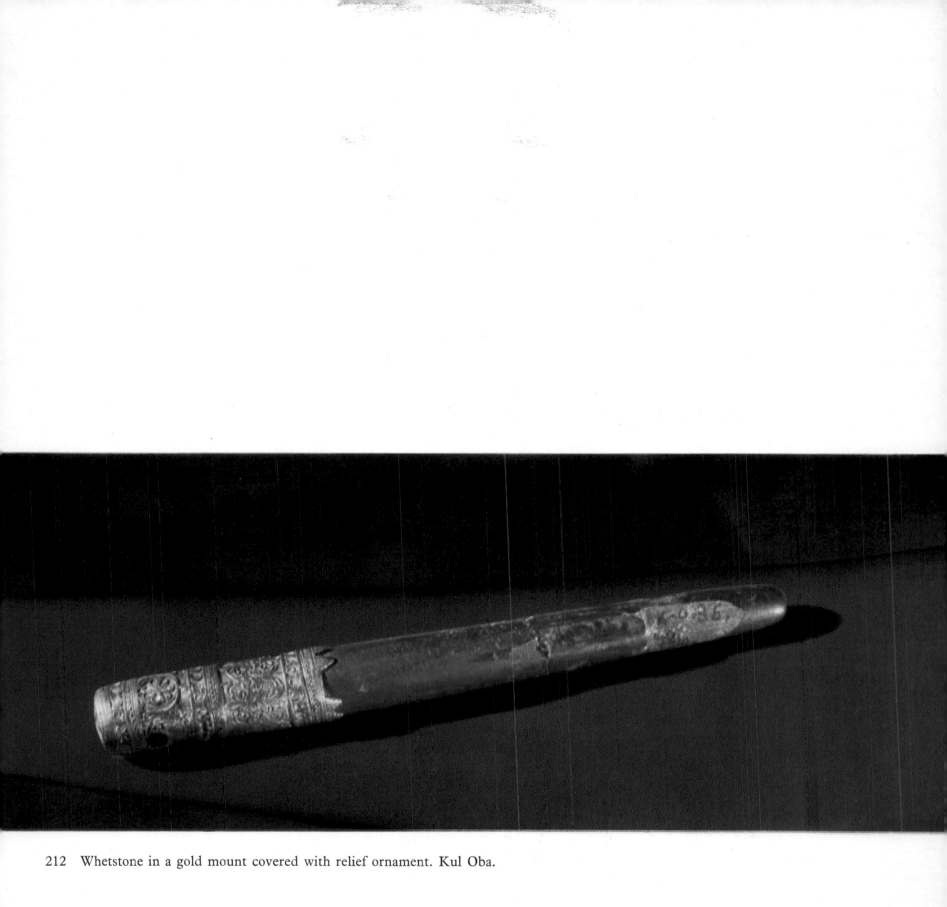

212 Whetstone in a gold mount covered with relief ornament. Kul Oba.

213 Round mirror with a gold-plated handle adorned with a relief design of stylized animals. Bronze, gold. Kul Oba.

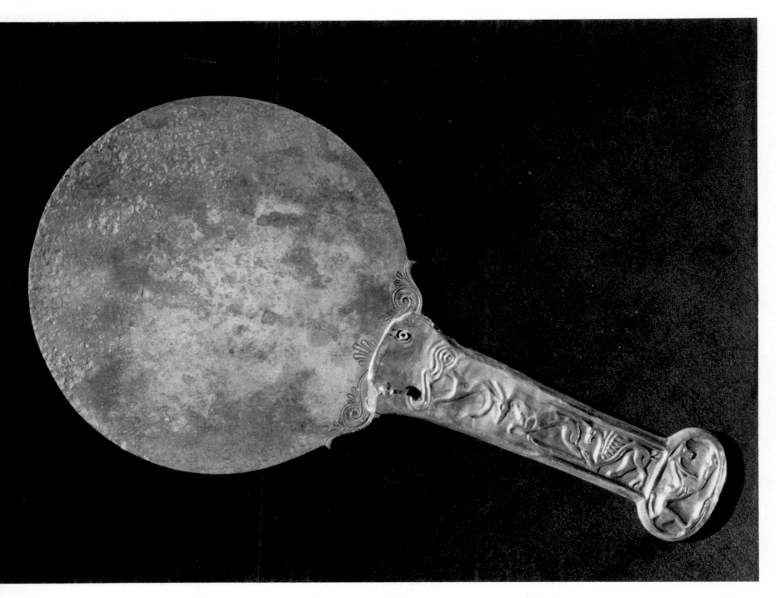

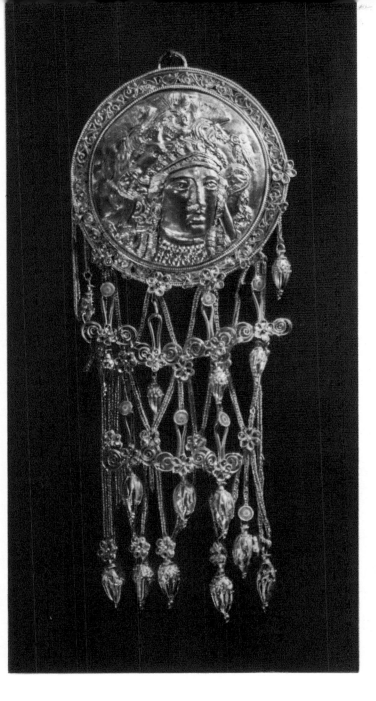

214, 215 Pair of round forehead pendants with a relief
design of Athena wearing a helmet richly
ornamented with griffins, from which hang
elaborate crossed chains. Gold, enamel. Kul
Oba.

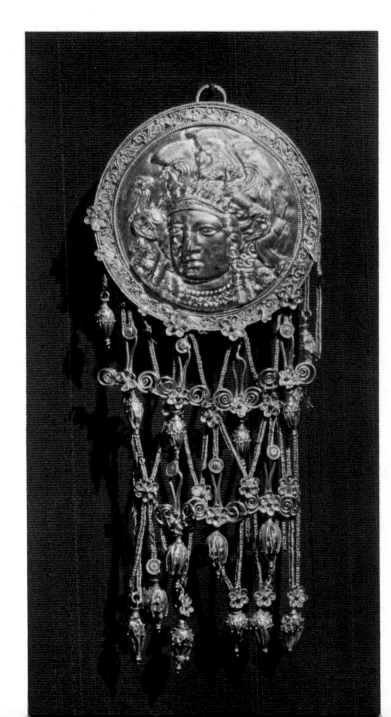

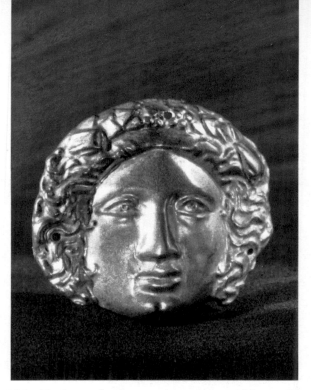

216 Embossed plaque shaped as a Maenad's head, seen full face, with abundant hair and a garland. Gold. Kul Oba.

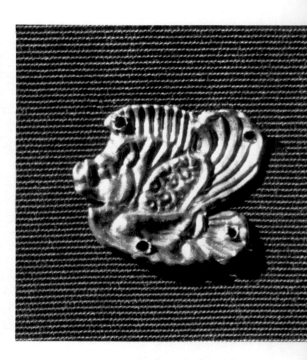

217 Plaque, embossed and shaped as the fore part of a boar, seen in profile, with a palmette behind it. Gold. Kul Oba.

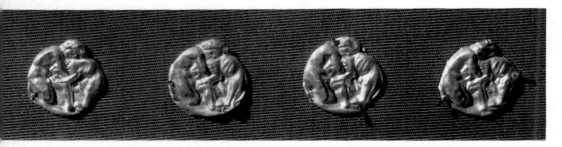

218 Plaques bearing an embossed design showing Hercules struggling with the lion. Gold. Kul Oba.

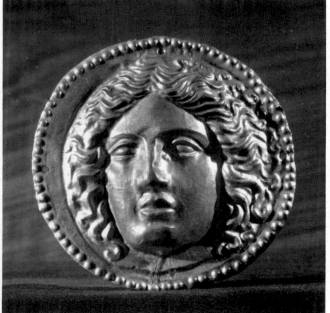

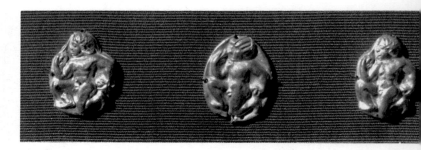

220 Embossed plaques in the shape of a nude youth running with fruit in his hand. Gold. Kul Oba.

219 Round plaque bearing the head of a young person with an elaborate hair-style, all worked in relief. Gold. Kul Oba.

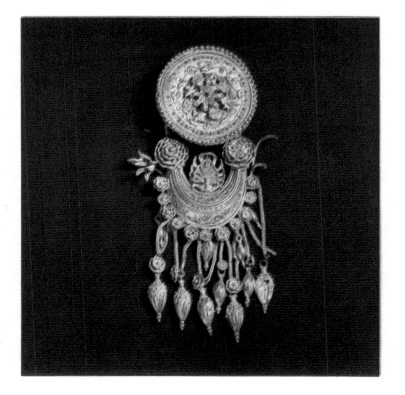

221 Forehead pendant in the form of a round disc supporting an elaborate crescent terminating in rosettes and hung with almond-shaped decoration suspended on plaited chains. Gold, enamel. Kul Oba.

222 Disc with a double rosette in the centre, surrounded by smaller six-petalled rosettes and tiny figures of Nereids and dolphins. Detail of the pendant shown in plate 221.

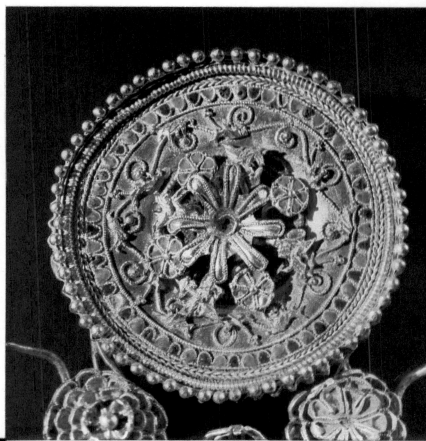

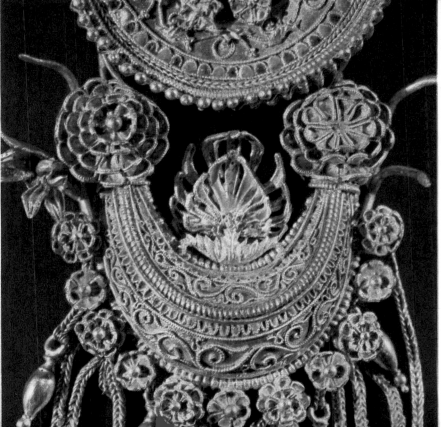

223 Boat-shaped ornament with elaborate filigree design and four-layer rosettes at the ends, a double-layer palmette in the middle and a row of rosettes below. Detail of the pendant shown in plate 221.

224 Embossed plaque in the shape of two figures of Scyths standing back to back and shooting arrows from their bows. Gold. Kul Oba.

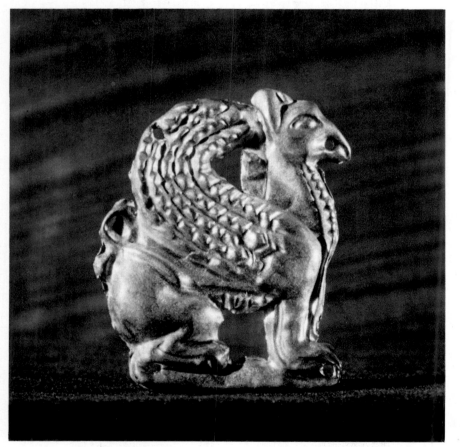

225 Embossed plaque in the shape of a seated eagle-griffin. Gold. Kul Oba.

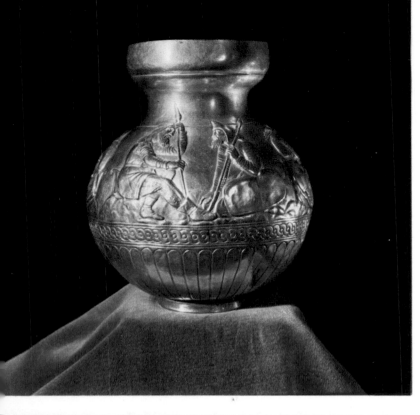

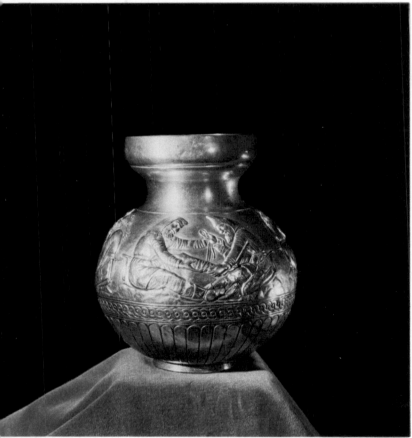

226 Spherical cup on a ring-shaped base with a low neck and wide rim. The sides are adorned with scenes from Scythian life. There is a pattern round the bottom. Gold. Kul Oba.

227 The spherical cup shown in plate 226, seen from the other side.

228 Relief design showing two seated Scyths facing one another. Detail of spherical cup shown in plate 226.

229 One Scyth dressing the wounded leg of another. Detail of spherical cup shown in plate 226.

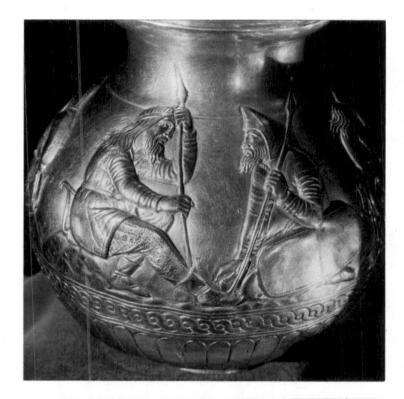

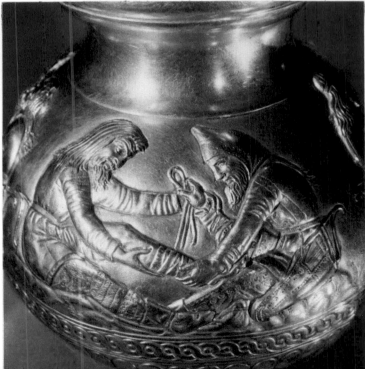

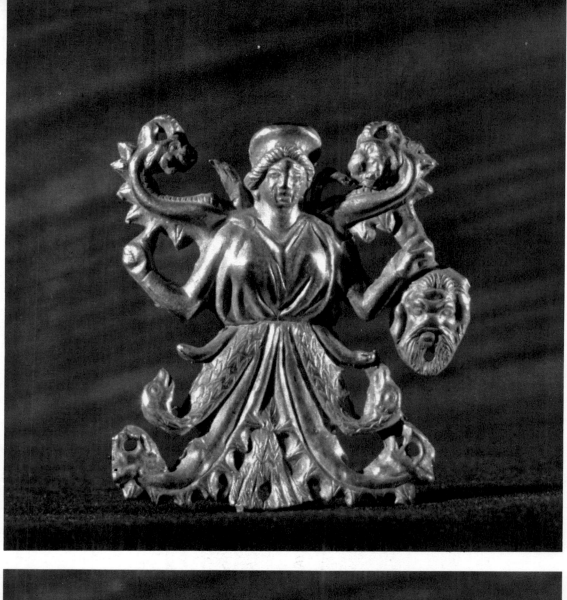

230 Embossed plaque in the form of a winged goddess wearing a *calathos*; the lower part of the body takes the form of twisted serpents and griffins. The deity holds a severed bearded head and a sword. Gold. Kul Oba.

231 Embossed plaque in the form of a bird pecking at a fish which it has in its claws. Gold. Kul Oba.

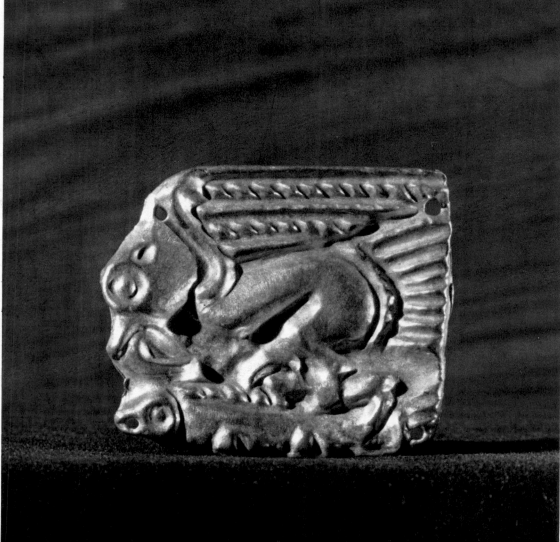

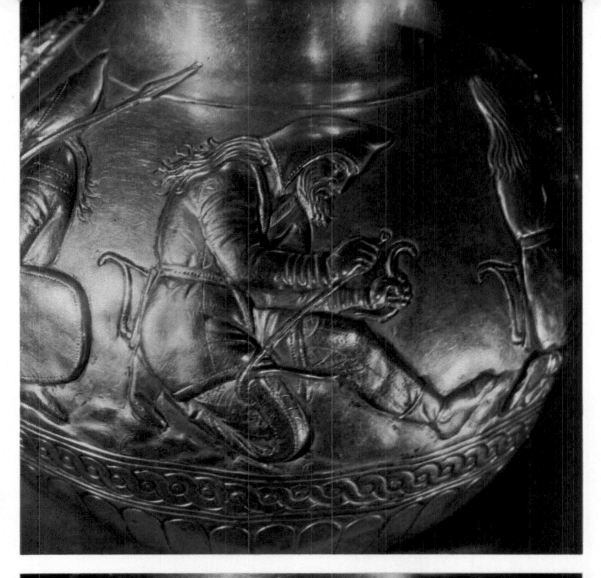

232 Scyth fixing a
bow-string. Detail
of spherical cup
shown in plate 226.

233 A tooth receives
attention. Detail
of spherical cup shown
in plate 226.

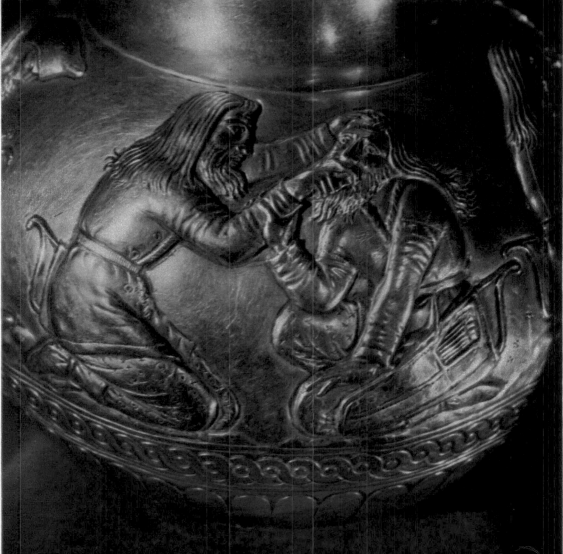

234 Square plaque with an embossed design, showing two dancing women set within a frame. Gold. Kul Oba.

235 Square plaque with an embossed design, showing a seated woman or goddess holding a mirror in her hand. A young Scyth, drinking from a *rhyton*, stands before her. The design is set within a frame. Gold. Kul Oba.

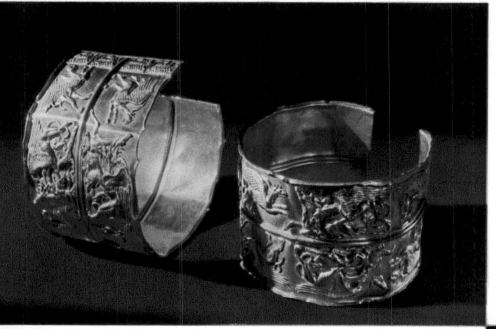

236 Pair of bracelets made from wide bands of gold divided into two by a longitudinal rib, each surface bearing similar designs of griffins attacking a stag. Gold. Kul Oba.

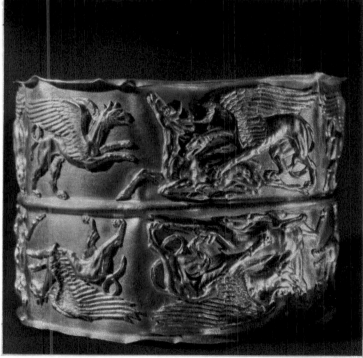

237 Griffins attacking a stag. Detail from the bracelet shown in plate 236.

238 End of bracelet shown in plate 236, having decorated border of lion protomes.

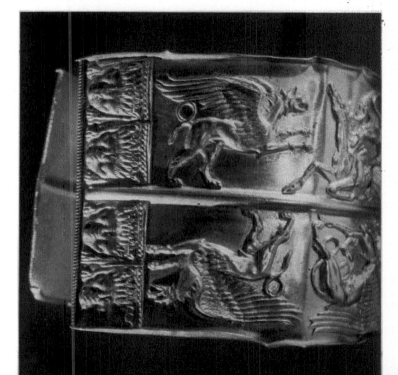

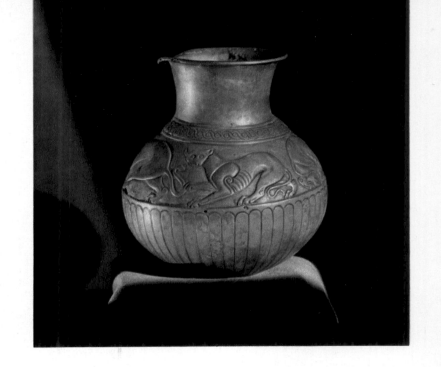

239 Spherical vase with a cylindrical neck and a slightly everted rim, its sides decorated with a frieze of figures of ducks and fish; above and below, vertical petals cover all the remaining surface. Silver. Kul Oba.

240 The other side of the spherical vase shown in plate 239.

241 Spherical vase with a cylindrical neck and everted rim; the upper half is ornamented with a broad frieze showing scenes of a stag being attacked by a lion and a lioness. Above the frieze is a narrow strip of guilloche, while below there are the upright petals of a rosette. Silver. Kul Oba.

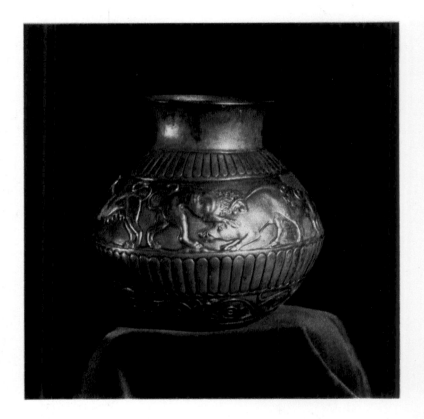

242 Spherical vase with a low cylindrical neck and everted rim. Around the upper part of the vessel is a frieze showing struggling beasts: two griffins attack a goat, a lion and a lioness devour a stag, a lion bites a boar. The frieze lies between two bands of petals. There is a frieze of plant ornament at the very bottom of the vase. Silver. Kul Oba.

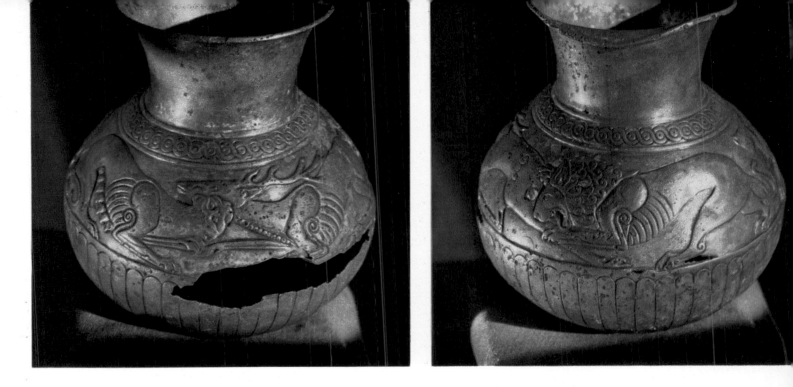

243 A lioness tearing at the throat of a stag. Detail of the silver cup shown in plate 241.

244 A lion attacking a stag from behind. Detail of the silver vase shown in plate 241.

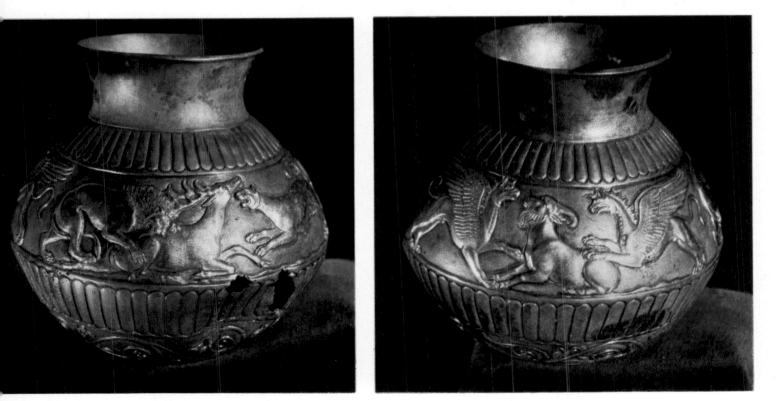

245 A stag attacked by a lion and a lioness. Detail of the silver vase shown in plate 242.

246 A goat attacked by two eagle-griffins. Detail of the silver vase shown in plate 242.

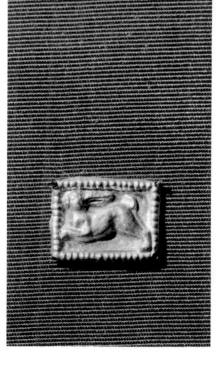

247 Square embossed plaque showing a leaping hare. Gold. Kul Oba.

249 Wire pin, the upper end of which is bent in a double loop and terminates in the figure of a little bird. Gold. Kul Oba.

248 Embossed plaque in the form of a profile figure of a recumbent lion. Gold. Kul Oba.

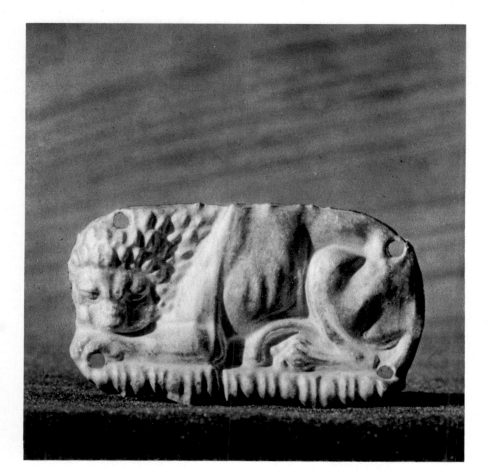

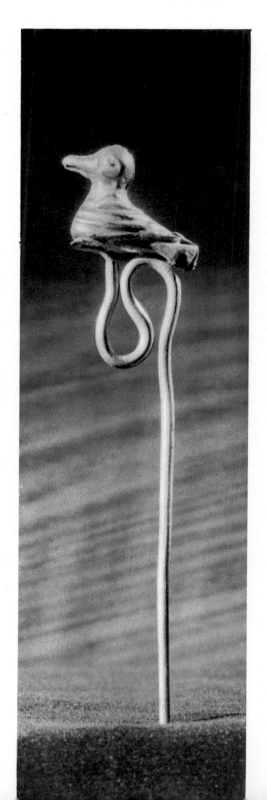

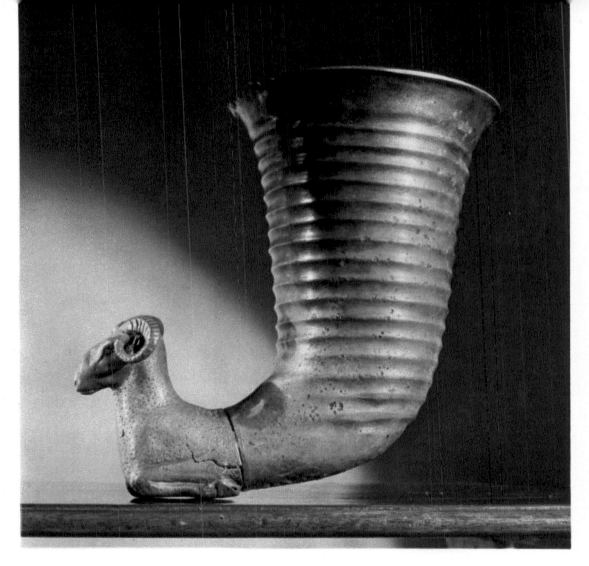

250 *Rhyton*, terminating in the forequarters of a ram. Silver. Kul Oba.

251 *Rhyton*, with a gold finial in the shape of a lion head. Silver, gold. Kul Oba.

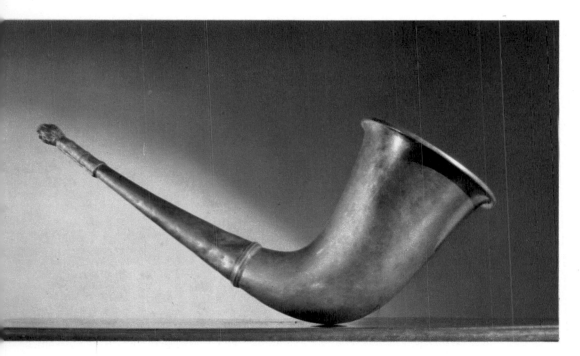

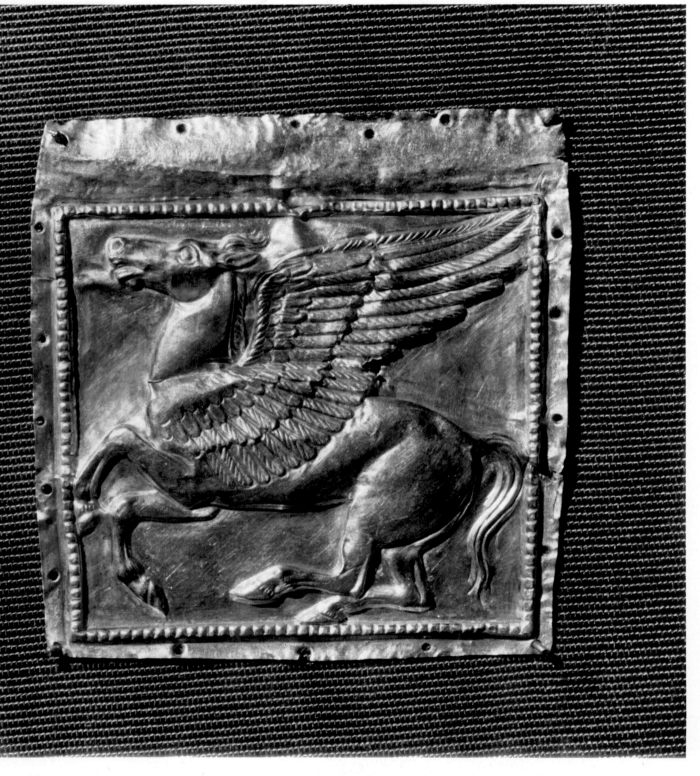

252 Square embossed plaque with a figure of Pegasus set within a frame. Gold. Kul Oba.

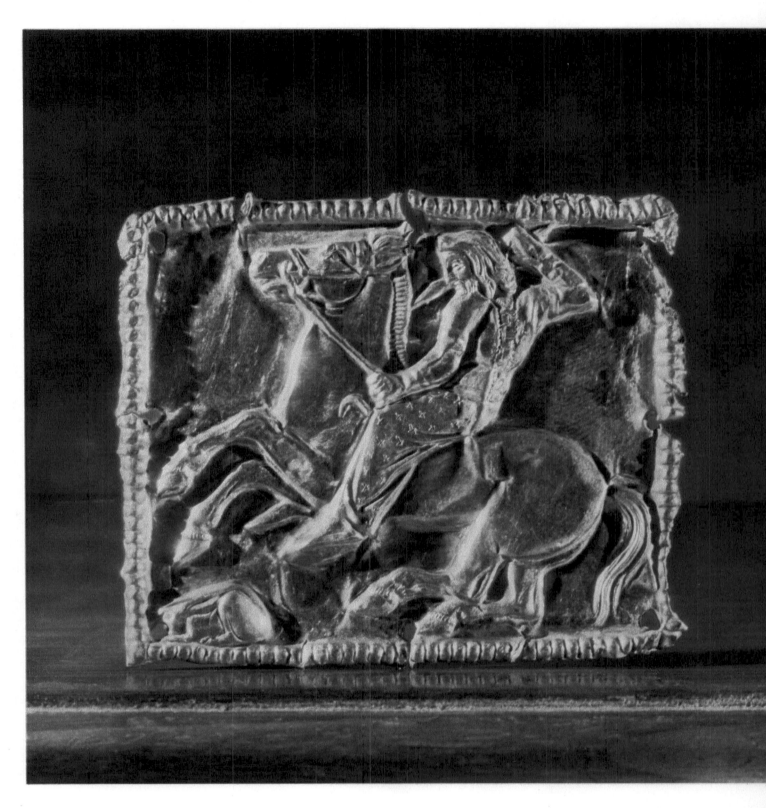

253 Square embossed plaque with the figure of a mounted Scyth hunting a hare, set within a frame. Gold. Kul Oba.

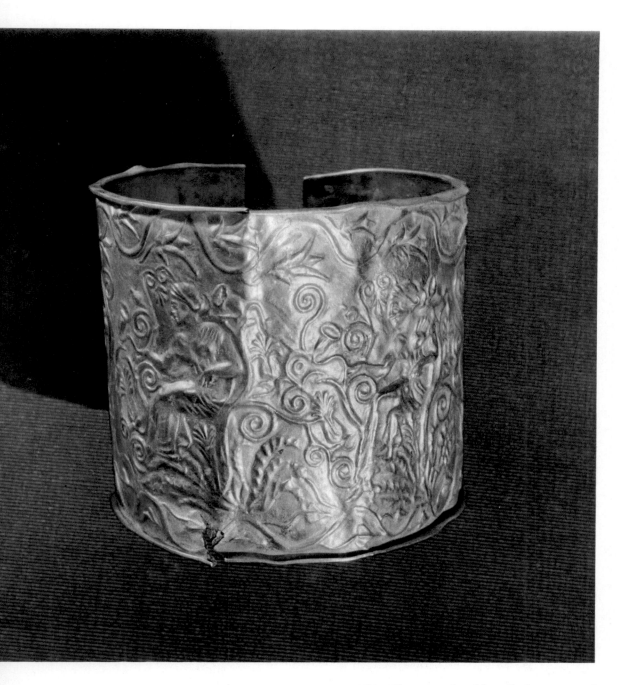

254 Truncated gold cylinder covered with plant ornament and the figure of a woman, repeated four times, seated among the branches. Gold. Kul Oba.

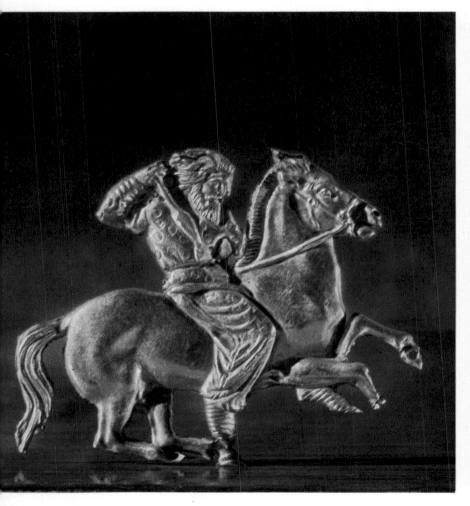

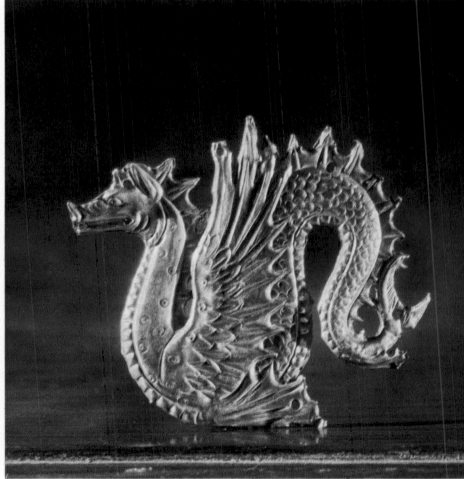

255 Plaque in the form of the profile figure of a mounted Scyth on a galloping horse. He holds a spear in his right hand. Gold. Kul Oba.

256 Plaque in the form of a hippocampus seen in profile. Gold. Kul Oba.

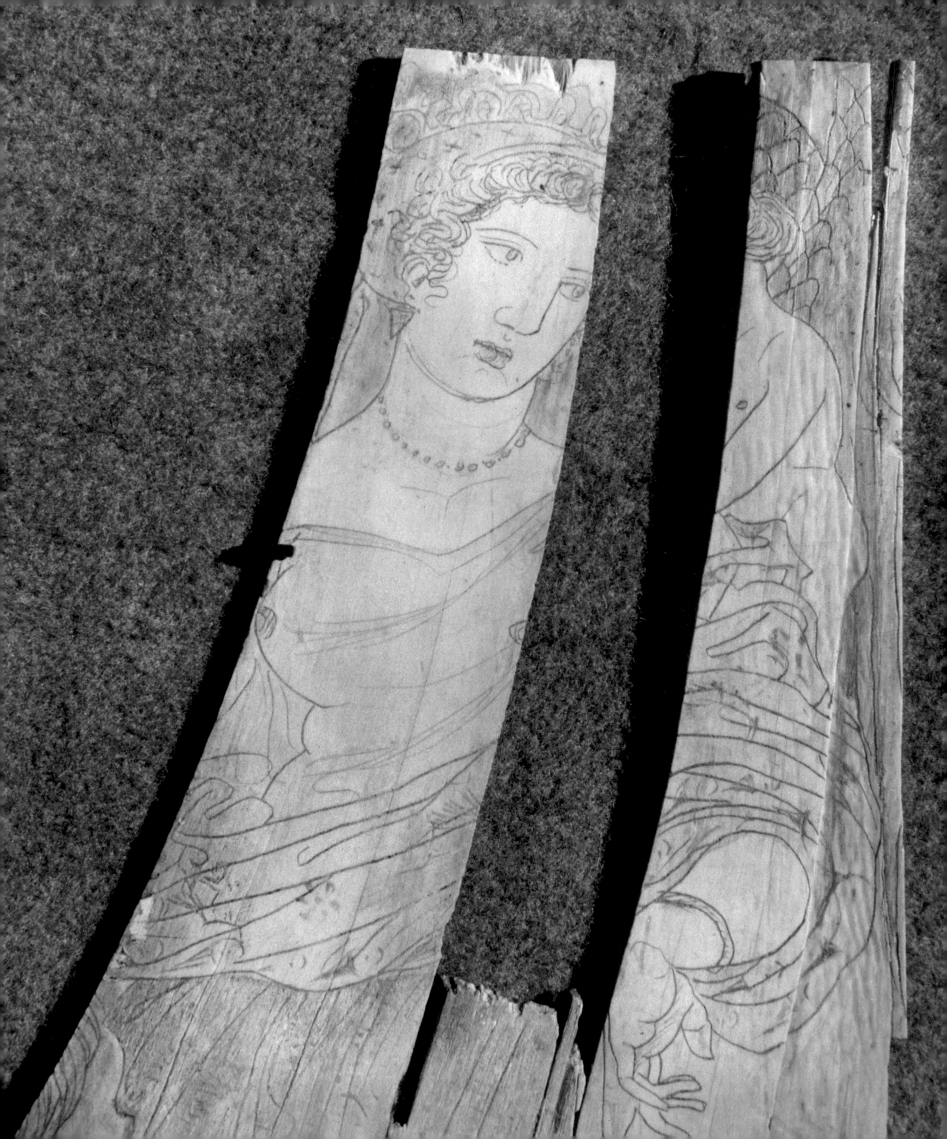

258 Fragments of an ivory sarcophagus. Above, a capital with Ionic volutes worked in relief, in the centre of which are glass hemispherical inlays. Centre, two fragments of a narrow ornamental border consisting of oblique crosses. Below, fragments of a painting showing the Judgement of Paris. Ivory, engraved. Kul Oba.

◄ 257 Aphrodite and Eros.
Detail of the painted ivory sarcophagus shown in plate 258.

259, 260 A long strip of ivory decorated with the figure of a youth in a chariot drawn by two pairs of horses in front of which run two women. Ivory, engraved. Kul Oba.

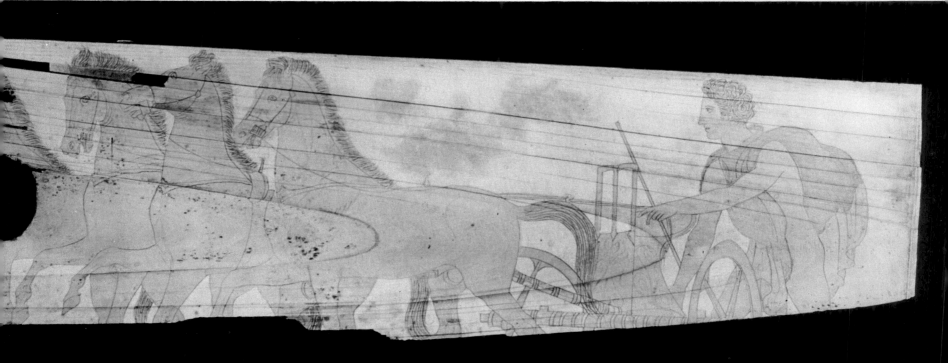

261 Athena and Aphrodite with Eros. Detail of the ivory sarcophagus shown in plate 258.

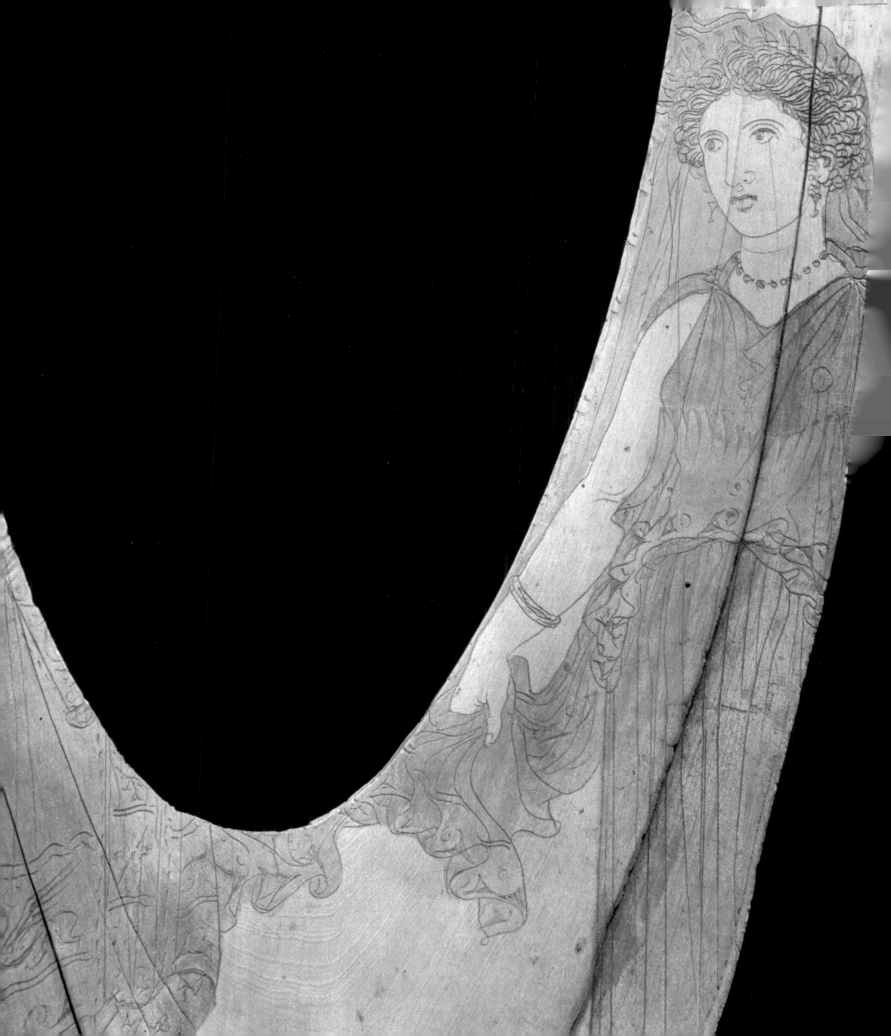

262 Woman holding the end of her cloak in her hand. Ivory, engraved. Kul Oba.

263 Lion-head finial. Gold, bronze. Kul Oba.

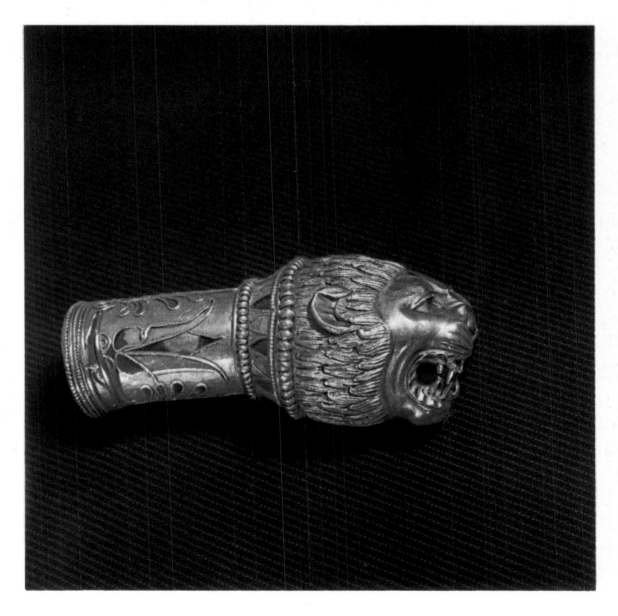

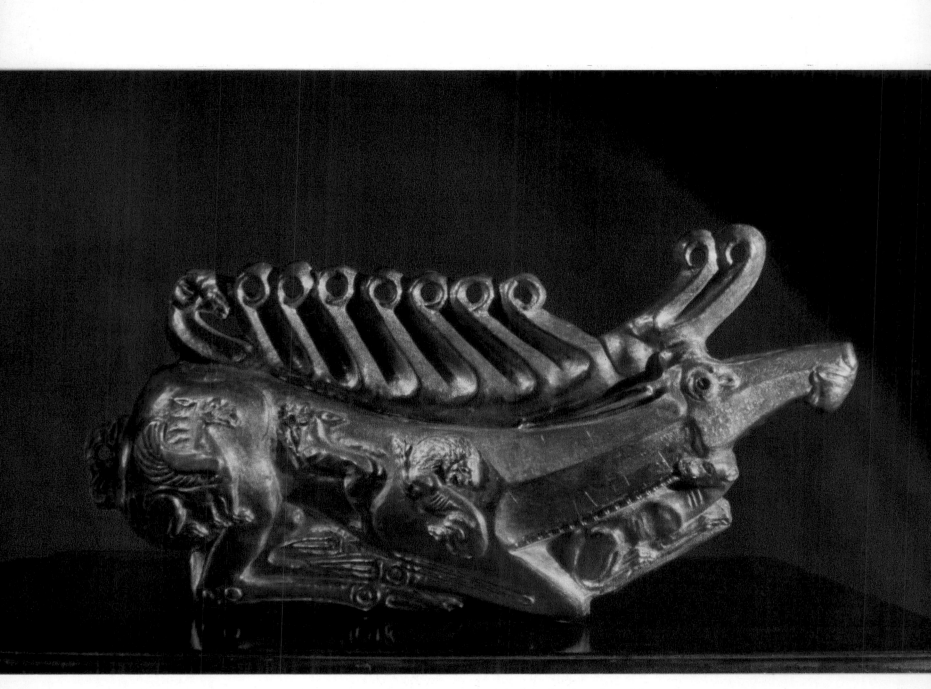

264 Centre-piece of a shield made in the form of a recumbent stag, with tiny figures of a griffin, a hare and a lion superimposed on its body and a dog lying under its neck. Gold. Kul Oba.

265 Stag head with the figure of a dog lying beneath the neck. Detail of the shield centre-piece shown in plate 264.

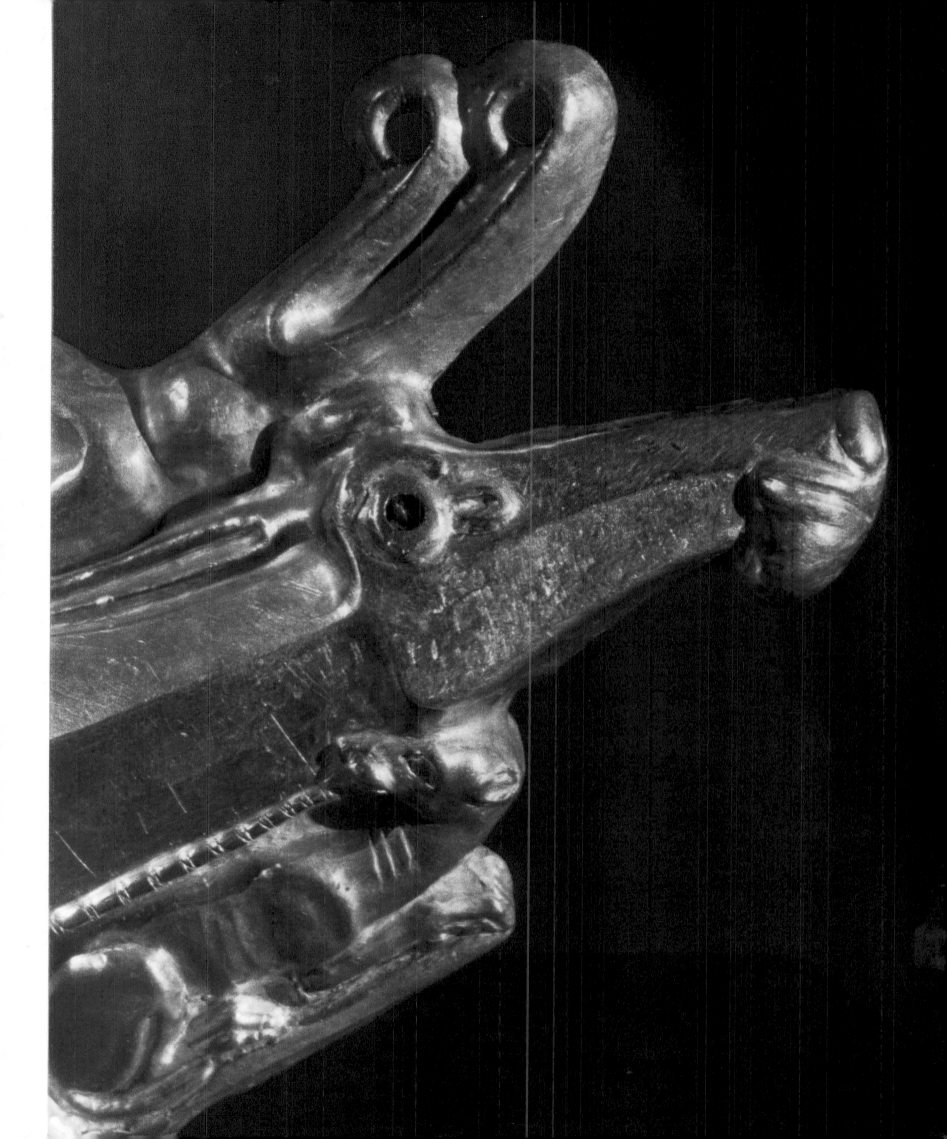

266 Plaque in the form of a dancing woman. Gold. Great Bliznitsa.

267 Plaque in the form of a dancing woman. Gold. Great Bliznitsa.

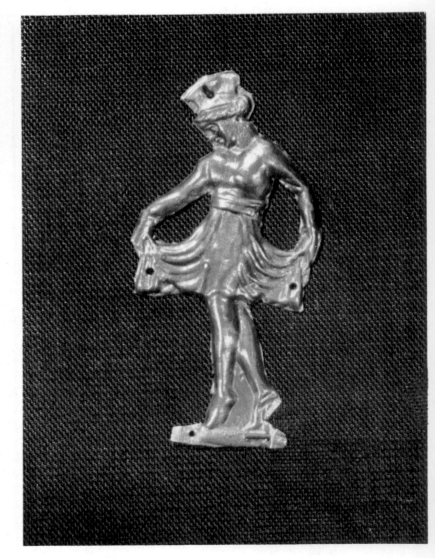

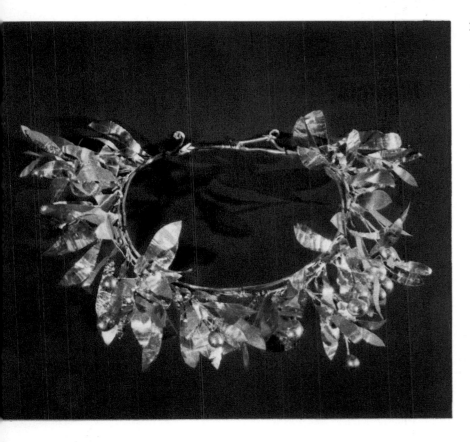

268 Burial wreath in the form of olive branches, with leaves and berries. Gold. Kekuvatsky Barrow.

270 *(Overleaf)* Arms and armour. A helmet with ▶ cheek-pieces fastened, a sword hilt mounted in gold, a pair of greaves, and arrow-heads. Iron, bronze, gold. Kekuvatsky Barrow.

269 A cluster of olive leaves. Detail of the burial wreath shown in plate 268.

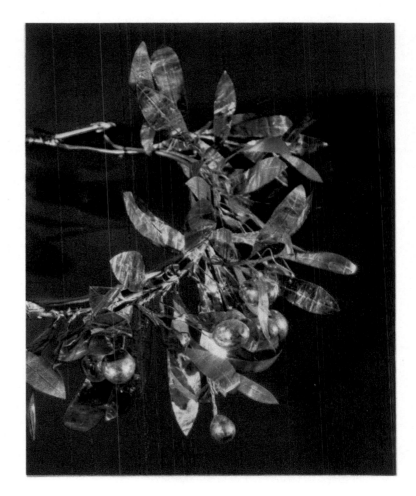

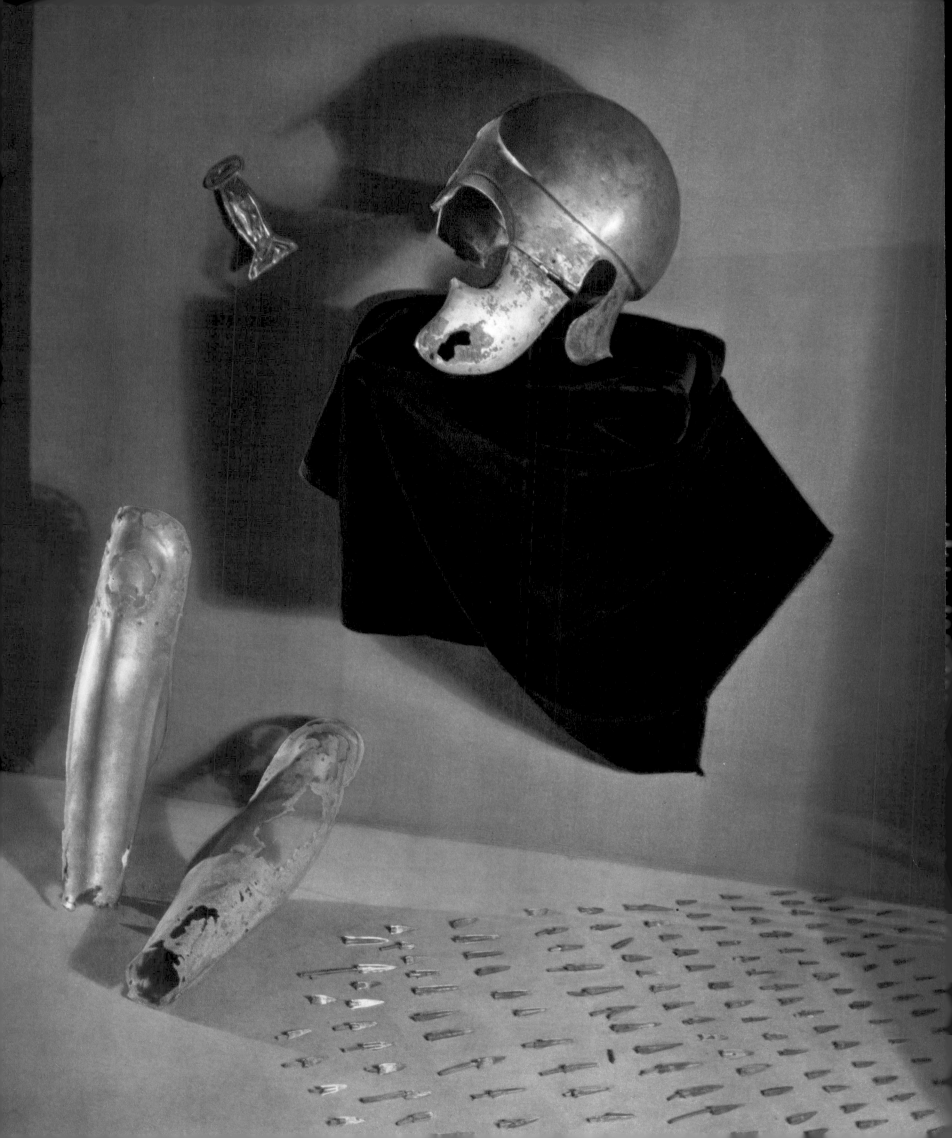

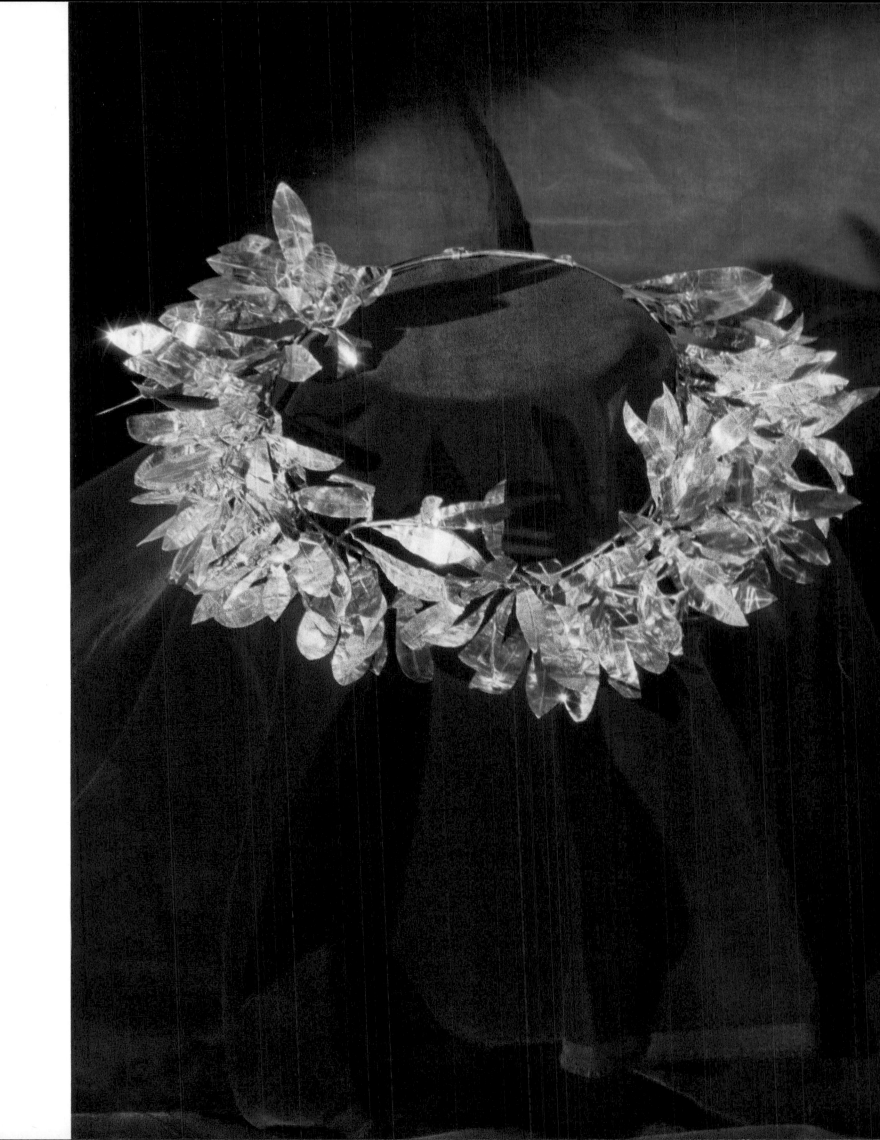

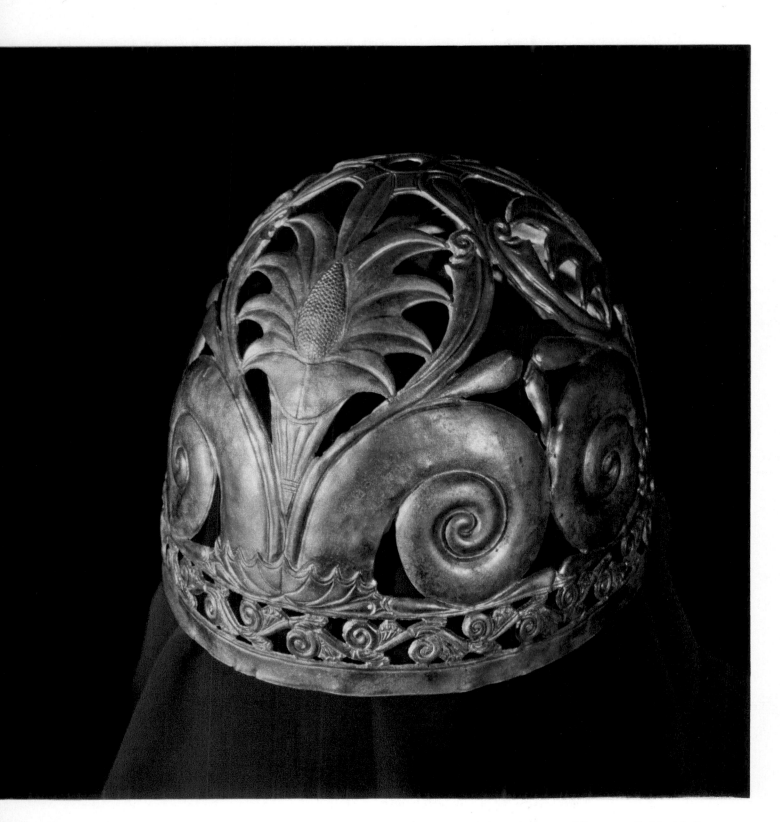

272 Half-oval helmet. Wrought openwork in the shape of volutes, acanthus shoots and flowers. Gold. Ak-Burun.

◄ 271 Wreath of olive branches. Gold. Great Bliznitsa.

273 Earring in the form of a flying Nike with a tiny rosette over her head. Gold. Pavlovsky Barrow.

274 Ring, bearing on the bezel the figures of two dancing women. Gold, glass. Pavlovsky Barrow.

275 A dragon surrounded by dolphins and fishes. Reverse side of the ring shown in plate 274.

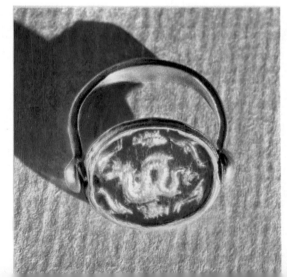

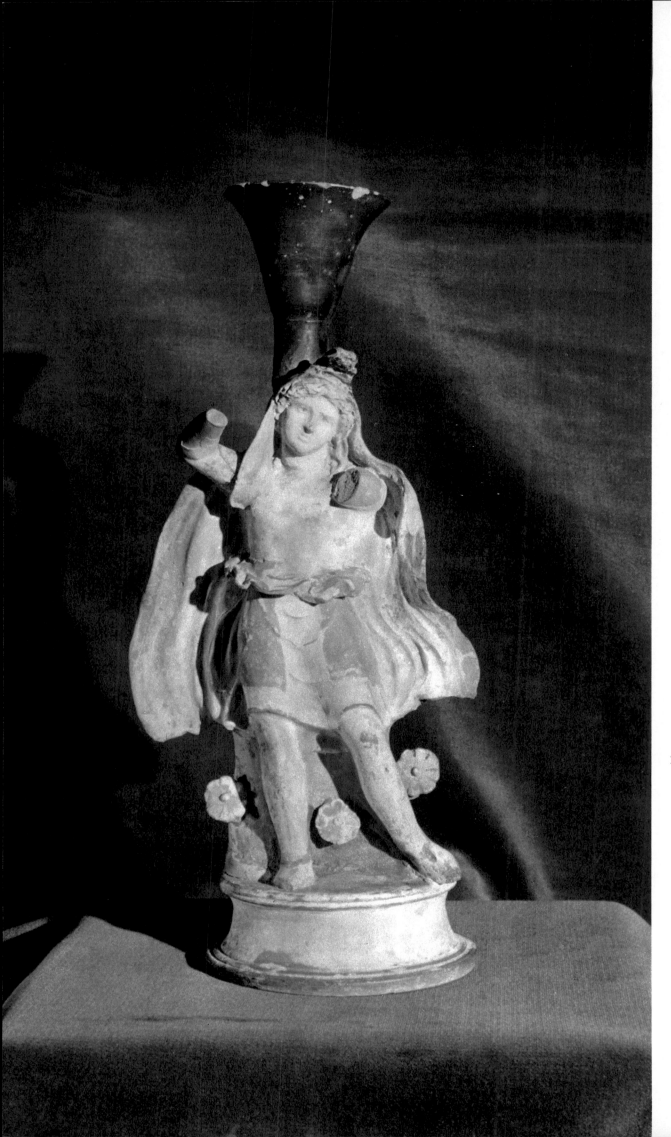

276 Sculptured *lecythos* in the form of a dancing barbarian. Clay, painted. Pavlovsky Barrow.

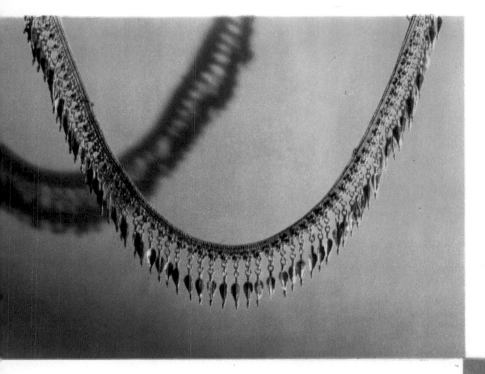

277 Plaited chain necklace decorated with rosettes and three-blade pendants, with finials in the form of lions holding the loop in their paws. Gold. Pavlovsky Barrow.

278 Red-figure *pelice* decorated with figures of the Eleusinian deities and a scene depicting the birth of Erichthonios. Clay, painted. Pavlovsky Barrow.

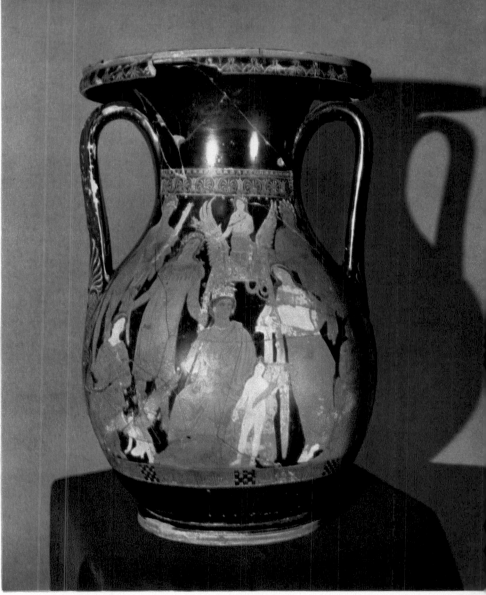

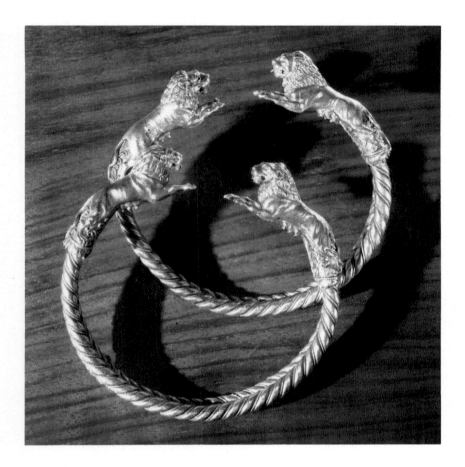

279 Pair of bracelets made of plaited bronze covered with gold, with finials in the form of lions. Great Bliznitsa.

280 Signet ring with a scarab cut in relief on one side and, on the other, an excised figure of Aphrodite with the young Eros who is fastening her sandal. Gold, scarab. Great Bliznitsa.

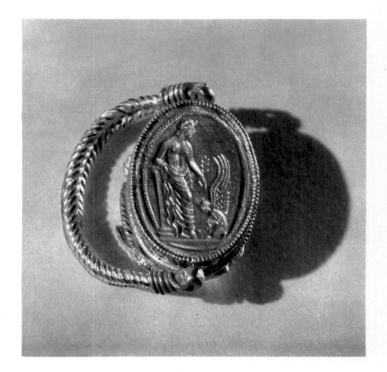

281

282

283

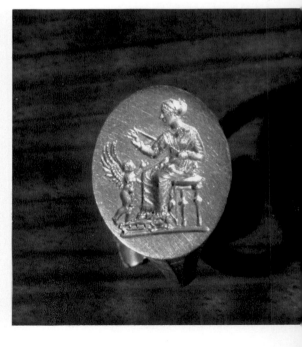

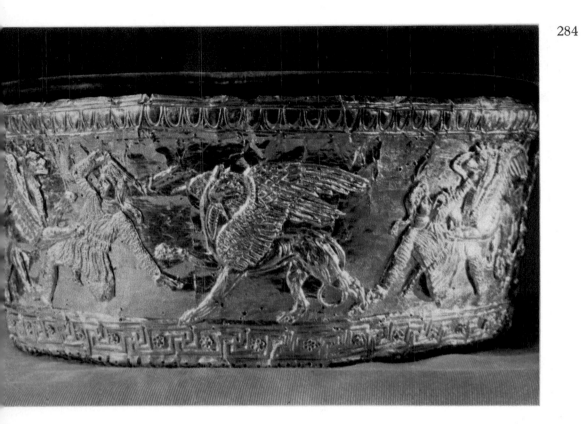

284 *Calathos* headdress shaped like a splayed basket. It consists of thirty pieces of gold joined together and decorated with a border of tongue-and-dart ornament along the upper, and with meanders and tiny rosettes inlaid with blue enamel along the lower edge. The field is filled with a relief design of barbarians (Arimaspi) fighting griffins. Worked in high relief, each figure forms a separate piece which has been cut out along its outline and then fastened to the background by little pins. Gold. Great Bliznitsa.

285 Another view of the *calathos* headdress shown in plate 284.

◄ 281 Signet bearing the excised figure of a woman sitting on a stool and playing with a dog which is standing on its hind legs before her. Gold. Great Bliznitsa.

◄ 282 Signet bearing the excised figure of a monster. The upper part of its body is that of a woman playing a lyre, while the lower part is that of a grasshopper with the head of a griffin at the end. Gold. Great Bliznitsa.

◄ 283 Signet with an intaglio design showing Aphrodite with an arrow in her hands and Eros standing in front of her, stretching out his hand for it. Gold. Great Bliznitsa.

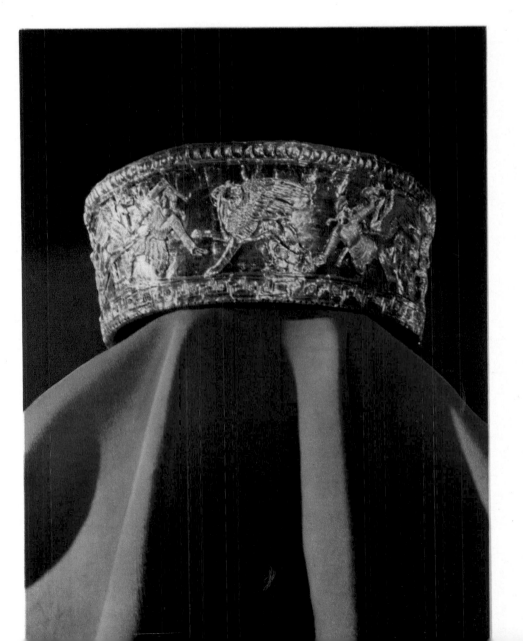

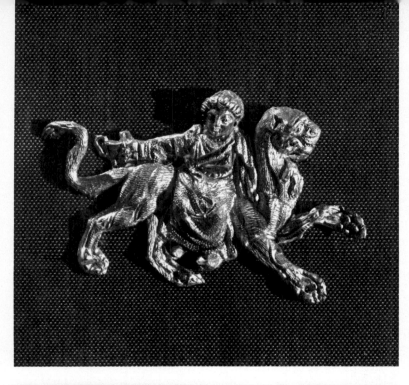

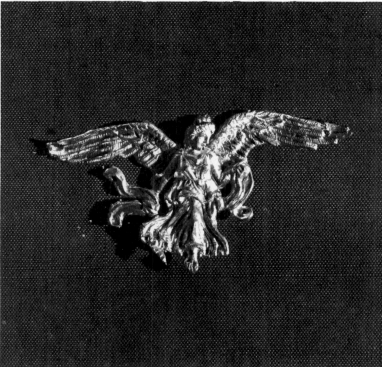

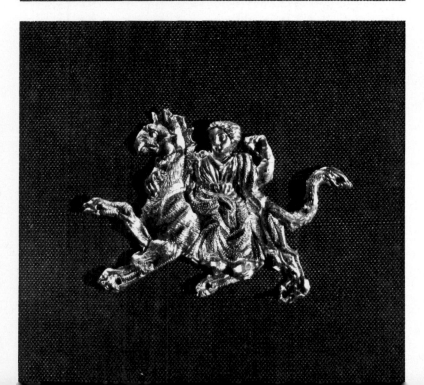

286 Plaque in the form of a woman with a *cantharos* in her hand. She is seated sideways on a panther. Gold. Great Bliznitsa.

287 Plaque in the form of a flying Nike seen from the front. Gold. Great Bliznitsa.

288 Plaque in the form of a woman seated on a griffin. Gold. Great Bliznitsa.

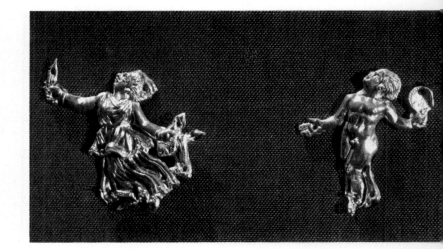

289 Two plaques, one of a girl in a long dress, the other of a nude youth. The girl has a knife in her right, and a lamb in her left hand, the youth is holding a tambourine. Gold. Great Bliznitsa.

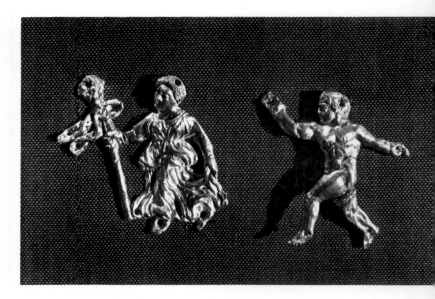

290 Two plaques, one of a girl, the other of a nude youth dancing. The girl holds a *thyrsus*. Gold. Great Bliznitsa.

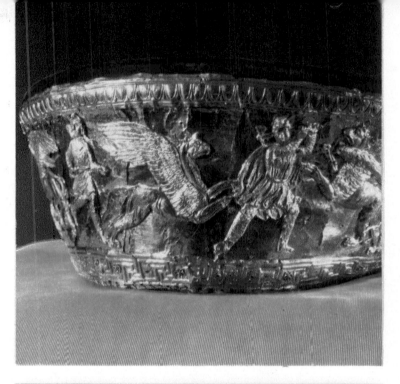

291 A youth with axe raised in an attempt to strike a griffin that is attacking his companion. Detail of the *calathos* shown in plate 284.

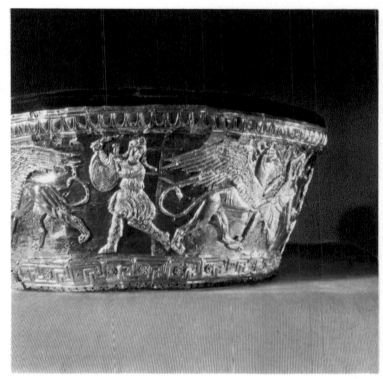

292 A youth fighting a griffin. Detail of the *calathos* shown in plate 284.

293 A youth lunges at a griffin with his sword. Detail of the *calathos* shown in plate 284.

294 A youth overcome by a griffin. Detail of the *calathos* shown in plate 284.

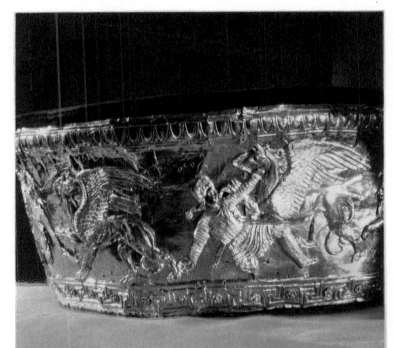

295 Crescent-shaped necklace with lion-head finials and an openwork design, done in relief, of different animals and trees. Gold, enamel. Great Bliznitsa.

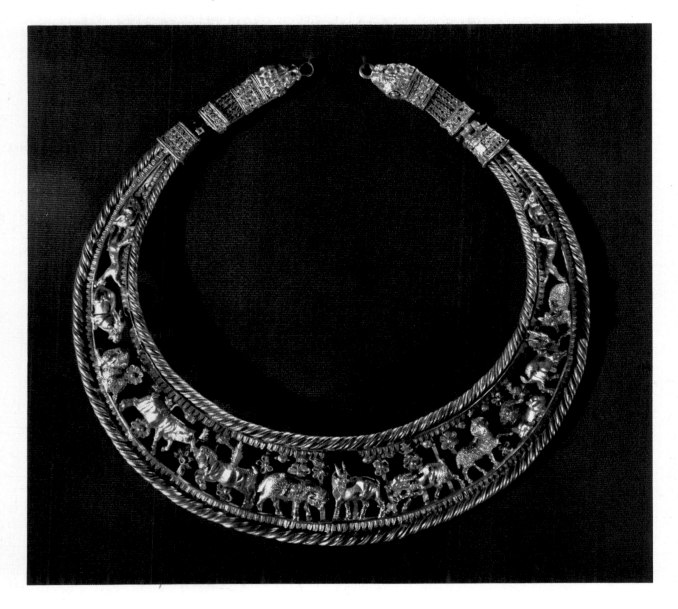

296 Pair of disc-like pendants each with the figure of a Nereid carrying the armour of Achilles and riding on a hippocampus. Twenty-four bud-shaped pendants hang on a lattice of chains suspended from the disc. Gold. Great Bliznitsa.

301 Fragment of engraved ivory that once adorned a wooden sarcophagus. Ivory. Great Bliznitsa.

303 Seated man holding a rod. Fragment of engraved ivory that once adorned a wooden sarcophagus. Ivory. Great Bliznitsa.

◄ 302 Seated man. Fragment of engraved ivory that once adorned a wooden sarcophagus. Ivory. Great Bliznitsa.

306 Plaited chain necklace closely hung with two rows of bud-shaped ► pendants with tiny rosettes. Gold. Great Bliznitsa.

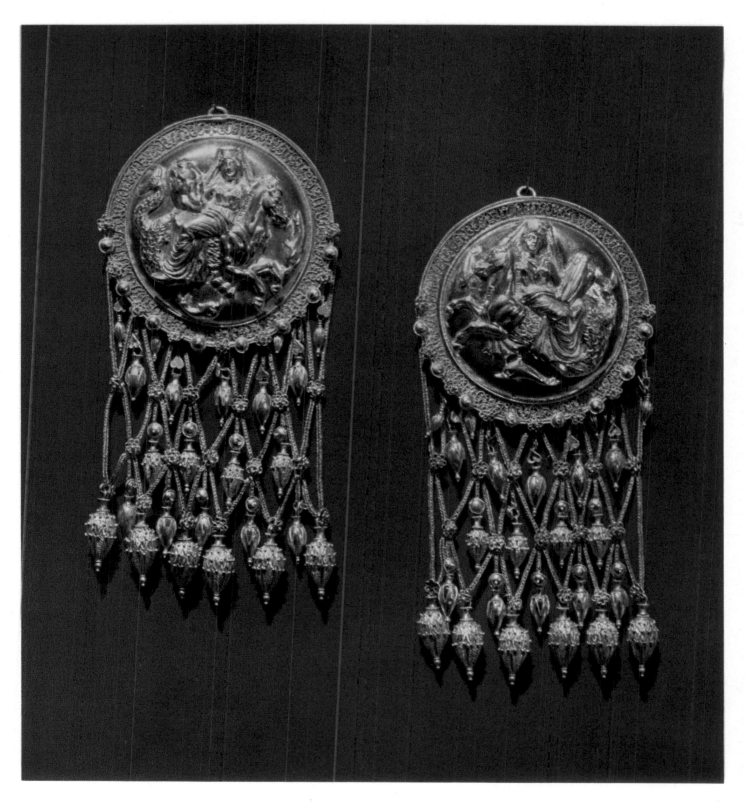

296 Pair of disc-like pendants each with the figure of a Nereid carrying the armour of Achilles and riding on a hippocampus. Twenty-four bud-shaped pendants hang on a lattice of chains suspended from the disc. Gold. Great Bliznitsa.

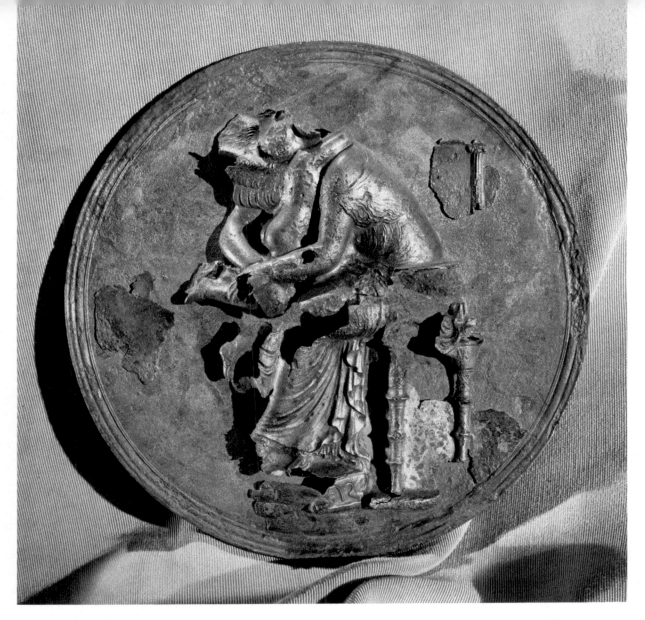

300 Figure of a Nereid carrying the armour of Achilles and seated on a hippocampus. Detail of the pendant shown in plate 296.

297 Round mirror-case decorated with the figure of Aphrodite sitting in a chair, Eros in her arms. Bronze. Great Bliznitsa.

298 Round mirror-case decorated with the figures of two young Greeks fighting a mounted Amazon. Bronze. Great Bliznitsa.

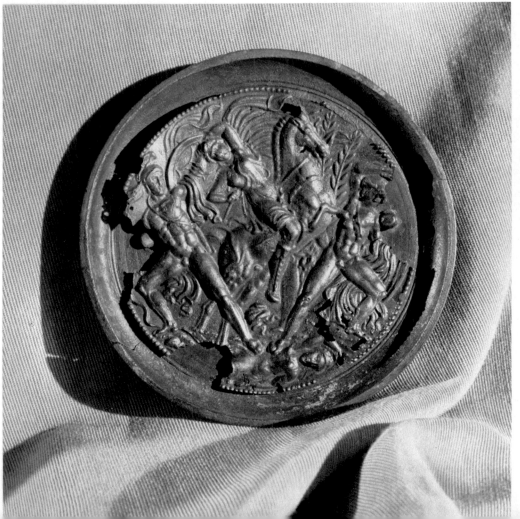

299 Round mirror-back decorated with the figures of two struggling *putti*. Bronze. Great Bliznitsa.

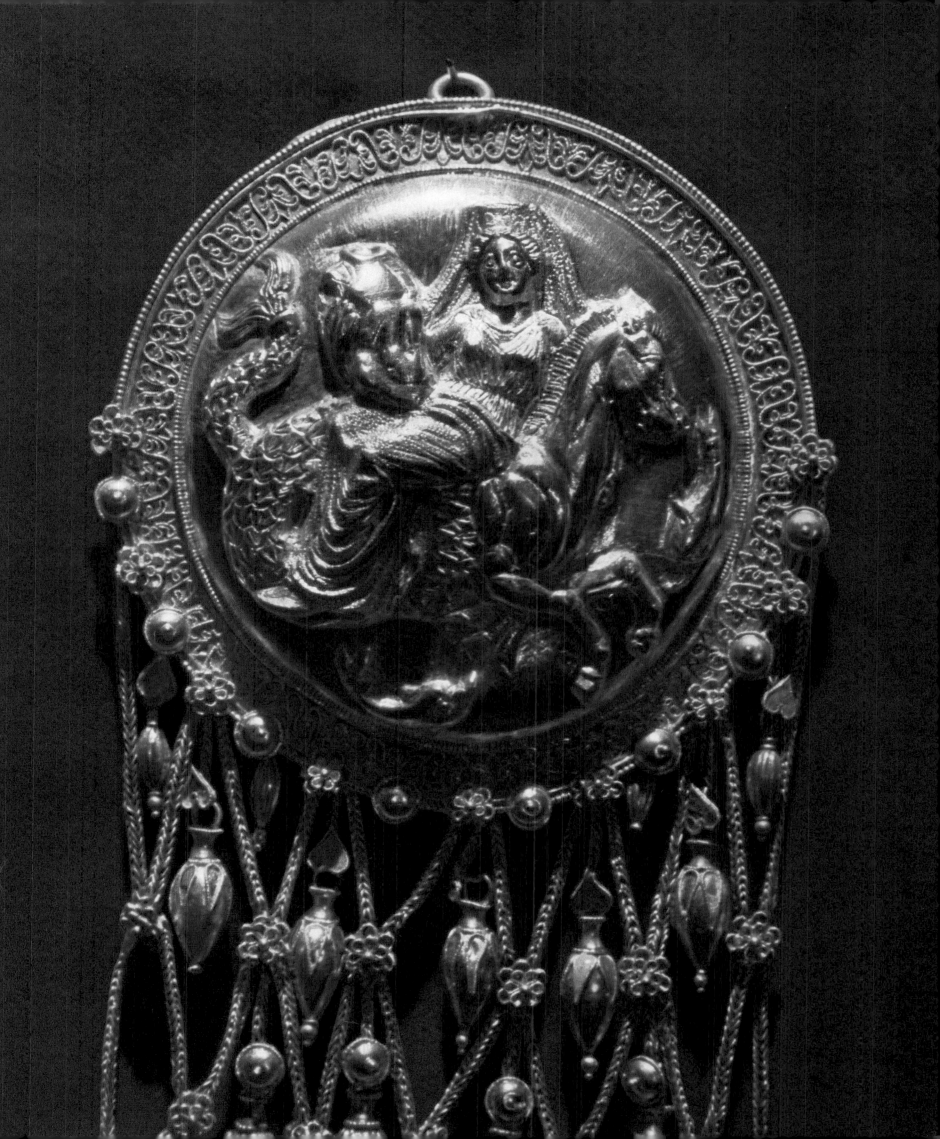

301 Fragment of engraved ivory
that once adorned a wooden
sarcophagus. Ivory. Great
Bliznitsa.

303 Seated man holding a rod. Fragment of engraved ivory that once adorned
a wooden sarcophagus. Ivory. Great Bliznitsa.

◄ 302 Seated man. Fragment of engraved ivory that once adorned a wooden
sarcophagus. Ivory. Great Bliznitsa.

306 Plaited chain necklace closely hung with two rows of bud-shaped ►
pendants with tiny rosettes. Gold. Great Bliznitsa.

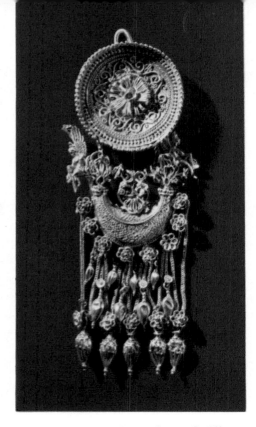

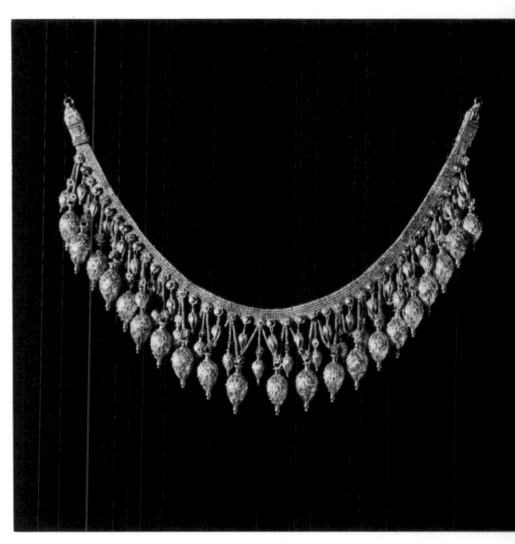

304 Disc-shaped earring of filigree work, within the centre a rosette surrounded by spiral-like ornament. A crescent decorated at one end with a figure of Eros and with an openwork palmette in the middle hangs below. From it dangle rosettes and bud-shaped pendants. Gold. Great Bliznitsa.

305 Necklace in the form of a plaited band with two rows of urn-shaped filigree pendants, decorated with granulation, and a similar row of larger pendants. Gold, enamel. Great Bliznitsa.

307 *Stlengis* bearing a design of locks of hair worked in relief. At each end there is the figure of a woman seated on a rock. Gold. Great Bliznitsa.

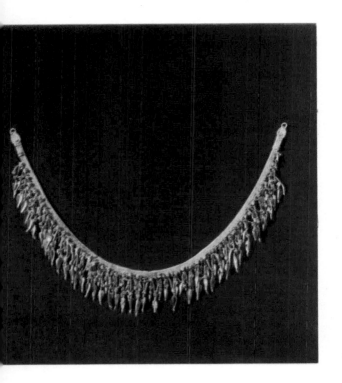

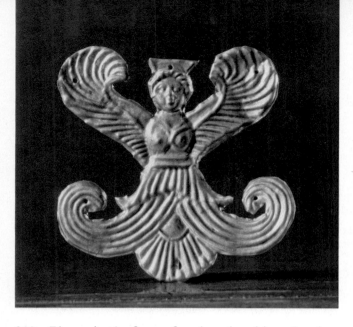

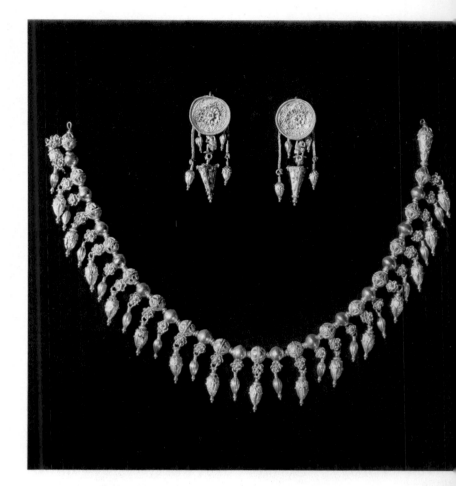

308 Plaque in the form of a winged goddess. In place of legs there are tendrils of acanthus extending on either side, with a palmette between them. Gold. Great Bliznitsa.

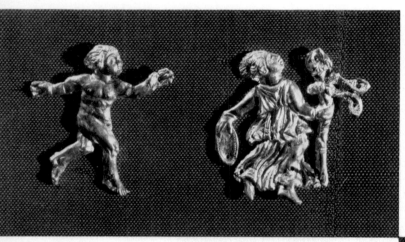

309 Pair of disc-shaped earrings, each decorated with a filigree rosette. Around a large central pendant, hanging pointed end down, are four almond-shaped pendants on chains. Above the central pendant is a figure of a dancing Scyth, and on its sides figures of satyrs and maenads. Necklace of round filigree beads, rosettes and little amphorae of different sizes. Gold. Great Bliznitsa.

310 Plaques in the form of two dancing figures, one of a nude youth, the other of a girl with a *thyrsus*. Gold. Great Bliznitsa.

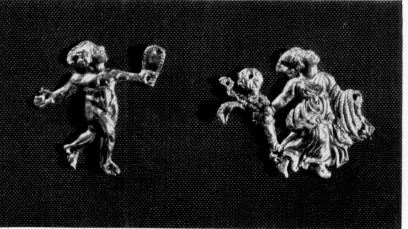

311 Plaques in the form of two dancing figures. Gold. Great Bliznitsa.

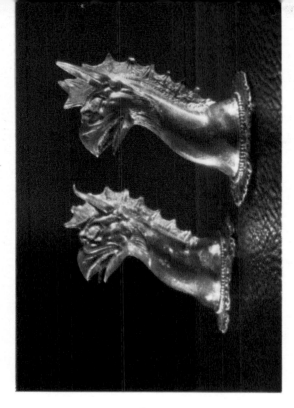

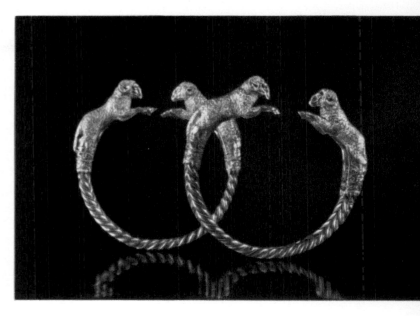

312 Two heads of eagle griffins. Gold. Great Bliznitsa.

313 Pair of bracelets terminating in figures of rams. Gold. Great Bliznitsa.

314 Ring bearing a design of a recumbent lion on the bezel. Gold, sard. Great Bliznitsa.

315 Woman's jewellery, including a *stlengis*, a pair of disc-shaped earrings with boat-like and urn-shaped pendants, a filigree necklace, and smooth beads with pendants. Gold. Great Bliznitsa.

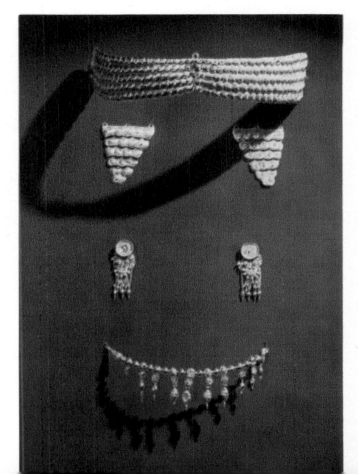

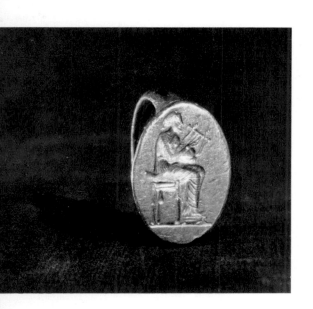

316 Ring, bearing on the bezel the figure of a seated woman playing the lyre. Gold. Kara-godeuashkh.

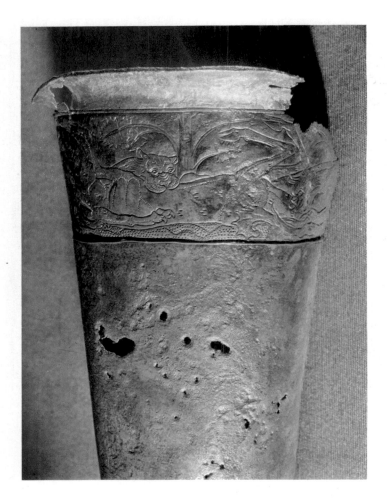

317 Detail of a silver *rhyton* shown in Fig. 158. Karagodeuashkh.

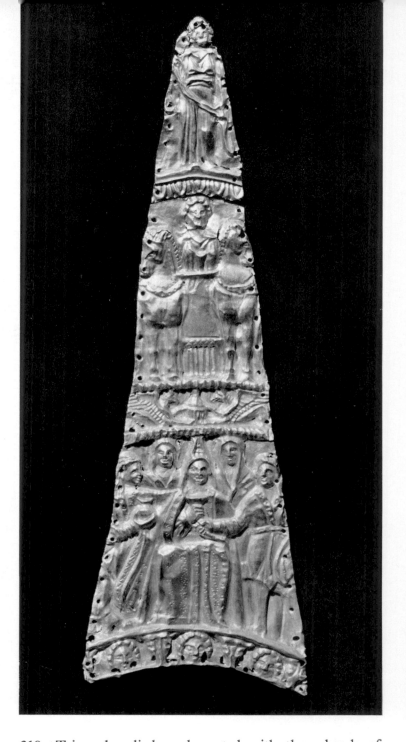

318 Triangular diadem decorated with three bands of figures. In the top register is the full-length figure of a woman seen from the front. In the middle register there is a pair of horses harnessed to a chariot driven by a man or woman. The bottom register shows the seated figure of a queen or goddess wearing a conical headdress. In her hand she has a *rhyton* which she is either giving to or taking from a Scyth who touches it with his right hand. To the right of the woman is another Scyth bearing a round cup or vase in his hands. Two female attendants stand behind. The bands are divided by narrow friezes. In the upper frieze there is a tongue-and-dart design, the middle one has griffins and the lowest masks and *bucrania*. Gold. Karagodeuashkh.

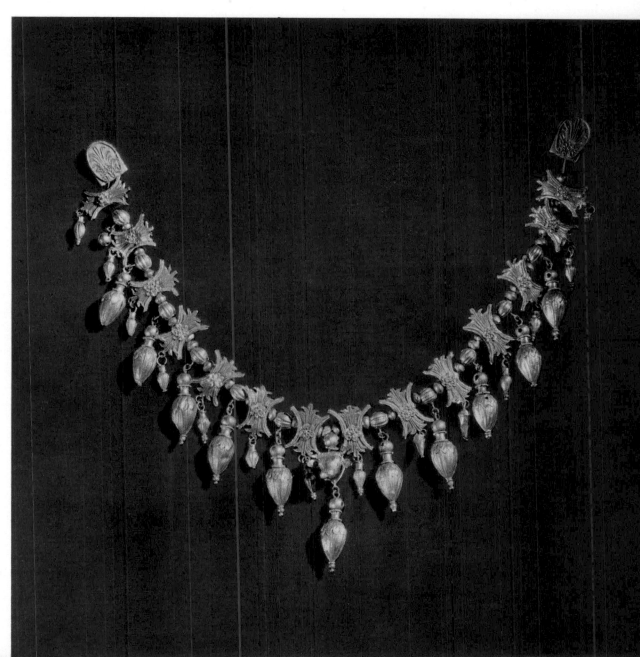

319 Necklace made of beads and tiny figured plaques, decorated with filigree palmettes and rosettes, supporting pendants and, in the middle, a bull head. At the ends are clasps adorned with palmettes. Gold. Karagodeuashkh.

320 Reconstruction showing woman adorned with jewellery. Karagodeuashkh.

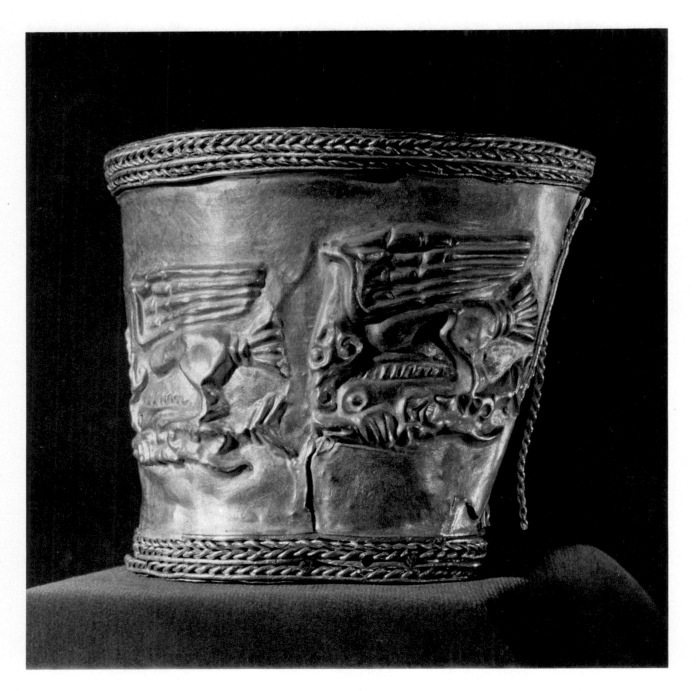

321 Upper part of a silver *rhyton* decorated in gold relief with the figure of a bird pecking at a fish. Elizavetovskaya.

322 Quadrangular plate-mounting of a *gorytus* with figure of a recumbent stag. Gold. Elizavetovskaya.

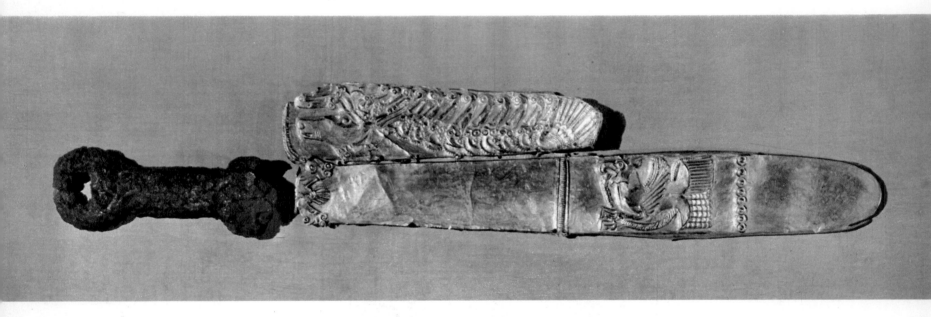

323 Iron sword in gold-plated scabbard. On the upper part is
a design, worked in relief, of two bird heads with a palmette
between them and a monster in the centre. On the long plate
for fastening the sword is the head of a stag seen in profile
with multi-tined stylized antlers ending in a palmette.
Iron, gold. Elizavetovskaya.

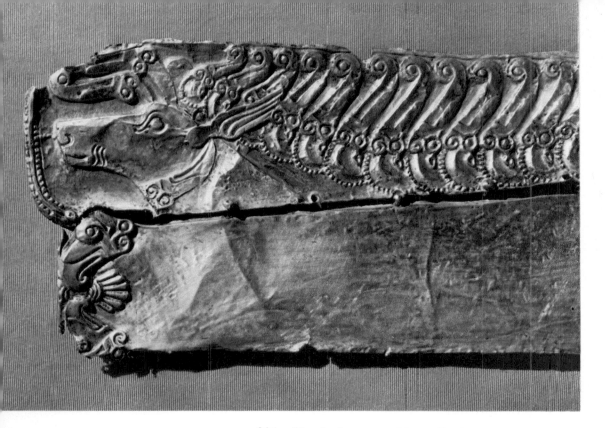

324 Head of a stag with stylized antlers.
Detail of the gold scabbard shown in plate 323.

325 Winged griffin devouring a snake.
Detail of the gold scabbard shown in plate 323.

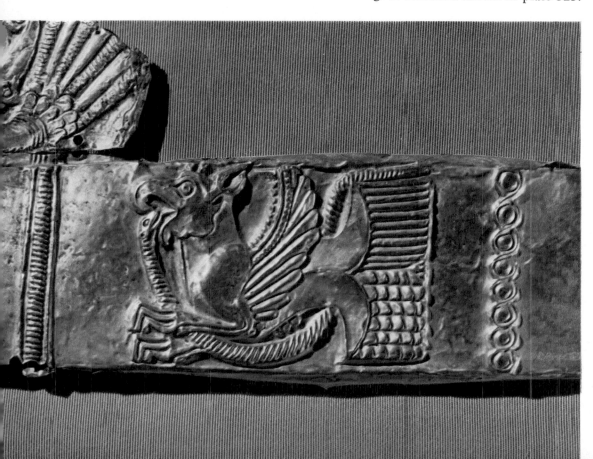

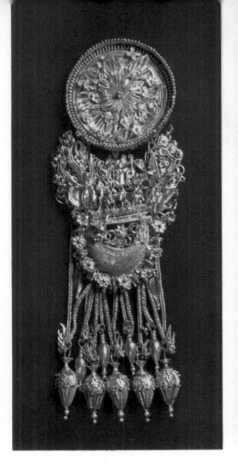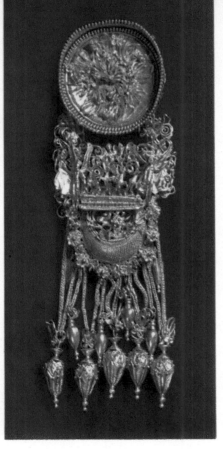

326, 327 Disc-shaped earrings covered with ornament and supporting a boat-shaped pendant decorated with a quadriga and bud-shaped pendants on chains. Gold. Theodosia.

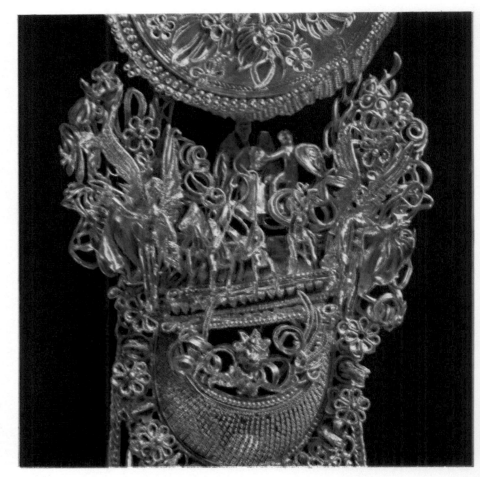

328 Boat-shaped pendant decorated with flowers, rosettes. Above it there is a quadriga and figures of winged genii on either side. Detail of earring shown in plate 326.

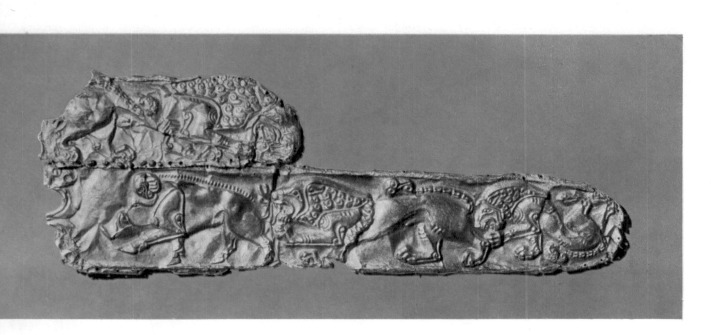

329 Scabbard plating with decorated figures of a boar followed by a lion, and a lion with its rump in reverse position at the lower end. On the fastening plate is another lion, this time devouring the head of an animal. Gold. Elizavetovskaya.

330 Figure of a boar on the upper part of scabbard and of a lion on the fastening plate. Detail of plate 329.

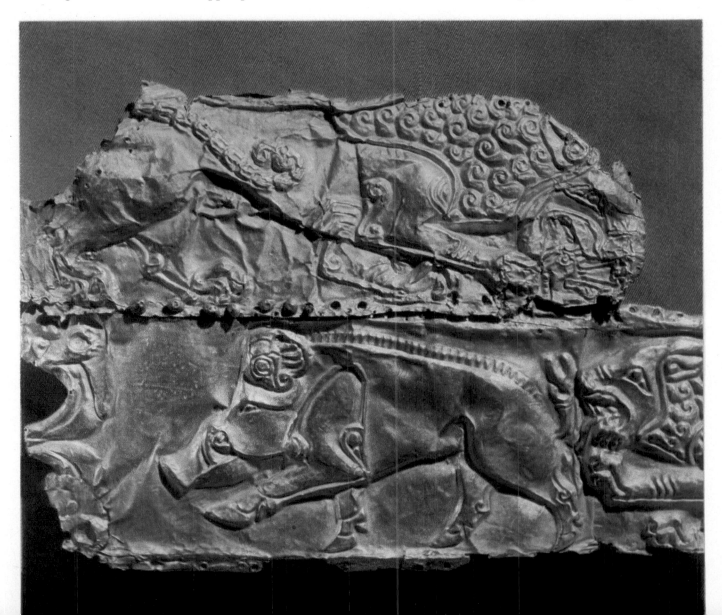

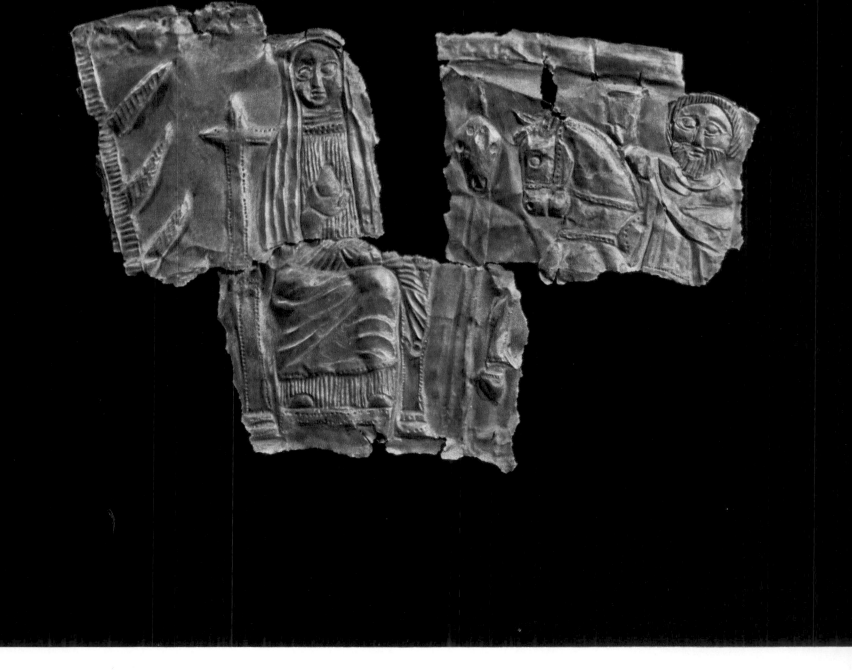

331 Rectangular plate bearing the figure of a goddess sitting on a throne and holding a pear-shaped object in her hand; to her right is a tree, and to the left a pole with an animal head stuck on it. A horseman with a *rhyton* in his raised hand approaches from the right. Gold. Merdzhana.

I Alexandropol Barrow. View before excavation.

II Ulski, Barrow 1 (1898). General view of grave.

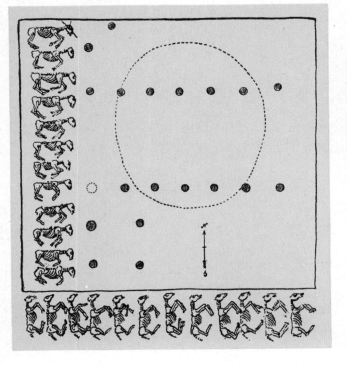

III Kelermes, Barrow 1 (1904). Plan of burial.

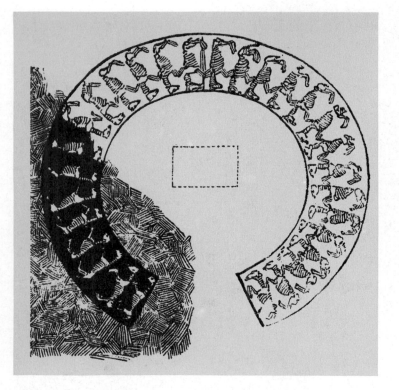

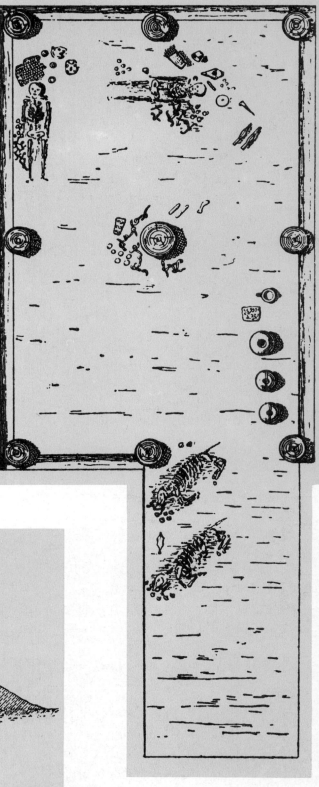

VI Zhurovka Barrow 400. Plan of burial.

IV Barrow 17, near Voronezhskaya village. Plan of burial.

V Kostromskaya, Barrow 1 (1897). Grave structure within mound.

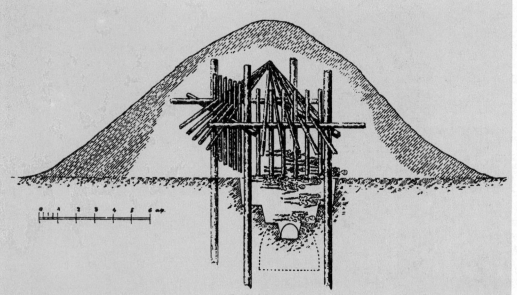

VII Seven Brothers, Barrow 2. Plan of burial.

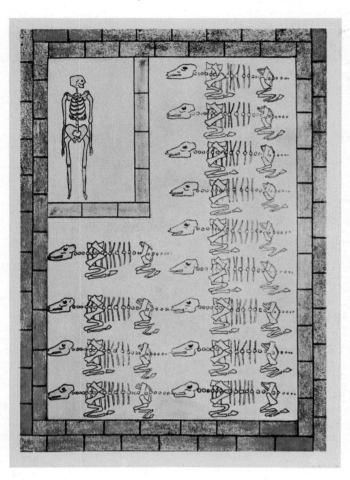

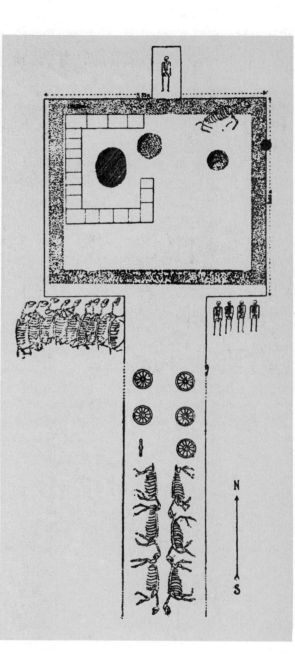

VIII Elizavetinskaya Barrow (1914). Plan of burial.

IX Solokha Barrow. Excavations of 1912.

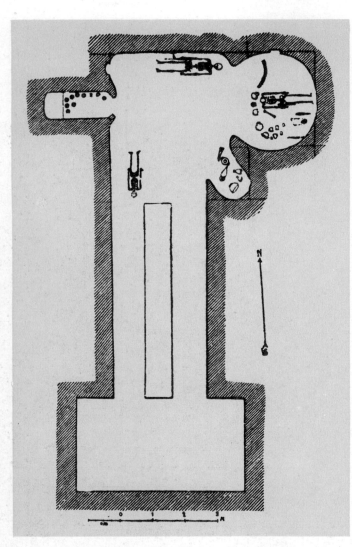

X Solokha Barrow. Plan of the side burial.

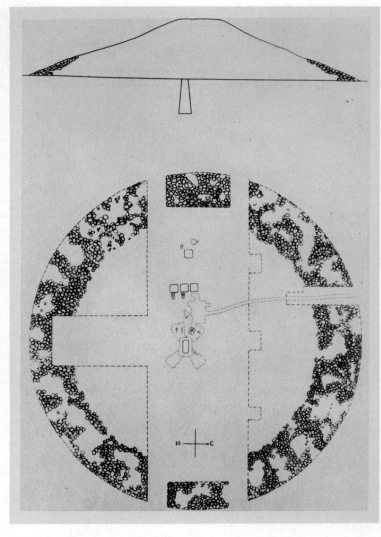

XI Chertomlyk. Plan of burial constructions.

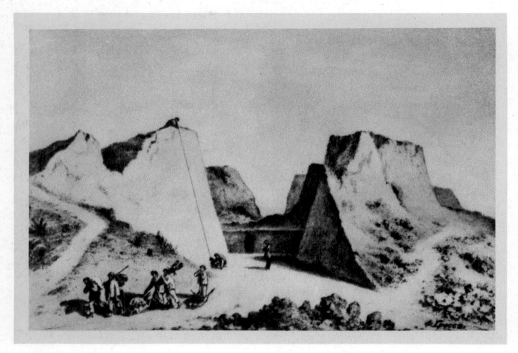

XII Great Bliznitsa. Excavations of 1884.
(After Gross.)

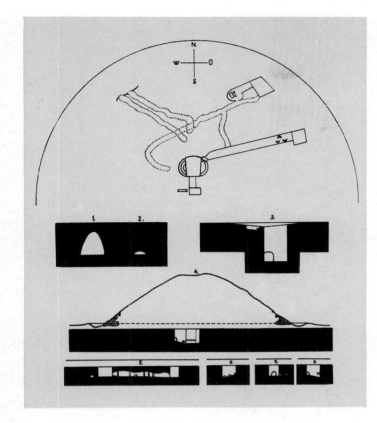

XIII Alexandropol Barrow.
Plan of burial structures and robbers' tunnels.

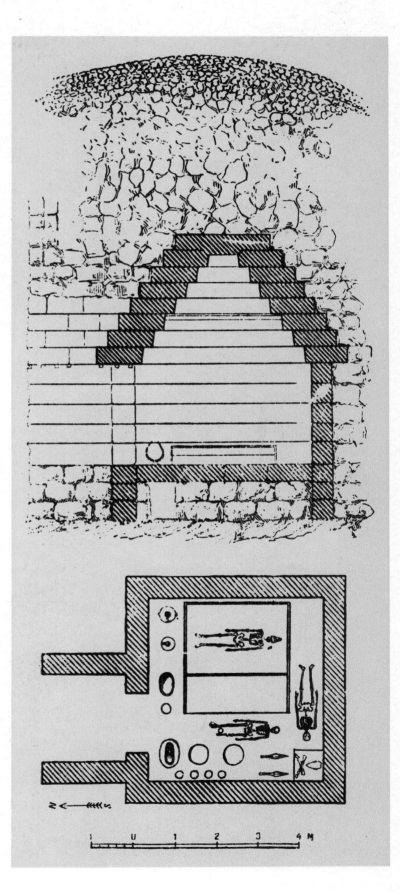

XIV Kul Oba. Plan of burial in a stone vault.

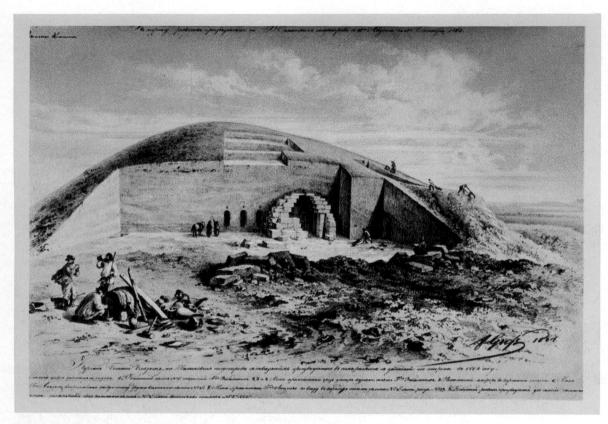

XV Great Bliznitsa. Excavations of 1864. (After Gross.)

XVII Great Bliznitsa. Plan of excavations. (1864—65.)

XVI Great Bliznitsa. Bust of Demeter painted on vault.

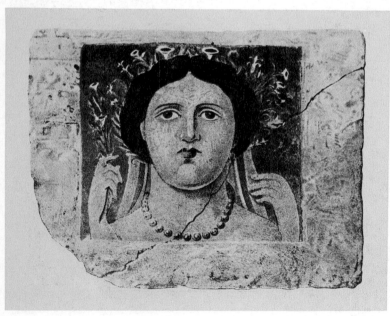

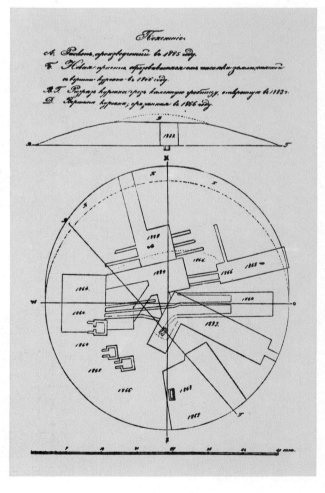

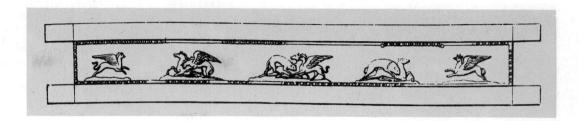

XVIII Kekuvatsky Barrow.
 Painted sarcophagus.

XIX Great Bliznitsa. Stone altar.
 (After Gross.)

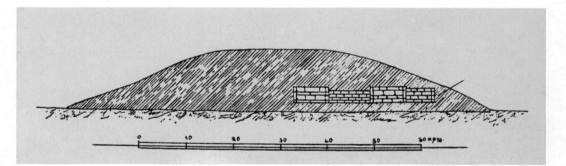

XX Karagodeaushkh.
 East-west section through barrow.

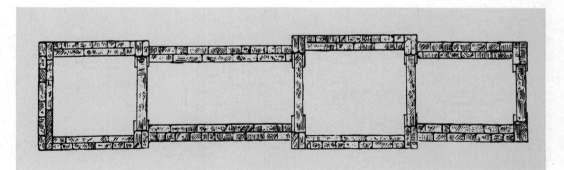

XXI Karagodeaushkh.
 Plan of tomb in the barrow.

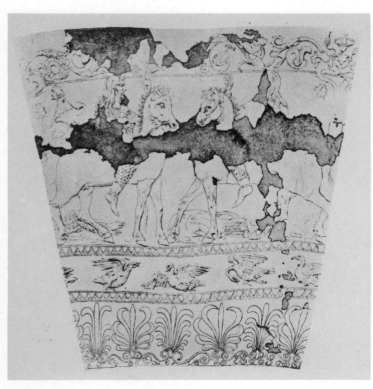

XXII Karagodeaushkh. Drawing of cult scene on the silver *rhyton*.

XXIII Great Bliznitsa. Picture of Demeter painted on the vault (After Gross.)

SELECT BIBLIOGRAPHY

Borovka, G. *Scythian Art*. New York 1928; London (reprint) 1965

Ebert, M. *Südrussland im Altertum*. 1921
 'Südrussland. Skytho-sarmatische Periode.' *Real-Lexikon der Vorgeschichte*, XIII. 1929

Farmakovsky, B. V. 'Arkhaichesky period v Rossii.' MAR, 34, 1914

Harmatta, J. *Studies in the History of the Scythians*. Budapest 1950

Jettmar, K. *Art of the Steppes*. London 1967

Khanenko, B.I. and V.I. *Drevnosti Pridneprovya i poberezhii Chernogo Morya*, II, III, VI.
 Kiev 1899/1907

Minns, E.H. *Scythians and Greeks*. Cambridge and New York 1913
 The Art of the Nomads. London 1924

Phillips, E.D. *The Royal Hordes*. London 1965

Potratz, J.A.H. *Die Skythen in Südrussland*. Basel 1928

Prushevskaya, E.O. 'Rodosskaya vasa i bronzovye veshchi iz mogily na Tamanskom poluostrove.'
 IAK, 63, 1917

Rabinovich, B.S. 'O datirovke nekotorykh skifshikh kurganov Srednego Pridneprovya.' *SA*, I,
 1936

Reinach, S. *Antiquités de la Russie Méridionale*. Paris 1891
 Antiquités du Bospore Cimmérien. Paris 1892

Rostovtsev, M.I. *Antichnaya dekorativnaya zhivopis na yuge Rossii*. St Petersburg 1914
 Iranians and Greeks in South Russia. Oxford 1922
 Skifiya i Bospor. 1925. German edition: *Skythien und Bosporus*. Berlin 1931
 'Voronezhsky serebryany sosud.' *MAR*, 34, 1914

Schefold, K. 'Der Skythische Tierstil in Südrussland.' *Eurasia Sept. Ant.*, XII, 1938

Silantyeva, L.F. 'Nekropol Nimfeya.' *MIA*, 69, 1952

Talbot Rice, Tamara. *The Scythians*. London 1957

NOTES ON THE FIGURES

1 Model *kibitka*. Clay. 20 cm. high. Kerch, 1911.

2 Embossed figure of a goat with its head turned back. Detail of gold casing from the sword hilt shown in plate 1. Melgunov Treasure.

3 Monster, with human head and hands, drawing a bow. Detail of gold scabbard casing shown in plate 1. Melgunov Treasure.

4 Diadem of triple chains linked by nine rosettes. At the ends of the diadem clusters of bells decorated with granulation are suspended on chains. Gold. 83.5 cm. long (65.7 cm. without pendants). Melgunov Treasure.

5 Bird of prey with spread, pointed wings, worked in relief. Four loops on back. Gold. 6 cm. high × 4.8 cm. wide. Melgunov Treasure.

6 Rectangular plaque decorated with embossed figures. Left to right: a seated monkey scratching its back, two long-necked and long-legged birds with confronted heads bent down, and a short-legged bird with a pointed beak walking to the right. The end of the plate is bent back. Gold. 11 cm. long × 2.6 cm. wide. Melgunov Treasure.

7 Runners for reins in the form of a ram head (2 cm. long), a twisted beast (2 cm.), a ram-bird (2.9 cm.) and an elongated hoof (2 cm.). Bone or horn. Kelermes, Barrows 1 and 2.

8 Two confronted lions. Detail of gold chape casing shown in plate 6. Kelermes, Barrow 1 (1903).

9 Twisted beast beneath panther's paw. Detail of the shield boss shown in plate 22. Kelermes, Barrow 1 (1903).

10 Cylindrical pole-top ending in a rosette. Gold. 3.7 cm. diam. Kelermes, Barrow 3 (1903).

11 Object of unknown purpose in the form of a hollow rod terminating in a cross, the projections of which end in figures of twisted animals, and with a round opening at the centre. Gold. 6.8 cm. long. Kelermes, Barrow 1 (1903).

12 Hollow terminal, flattened and decorated with gold denticulations. Silver, gold. 10 cm. long × 2.8 cm. wide. Kelermes, Barrow 2 (1904).

13 Runners for reins shaped as schematic bird heads. Bronze-gilt. 2.4 cm. long. Kelermes, Barrow 2 (1903).

14 Two confronted beasts. Bronze. 4.3 cm. long. Tsukur Estuary.

15 Head of a ram-bird. The beast's horns are composed of little hares. Bone or horn. 4.5 cm. long. Temir Mountain.

16 Plaque in the shape of an animal bent into a circle with a round opening in the middle. Bone or horn. 2.9 cm. long. Temir Mountain.

17 Figure of panther, seen from the side. Gold. 3.5 cm. long. Ulski, Barrow 1 (1908).

18 Finial in the form of an animal's head with round protruding eyes and a little hare at the nostril. There is a band of triangular hollows meant for inlay around the base. Gold. 10 cm. long × 5 cm. wide. Ulski, Barrow 2 (1909).

19 Gold lunate pendant decorated with triangles of pellets and enamel. 5.3 cm. long. Pointed Barrow, Tomakovka.

20 Triangular plate with embossed design of an animal leg. The upper edge is bent over. Gold. 5.3 cm. long × 2.3 cm. wide. Baby Barrow.

21 Two-handled cauldron on a narrow foot, ornamented with schematic ox heads, concentric circles, palmettes and triangles. Bronze. 47 cm. high × 39 cm. wide. Raskopana.

22 Button decorated with triangles of pellets. There is a loop at the back. Gold. 2.5 cm. long.

23 Sword chape with, along the upper edge, almond-shaped filigree cells intended to hold inlay. Gold. 18.8 cm. long × 5.8 cm. wide. Golden Barrow.

24 Twisted animal worked in relief, its rump turned through a circle towards its head. Its paws touch its muzzle, and from the shoulder projects the figure of an elk. There is a loop on the back. Bronze. 10.5 cm. long × 9.7 cm. wide. Kulakovsky Barrow.

25 Carnivore standing on a clawed bird's foot. There are two loops at the back. Bronze. 7.1 cm. high × 4.6 cm. wide. Zhurovka, Barrow G.

26 Fragment of a cheek-piece with three openings, ending in a ram-bird head. Bone or horn. 9.9 cm. long. Zhurovka, Krivorukovo, Barrow 407.

27 Elongated plaque with an animal at one end, and a long pointed hoof at the other. There is a loop at the back. Bronze. 9.8 cm. long. Zhurovka, Krivorukovo, Barrow 400.

28 Buckle in the form of two elongated elk heads seen in profile with the cross-piece at eye level and a stud at the opposite end. Bronze. 9.2 cm. long × 5.6 cm. wide. Zhurovka, Krivorukovo, Barrow 400.

29 Chased plate, with the upper edge bent over and the lower end rounded, showing a relief figure of a recumbent stag with head turned back and symmetrically extended antlers. Gold. 8.4 cm. long × 6.7 cm. wide. Zhurovka, Krivorukovo, Barrow 400.

30 Two plaques in the form of an animal seen in profile, its head turned *en face*. There are two loops at the back. Bronze. 5.4 cm. long × 3.9 cm. wide. Zhurovka, Krivorukovo, Barrow 401.

31 Elongated bridle frontlet with a rhomboidal widening in the middle and triangular ends decorated with figures worked in relief. At the top a recumbent stag, in the middle on a little plate attached to the frontlet, a bird with downswept wings, and at the bottom two bird heads. Gold. 24.5 cm. long × 4.9 cm. wide. Zhurovka, Krivorukovo, Barrow 401.

32	Rectangular mounting with embossed design of a stag head. The upper edge of the plate is bent over, and has attached to it a narrow strip, decorated with pellets workde in relief. Gold. 11.6 cm. high × 5.5 cm. wide. Zhurovka, Krivorukovo, Barrow 401.
33	Mirror with handle, decorated at the top with a stag and at the bottom with a ram head. Bronze. 32 cm. long. Olbia.
34	Cross-shaped plaque with schematic bird heads at the ends, two pairs of ram heads worked in relief, and a contorted beast in a circle at the intersection. Bronze. 11.2 cm. long × 9.4 cm. wide. Olbia.
35	Plaques in the form of flying birds (2 cm.), ram heads (2.4 cm.), a rosette (1.9 cm.), a Gorgon head (2.2 cm.) and a seated sphinx seen in profile (2.8 cm.). Gold. Nymphaeum, Barrow 24.
36	Ring, with the figure of a cow suckling a calf on the bezel. Gold, glass. 3.1 × 4.5 cm. Nymphaeum, Barrow 24.
37	Ring, with a flying Nike on the bezel. Gold. 2.4 cm. long × 0.7 cm. wide. Nymphaeum, Barrow 17.
38	Plaque in the form of a bird in flight. Gold. 1.4 cm. long. Nymphaeum, Barrow 17.
39	Plaques shaped as profile figures of recumbent lions. Each has two loops on the back. Gold. 1.1 cm. long. Nymphaeum, Barrow 17.
40	Plaque in the form of a lion head seen in profile, its mouth open and the mane treated as triangles. There is a loop on the back. Bronze. 7.5 cm. long. Nymphaeum, Barrow 32.
41	Necklace of beads made up of pellets and almond-shaped pendants. Gold. 27.4 cm. long. Seven Brothers, Barrow 2.
42	Plaque in the form of a human head and a lion head, back to back, united by a common comb and two central spirals. Gold. 3.5 cm. high. Seven Brothers, Barrow 2.
43	Plaque in the form of an owl with its head turned *en face*. Gold. 3.4 cm. high. Seven Brothers, Barrow 2.
44	Plaques in the form of a lion with head turned back, its raised tail terminating in a bird head. Gold. 2 cm. long. Seven Brothers, Barrow 2.
45	Round plaques in the form of a Medusa head. Gold. 2.6 cm. long. Seven Brothers, Barrow 2.
46	Plaque in the form of bearded Silenus. Gold. 3.4 cm. high. Seven Brothers, Barrow 2.
47	Plaques in the form of ox heads. Gold. 3 cm. high. Seven Brothers, Barrow 2.
48	Plaques in the form of ram heads. Gold. 3 cm. high. Seven Brothers, Barrow 2.
49	Plaques in the form of winged boars seen in profile backed by a palmette. Gold. 4.6 cm. long. Seven Brothers, Barrow 2.
50	Plaque in the form of a bird with its head turned backwards. Gold. 2.4 cm. long. Seven Brothers, Barrow 2.
51	Plaques in the form of a rosette and palmettes worked in relief. Gold. 3.2 cm., 2.5 cm. and 2.3 cm. long respectively. Seven Brothers, Barrow 2.

52 Parts of a *rhyton*: gold lion head finial and silver top of horn with smooth surface. 6.7 cm. and 9.2 cm. long respectively. Seven Brothers, Barrow 2.

53 *Phiale* with a frieze of Sileni heads inside its central boss. Silver. 21.5 cm. diam. Seven Brothers, Barrow 2.

54 Vessel stand supported on three legs shaped as animal paws. Bronze. 21.5 cm. diam. Seven Brothers, Barrow 2.

55 Goblet and lid with bud-shaped handle in centre. Alabaster. 17.3 cm. high. Seven Brothers, Barrow 2.

56 Chased vessel handle shaped as two confronted bird heads. Gold. 7.5 cm. long. Seven Brothers, Barrow 2.

57 Plaque with a rhomboidal widening in the middle. A horse frontlet; it is decorated with three recumbent stags one above the other, their heads bearing symmetrical antlers curling inwards. Bronze. 12 cm. long. Seven Brothers, Barrow 2.

58 *Rhyton* terminating in a ram head. Gold. 23.5 cm. long. Seven Brothers, Barrow 4.

59 *Rhyton* with the front of a recumbent dog at the lower end and engraved pattern of scales on the upper end. Gold. 27 cm. long. Seven Brothers, Barrow 4.

60 Double-holed cheek-piece in the form of a carnivore with its rump twisted round. Bronze. 8.8. cm. long. Seven Brothers, Barrow 4.

61 Double-holed cheek-piece in the form of a lion with its rump twisted round. Bronze. 9.5 cm. long. Seven Brothers, Barrow 4.

62 Round plaques in the form of a curled-up lion, worked in relief. Bronze. 4.6 cm. diam. Seven Brothers, Barrow 4.

63 Bridle plaque in the form of a recumbent stag with head turned backwards and widely palmated antlers symmetrically spread. Bronze. 6.6 cm. high. Seven Brothers, Barrow 4.

64 Bridle plaque in the form of a stag's head with an antler treated as three diverging bird heads, all worked in relief. Bronze. 5.7 cm. high. Seven Brothers, Barrow 4.

65 Horse frontlets decorated with heads of stag-birds. Bronze. 8.6 cm. long. Seven Brothers, Barrow 4.

66 Bridle plaques shaped as birds with triangular spread wings and raised heads with duck-like beaks. Bronze. 3.9 cm. long; 3.1 cm. long. Seven Brothers, Barrow 4.

67 Square plaque decorated with the profile figure of a sphinx. Gold. 2.7 cm. long. Seven Brothers, Barrow 6.

68 Round plaques with profile and facing human heads worked in relief. Gold. (*a*) 1.6 cm., (*b*) 1.4 cm. diam. Seven Brothers, Barrow 6.

69 Plaque in the form of a palmette. Gold. 1.2 cm. high. Seven Brothers, Barrow 3.

70 Plaque in the form of a lion seen from the side with the head turned back and tail raised. Gold. 3 cm. long. Seven Brothers, Barrow 3.

71 Plaque in the form of a recumbent goat. Gold. 3 cm. long. Seven Brothers, Barrow 3.

72 Triangular plaque filled with granulation. Gold. 1.5 cm. long. Seven Brothers, Barrow 3.

277

73 Openwork plate with an ornamental motif, recognizable as the head of a stag with its antlers spreading out in all directions and terminating in schematic bird heads. Bronze. 9 cm. high. Elizavetinskaya (1917).

74 Openwork plate forming the end of a cheek-piece with stag antlers developed into stylized branches. Bronze. 16 cm. long. Seven Brothers, Barrow 3.

75 Cheek-piece with an openwork plate in the form of antlers evolving into bird heads. Bronze. 7.5 cm. high. Elizavetinskaya (1917).

76 Openwork plaque from a cheek-piece terminal in the form of two stags with ornamental antlers and heads back to back. Bronze. 8.2 cm. high. Elizavetinskaya (1917).

77 Plaques in the form of a bird with profile view of head and body, wings and tail stylized. Gold. 2.5 cm. long. Solokha, central burial.

78 Plaques in the form of a recumbent stag, worked in relief. Gold. 2.3 cm. long. Solokha.

79 Openwork plaque in the form of a lion. Gold. 2.8 cm. long. Solokha.

80 Square plaque with an embossed design of a lion tearing a stag. Gold. 3 cm. long. Solokha.

81 Square plaques with embossed designs of two crouching Scyths drinking out of a horn. Gold. 2.9 cm. long. Solokha.

82 Bracelets with ribbed decoration. Gold. 6.9 and 7.3 cm. diam. Solokha.

83 Torque with lion-head finials. The ends are joined by a wire knot. Gold. 30 cm. diam. Solokha.

84 Rectangular plate from the casing of a wooden vessel with an embossed design of a fish, and little nails with large hemispherical heads along the edge. The upper edge is curved. Gold. 10.1 cm. long × 4.1 cm. wide. Solokha.

85 Rectangular plaque with bent-back upper edge, from the casing of a wooden vessel. It is embossed with a design of a recumbent stag, and little nails with hemispherical heads along the edge. Gold. 3.8 cm. wide × 5.1 cm. long. Solokha.

86 Square plaque embossed with a griffin. Gold. 3.3 cm. sq. Solokha.

87 Two lion-griffins confronting one another above an ornamental border. Detail of *gorytus* casing shown in plate 160. Solokha.

88 Horse frontlet shaped as a griffin head with mouth open. Palmette at the bottom. Bronze, gold. 2.1 cm. high × 4 cm. long. Solokha.

89 Oval openwork pole-top with two loops and a flat openwork stag with schematic antlers above. Bronze. 16.6 cm. high × 7.2 cm. wide. Chertomlyk.

90 Flat pole-top in the form of a frame filled with two double spirals with a vertical rod between them. Above the frame is a profile animal with a serrated comb on its neck. There are three apertures in the socket. Bronze. 17.1 cm. high × 9.3 cm. wide. Chertomlyk.

91 Brazier with a cylindrical socket at one side and openwork sides created by two bands of S-spirals. Bronze. Length, with handle, 19 cm., height 11.6 cm. Chertomlyk.

92 Two torques made of cylindrical rods with overlapping ends. One terminates in recumbent lions, the other has six figures of animals at each end. Gold. 14.8 and 15.7 cm. diam. Chertomlyk.

93 Rectangular plaque embossed with a design of a recumbent eagle-griffin seen in profile. Gold. 2.9 × 2.7 cm. Chertomlyk.

94 Rectangular plaque embossed with a design of a hare. Gold. 2.1 cm. × 1.6 cm. Chertomlyk.

95 Round plaque embossed with a design of a Gorgon head with five drop-like pendants on rings. Gold. 4.9 cm. diam. Chertomlyk.

96 Reconstruction of a 'queen's' funeral adornments. Chertomlyk.

97 Square plaque embossed with a design of a seated goddess *en face* in the middle, an altar with flame above on her left, and a worshipping Scyth with a vessel in his hands seen from the side. Electrum. 3 cm. × 3.1 cm. Chertomlyk.

98 Ring with an intaglio of a flying duck on the bezel. 2 cm. long, bezel 1.5 cm. wide. Chertomlyk.

99 Detail of silver scoop with handle terminating in a dog's head. Chertomlyk.

100 Round plaques embossed with designs of a bearded head seen in profile. Gold. 1.9 cm. diam. Chertomlyk.

101 Rectangular plaque embossed with the figure of a hippocampus with stag antlers. Gold. 2.5 cm. × 3 cm. Chertomlyk.

102 Square plaques decorated with the figure of a Scyth fighting a griffin. *Astragalos* along the edge. Gold. 2.4 cm. × 2.5 cm. Chertomlyk.

103 Round plaque decorated with the figure of a nude Hercules strangling a lion. Gold. 2.2 cm. diam. Chertomlyk.

104 Square plaque embossed with a design of flowers. Gold. 1.9 cm. × 1.7 cm. Triangular plaque ornamented with granulation. Gold. 1.5 cm. long. Round plaque in the form of a rosette. Gold. 1.8 cm. diam. Chertomlyk.

105 Rectangular plaques embossed with the figure of a lion seizing a stag. Gold. 2.9 cm. long. Chertomlyk.

106 Plaque showing a helmeted Athena in profile and a lion mask back to back. Gold. 2.4 cm. × 2.3 cm. Chertomlyk.

107 Rectangular plaque embossed with the profile figure of an ox, head turned *en face*. Edges denticulated. Gold. 1.6 cm. × 1.9 cm. Chertomlyk.

108 Figurine of a sphinx with remains of a broken rod below. Electrum, silver. 2.5 cm. high × 2 cm. wide. Chertomlyk.

109 Parts of a *calathos*-type female headdress in the form of gold plates for sewing on, bearing impressed and openwork designs of animals and ornaments. Also almond-shaped pendants, together with the five necklaces of beads and plaited threads with pendants. Gold. Band about 4 cm. broad; pendants about 3.4 cm. long. Chertomlyk.

110 Ring with intaglio of an ox on the bezel. Gold. 2.3 cm. × 2.5 cm. Chertomlyk.

111 Ring with intaglio of a dog gnawing a bone on the bezel. Gold. 2.3 cm. diam. Chertomlyk.

112 Cauldron with six figures of standing goats, used for handles, around the rim, and with relief piping forming rhombs on the surface. Bronze. 1.07 m. high. Chertomlyk.

279

113	Cauldron with two handles on the rim and relief piping forming rhomboid figures on the surface. Bronze. 59 cm. high. Chertomlyk.
114	Rectangular plaque embossed with the figure of a woman (goddess) sitting on a throne and holding a mirror. A worshipping Scyth drinks from a horn. The edge is decorated. Gold. 3.6 cm. × 3.8 cm. Chertomlyk.
115	Round embossed plaque shaped as the head of a full-face Dionysus with abundant hair and wearing an ivy wreath. Gold. 3.6 cm. × 3.9 cm. Chertomlyk.
116	Confronted griffins and palmettes, worked in relief. Detail of the mounting of the *gorytus* shown in plate 181. Gold. 19 cm. long × 6.5 cm. wide. Chertomlyk.
117	Whetstone with a gold terminal. 18.5 cm. long. Chertomlyk.
118	Casing for sword-hilt, worked in relief, having a spotted panther on the pommel, a profile schematic figure of a stag with antlers thrust forward on the handle and confronted griffins on the guard. Gold. 14 cm. long. Chertomlyk.
119	Bridle trappings consisting of a plate frontlet with engraved and sculptured animal head; two cheek-pieces with designs of birds and ornament, partly in outline and partly engraved; two runners shaped as truncated cones; six discs with a silver loop on the reverse. Gold. 5.5 cm. × 3.7 cm.; 8.2 cm. × 8.3 cm.; 2.2 cm. diam.; 1 cm. and 0.8 cm. high, respectively. Chertomlyk.
120	Saddle trappings consisting of figured and rectangular embossed or *repoussé* plates from the front and back pommel, and four discs with traces of silver loops on the reverse. Gold. Plates 31 cm. and 21.8 cm. long × 2.2 cm. wide; discs 5.5 cm. diam. Chertomlyk.
121	Parts of a headdress consisting of a long band with tapering ends decorated with acanthus, narrow bands with almond-shaped pendants attached by rings or hooks, and figures of dancing maenads. Gold. Maximum width of band 3.6 cm.; maenads 4.6 cm. high. Deev Barrow.
122	Pair of pendants shaped as sphinxes from which figurines of little ducks are suspended by chains. Gold. 7.2 cm. high × 2.4 cm. wide. Deev Barrow.
123	Pole-top with socket shaped like a truncated cone, decorated with the figure of a hippocampus seizing a four-footed animal. Bronze. 13.3 cm. high × 8.6 cm. wide. Krasnokutsk Barroro.
124	Biconical cut-out pole-top decorated with two loops and a griffin. Bronze. 17.2 cm. high × 8.2 cm. wide. Krasnokutsk Barrow.
125	Biconical cut-out pole-top decorated with two loops and a figure of a flying bird. Bronze. 8.8 cm. high × 5 cm. wide. Krasnokutsk Barrow.
126	Horse frontlet decorated with the head of an animal with protruding ears and open mouth. Silver. 9.1 cm. high × 4.7 cm. wide. Krasnokutsk Barrow.
127	Swastika plaque with four animal heads grouped around a central circle. There is a loop on the back. Silver, engraved. 6 cm. diam. Krasnokutsk Barrow.
128	Openwork figured and engraved plaque having two animal heads with long necks at the top and curving ornamental stripes at the bottom. There is a loop on the back. Silver, engraved. 14.5 cm. high × 8.9 cm. wide. Krasnokutsk Barrow.
129	Rectangular plate with engraved designs of two griffin heads back to back at the top and ornamental stripes and palmettes at the bottom. Silver, engraved. 8.8 cm. high × 6.3 cm. wide. Krasnokutsk Barrow.

130 Plaque in the form of a winged goddess *en face* holding two beasts, the fore parts of which are flanking her. Iron with silver mounting; one side is covered with gold leaf. 10 cm. high × 12 cm. wide. Alexandropol Barrow.

131 Openwork plaques decorated with fighting beasts. Gold. 4.6 cm. wide. Alexandropol Barrow.

132 Bridle frontlet shaped as an oval plate with two palmettes in relief and a sculptured horse head with a knob on its forehead and an aperture in the neck. Gold. Head 2.7 cm. high; plate 4.5 cm. long × 2.3 cm. wide. Alexandropol Barrow.

133 Openwork plaque with semicircular upper edge enclosing two confronted griffins. A tongue-and-dart pattern runs along the convex edge, lotus flowers and palmettes along the bottom. Gold. 9.4 cm. high × 8.6 cm. wide. Alexandropol Barrow.

134 Openwork plaque of the same type as shown in fig. 133, but with a griffin and a hippocampus attacking a carnivore as theme. Gold. 9.3 cm. high × 8.7 cm. wide. Alexandropol Barrow.

135 Torque with lion-head finials, and two boat-shaped earrings with a griffin head at one end and a granulated design on the surface. Gold. Torque 23 cm. diam.; earrings 6.3 cm. high. (*a*) Talayevsky Barrow, (*b*) Dort Oba, Barrow 2.

136 Plaque in the form of a recumbent lion worked in relief. Gold. 3.9 cm. long. Dort Oba, Barrow 2.

137 Plaque in the form of a sphinx seen from the side. Gold. 2.8 cm. long. Dort Oba, Barrow 2.

138 Plaques in the form of a four-legged winged beast, its tail terminating in bird heads. Gold. 2.9 cm. long. Dort Oba, Barrow 2.

139 Detail of painted plank of a sarcophagus. Wood. 2.25 m. long × 0.20 m. wide. Kul Oba.

140 Torque, the terminals decorated with figures of recumbent lions. Electrum. 21.8 cm. diam. Kul Oba.

141 Ring decorated with the figures of four recumbent lions. Gold. 2.5 cm. diam. Kekuvatsky Barrow.

142 Ring decorated with the figure of a recumbent lion on one side and the figure of Artemis with a bow on the other. Gold. Bezel 1.2 cm. high. Great Bliznitsa.

143 Other side of ring shown in fig. 142.

144 Ring with sculptured figure of a scarab on one side and an intaglio figure of Aphrodite with young Eros fastening her sandal on the back. (See also plate 280.) Gold. Bezel 2.5 cm. long. Great Bliznitsa.

145 Square plaque showing a head of Demeter, with ears of corn in her hair framed in a wide border of ovoids, all worked in relief. Gold. 6 cm. long. Great Bliznitsa.

146 Plaque similar to that shown in fig. 145, but depicting a head of Kore with torch. Gold. 6 cm. long. Great Bliznitsa.

147 Plaque similar to that shown in fig. 145, but depicting a wreathed head of Hercules with his club. Gold. 6 cm. long. Great Bliznitsa.

148 Round plaque with a Gorgon head. Gold. 4.5 cm. diam. Great Bliznitsa.

149 Round plaques in the form of rosettes. Gold. 4.9 cm. and 2.5 cm. diam. Great Bliznitsa.

150	Round plaques embossed with a Helios head, protome of Pegasus, and an Athena head *en face*. Gold. 1.3 cm. diam. Great Bliznitsa.
151	Two-holed cheek-piece terminating at one end in a stag head set in a quadrangular frame and at the other in a hoof. Bronze. 13.5 cm. long; frame 5 cm. wide. Great Bliznitsa.
152	Spiral bracelet with the figure of a recumbent lion and a palmette worked in relief at the ends. Gold. 7 cm. diam. Great Bliznitsa.
153	Statuette of Hercules holding an amphora and a club. Clay. 11.4 cm. high. Great Bliznitsa.
154	Spiral bracelet terminating in relief figures of hippocampi. Gold. 7 cm. diam. Karagodeuashkh.
155	Round medallion bearing a human head wearing an ivy wreath. The edges of the medallion are turned in. Gold. 3.4 cm. diam. Karagodeuashkh.
156	Two *rhyta* decorated around the upper edge with engraved figures of a panther attacking a stag, a lion, an ox, and palmettes. Silver. 47 cm. and 35.4 cm. long. Karagodeuashkh.
157	A mounted figure. Detail of *rhyton* decorated with engravings and relief designs of cult scenes, birds and a scale ornament. Silver. 62.2 cm. high. Karagodeuashkh.

LIST OF SITE DIAGRAMS

LIST OF PLATES

Frontispiece: Detail of *rhyton* shown in plate 117.

1 Hilt and scabbard of sword. Sheet gold. Hilt 16.5 cm. long; scabbard 43.4 cm. long × 12.1 cm. wide. Melgunov Treasure.

2, 3 Details of upper part of scabbard shown in plate 1.

4 Egg-shaped openwork pole-top. Bronze. 35 cm. high × 11.5 cm. wide. Kelermes, Barrow 3 (1903).

5 Two pole-tops. Bronze. 17.1 cm. high × 10 cm. wide. Kelermes, Barrow 1 (1904).

6 Sword in scabbard. Iron. Hilt and scabbard embossed in sheet gold. Hilt 15.5 cm. long, 7 cm. wide; scabbard 47 cm. long, 14.1 cm. wide. Kelermes, Barrow 1 (1903).

7 Detail of lower portion of hilt and upper portion of scabbard shown in plate 6.

8 Detail of scabbard shown in plate 6.

9 Ceremonial hatchet. Butt, shaft-hole and handle mounted in sheet gold. 72 cm. long. Kelermes, Barrow 1 (1903).

10—19 Details of hatchet shown in plate 9.

20 Fragments of *rhyton* with engraved design. Silver. 6.5 cm. diam. Kelermes, Barrow 3 (1903).

21 Rectangular plate from casing of *gorytus*. Gold. 40.5 cm. long × 22.2 cm. wide. Kelermes, Barrow 4 (1903).

22 Shield centre-piece. Gold. Ear, eye and nose inlaid with coloured enamel. 36.6 cm. long × 16.2 cm. high. Kelermes, Barrow 1 (1903).

23 Back of shield shown in plate 22.

24 Panther's head. Detail of shield centre-piece shown in plate 22.

25 Diadem or headband. Gold, traces of enamel. 21 cm. diam., 1.8 cm. high. Kelermes, Barrow 3 (1903).

26 Detail of diadem shown in plate 25.

27 Detail of diadem shown in plate 28.

28 Diadem. Gold, amber inlay in the central rosette. 66.8 cm. long × 7.2 cm. wide. Kelermes, Barrow 1 (1903).

29 Back of mirror. Silver and gold leaf. 17 cm. diam. Kelermes, Barrow 4 (1904).

30—33 Sections of back of mirror shown in plate 29.

34 Semi-cylindrical hollow object of uncertain purpose. Gold and amber. 19.2 cm. long. Kelermes, Barrow 2 (1904).

35 Mirror. Bronze. 15.2 cm. diam. Kelermes, Barrow 2 (1904).

36 Two semi-cylindrical objects, purpose uncertain, as shown in plate 34. Kelermes, Barrow 2 (1904).

37—39 Details of plate 34.

283

85, 86	Pair of earrings. Gold. 3.5 cm. long. Olbia.
87	Candelabrum. Bronze. 1.16 m. high. Nymphaeum, Barrow 24.
88, 89	Back and front views of figure on candelabrum shown in plate 87.
90	Necklace. Gold and enamel. 18 cm. long, individual links 1.5 cm. long. Nymphaeum, Barrow 17.
91	Part of a double-perforated cheek-piece. Bronze. 9.1 cm. long. Nymphaeum, Barrow 24.
92	Bridle plaque. Bronze. 4.1 cm. long. Nymphaeum, Barrow 24.
93	Embossed bridle plaque. Bronze. 4.4 cm. long. Nymphaeum, Barrow 24.
94	Embossed ornament. Gold. 2.9 cm. high × 3.1 cm. wide. Nymphaeum, Barrow 17.
95	Embossed figure. Gold. 2.6 cm. long. Nymphaeum, Barrow 17.
96	Embossed ornament. Gold. 4.5 cm. high. Nymphaeum, Barrow 17.
97	Embossed ornament. Gold. 2.2 cm. high. Nymphaeum, Barrow 17.
98	Boat-shaped earring. Gold. 2.3 cm. high. Nymphaeum, Barrow 17.
99	Embossed ornament. Gold. 2.9 cm. high. Nymphaeum, Barrow 17.
100	Embossed ornament. Gold. 2.4 cm. long. Nymphaeum, Barrow 17.
101	Embossed ornament. Gold. 4.1 cm. long. Nymphaeum, Barrow 17.
102	Embossed ornament. Gold. 2.2 cm. long. Nymphaeum, Barrow 17.
103	Embossed ornament. Gold. 2.2 cm. high. Nymphaeum, Barrow 17.
104	Embossed ornament. Gold. 2.2 cm. high. Nymphaeum, Barrow 17.
105	Embossed ornament. Gold. 2.3 cm. long. Nymphaeum, Barrow 17.
106	Embossed ornament. Gold. 2.4 cm. long. Nymphaeum, Barrow 17.
107	Embossed ornament. Gold. 3.5 cm. long. Seven Brothers, Barrow 2.
108	Embossed ornament. Gold. 2.6 cm. long. Seven Brothers, Barrow 2.
109	Embossed ornament. Gold. 2.3 cm. high. Seven Brothers, Barrow 2.
110	Embossed ornament. Gold. 2.4 cm. high. Seven Brothers, Barrow 2.
111	Embossed ornament. Gold. 3.1 cm. long. Seven Brothers, Barrow 2.
112	Embossed ornament. Gold. 2.6 cm. long. Seven Brothers, Barrow 2.
113	Embossed pectoral. Silver with gold plating. 34.3 cm. high. Seven Brothers, Barrow 2.
114	Two bridle frontlets. Bronze. 6 cm. high. Seven Brothers, Barrow 2.
115	Bridle plate. Bronze. 9 cm. long. Seven Brothers, Barrow 2.
116	Triangular plate. Gold. 9.4 cm. high × 11 cm. wide. Seven Brothers, Barrow 2.
117	*Rhyton*. Silver, traces of gold mounting. 63 cm. long, 14.6 cm. and 4 cm. diam. Seven Brothers, Barrow 4.
118	Triangular plate. Gold. 10.3 cm. high. Seven Brothers, Barrow 4.
119	Detail of silver *rhyton* shown in plate 117.
120	Triangular plate. Gold. 12.6 cm. high × 10 cm wide. Seven Brothers, Barrow 4.
121	Triangular plate. Gold. 8.3 cm. high. Seven Brothers, Barrow 4.
122	Triangular plate. Gold. 9.8 cm. high. Seven Brothers, Barrow 4.
123	Part of cheek-piece. Bronze. Seven Brothers, Barrow 4.
124	Mirror-handle. Bronze. 25 cm. high. Seven Brothers, Barrow 4.
125	Double-perforated cheek-piece. Bronze. 17 cm. long. Seven Brothers, Barrow 2.
126	Bridle plaque. Bronze. 19.5 cm. long. Seven Brothers, Barrow 4.
127	Bridle plaque. Bronze. 7 cm. long. Seven Brothers, Barrow 4.
128	Bridle plaque. Bronze. 6 cm. long. Seven Brothers, Barrow 4.
129	Bridle frontlet. Bronze 4.8 cm. high. Seven Brothers, Barrow 4.
130	Bridle plaque. Bronze. 4.7 cm. long. Seven Brothers, Barrow 4.
131	Ring. Electrum, chalcedony and gold. 2.8 cm. long. Seven Brothers, Barrow 3.
132	Ring. Gold. 1.6 cm. long. Seven Brothers, Barrow 6.
133	Bracelet of plaited wire. Gold. 23.7 cm. long. Seven Brothers, Barrow 4.
134	Ring. Gold. 2.8 cm. long. Seven Brothers, Barrow 6.
135	Plaque from the end of cheek-piece. Bronze. 12.1 cm. long. Seven Brothers, Barrow 3.
136	Ornamental plaque. Bronze. 10.4 cm. long. Seven Brothers, Barrow 3.
137	Sword pommel. Iron, silver. 6 cm. long. Seven Brothers. Barrow 3.

LIST OF BARROWS

Ak-Burun, near Kerch. Excavated by the Russian War Department in 1875.
Literature: OAK, 1875, p. XXXII ff; 1876, p. 5 ff, pls I, II.

Ak-Mechet at Kara-Markit, near the Bay of Ak-Mechet, Crimean region. Chance finds in 1885.
Literature: OAK, 1882—8, pp. XXI, 126, figs 107—8.

Alexandropol Barrow (Meadow Tomb), at the village of Alexandropol in Dnepropetrovsk region. Accidental finds in 1851 followed by excavations in 1852/4 and 1855/6.
Literature: Izvlechenie iz vsepoddanneishego otczeta ob arkh. razyskaniyakh, 1853 (St Petersburg, 1855), p. 50 ff, figs 22—56. *OAK*, 1859, p. IV ff. *DGS*, I, pp. 1—25, figs on pp. 1, 24, 25, pls A, I—XXI. *ZRAO*, VII (1895), p. 24 ff, pls I—XVI. *RD*, 2, p. 90 ff, figs 73—89.

Annovka, farm in Dnepropetrovsk region (formerly Kherson government and Odessa district). Accidental finds in 1896.
Literature: OAK, 1897, p. 79, fig. 186. *MAR*, 32, p. 25 ff, pl. III.

Baby, at Mikhailovo-Apostolovo in Dnepropetrovsk region. Dug by Evarnitsky in 1897.
Literature: OAK, 1897, p. 133 ff, figs 257—69.

Bolshaya (Great) Bliznitsa, at the village of Steblievka in the Taman Peninsula. Excavations by E.I. Zabelin and A.E. Lyutsenko in 1864, the latter in 1865/8, Verebryusov in 1883, Gross in 1884/5.
Literature: OAK, 1864, pp. IV—X; 1865, p. 111, app. p. 5 ff, pls I—VI; 1866, app. p. 5 ff; pls I—II; 1868, p.V ff; 1869, p. 5, pls I—IV; 1882—8, pp. XXXVIII—IX. L. Stephani, *Grobnitsa zhritsy Demetry* (St Petersburg, 1873). *ADZH*, 10—29, figs 1—5, pls IV—VI, VII (2—4), VII—X, XI (1). *RD*, I, p. 109 ff, figs 23,43, 45, 55, 66—8, 75, 81, 84, 91, 99—103, 124—7.

Chertomlyk, north-west of Nikopol in Dnepropetrovsk region. Excavations by Zabelin in 1862/3.
Literature: OAK, 1862, p. XVI ff; 1863, p. III. *DGS*, 2, p. 74 ff; figs on pp. 81, 82, 92, 108, 109, 114, 118, pls XXVII—XXXI. *Drevnosti*, I, p. 71 ff. *RD*, 2, p. 105 ff, figs 93—8. *Sbornik Bobrinskomu*, p. 45 ff, pls 10a, 17b, c, 22d.

Chmyrev, at Belozerka, Zaporozhie region. Excavations by Braun in 1898 and Veselovsky in 1909/10.
Literature: OAK, 1898, p. 26 ff, figs 24—41, 143, 144; 1909—10, p. 127, figs 190—202. *IAK*, 19, p. 96 ff, figs 32—72.

Deev Barrow, at Nizhniye Serogozy in Kherson region. Excavated by Veselovsky in 1891, and by Dumberg in 1897.
Literature: OAK, 1891, p. 73, figs 53, 54; 1897, p. 31, figs 94—126, *IAK*, 19, p. 169 ff, figs 4, 36—41, pls XII (1—28), XIV (31), XV (1—3, 4—6, 9—11, 39).

Dort Oba, near farm 'Krasny', Simferopol region in Crimea. Excavations by Veselovsky in 1892.
Literature: OAK, 1892, p. 6 ff, figs. 4—6.

Elizavetinskaya, Krasnodar territory. Excavations by Veselovsky in 1912/17.
 Literature: OAK, 1912, p. 57 ff, figs 84, 85; 1913–15, p. 148 ff, figs 229–36. *IAK*,
 65, p. 1 ff, pl. I. *MAR*, 37, p. 66, fig. 34.

Elizavetovskaya, Rostov region. Excavations by Ushakov in 1901 and Miller in 1908/14.
 Literature: OAK, 1911, p. 150; 1908, p. 129, figs 185, 186; 1909/10, p. 141 ff,
 fig. 210. *IAK*, 35, p. 86 ff, figs 1–30, pl. V; 56, p. 225 ff, figs 1–60; *OAK*, 1912,
 p. 51 ff; 1913–15, p. 171.

Five Brothers, near Elizavetovskaya in Rostov region. Excavations by Shilov in 1959.
 Literature: SA, 1961, I, p. 150 ff, figs 1–15.

Frequent Barrows, near Voronezh city. Excavations by the city's research archive committee
 in 1910/15.
 Literature: SA, VIII, p. 9 ff, figs 1–42. *MAR*, 34, p. 79 ff, pls I–III, V (2).

Geremes Barrow, near Geremes farm, Zaporozhie region. Excavations by Zabelin in 1859.
 Literature: OAK, 1859, p. VI. *DGS*, 2, p. 29 ff, figs on pp. 29, 42, pls B, I and
 XII (1, 3, 4, 6, 8, 9). *RD*, 2, p. 101, fig. 90.

Golden Barrow, near Simferopol in the Crimea. Excavations by Veselovsky in 1890.
 Literature: OAK, 1890, p. 4 ff, figs 1–3. *MAR*, 37, p. 40, pl. IX.

Ilyintsi, Vinnitsky region (formerly Kiev government). Excavations by Brandenburg in 1901–2.
 Literature: Sbornik Bobrinskomu, p. 55 ff, fig. 1, pls I, III.

Karagodeuashkh, near Krymskaya village, Krasnodar territory. Excavations by Felitsin in 1888.
 Literature: OAK, 1882/8, p. CCXVI ff. *MAR*, 13.

Kelermes, Krasnodar territory. Excavations by Schultz in 1903, and Veselovsky in 1904.
 Literature: OAK, 1903, p. 168; 1904, p. 85 ff, figs 134–60

Kekuvatsky Barrow, near Kerch. Excavations by Ashik in 1839.
 Literature: DBK, p. XIX, pls IV (2), XVIII (6), XXVII (16, 17), XXVIII (4, 8),
 XXXIV (2).

Kostromskaya, Krasnodar territory. Barrow 1 excavated by Veselovsky in 1897.
 Literature: OAK, p. 11 ff, figs 42–8.

Kherson, north of the town on the road to Rozhnov farm. Robbed. Excavated in 1896.
 Literature: OAK, 1896, p. 82 ff, figs 336–8. *MAR*, 32, p. 1 ff, pl. 1.

Krasnokutsk Barrow, near village of same name in Dnepropetrovsk region. Excavation by Za-
 belin in 1860.
 Literature: OAK, 1860, p. VII ff. *DGS*, 2, p. 43 ff, pls C, CXXIII–V. *RD*, 2,
 p. 43, figs 91–2. Semenov-Zuser, Krasnutskiye Kurgany, *Zapiski Kharkovskogo Gos.*
 Univ., 15 (1939), p. 63 ff.

Kulakovsky, between rivers Alma and Kacha in the Crimea. Barrow 2 dug by Kulakovsky in 1895.
 Literature: OAK, 1895, p. 17 ff, figs 32–4.

Kul Oba, near Kerch. Discovered accidentally in 1830. Inspected by Lyutsenko in 1875.
 Literature: DBK, p. XXII, pls II (1–3), VIII (1, 2), IX (1), XIII (1–3), XIX
 (1, 4), XX (6, 9, 11), XXV, XXVI (2, 3), XXVII (10), XXVII (8), XXX (7, 9, 10),
 XXXI (7), XXXII (1, 2), XXXIII (1), XXXIV (1–4), XXXV (4–6), XXXVII (1).
 XLI (1, 11–13), LXXIX (1, 2, 7–10, 13, 14, 17), LXXX (14, 19), LXXXIII,
 LXXXIV. Ashik, *Bosporskoye Tsarstvo*, II (Odessa, 1848), p. 29 ff. *RD*, 2, p. 35 ff,
 figs 1, 20, 34, 38, 44, 64–72, 117–20, 125, 126, 130, 131, 135, 144. *OAK*, 1875,
 p. XXXI.

Lemeshev Barrow, near Great Znamenka, Kherson region. Excavated by Veselovsky in 1911.
 Literature: OAK, 1911, p. 33 ff, figs 61–3.

Little Lepatikha, Kherson region. Barrow 2 dug by Veselovsky in 1915.
 Literature: OAK, 1913/15, p. 136 ff, figs 222, 275.

Martonosha, Kirovograd region. Chance finds in 1870, excavated by Yastrebov in 1889.
 Literature: OAK, 1889, p. 36 ff, fig. 12. *MAR*, 32, p. 36 ff, figs 16–18.

Melgunov Treasure, 'Litoy Barrow', near Kirovograd in Kirovograd region. Excavations by
 Melgunov in 1763, and by Yastrebov in 1894.

291

Literature: MAR, 31. *ZRAO* XII, 1—2, p. 270 ff (Spyzin).

Merdzhany, near Anapa, Krasnodar territory. Excavated by Spiro in 1876.

Literature: IAK, 19, p. 133 ff, pls X—XII (Rostovtsev).

Mordvinov Barrow, near Kakhovka, Kherson region. Barrow 1 excavated in 1916.

Literature: Hermes, 1916 (12), p. 1 ff.

Nymphaeum Barrows, near village of Geroyevskoye (Eltigen) on Kerch peninsula. Excavated between 1867 and 1880.

Literature: OAK, 1867, p. XVI, pl. V (1); 1868, pls I, (1—4), V (1, 3, 4), VI; 1876, pp. VIII ff, 220, figs on pp. 222, 223, 228—34, 240, pl. III. *MIA*, 69, pp. 5—107, figs 1—51.

Oguz, at Nizhniye Serogozy in Kherson region. Dug by Veselovsky in 1891/4 and by Rot in 1904.

Literature: OAK, 1891, p. 72; 1892, p. 2; 1893, p. 7; 1894, pp. 9 ff, 62 ff, figs 128—32; 1903, p. 166, fig. 323. *IAK*, 19, p. 157 ff, 1877, figs 1—35, pl. XIV. *DP*, VI (473—98).

Pavlovsky Barrow, near Kerch on Cape Pavlovsky. Excavated by Lyutsenko in 1858.

Literature: OAK, 1859, app. 1, p. 5 ff, app. 2, p. 30 ff, pls I—III, V (1—6); 1878/9, p. 40, pl. III (1—3). *DBK*, pl. XXXIV (2). *RD*, 2, fig. 40.

Pointed Barrow, near Tomakovka in Dnepropetrovsk region. Excavated by Zabelin in 1861 and chance finds in 1862.

Literature: OAK, 1861, p. VIII ff. *DGS*, 2, p. 62 ff, pls D, XXVI (8, 10, 13, 14, 16—18). *RD*, 2, p. 114.

Raskopana Barrow, at Mikhailovo-Apostolovo in Dnepropetrovsk region. Dug in 1897.

Literature: OAK, 1897, p. 133 ff, fig. 270.

Rogachik, Upper, Kherson region. Dug by Veselovsky in 1914.

Literature: OAK, 1913—15, p. 132 ff, figs 218—21.

Ryzhanovsky Barrow, Cherkassk region. Barrow 4 dug in 1887.

Literature: Smela, II, p. 138 ff, fig. 18, pls XVI—XIX. *MRZ*, p. 71 ff, figs 17—33.

Seven Brothers, near Varennikovskaya village in Krasnodar region. Dug 1875/8.

Literature: OAK, 1875, p. IV ff; 1876, p. III ff, app. pp. 5, 115, 118, 122, 127, 129, 133—8, 147—9, 219, figs on pp. 123—7, 130—7, pls I (1—5), II (2—9, 15—22), III (1—36), IV; 1877, p. 6 ff, figs on pp. 5—9, 13, 14, pls I (1—4), II; 1878—9, pp. VII—VIII, app. pp. 120—34, figs 2, 4, 5, pls IV, V; 1880, p. 95, pl. IV (11—18); 1881, p. 5 ff, fig. on p. 7, pl. I (1—4). *RD*, 2, p. 117 ff, figs 102—5.

Solokha, between Great Znamenka and Upper Rogachik in Zaporozhie region. Dug by Veselovsky in 1912/13.

Literature: OAK, 1912, p. 40 ff, figs 54—64; 1913—15, p. 104 ff, figs 173—217. *IAK*, 47, p. 96 ff, pls II and III; supp. to issue 50, p. 192 ff. *Starye Gody* (Feb., 1914; March, 1919). *IRAIMK*, II, p. 23, pls IV—IX.

Shulgovka or Novonikolayevka, Zaporozhie region. Dug by Veselovsky in 1889/91.

Literature: OAK, 1889, p. 17 ff, figs 8—10; 1890, p. 14 ff, figs 6—11; 1891, p. 69 ff, figs 43—52.

Talayevsky Barrow, near Fruktovoye in the neighbourhood of Simferopol. Dug by Veselovsky in 1891.

Literature: OAK, 1891, p. 76 ff, figs 56—8. *Istoriya i Arkheologiya Drevnego Kryma*, 1957, p. 155 ff, figs 1—19.

Temir Mountain, near Kerch. Big barrow, pit 81, dug in 1870.

Literature: OAK, 1870—1, p. XX ff.

Tsimbalka, near Great Belozerka in Zaporozhie region. Dug by Zabelin in 1867/8.

Literature: OAK, 1867, p. XIX; 1868, p. XIV ff. *RD*, 2, p. 115 ff.

Tsukur estuary, western shore of the estuary in the Taman peninsula. Chance find in 1913.

Literature: IAK, 63, p. 31 ff, figs 6, 11, 17, 18, pl. III.

Ulski village, Krasnodar district. Dug by Veselovsky in 1898, 1908 and 1909.

Literature: OAK, 1898, p. 29 ff, figs 42—7, pl. opp. p. 32; 1908, p. 118, figs 166—9; 1909/10, p. 147 ff, figs 211—19. *MAR*, 31, pls VI (1), XII (4—6). *IRAIMK*, II, p. 193 ff, pl. XV.

Ushakovsky Barrow, see Elizavetovskaya.

Ust-Labinskaya, Krasnodar territory. Barrow 2 dug by Veselovsky in 1903.

Literature: OAK, 1903, p. 69, fig. 127.

Voronezhskaya, Krasnodar territory. Dug by Veselovsky in 1903.

Literature: OAK, 1903, p. 75, figs 139—53.

Zhurovka, at the village of that name on plots of Krivorukovo and Goryachevo. Kiev region Dug by Bobrinsky in 1903 and 1904.

Literature: IAK, 14, p. 5 ff, figs 1—80; 17, p. 77 ff, figs 1—39.

ABBREVIATIONS

ADZ:	Rostovtsev, M.I., *Antichnaya dekorativnaya zhivopis*
DBK:	*Drevnosti Bospora Kimmeriyskogo*
DHS:	*Drevnosti Herodotovoy Skifii*
DP:	Khanenko, B.I., V.I., *Drevnosti Pridneprovya*
Drevnosti:	*Drevnosti. Trudy Moskovskogo archeologicheskogo obshchestva*, Moscow
IAK:	*Izvestiya Imperatorskoy Arkheologicheskoy Komissii*, St Petersburg — Petrograd
IRAIMK:	*Izvestiya Rossiiskoy Akademii Istorii Materialnoy Kultury*, Petrograd
ITUAK:	*Izvestiya Tavricheskoy uchenoy arkhivnoy komissii*, Simferopol
MAR:	*Materialy po Arkheologii Rossii*, St. Petersburg
MIA:	*Materialy i Issledovaniya po Arkheologii SSSR.*, Moscow — Leningrad
OAK:	*Otchet Imperatorskoy Arkheolohicheskoy Komissii*, St Petersburg — Petrograd
RD:	Tolstoy, I.I., Kondakov, N.P., *Russkiye Drevnosti*
RLV:	*Real-Lexicon der Vorgeschichte* (Ebert M.)
SA:	*Sovetskaya Arkheologiya*, Moscow—Leningrad
Sbornik Bobrinskomu: Sbornik Arkheologicheskikh Statei, podnessennyi grafu A.A. Bobrinskomu v den 25-letiya predsedatelstva v Imperatorskoy Arkheologicheskoy Komissii, St Petersburg, 1911	
Smela:	Bobrinsky, A.A., *Kurgany i sluchainye nakhodki bliz mestechka Smela*
ZOO:	*Zapiski Odesskogo arkheologicheskogo obshchestva*, Odessa
ZRAO:	*Zapiski imperatorskogo Russkogo arkheologicheskogo obshchestva*, St Petersburg

INDEX